P9-DFV-993

Adobe Photoshop CS6 for Photographers

A professional image editor's guide to the creative use of Photoshop for the Macintosh and PC

Martin Evening

ELSEVIER

AMSTERDAM • BOSTON • HEIDELBERG • LONDON • NEW YORK • OXFORD
PARIS • SAN DIEGO • SAN FRANCISCO • SINGAPORE • SYDNEY • TOKYO
Focal Press is an imprint of Elsevier

Focal Press is an imprint of Elsevier
The Boulevard, Langford Lane, Kidlington, Oxford, OX5 1GB, UK
30 Corporate Drive, Suite 400, Burlington, MA 01803, USA

First published 2012

Copyright © 2012, Martin Evening. Published by Elsevier Ltd. All rights reserved

The right of Martin Evening to be identified as the author of this work has been
asserted in accordance with the Copyright, Designs and Patents Act 1988

No part of this publication may be reproduced or transmitted in any form or by
any means, electronic or mechanical, including photocopying, recording, or any
information storage and retrieval system, without permission in writing from the
publisher. Details on how to seek permission, further information about the Publisher's
permissions policies and our arrangement with organizations such as the Copyright
Clearance Center and the Copyright Licensing Agency, can be found at our website:
www.elsevier.com/permissions

This book and the individual contributions contained in it are protected under copyright
by the Publisher (other than as may be noted herein).

British Library Cataloguing in Publication Data
A catalogue record for this book is available from the British Library

Library of Congress Control Number: 2012937004

ISBN: 978-0-240-52604-1

For information on all Focal Press publications
visit our website at focalpress.com

Printed and bound in Canada

12 13 14 15 10 9 8 7 6 5 4 3 2 1

Working together to grow
libraries in developing countries

www.elsevier.com | www.bookaid.org | www.sabre.org

ELSEVIER BOOK AID
 International Sabre Foundation

Trademarks/Registered Trademarks
Brand names mentioned in this book are protected by their respective trademarks
and are acknowledged

Contents

1 Photoshop fundamentals 1

2 Configuring Photoshop 85

3 Camera Raw image processing 127

10 Blur, optical and lighting effects filters 577

11 Image management 623

12 Print output 687

13 Automating Photoshop 711

Index 725

Introduction

When I first started using Photoshop, it was a much simpler program to get to grips with compared with what we see today. Since then Adobe Photoshop CS6 has evolved to give photographers all the tools they need. My aim is to provide you with a working photographer's perspective of what Photoshop CS6 can do and how to make the most effective use of the program.

One of the biggest problems writing a book about Photoshop, is that while new features are always being added, Adobe rarely removes anything from the program. Hence, Photoshop has got bigger and more complex over the 16 years or so I have been writing this series of books. When it has come to updating each edition this has left the question, 'What should I add and what should I take out?' This edition of the book is actually slightly bigger than previous versions, but is completely focused on the essential information you need to know when working with Photoshop, Camera Raw and Bridge, plus all that's new in Photoshop CS6 for photographers. Consequently, you'll find a lot of the content goes into greater detail than before on subjects such as Camera Raw editing and high dynamic range imaging.

I work mostly as a professional studio photographer, running a photographic business close to the heart of London. On the days when I am not shooting or working on production, I use that time to study Photoshop, present seminars and write my books. This is one of the reasons why this series of Photoshop books has become so successful, because I have had plenty of experience working as a professional photographer. Although I have had the benefit of a close involvement with the people who make the Adobe Photoshop program, I make no grandiose claims to have written the best book ever on the subject. Like you, I too have had to learn all this stuff from scratch. I simply write from personal experience and aim to offer a detailed book on the subject of digital photography and Photoshop. It is not a complete guide to everything that's in Photoshop, but it is one of the most thorough and established books out there; one that's especially designed for photographers.

Macintosh and PC keys

Throughout this book I refer to the keyboard modifier keys used on the Macintosh and PC computers. Where the keys used are the same on both platforms, such as the *Shift* key, these are printed in gray. Where the keys used are different on each system, I show the Macintosh keys in magenta and the PC equivalents in blue. So, if the shortcut used is Command (Mac) and Control (PC) this appears abbreviated in the text as: ⌘ and *ctrl*.

This title was initially aimed at intermediate to advanced users, but it soon became apparent that all sorts of people were enjoying the book. As a result of this, I have over the years adapted the content to satisfy the requirements of a broad readership. I still provide good, solid, professional-level advice, but at the same time I try not to assume too much prior knowledge, and make sure everything is explained as clearly and simply as possible. The techniques shown here are based on the knowledge I have gained from working alongside the Photoshop engineering team at various stages of the program's development as well as some of the greatest Photoshop experts in the industry – people such as Katrin Eismann, the late Bruce Fraser, Mac Holbert, Ian Lyons, Andrew Rodney, Seth Resnick, Jeff Schewe and Rod Wynne-Powell, who I regard as true Photoshop masters. I have drawn on this information to provide you with the latest thinking of how to use Photoshop to its full advantage. So rather than me just tell you "this is what you should do, because that's the way I do it", you will find frequent references to how the program works and reasons why certain approaches or methods are better than others. These discussions are often accompanied by diagrams and step-by-step tutorials that will help improve your understanding of the Photoshop CS6 program. The techniques I describe here have therefore evolved over a long period of time and the methods taught in this book reflect the most current expert thinking about Photoshop. What you will read here is a condensed version of that accumulated knowledge. I recognize that readers don't want to become bogged down with too much technical jargon, so I have aimed to keep the explanations simple and relevant to the kind of work most photographers do.

We have recently seen some of the greatest changes ever in the history of photography, and for many photographers it has been a real challenge to keep up with all these latest developments. Photoshop has changed a lot over the years, as has digital camera technology. As a result of this, as each new version of Photoshop comes out I have often found it necessary to revise many of the techniques and workflow steps that are described here. This is in many ways a personal guide and one that highlights the areas of Photoshop that I find most interesting, or at least those which I feel should be of most interest. My philosophy is to find out which tools in Photoshop allow you to work as efficiently and as

non-destructively as possible and preserve all of the information that was captured in the original, plus take into account any recent changes in the program that require you to use Photoshop differently. Although there are lots of ways to approach using Photoshop, you'll generally find with Photoshop CS6 that the best tools for the job are often the simplest. I have therefore structured the chapters in the book so that they follow a typical Photoshop workflow. Hopefully, the key points you will learn from this book are that Camera Raw is the ideal, initial editing environment for all raw images (and sometimes non-raw images too). Then, once an image has been optimized in Camera Raw, you can use Photoshop to carry out the fine-tuned corrections, or more complex retouching.

What's different in this book

This version has been re-edited to put most of its emphasis on the Photoshop tools that are most essential to photographers as well as all that's new in Photoshop CS6. There are a number of significant changes I would like to point out here. Firstly, the book no longer comes with a DVD and all additional content is now available on-line via the www.photoshopforphotographers.com website. Here, you can access movie tutorials to accompany some of the techniques shown in the book and download many of the images that appear in the book to try out on your own. You can also access around 200 pages of additional book content in the form of PDF downloads. For example, there is a 32-page printable guide to all the keyboard shortcuts for Photoshop, Camera Raw and Bridge. You may also notice that I have removed the Color Management and Web Output sections. The content in these two chapters has barely changed over the last six editions and I reckon there are a lot of readers who will have already bought at least one of my books previoulsy. In order to make way for new content I decided it was time to remove these and provided them as PDFs on the book website.

Lastly, there is a Help Guide section with illustrated descriptions of all the tools and panels found in Photoshop. To gain access to all these extra items, please refer to the instructions over the page.

The Ultimate Workshop

Adobe Photoshop CS6 for Photographers can be considered an 'essentials' guide to working with Photoshop CS6. But if you want to take your Photoshop skills to the next level I suggest you might like to take a look at *Adobe Photoshop CS5 for Photographers: The Ultimate Workshop*. This is a book that I coauthored with Jeff Schewe. It mainly concentrates on various advanced Photoshop tricks and techniques and is like attending the ultimate training workshop on Photoshop. I should point out that there won't be a CS6 update to this particular book. This is because most of the information in that book is not quite so version-specific as this main book.

Username and password

Here are the details to access the on-line book content.
Login: 3101-1901
Password: superstition

Accessing the on-line content

The additional content associated with the book is now available on-line. This mainly includes the Tools and Panels Help Guide, movie tutorials, plus an archive of extra written content available as PDF downloads. First, go to www.photoshopforphotographers.com, then go to the main page shown below and click on the 'Access online content' button shown in Figure 1.

Figure 1 To access the on-line content, go to www.photoshopforphotographers.com and click on the 'Access online content' button. This takes you to the second page shown here where you just need to enter in the username and password (which are provided on this page). You'll then be able to access the Help Guide shown in Figure 2.

Figure 2 This shows the Tools and Panels section of the *Adobe Photoshop for Photographers Help Guide*. You can access here extra content such as layer styles, movie tutorials, PDF documents and download some of the images used in this book.

Contacting the publisher/author

If you have a problem to do with the book or wish to contact the publisher, please email: G.Smith@elsevier.com.
If you would like to contact the author, please email: martin@martinevening.com.

Acknowledgments

I must first thank Andrea Bruno of Adobe Europe for initially suggesting to me that I write a book about Photoshop aimed at photographers, plus none of this would have got started without the founding work of Adam Woolfitt and Mike Laye who helped establish the Digital Imaging Group (DIG) forum for UK digital photographers. Thank you to everyone at Focal Press: Valerie Geary, Kate Iannotti, Lisa Jones and Graham Smith. The production of this book was done with the help of Rod Wynne-Powell, who tech edited the final manuscript and provided me with technical advice, Matt Wreford who helped with the separations, Soo Hamilton who did the proofreading and Jason Simmons, who designed the original book layout template. I must give a special mention to fellow Photoshop alpha tester Jeff Schewe for all his guidance and help over the years (and wife Becky), not to mention the other members of the 'pixel mafia': Katrin Eismann, Seth Resnick, Andrew Rodney and Bruce Fraser, who sadly passed away in December of 2006.

Thank you also to the following clients, companies and individuals: Adobe Systems Inc., Neil Barstow, Russell Brown, Steve Caplin, Jeff Chien, Kevin Connor, Harriet Cotterill, Eric Chan, Chris Cox, Eylure, Claire Garner, Greg Gorman, Mark Hamburg, Peter Hince, Thomas Holm, Ed Horwich, David Howe, Bryan O'Neil Hughes, Carol Johnson, Julieanne Kost, Peter Krogh, Tai Luxon, Ian Lyons, John Nack, Thomas Knoll, Bob Marchant, Marc Pawliger, Pixl, Herb Paynter, Red or Dead Ltd, Eric Richmond, Addy Roff, Gwyn Weisberg, Russell Williams, *What Digital Camera* and X-Rite. Thank you to the models, Courtney Hooper, Egle, Jasmin, Alex Kordek and Sundal who featured in this book, plus my assistants Harry Dutton and Rob Cadman. And thank you too to everyone who has bought my book. I am always happy to respond to readers' emails and hear comments good or bad (see sidebar).

Lastly, thanks to all my friends and family, my wife Camilla who has been so supportive over the last year, and especially my late mother for all her love and encouragement.

Martin Evening, March 2012

Chapter 1

Photoshop Fundamentals

L et's begin by looking at some of the essentials of working with Photoshop, such as how to install the program, the Photoshop interface, what all the different tools and panels do, as well as introducing the Camera Raw and Bridge programs.

The Photoshop CS6 interface has seen a radical redesign, with the introduction of four themed appearance settings that offer users different levels of interface brightness. Even if you are already familiar with how Photoshop works, or have read previous editions of this book, I would still recommend you begin by reading through this chapter first in order to learn about some of the things that are new to this latest version of the program. You can also use this chapter as a reference, as you work through the remainder of the book.

Macintosh and PC keys

Throughout this book I refer to the keyboard modifier keys used on the Macintosh and PC computers. Where the keys used are the same on both platforms (such as the *Shift* key) these are printed in gray. Where the keys used are different on each system, I show the Macintosh keys in magenta and the PC equivalents in blue. So, if the shortcut used is Command (Mac) and Control (PC) this appears abbreviated in the text as: ⌘ and *ctrl*.

Adobe Photoshop activation limits

You can install Photoshop on any number of computers, but only a maximum of two installations can be active at any one time. To run Photoshop on more computers than this requires a deactivation and reactivation only rather than a complete uninstall and reinstall. There is also the added benefit that registering your product entitles you to various reward goodies.

Photoshop installation

Installing Photoshop (Figure 1.1) is as easy as installing any other application on your computer, but do make sure that any other Adobe programs or web browsers are closed prior to running the installation setup. After entering your serial number details, you will be asked to enter your Adobe ID or create a new Adobe ID account. This is something that has to be done in order to activate Photoshop and the reason for this is to limit unauthorized distribution of the program. Basically, the standard license entitles you to run Photoshop on up to two computers, such as a desktop and a laptop machine.

Figure 1.1 The Photoshop installer procedure is more or less identical on both Mac and PC systems. As you run through the installation process you will be asked to register the program by entering your Adobe ID or create a new Adobe ID account. If installing on a machine running an older version of Photoshop, you will also be asked if you wish to migrate the preset settings from the older program (see also page 720).

The Photoshop interface

The Photoshop CS6 interface shares the same design features as all the other CS6 creative suite programs, which makes it easier to migrate from working in one CS6 program to another. You can also work with the Photoshop program as a single application window on both the Mac and PC platforms (Figures 1.2 and 1.3). This arrangement is more in keeping with the interface conventions for Windows, plus you also have the ability to open and work with Photoshop image documents as tabbed windows. But note that now the Application bar is gone, the Workspace options can be accessed via the Options bar. Meanwhile, the documents layout options are now solely available via the Window ⇨ Arrange menu.

Macintosh default workspace

The Macintosh default workspace setting uses a classic layout where the panels appear floating on the desktop. If you go to the Window menu and select 'Application Frame', you can switch to the Application window layout shown in Figure 1.2.

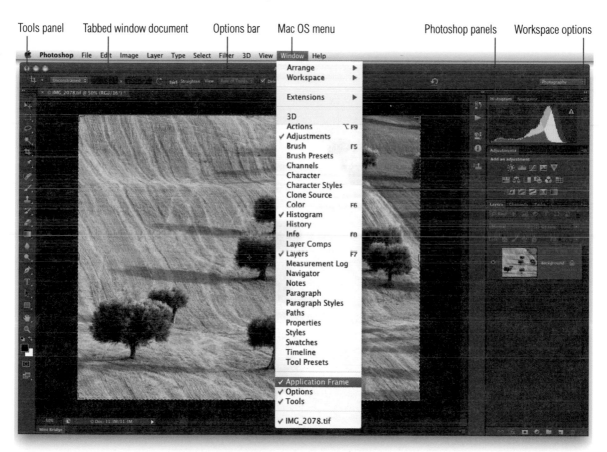

Tools panel Tabbed window document Options bar Mac OS menu Photoshop panels Workspace options

Figure 1.2 This shows the Photoshop CS6 Application Frame view for Mac OS X, using the default, dark UI settings. To switch between the classic mode and the Application Frame workspace, go to the Window menu and select or deselect the Application Frame menu item.

Tools panel Options bar Windows OS menu Tabbed window document Photoshop panels Workspace options

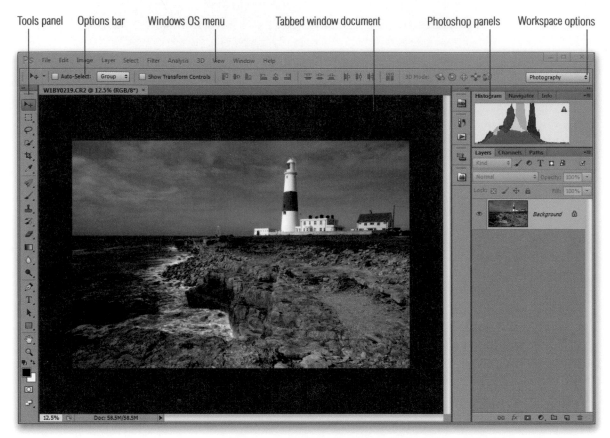

Figure 1.3 The Photoshop CS6 interface for the Windows OS. This has been captured using the middle light gray theme and the Photography workspace setting.

The Photoshop panels are held in placement zones with the Tools panel normally located on the left, the Options bar running across the top and the other panels arranged on the right, where they can be docked in various ways to economize on the amount of screen space that's used yet still remain easily accessible. This default arrangement presents the panels in a docked mode, but over the following few pages we shall look at ways you can customize the Photoshop interface layout. For example, you can reduce the amount of space that's taken up by the panels by collapsing them into compact panel icons (see Figures 1.27 and 1.28).

Creating a new document

To create a new document in Photoshop with a blank canvas, go to the File menu and choose New… This opens the dialog shown in Figure 1.4, where you can select a preset setting type from the Preset pop-up menu followed by a preset size option from the Size menu. When you choose a preset setting, the resolution adjusts automatically depending on whether it is a preset intended for print or one intended for computer screen type work (you can change the default resolution settings for print and screen in the Units & Rulers Photoshop preferences). Alternatively, you can manually enter dimensions and resolution for a new document in the fields below.

The Advanced section lets you do extra things like choose a specific profiled color space. After you have entered the custom settings in the New Document dialog these can be saved by clicking on the Save Preset… button. In the New Document Preset dialog shown below, you will notice that there are also some options that will allow you to select which attributes are to be included in a saved preset.

Note that if you make a selection, such as Select All and follow this with Edit Copy, when you choose New Document it will do so using the same pixel dimensions as the selection. And, when you do this in Photoshop CS6, it also retains the color space.

Pixel Aspect Ratio

The Pixel Aspect Ratio is there to aid multimedia designers who work with stretched screen video formats. So, if a 'non-square' pixel setting is selected, Photoshop creates a scaled document which previews how a normal 'square' pixel Photoshop document will actually display on a stretched wide screen. The title bar will add [scaled] to the end of the file name to remind you that you are working in this special preview mode. When you create a non-square pixel document the scaled preview can be switched on or off by selecting the Pixel Aspect Correction item from the View menu.

Mobile & Devices presets

New document presets have now been added for common devices such as the iPhone and iPad.

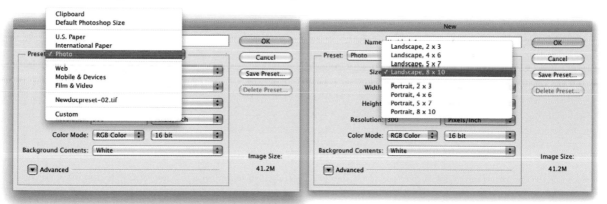

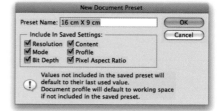

Figure 1.4 When you choose File ⇨ New, this opens the New document dialog shown here (top left). Initially, you can go to the Preset menu and choose a preset setting such as: Photo, Web or Film & Video. Depending on the choice you make here, this will affect the size options that are available in the Size menu (shown top right). If you use the New document dialog to configure a custom setting, you can click on the Save Preset… button to save this as a new Document preset (right). When you do this the new document preset will appear listed in the main preset menu (top left).

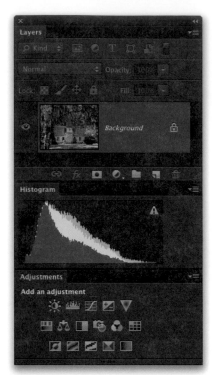

Figure 1.5 This shows an example of how the Photoshop panels look when the default UI setting is selected.

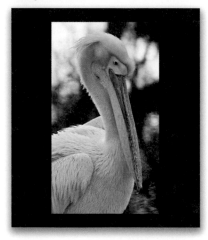

Figure 1.6 This shows an image that was curves adjusted while viewed against a black canvas color.

User interface brightness

The most noticeable new change in Photoshop CS6 is the interface, which not only has newly-designed panels and icons, but also offers the user four color themes with different levels of brightness (you can adjust the program's appearance via the Interface preferences shown in Figure 1.7).

Having the ability to adjust the brightness of the interface has to be a good thing. But, having said that, you do need to decide carefully which setting is right for the kind of work you do. By default, Photoshop CS6 uses a dark color theme and Figure 1.5 shows an example of how the Layers and Histogram Photoshop panels will look when this is selected. Now, dark themes can look quite nice when they are implemented well. For example, the Lightroom interface has been a great success. But the thing to be aware of here is that the dark default setting in Photoshop CS6 isn't particularly easy to read, especially if you are working on a large display where the panel lettering can appear quite small (more of which later). More importantly, the canvas color is linked to the interface brightness setting, and in the case of the dark default, it's almost completely black. This can lead to problems when editing photographic images because how we perceive tone and color is very much dependent on what surrounds the image.

To show you what I mean, take a look at the photograph in Figure 1.6. Do you think it looks OK? Now compare this with the Figure 1.9 version on page 9. Does it still look the same when viewed against white? Actually, I adjusted these two versions of the photograph separately using a Curves adjustment to obtain what I thought looked like the best-looking result, first against the black background and then against white. You can see a comparison of these two versions, both displayed against a neutral gray background (Figure 1.10). This highlights the fact that the canvas color can greatly affect the edit decisions we make. What you have to understand here is that Photoshop is a program that's used by a wide variety of customers. For example, those who work in video will probably find that a dark interface works best for them. This is because the work they produce is intended to be viewed in dark surroundings. Photographers on the other hand are mostly focused on how photographs will look when they are printed, and where the photographs they edit will ultimately be viewed against a paper white background.

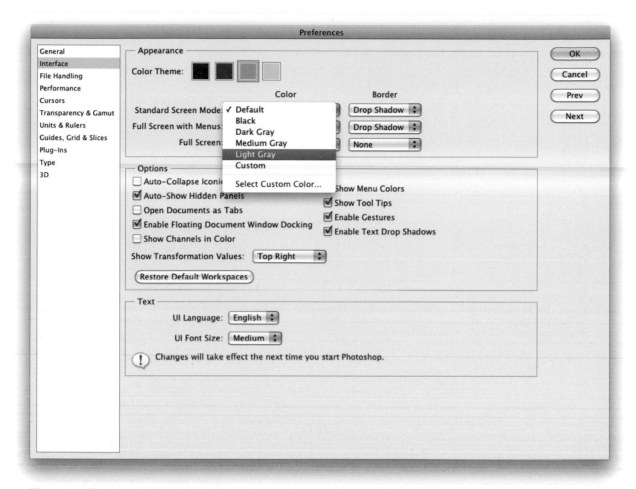

Figure 1.7 This shows the Photoshop Interface preferences, where you will want to edit the canvas color and set this to 'Light Gray'.

Regardless of whichever interface theme you decide to use, I strongly recommend you customize the Photoshop CS6 canvas color to make it suitable for photo editing work. To do this, Choose Photoshop ⇨ Preferences ⇨ Interface… (Mac), or Edit ⇨ Preferences ⇨ Interface… (PC). This opens the dialog shown in Figure 1.7, where, if you go to the Standard Screen, Full Screen with Menus and Full Screen options you can click on the pop-up menu and choose an appropriate canvas color. If you would like to match the previous Photoshop canvas color, I suggest you choose the Light Gray option. Do this for each menu and click OK.

Figure 1.8 This shows a comparison of the different interface options. The top row shows examples of the four main brightness themes in Photoshop CS6 ranging from the lightest to the darkest. In the bottom row, the bottom left example shows how these same panels looked when viewed in Photoshop CS5. Next to this I selected out the second darkest theme from the top row and captured this using the default small UI font size, next to it the medium UI font size and lastly, the large UI font size.

The other thing to consider is the legibility of the interface. Figure 1.8 shows a quick comparison of the different interface brightness settings. If you compare the CS6 panel design with that used in CS5, you'll notice that the separation between panels is less distinct and the panel lettering doesn't stand out so well. This isn't helped either by the 'dark wash' effect as you select darker themes. It seems to me that the lack of tone contrast in the overall interface tends to make the panels blend together such that they are less distinct compared to CS5. However, there are things you can do to further tweak the interface. If you refer to Figure 1.7 there is an option marked 'Enable Text Drop Shadows'. This allows you to add a drop shadow edge to the lettering (actually it's a white edge). With the two dark themes this is really effective in making the lettering stand out more, but with the two lighter themes it just makes the lettering harder to read. Another thing you can do is to adjust the UI font size (see Figure 1.7). Any changes you make here won't take place until you relaunch Photoshop. As you can see in Figure 1.8, increasing the font size marginally increases the overall size of the panels, but this certainly makes the lettering stand out more clearly. Throughout this book I mainly captured the screen shots using the medium light gray theme with a medium UI font size and the Enable Text Drop Shadows disabled.

Figure 1.9 This shows the same image as in Figure 1.6, but curves adjusted while viewed against a white canvas.

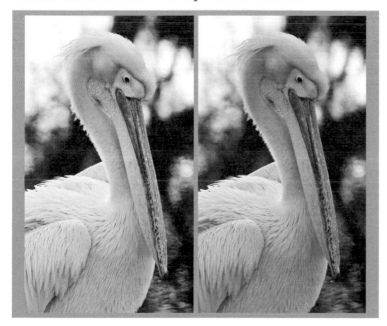

Figure 1.10 Here, you see how the image views shown in Figure 1.6 and 1.9 looked when compared alongside each other using the 'Light Gray' canvas color. The white background edited version is on the left and the black background edited version is on the right. Do they still look the same to you? As you can see, although these image views each looked fine when viewed against a black or white background, when you compare them side by side, you can see that the canvas color choice has had quite an impact on how the image was perceived when making those all-important tone adjustments.

OpenGL display performance

If the video card in your computer has OpenGL and you have 'Enable OpenGL Drawing' selected in the Photoshop Performance preferences, you can take advantage of the OpenGL features that Photoshop supports. For example, when OpenGL is enabled you will see smoother-looking images at all zoom display levels, plus you can temporarily zoom back out to fit to screen using the Bird's-eye view (page 55), or use the Rotate view tool to rotate the on-screen image display (see page 57).

Dual monitor setup

Those users who are working with a dual monitor setup will notice that new documents are opened on whichever display the current target document is on.

Reveal in Finder

Mac OS X users will also see a 'Reveal in Finder' option in the document tab contextual menu for pre-existing (saved) images.

Tabbed document windows

Let's now look at the way document windows can be managed in Photoshop. The default preference setting forces all new documents to open as tabbed windows, where new image document windows appear nested in the tabbed document zone, just below the Options bar. In Figure 1.11 I have highlighted the tabbed document zone in yellow, where I currently had four image documents open. This approach to managing image documents can make it easier to locate a specific image when you have several image documents open at once. To select an open image, you simply click on the relevant tab to make it come to the front. When documents aren't tabbed in this way, you'll often have to click and drag on the document title bars to move the various image windows out the way until you have located the image document you were after.

Of course, not everyone likes the idea of tabbed document opening and if you find this annoying you can always deselect the 'Open Documents as Tabs' option in the Interface preferences (circled in Figure 1.12). This allows you to revert to the old behavior where new documents are opened as floating windows. On the other hand you can have the best of both worlds by clicking on a tab and dragging it out from the docked zone. This action lets you easily convert a tabbed document to a floating window (as shown in Figure 1.13). Alternatively, you can right mouse-click on a tab to access the contextual menu from where you can choose from various window command options such as 'Move to a New Window', or 'Consolidate All to Here'. The latter gathers all floating windows and converts them into tabbed documents. You can also use the N-up display options (see Figure 1.15) to manage the document windows.

With Mac OS X, you can mix having tabbed document windows with a classic panel layout. If you disable the Application Frame mode (Figure 1.2) and use the Open Documents as Tabs preference or the 'Consolidate All to Here' contextual menu command, you can still have the open windows arranged as tabbed documents.

Figure 1.11 The default Photoshop behavior is for image documents to open as tabbed windows (highlighted here in yellow), docked to the area just below the Options bar. Click on a tab to make a window active and click on the 'X' to close a document window.

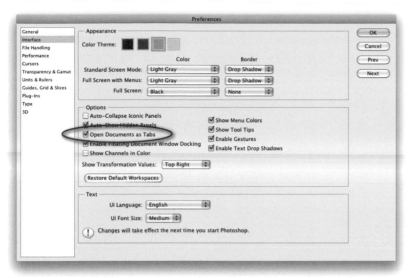

Figure 1.12 The Photoshop Interface preferences.

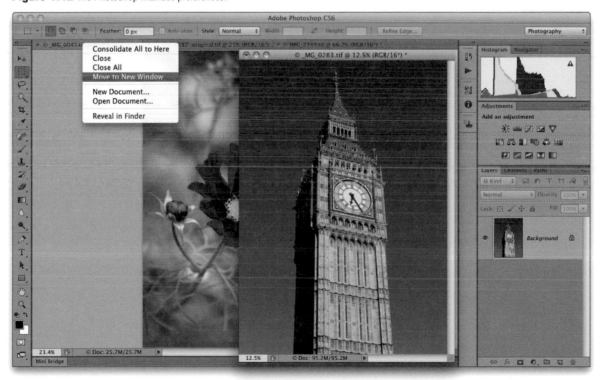

Figure 1.13 This screen shot shows the two ways you can convert a tabbed document to a floating window, either by dragging a tab out from the tabbed windows zone, or by using the contextual menu.

Switching between windows

The ⌘ `` ` `` ctrl `` ` `` shortcut can be used to toggle between open window documents and use ⌘ Shift `` ` `` ctrl Shift `` ` `` to reverse the order.

Dragging layers between tabs

To drag layers between tabbed documents you need to use the move tool and drag from the document to the target tab. Wait a few seconds and then (very importantly) you have to drag down from the tab to the actual image area to complete the move.

Managing document windows

Documents can also be tabbed into grouped document windows by dragging one window document across to another (see Figure 1.14). You can also manage the way multiple document windows are displayed on the screen. Multiple window views are useful if you wish to compare different soft proof views before making a print (see Chapter 12 for more about soft proofing in Photoshop). With floating windows you can Choose Window ⇨ Arrange ⇨ Cascade to have all the document windows cascade down from the upper left corner of the screen, or choose Window ⇨ Arrange ⇨ Tile to have them appear tiled edge to edge. With document windows (tabbed or otherwise) you can use the Document Layout menu to choose any of the 'N-up' options that are shown in Figure 1.15. This document layout method offers a much greater degree of control and lets you choose from one of the many different layout options shown in Figure 1.15.

Figure 1.14 Floating windows can be grouped as tabbed document windows by dragging the title bar of a document across to another until you see a blue border (as shown above). You can also click on the title bar (circled in red) to drag a group of tabbed document windows to the tabbed windows zone.

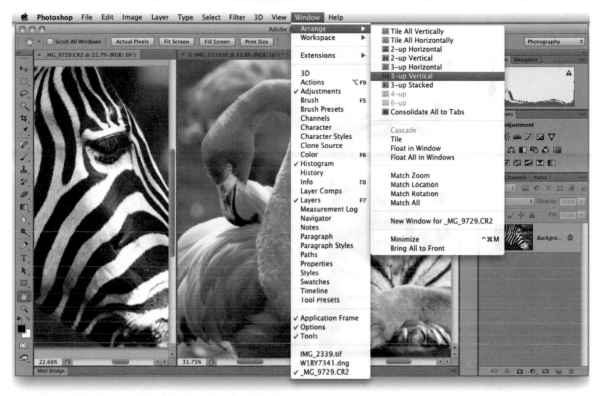

Figure 1.15 This shows the 'N-up' display options for tabbed document windows.

Synchronized scroll and zoom

In the Window ⇨ Arrange submenu (Figure 1.15), there are menu
controls that allow you to match the zoom, location (and rotation)
for all document windows, based on the current foreground image
window. The Match Zoom command matches the zoom percentage
based on the current selected image, while the Match Location
command matches the scroll position. You can also synchronize the
scrolling or magnification by depressing the *Shift* key as you scroll
or zoom in and out of any window view.

It is also possible to create a second window view of the
image you are working on, where the open image is duplicated in
a second window. For example, you can have one window with
an image at a Fit to Screen view and the other zoomed in on a
specific area. Any changes you make to the image can be viewed
simultaneously in both windows (see Figure 1.16).

Figure 1.16 To open a second window view of a Photoshop document, choose Window ⇨ Arrange ⇨ New Window for (document name). Any edits that are applied to one document window are automatically updated in the second window preview.

Image document window details

The boxes in the bottom left corner of the image window display extra information about the image (see Figure 1.17). The left-most box displays the current zoom scale percentage for the document view. Here, you can type in a new percentage for any value you like from 0.2% to 1600% up to two decimal places and set this as the new viewing resolution. The Zoom status box also has a scrubby slider option. If you hold down the ⌘ *ctrl* key as you click inside the Zoom status box (see Figure 1.17 below) you can dynamically zoom in and out as you drag left or right, and at double the speed with the *Shift* key held down as well. The zoom tool Options bar also offers a scrubby zoom option, which I describe later on page 54. In the middle is a Work Group Server button that can be used to check in or check out a document that is being shared over a WebDAV server.

Figure 1.17 The document status is shown in the bottom left corner of the document window. ⌘ *ctrl*-clicking inside the Zoom status box allows you to access the scrubby slider feature.

To the right of this is the status information box, which can be used to display information about the image. If you mouse down on the arrow to the right of this box, you will see a list of all the items you can choose to display here (see Figure 1.18).

If you mouse down in the status information box, this displays the width and height dimensions of the image along with the number of channels and image resolution. If you hold down the ⌘ *ctrl* key as you mouse down on the status information box, this will show the image tiling information.

⌘ click on this proxy icon to reveal the path to file from the disk volume (Mac only)

Figure 1.18 This shows the window layout of a Photoshop document as it appears on the Macintosh. If you mouse down in the status information box, this displays the file size and resolution information. If you hold down ⌘ *ctrl* key as you mouse down in the status information box, this displays the image tiling information. Lastly, if you mouse down on the arrow icon next to the status information box, you can select the type of information you wish to see displayed there (the Status items are described on the right).

Adobe Drive (formerly Version Cue)
Current Adobe Drive status.

Document Sizes
The first figure represents the file size of a flattened version of the image. The second shows the size if saved including all layers.

Document Profile
The color profile assigned to the document.

Document Dimensions
This displays the physical image dimensions, as would be shown in the Image Size dialog box.

Measurement Scale
Measurement units (extended version only).

Scratch Sizes
First figure shows amount of RAM memory used. Second figure shows total RAM memory available to Photoshop after taking into account the system and application overhead.

Efficiency
This summarizes how efficiently Photoshop is working. Basically it provides a simplified report on the amount of scratch disk usage.

Timing
Displays the time taken to accomplish a Photoshop step or the accumulated timing of a series of steps. Every time you change tools or execute a new operation, the timer resets itself.

Current Tool
This displays the name of the tool you currently have selected. This is a useful aide-mémoire for users who like to work with most of the panels hidden.

32-bit Exposure
This Exposure slider control is only available when viewing 32-bit mode images.

Save Progress
Shows the current background save status.

Title bar proxy icons (Mac only)

Macintosh users will see a proxy image icon in the title bar of any floating windows. The proxy icon appears dimmed when the document is in an unsaved state and is reliant on there being a preview icon saved with the image. For example, many JPEGs will not have an icon until they have been resaved as something else. If you hold down the ⌘ or *ctrl* key and mouse down on the proxy icon in the title bar you will see a directory path list like the one shown in Figure 1.18. You can then use this to navigate and select a folder location from the directory path and open it in the Finder.

Info panel status information

The status information box can only show a single item at a time. However, if you open the Info panel options shown below in Figure 1.19, you can check any or all of the Status Information items shown here so that the items that are ticked appear in the middle section of the Info panel. In addition to this, you can choose to enable 'Show Tool Hints'. These appear at the bottom of the Info panel and will change according to any modifier keys you have held down at the time, to indicate any extra available options.

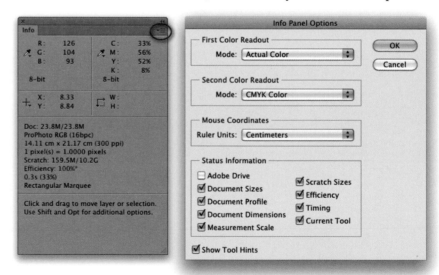

Figure 1.19 If you go to the Info panel options menu (circled) and choose Panel Options… this opens the Info Panel Options dialog. Here, you can choose which Status items you would like to see displayed in the Status Information section of the Info panel. The above Info panel screen shot shows all the Status Information items along with the Show Tool Hints info display.

Rulers, Guides & Grid

Guides can be added at any time to an image document (providing the Rulers are displayed) and flexibly positioned anywhere in the image area (see Figure 1.20). To add a new guide, you just need to mouse down on the ruler bar and drag a new guide out and then release the mouse to drop the guide in place. Once positioned, guides can be used for the precise positioning and alignment of image elements. If you are not happy with the placement of a guide, you can select the move tool and drag the guide into the exact required position. But once positioned, it is sometimes a good idea to lock all guides (View ⇨ Lock Guides) to avoid accidentally moving them again. You can also place a guide using View ⇨ New Guide… and in the New Guide dialog (Figure 1.21) enter an exact position for either the horizontal or vertical axis. The Grid (which is shown over the page in Figure 1.22) provides a means for aligning image elements to a horizontal and vertical axis (to alter the grid spacing, open the Photoshop preferences and select Guides & Grid).

View menu options

The View Extras items can also be selected via the View menu. To turn ruler visibility on or off, choose View ⇨ Rulers (⌘ R / ctrl R) and use the View ⇨ Show submenu to toggle the visibility of the Guides (⌘ ; / ctrl ;), or Grid (⌘ ' / ctrl '). If a tick mark appears next to an item in the View ⇨ Show menu, it means it is switched on. Select the item in the menu again and release the mouse to switch it off.

Altering the Ruler units

If the ruler units need altering, just ctrl right mouse-click on one of the rulers and select a new unit of measurement. If the rulers are visible but the guides are hidden, dragging out a new guide will make all the other hidden guides reappear again.

Figure 1.20 This shows an image displaying the rulers and guides. To place a new guide first choose View ⇨ Rulers. You can then drag from either the horizontal or vertical ruler to place a new guide. If you hold down the *Shift* key as you drag, this makes the guide snap to a ruler tick mark (providing View ⇨ Snap is checked). If you hold down the ⌥ *alt* key as you drag this allows you to switch dragging a horizontal guide to dragging it as a vertical (and vice versa). Lastly, you can use ⌘ H / ctrl H to toggle hiding/showing all extras items, like Guides.

Figure 1.21 The New Guide dialog.

Figure 1.22 The Grid view can be enabled by choosing View ⇨ Show ⇨ Grid. When the Grid view is switched on it can be used to help align objects to the horizontal and vertical axis.

Figure 1.23 The Pixel Grid view can be enabled by going to the View ⇨ Show menu and selecting 'Pixel Grid'. When checked, Photoshop displays the pixels in a grid whenever an image is inspected at a 500% magnification or greater.

'Snap to' behavior

The Snap option in the View menu allows you to toggle the 'snap to' behavior for the Guides, Grid, Slices, Document bounds and Layer bounds. The shortcut for toggling the 'snap to' behavior is ⌘ _Shift_ ; _ctrl_ _Shift_ ;. When the 'snap to' behavior is active and you reposition an image, type or shape layer, or use a crop or marquee selection tool, these will snap to one or more of the above. It is also the case that when 'snap to' is active, and new guides are added with the _Shift_ key held down, a guide will snap to the nearest tick mark on the ruler, or if the Grid is active, to the closest grid line. Objects on layers will snap to position when placed within close proximity of a guide edge. The reverse is also true: when dragging a guide, it will snap to the edge of an object on a layer at the point where the opacity is greater than 50%. Also note that when Smart Guides are switched on in the View ⇨ Show menu, these can help you align layers as you drag them with the move tool (see page 124 for more details).

Pixel Grid view

The Pixel Grid view described in Figure 1.23 can only be enabled if you have OpenGL enabled and the Pixel Grid option selected in the View menu. It is useful when editing things like screen shots and can, for example, aid the precise placement of the crop tool.

The Photoshop panels

The default workspace layout settings place the panels in a docked layout where they are grouped into column zone areas on the right. However, the panels can also be placed anywhere on the desktop and repositioned by mousing down on the panel title bar (or panel icon) and dragging them to a new location. A double-click on the panel tab (circled red in Figure 1.24) compacts the panel upwards and double-clicking on the panel tab unfurls the panel again. A double-click on the gray panel header bar (circled blue in Figure 1.24) collapses the panel into the compact icon view mode and double-clicking on the same panel header expands the panel again. Some panels, such as the Layers panel can be resized horizontally and vertically by dragging the bottom right corner tab, or by hovering the cursor over the left, right or bottom edge and dragging. Others, such as the Info panel are of a fixed height, where you can only adjust the width of the panel by dragging the side edges or the corner tab.

Panels can be organized into groups by mousing down on a panel tab and dragging it across to another panel (see Figure 1.25). When panels are grouped in this way they'll look a bit like folders in a filing cabinet. Just click on a tab to bring that panel to the front of the group and to separate a panel from a group, mouse down on the panel tab and drag it outside the panel group again.

Figure 1.24 Photoshop panels can be collapsed with a double-click in the empty panel tab area (circled in red), while a double-click on the panel header (circled in blue) shrinks the panel to the compact panel size shown here.

Figure 1.25 To group panels together, mouse down anywhere on the panel header and with the mouse held down, drag the tab across to another panel, or group of panels (a blue surround appears when you are within the dropping zone) and release the mouse once it is inside the other panels. To remove a panel from a group, mouse down on the panel tab and drag it outside the panel group.

Figure 1.26 As you reposition a panel and prepare to dock it inside or to the edges of the other panels, a thick blue line indicates that, when you release the mouse, this is where the panel will attach itself.

Figure 1.27 When panels are docked you can adjust the width of the panels by dragging anywhere along the side edge of the panels.

Panel arrangements and docking

The default 'Essentials' workspace arranges the panels using the panel layout shown in Figure 1.2 (seen at the beginning of this chapter), but there are quite a few other different workspace settings you can choose from. It is also easy to create custom workspace settings by arranging the panels to suit your own preferred way of working and save these as a new setting. Panels can be docked together by dragging a panel to the bottom or side edge of another panel. In Figure 1.26 you can see how a thick blue line will appear as a panel is made to hover close to the edge of another panel. Release the mouse at this point and the panel will become docked to the side, or to the bottom of the other panels.

When panels are compressed (as shown in the middle and bottom examples in Figure 1.24), you can drag on either side of the panel to adjust the panel's width. At the most compact size, only the panel's icon is displayed, but as you increase the width of a panel (or column of panels), the panel contents expand and you'll get to see the names of the panels appear alongside their icons (see Figure 1.27).

Just remember if you can't find a particular panel, then it may well be hidden. If this happens, go to the Window menu, select the panel name from the menu and it will reappear again on the screen. It is worth remembering that the *Tab* key shortcut (also indicated as ⇥ on some keyboards) can be used to toggle hiding and showing all the panels, while *Tab* *Shift* toggles hiding/ showing all the currently visible panels except for the Tools panel and Options bar. These are useful shortcuts to bear in mind. So, if you are working in Photoshop and all your panels seem to have disappeared, just try pressing *Tab* and they'll soon be made visible again.

In the Figure 1.28 example, the tabbed image documents fill the horizontal space between the Tools panel on the left and the three panel columns on the right. I have also shown here how you can mouse down on the column edge to adjust the column width (see the double arrow icon that's circled in red). Photoshop panels can be grouped into as many columns as you like within the application window, or positioned separately outside the application window, such as on a separate monitor (see 'Working with a dual display setup on page 26).

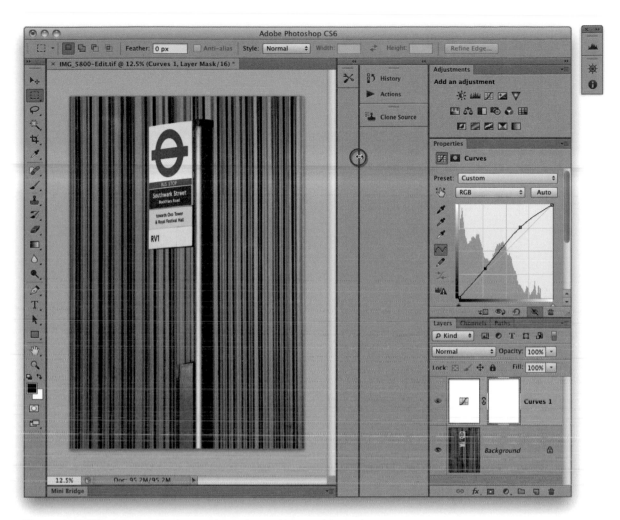

Figure 1.28 This shows a multi column workspace layout with some of the panels grouped in a docked, compact icon layout, outside the main application window. Note that the application frame is always topmost and can sometimes obscure any floating panels.

Panel positions remembered in workspaces

In the past it was always necessary to resave the workspace setting after you had made any refinements to the layout of the panels. Photoshop is now able to remember panel positions after switching workspaces. When you select a workspace and modify the layout of the panels, the new layout position is remembered when you next choose to use that particular workspace.

Closing panels

To close a panel, click on the close button in the top right corner (or choose 'Close' from the panel options fly-out menu).

Help menu searches

Here is an interesting tip for Mac users who are running Mac OS X 10.6 or later. If you go to the Photoshop Help menu and start typing the first few letters for a particular menu command, the Help menu lists all the available menu options. Now roll the mouse over a search result: Photoshop locates the menu item for you and points to it with an arrow.

Customizing the menu options

As the number of features in Photoshop has grown over the years, the menu choices have become quite overwhelming and this is especially true if you are new to Photoshop. However, if you go to the Edit menu and choose Menus…, this opens the Keyboard Shortcuts and Menus dialog shown in Figure 1.30, where you can customize the menu options and decide which menu items should remain visible. This Customize menu feature is like a 'make simpler' command. You can hide those menu options you never use and apply color codings to the menu items you use most (so that they appear more prominent). The philosophy behind this feature is: 'everything you do want with nothing you don't'. For example, if you select the 'New in CS6' workspace (Figure 1.29), this applies a custom menu setting in which all the new Photoshop CS6 menu items are color coded blue. You can also edit and create your own menu settings, but note that if you set up the Menu options so that specific items are hidden from view, a 'Show All Menu Items' command will appear at the bottom of the menu list. You can select this menu item to restore the menu so that it shows the full list of menu options again.

Figure 1.29 This shows the 'New in CS6' menu setting in use, which color codes in blue all the menu items that are new to Photoshop CS6.

Figure 1.30 The Keyboard Shortcuts and Menus dialog.

Customizing the keyboard shortcuts

While you are in the Keyboard Shortcuts and Menus dialog, you can click on the Keyboard Shortcuts tab to reveal the keyboard shortcut options shown below in Figure 1.31 (or you can go to the Edit menu and choose Keyboard Shortcuts…). In this dialog you first select which kinds of shortcuts you want to create, i.e. Application Menus, Panel Menus or Tools. You can then navigate the menu list, click in the Shortcut column next to a particular menu item and hold down the combination of keys you wish to assign as a shortcut for that particular tool or menu item. Now the thing to be aware of here is that Photoshop has already used up nearly every key combination there is, so you are likely to be faced with the choice of reassigning an existing shortcut, or using multiple modifier keys such as: ⌘ ⌥ *Shift* or *ctrl* *alt* *Shift* plus a letter or Function key, when creating new shortcuts.

Creating workspace shortcuts
If you scroll down to the Window section in the Keyboard Shortcuts for Application Menus, you will see a list of all the currently saved Workspace presets. You can then assign keyboard shortcuts for your favorite workspaces. This will allow you to jump quickly from one workspace setting to another by using an assigned keyboard shortcut.

Figure 1.31 The Keyboard Shortcuts and Menus dialog showing the keyboard shortcut options for the Photoshop Application Menus commands.

Figure 1.32 The Save Workspace menu in Photoshop can be used to save custom panel workspace setups. These can be recalled by revisiting the menu and highlighting the work-space name. To remove a workspace, choose Delete Workspace… from the menu.

Task-based workspaces

You can use workspaces to access alternative panel layouts, tailored for different types of Photoshop work. You can also save a current panel arrangement as a new custom workspace via the Options bar Workspace list menu or by going to the Window menu and choosing Workspace ⇨ New Workspace… This opens the dialog box shown in Figure 1.32, which asks you to select the items you would like to have included as part of the workspace (the workspace settings can also include specific keyboard shortcuts and menu settings). The saved workspace will then appear added to the Options bar Workspace list (see Figure 1.33). Here, you will also be able to choose 'Reset Workspace', to restore the workspace settings (this can be particularly useful after altering the computer screen resolution).

Figure 1.33 The Workspace list settings can be accessed via the Application bar menu (shown here), or via the Window ⇨ Workspace submenu. Workspace settings are automatically updated as you modify them. However, to reset a workspace back to the default setting, you can do so via the Workspace list menu (circled above).

One of the big recent improvements has been to force all workspace settings to include panel locations and have them update as you modify the layout you are working in. This means if you select a workspace and fine-tune the panel layout or other settings, these tweaks are automatically updated. When you switch to another workspace and back to the original, the updated settings are remembered (although you do have the option of reverting to the original saved setting). As you can see in Figure 1.32, saving keyboard shortcuts and menus is optional and the way things stand now, if you choose not to include these settings as part of the workspace, the menu and keyboard shortcuts used in the last selected workspace remain sticky. Let's say you save a custom workspace that excludes saving menus and shortcuts. If you switch to a workspace setting that makes use of specific menus or keyboard shortcuts and switch back again you can add these menu and shortcuts settings to the current workspace setting (until you reset).

Saved workspaces location
Custom and modified workspaces are saved to the following locations: User folder/Library/Preferences/ Adobe Photoshop CS6 Settings/ (Mac), userfolder\AppData\Roaming\Adobe\Adobe Photoshop CS6\Adobe Photoshop CS6 Settings\ (Windows).

Figure 1.34 Here is an example of the Photography workspace in use.

Working with a dual display setup

If you have a second computer display, you can arrange things so that all panels are placed on the second display, leaving the main screen clear to display the image document you are working on. Figure 1.35 shows a screen shot of a Dual display panel layout workspace that I use with my computer setup. In this example I have ensured that only the panels I use regularly are visible. The important thing to remember here is to save a custom panel layout like this as a workspace setting so that you can easily revert to it when switching between other workspace settings.

Figure 1.35 This shows an example of how you might like to arrange the Photoshop panels on a second display, positioned alongside the primary display.

Chapter 1
Photoshop Fundamentals

Adobe™ Configurator 3 application

Adobe Configurator 3 is an Adobe AIR™ application that can be used to create custom Extension panels that contain all your most-used tools and favorite menu commands – it's a perfect solution for those who wish Photoshop could be made less complicated. Basically, you can use the Configurator interface that's shown below in Figure 1.36 to drag and drop various tools and menu commands to the workspace area. Once you are happy with the layout you can choose File ⇨ Export to save this as a new Photoshop panel. To load the exported panel, relaunch Photoshop, go to the Window ⇨ Extensions submenu in Photoshop and select the new panel from the menu list. Configurator 3 provides built-in support for localized languages, it can include HTML links and includes container objects that can help you to create more efficient and professional-looking panels.

Accessing Adobe Configurator

The Adobe Configurator program is available from the following url: http://labs.adobe.com/downloads/configurator.html. The latest version lets you add some Photoshop CS6 specific commands. To install, go to the Applications/Programs folder and place the exported panel in the Adobe Photoshop CS6/Plug-ins/Panels/Custom panels folder.

Figure 1.36 This shows on the left the Adobe Configurator 3 interface and on the right, what the exported extension panel looked like when it was opened in Photoshop.

27

Figure 1.37 On the left you can see the default single column panel view. However, you can click on the double arrow (circled) to toggle between this and the double column view shown on the right. Where tools are marked with a triangle in the bottom right corner, you can mouse down on the tool to see the other tools that are nested in that particular group.

Photoshop CS6 Tools panel

The Tools panel, shown in Figure 1.38, contains 65 separate tools. Clicking any tool automatically displays the tool Options bar (if it is currently hidden) from where you can manage the individual tool settings (see page 30). Many of the tools in the Tools panel have a triangle in the bottom right corner of the tool icon, indicating there are extra tools nested in this tool group. You can mouse down on a featured tool, select any of the other tools in this list and make that the selected tool for the group (see Figure 1.37).

You will notice that most of the tools (or sets of tools) have single-letter keystrokes associated with them. These are displayed whenever you mouse down to reveal the nested tools or hover with the cursor to reveal the tool tip info (providing the 'Show Tool Tips' option is switched on in the Photoshop Interface preferences). You can therefore use these key shortcuts to quickly select a tool without having to go via the Tools panel. For example, pressing *V* on the keyboard selects the move tool and pressing *J* will select one of the healing brush group of tools (whichever is currently selected in the Tools panel). Photoshop also features spring-loaded tool selection behavior. If instead of clicking you hold down the key and keep it held down, you can temporarily switch to using the tool that's associated with that particular keystroke. Release the key and Photoshop reverts to working with the previously selected tool again.

Where more than one tool shares the same keyboard shortcut, you can cycle through the other tools by holding down the *Shift* key as you press the keyboard shortcut. If on the other hand you prefer to restore the old behavior whereby repeated pressing of the key would cycle through the tool selection options, go to the Photoshop menu, select Preferences ⇨ General and deselect the 'Use Shift Key for Tool Switch' option. Personally, I prefer using the Shift key method. You can also *⌥* *alt*-click a tool icon in the Tools panel to cycle through the grouped tools.

There are specific situations when Photoshop will not allow you to use certain tools and displays a prohibit sign (◯). For example, you might be editing an image in 32-bit mode where only certain tools can be used when editing a 32-bit image. Clicking once in the image document window will call up a dialog explaining the exact reason why you cannot access or use a particular tool.

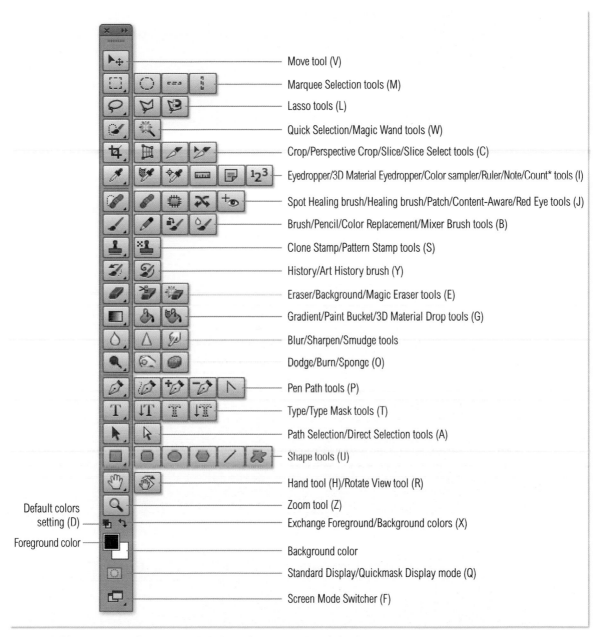

Move tool (V)

Marquee Selection tools (M)

Lasso tools (L)

Quick Selection/Magic Wand tools (W)

Crop/Perspective Crop/Slice/Slice Select tools (C)

Eyedropper/3D Material Eyedropper/Color sampler/Ruler/Note/Count* tools (I)

Spot Healing brush/Healing brush/Patch/Content-Aware/Red Eye tools (J)

Brush/Pencil/Color Replacement/Mixer Brush tools (B)

Clone Stamp/Pattern Stamp tools (S)

History/Art History brush (Y)

Eraser/Background/Magic Eraser tools (E)

Gradient/Paint Bucket/3D Material Drop tools (G)

Blur/Sharpen/Smudge tools

Dodge/Burn/Sponge (O)

Pen Path tools (P)

Type/Type Mask tools (T)

Path Selection/Direct Selection tools (A)

Shape tools (U)

Hand tool (H)/Rotate View tool (R)

Zoom tool (Z)

Default colors setting (D)

Exchange Foreground/Background colors (X)

Foreground color

Background color

Standard Display/Quickmask Display mode (Q)

Screen Mode Switcher (F)

Figure 1.38 This shows the Tools panel with the keystroke shortcuts shown in brackets.
*Note that the count tool is only available in the extended version of Photoshop.

Hovering tool tips

In order to help familiarize yourself with
the Photoshop tools and panel functions,
a Help dialog box normally appears after a
few seconds whenever you leave a cursor
hovering over any one of the Photoshop
buttons or tool icons. Note that this is
dependent on having the 'Show Tool Tips'
option checked in the Interface preferences.

Options bar

The Options bar (Figure 1.39) normally appears at the top of
the screen, just below the Photoshop menu, and you will soon
appreciate the ease with which you can use it to make changes
to any of the tool options. However, it can be removed from its
standard location and placed anywhere on the screen by dragging
the gripper bar on the left edge (circled in Figure 1.39).

The Options bar contents will vary according to which tool
you have currently selected and you'll see several examples of the
different Options bar layouts in the rest of this chapter (a complete
list of the Options bar views can be seen in the Help Guide for
Photoshop tools on the book website). Quite often you will see tick
(☑) and cancel (🚫) buttons on the right-hand side of the Options
bar and these are there so that you can OK or cancel a tool that is
in a modal state. For example, if you were using the crop tool to
define a crop boundary, you could use these buttons to accept or
cancel the crop, although you may find it easier to use the *Enter*
key to OK and the *esc* key to cancel such tool operations. Also,
as I mentioned earlier on page 20, you can use the *Shift* *Tab*
shortcut to toggle hiding the panels only and keeping just the Tools
panel and Options bar visible.

Tool Presets

Many of the Photoshop tools offer a wide range of tool options.
And, as you adjust the Options bar settings, such as the Opacity,
you can *ctrl* right mouse down on the tool icon in the Options bar
and choose 'Reset Tool' or 'Reset All Tools' from the contextual

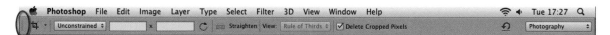

Figure 1.39 The Options bar, which is shown here docked to the main menu.

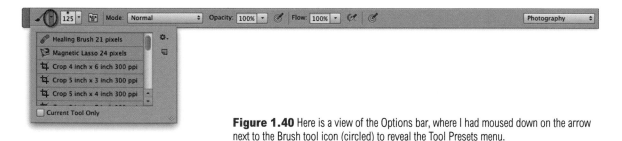

Figure 1.40 Here is a view of the Options bar, where I had moused down on the arrow
next to the Brush tool icon (circled) to reveal the Tool Presets menu.

menu. This will reset the Options bar to the default settings. In order to manage the tool settings effectively, the Tool Presets panel can be used to store multiple saved tool settings, which can then also be accessed via the Options bar (Figure 1.40), or the Tool Presets panel (Figure 1.41).

With Tool Presets you can access any number of tool options very quickly and this can save you the bother of having to reconfigure the Options bar settings each time you choose a new tool. For example, you might find it useful to save crop tool presets for all the different image dimensions and pixel resolutions you typically use. Likewise, you might like to store pre-configured brush preset settings, rather than have to keep adjusting the brush shape and attributes. To save a new tool preset, click on the New Preset button at the bottom of the Tool Presets panel and to remove a preset, click on the Delete button next to it.

If you mouse down on the Tool Presets options button (circled in Figure 1.41), you can use the menu shown in Figure 1.42 to manage the various tools presets. In Figure 1.41 the Current Tool Only option (at the bottom) was deselected which meant that all the tool presets could be accessed at once. This can be useful, because clicking on a preset simultaneously selects the tool and the preset at the same time. Most people though will find the Tool Presets panel is easier to manage when the 'Current Tool Only' option is checked.

You can use the Tool Presets panel to save or load pre-saved tool preset settings. For example, if you create a set of custom presets, you can share these with other Photoshop users by choosing Save Tool Presets… This creates a saved set of settings for a particular tool. Another thing that may not be immediately apparent is the fact that you can also use tool presets to save type tool settings. This again can be useful, because you can save the font type, font size, type attributes and font color settings all within a single tool preset. This feature can be really handy if you are working on a Web or book design project.

One important thing to bear in mind here is that since there has been a recent major update to the Photoshop painting engine, any painting tool presets that are created in Photoshop CS5 or CS6 will not be backward compatible with earlier versions of the program. Similarly, you won't be able to import and use any painting tool presets that were created in earlier versions of Photoshop either.

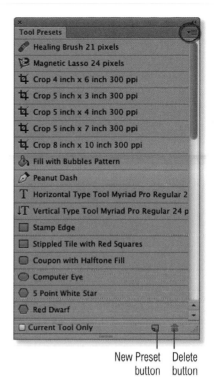

New Preset button Delete button

Figure 1.41 The Tool Presets panel.

Figure 1.42 The Tool Presets options.

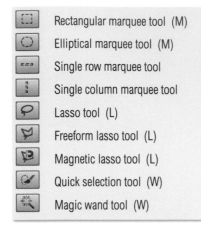

Rectangular marquee tool (M)	
Elliptical marquee tool (M)	
Single row marquee tool	
Single column marquee tool	
Lasso tool (L)	
Freeform lasso tool (L)	
Magnetic lasso tool (L)	
Quick selection tool (W)	
Magic wand tool (W)	

The Paste Special menu commands

The standard Paste command pastes the copied pixels as a new layer centered in the image. The Paste Special submenu offers three options. The Paste In Place command (\mathcal{H} *Shift* V *ctrl* *Shift* V) pastes the pixels that have been copied from a layer to create a new layer with the pixels in the exact same location. If the pixels have been copied from a separate document, it pastes the pixels into the same relative location as they occupied in the source image. Paste Into (\mathcal{H} \mathcal{X} *Shift* V *ctrl* *alt* *Shift* V) pastes the clipboard contents inside a selection, while Paste Outside pastes the clipboard contents outside a selection.

Figure 1.43 The first time you use the Macintosh \mathcal{H} H keyboard shortcut, this pops a dialog asking you to select the desired default behavior.

Selection tools

The Photoshop selection tools are mainly used to define a specific area of the image that you wish to modify, or have copied. The use of the selection tools in Photoshop is therefore just like highlighting text in a word processor program in preparation to do something with the selected content. In the case of Photoshop, you might want to make a selection to define a specific area of the image, so that when you apply an image adjustment or a fill, only the selected area is modified. Alternatively, you might use a selection to define an area you wish to copy and paste, or define an area of an image that you want to copy across to another image document as a new layer. The usual editing conventions apply and mistakes can be undone using the Edit ⇨ Undo command (\mathcal{H} Z *ctrl* Z), or by selecting a previous history state via the History panel. The \mathcal{H} H *ctrl* H keyboard shortcut can be used to hide an active selection, but note that on a Macintosh, the first time you use the \mathcal{H} H keyboard shortcut, this opens the dialog shown in Figure 1.43, where you will be asked to select the desired default behavior: do you want this shortcut to hide the Photoshop application, or hide all extras?

The marquee selection tool options include the rectangular, elliptical and single row/single column selection tools. In Figure 1.44 I have shown the elliptical marquee tool in use and below that in Figure 1.45, an example of how you can use the rectangular marquee tool. The lasso tool can be used to draw freehand selection outlines and has two other modes: the polygon lasso tool, which can draw both straight line *and* freehand selections plus the magnetic lasso tool, which is like an automatic freehand lasso tool that is able to auto-detect the edge you are trying to trace.

The quick selection tool is a bit like the magic wand tool as it can be used to make selections based on pixel color values; however the quick selection tool is a little more sophisticated than the standard magic wand and hence it has been made the default tool in this particular tool group. As you read through the book you'll see a couple of examples where the quick selection tool can be used to make quite accurate selections based on color and how these can then be modified more precisely using the Refine Edge command. For full descriptions of these and other tools mentioned here don't forget to check out the *Photoshop CS6 for Photographers Help Guide* on the website.

Figure 1.44 A selection can be used to define a specific area of an image that you wish to work on. In this example, I made an elliptical marquee selection of the cup and saucer and followed this with an image adjustment to make the colors warmer.

Figure 1.45 In this example I used the rectangular marquee tool to make a marquee selection of the door. I then applied a Hue/Saturation adjustment to modify the colors within the selection area.

Color Range tip

A Color Range selection tool can only be used to make discontiguous selections. However, it is possible to make a selection first of the area you wish to focus on and then choose Color Range to make a color range selection within the selection area.

Out-of-gamut selections

Among other things, you can use the Color Range command to make a selection based on out-of-gamut colors. This means you can use Color Range to make a selection of all the 'illegal' RGB colors that fall outside the CMYK gamut and apply corrections to these pixels only. To be honest, while Color Range allows you to do this, I don't recommend using Photoshop's out-of-gamut indicators to modify colors in this way. Instead, I suggest you follow the instructions on soft proofing in Chapter 12.

Skin tone and faces selections

There is now a Skin Tones option available in the Selector menu. You can use this to specifically select skin tone colors in an image. There is also a separate 'Detect Faces' checkbox (which is available when the Localized Color Clusters checkbox is activated). When Detect Faces is enabled it uses a face detection algorithm to automatically look for and select faces in a photo. It appears to be effective with all different types of skin colors. Checking the Detect Faces option in conjunction with a Skin Tones selection can often really help narrow down a selection to select faces only.

Color Range

In the Photoshop Select menu you will see an item called 'Color Range', which is a color-based selection tool (Figure 1.46). While the quick selection and magic wand tools create selections based on luminosity, Color Range can be used to create selections that are based on similar color values. Some important new functionality was added to Color Range in Photoshop CS4, which has since turned this into a very powerful selection making tool.

To create a Color Range selection, go to the Select menu, choose Color Range… and click on the target color anywhere in the image window (or Color Range preview area) to define the initial selection. To add colors to this selection, select the Add to Sample eyedropper and keep clicking to expand the selection area. To subtract from a selection, click on the Subtract from Sample eyedropper and click in the image to select the colors you want to remove from the selection. You can then adjust the Fuzziness slider to adjust the tolerance of the selection, which increases or decreases the number of pixels that are selected based on how similar the pixels are in color to the already sampled pixels.

If the Localized Color Clusters box is checked, Color Range can process and merge data from multiple clusters of color samples. As you switch between 'sampling colors to add to a selection' and 'selecting colors to remove', Photoshop calculates these clusters of color samples within a three-dimensional color space. As you add and subtract colors Photoshop can produce a much more accurate color range selection mask based on the color sampled data. When Localized Color Clusters is checked the Range slider lets you determine which pixels are to be included based on how far or near a color is from the sample points that are included in the selection.

The selection preview options for the document window can be set to None (the default), Grayscale, a Matte color such as the White Matte example shown in Figure 1.47, or as a Quick Mask. Overall I find that Grayscale is a really useful preview mode if you want to get a nice large view in the document window of what the Color Range selection will look like and this is especially useful if you find the small Color Range dialog preview too small to judge from. This is just a brief introduction to working with Color Range and you'll find a further example coming up later in Chapter 9 (see page 516).

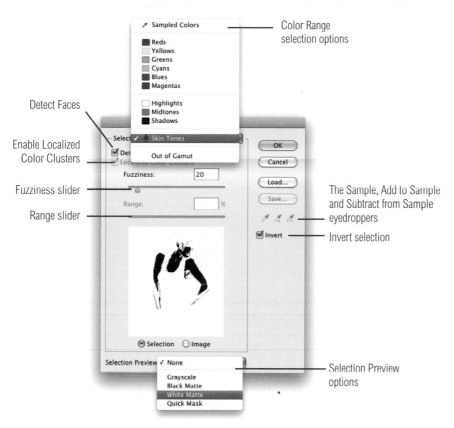

Color Range
selection options

Detect Faces

Enable Localized
Color Clusters

Fuzziness slider

Range slider

The Sample, Add to Sample
and Subtract from Sample
eyedroppers

Invert selection

Selection Preview
options

Figure 1.46 This shows the Color Range dialog with expanded menus that show the full range of options for the Color Range selection dialog.

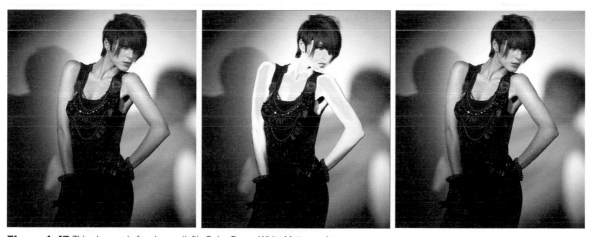

Figure 1.47 This shows a before image (left), Color Range White Matte preview (middle) and a color adjusted image (right) made using a Color Range selection.

Modifier keys

Macintosh and Windows keyboards have slightly different key arrangements, hence the reason for me including double sets of instructions throughout the book, where the ⌘ key on the Macintosh is equivalent to the *ctrl* key on a Windows keyboard and the Macintosh ⌥ key is equivalent to the *alt* key in Windows. Although on most Macintosh keyboards you'll find the Option key is labeled 'Alt' anyway (see Figure 1.49).

Windows users (and Mac users using a 'mighty mouse', or equivalent mouse) can use the right mouse button to access the contextual menus (Mac users can also use the *ctrl* key to access these menus) and, finally, the *Shift* key which is the same on both Mac and PC computers.

These keys are commonly referred to as 'modifier' keys, because they can modify tool behaviors. In Figure 1.48 you can see how if you hold down the *Shift* when drawing an elliptical marquee selection this constrains the selection to a circle. If you hold down ⌥ *alt* when drawing a marquee selection it centers the selection around the point where you first clicked on the image. If you hold down *Shift* ⌥ *Shift* *alt* when drawing an elliptical marquee selection, this constrains the selection to a circle and centers the selection around the point where you first clicked. The Spacebar is a modifier key too in that it allows you to reposition a selection midstream.

Figure 1.48 These composite screen shots show Quick Mask views of selections created by dragging out from the center with *Shift* held down (top), with ⌥ *alt* held down (middle) and *Shift* ⌥ *Shift* *alt* (bottom).

Figure 1.49 This shows the modifier keys (shaded in orange), showing both the Macintosh and Windows equivalent key names. The other keys commonly used in Photoshop are the Tab and Tilde keys, shown here shaded in blue.

After you have created an initial selection the modifier keys will behave differently. In Figure 1.50 you can see how if you hold down the *Shift* key as you drag with the marquee or lasso tool, this adds to the selection (holding down the *Shift* key and clicking with the magic wand tool also adds to an existing selection). If you hold down the ⌥ *alt* key as you drag with the marquee or lasso tool, this subtracts from an existing selection (as does holding down the ⌥ *alt* key and clicking with the magic wand tool). And the combination of holding down the *Shift* ⌥ *Shift alt* keys together whilst dragging with a selection tool (or clicking with the magic wand) will create an intersection of the two selections. As well as using the above shortcuts, you will find there are also equivalent selection mode options in the Options bar for the marque and lasso selection tools (see Figure 1.51).

Modifier keys can also be used to modify the options that are available elsewhere in Photoshop. For example, if you hold down the ⌥ *alt* key as you click on, say, the marquee tool in the Tools panel you will notice how this allows you to cycle through all the tools that are available in this group. Whenever you have a Photoshop dialog box open it is worth exploring what happens to the dialog buttons when you hold down the ⌥ *alt* key. You will often see the button names change to reveal more options (typically, the Cancel button will changes to say 'Reset' when you hold down the ⌥ *alt* key).

Figure 1.50 These composite screen shots show examples of selections that have been modified after the initial selection stage. The top view shows an elliptical selection combined with a rectangular selection with *Shift* held down, adding to a selection. The middle view shows an elliptical selection combined with a rectangular selection with ⌥ *alt* held down, which subtracts from the original selection. The bottom view shows an elliptical selection combined with a rectangular selection with *Shift* ⌥ *Shift alt* held down, which results in an intersected selection.

Normal Subtract from Selection

Add to Selection

Intersect Selection

Figure 1.51 The Options bar has four modes of operation for each of the selection tools: Normal; Add to Selection; Subtract from Selection; and Intersect Selection. These are equivalent to the use of the modifier modes described in the main text when the tool is in Normal mode.

Brush tool (B)

Pencil tool (B)

Mixer brush tool (B)

Blur tool

Sharpen tool

Smudge tool

Dodge tool (O)

Burn tool (O)

Sponge tool (O)

The new round brush presets

As mentioned in the main text, there are now just six round brush presets. These allow you to select hard or soft brushes with either no pressure-linked controls, the brush size linked to the amount of pressure applied, or brush opacity linked to the amount of pressure applied.

Painting tools

The next set of tools we'll focus on are the painting tools, which include: the brush, pencil, mixer brush, blur, sharpen, smudge, burn, dodge and sponge tools. These can be used to paint, or used to edit the existing pixel information in an image. If you want to keep your options open you will usually find it is preferable to carry out your paint work on a separate new layer. This allows you to preserve all of the original image on a base layer and you can easily undo all your paint work by turning off the visibility of the paint layer.

When you select any of the painting tools, the first thing you will want to do is to choose a brush, which you can do by going to the Brush Preset Picker (the second item from the left in the Options bar) and select a brush from the drop-down list shown in Figure 1.52. Here, you can choose from the many different types of brushes, including the bristle shape brushes that were added in Photoshop CS5. The Size slider can be used to adjust the brush size from a single pixel to a 5000 pixel-wide brush. If one of the standard round brushes is selected you can also use the Hardness slider to set varying degrees of hardness for the brush shape. Note here that there are now only six round brush presets: soft round/hard round, soft round pressure size/hard round pressure size and soft round pressure opacity and hard round pressure opacity.

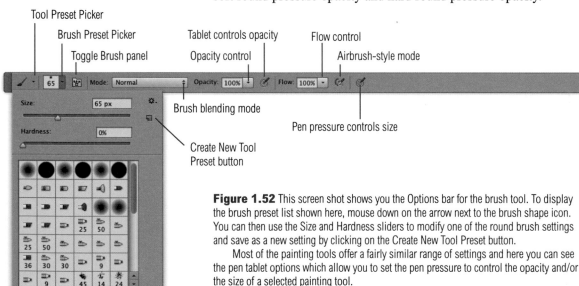

Figure 1.52 This screen shot shows you the Options bar for the brush tool. To display the brush preset list shown here, mouse down on the arrow next to the brush shape icon. You can then use the Size and Hardness sliders to modify one of the round brush settings and save as a new setting by clicking on the Create New Tool Preset button.

Most of the painting tools offer a fairly similar range of settings and here you can see the pen tablet options which allow you to set the pen pressure to control the opacity and/or the size of a selected painting tool.

On-the-fly brush changes

Instead of visiting the Brush Picker every time you want to adjust the size or hardness of a brush, you will often find it is quicker to use the square bracket keys (as described in Figures 1.53 and 1.54) to make such on-the-fly changes. Also, if you *ctrl* right mouse-click on the image you are working on this opens the Brush Preset menu directly next to the cursor. Click on the brush preset you wish to select and once you start painting, the Brush Preset menu closes (or alternatively, use the *esc* key). Note that if you are painting with a Wacom™ stylus you can close this pop-up dialog by lifting the stylus off the tablet and squeezing the double-click button. If you *ctrl* *Shift*-click or right mouse *Shift*-click in the image while using a brush tool, this opens the blending mode list shown in Figure 1.55. These blend modes are like rules which govern how the painted pixels are applied to the pixels in the image below. For example, if you paint using the Color mode, you'll only alter the color values in the pixels you are painting.

Figure 1.53 There is no need to visit the Brush or Tool presets each time you want to change the size of a brush. You can use the right square bracket key ▯ to make a brush bigger and the left square bracket key ▯ to make it smaller.

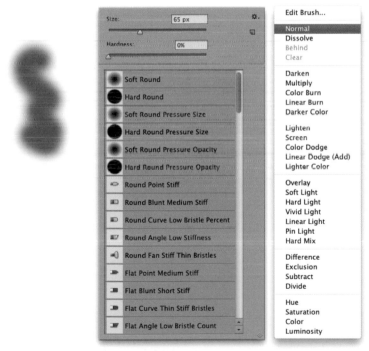

Figure 1.54 You can combine the square bracket keys with the Shift key on the keyboard. You can use *Shift* ▯ to make a round brush edge harder and use *Shift* ▯ to make a round brush edge softer. Note that this only applies when editing one of the round brush presets.

Figure 1.55 When using any of the paint tools in Photoshop, a *ctrl*-click or right mouse-click opens the Brush Preset menu (middle), while a *ctrl* *Shift*-click or right mouse *Shift*-click reveals the brush blending modes list shown on the right.

Non-rotating brushes

If you use the rotate tool to rotate the canvas, Photoshop CS6 now prevents the brushes from rotating too. You can continue to paint with the same brush orientation at all canvas rotation angles.

Brush preview overlay color

If you go to the Photoshop Cursors preferences you can customize the overlay color that's used for the brush preview.

Hue, brightness and saturation

When you use the key combination described here to access the HUD Color Picker, you can hold down the Spacebar to freeze the cursor position. You can then select a hue color from the hue wheel/strip, freeze the hue color selection and switch to select a brightness/saturation value.

On-screen brush adjustments

Providing you have the OpenGL option enabled in the Performance preferences, Photoshop offers you on-screen brush adjustments and a HUD (heads up display) Color Picker. If you hold down the *ctrl* *⌥* keys (Mac), or the *alt* key and right-click (PC), dragging to the left makes the brush size smaller and dragging to the right, larger. Also, if you drag upwards this makes a round brush shape softer, while dragging downwards makes a round brush shape harder. Note here how the brush hardness is represented with a quick mask type overlay. If you hold down the *⌘* *⌥* *ctrl* keys (Mac), or the *alt* *Shift* keys and right-click (PC), this opens the Heads Up Display Color Picker where for as long as you have the mouse held down you can move the cursor over the outer hue wheel or hue strip to select a desired hue color and then inside the brightness/saturation square to select the desired saturation and luminosity. The point where you release the mouse selects the new foreground color. Figure 1.56 shows examples of how the paint tool cursor looks for both the on-screen brush size/hardness adjustments and the Hue Wheel HUD Color Picker displays.

Figure 1.56 You can dynamically adjust the brush size and hardness of the painting tool cursors on screen, or open the Heads Up Display Color Picker using the modifier keys described in the main text (providing OpenGL drawing is enabled). See Chapter 2 for more information on how to select alternative HUD display options.

Brush panel

Over in the Brush panel if you click on the Brush Presets button (circled in Figure 1.58), this opens the Brush Presets panel listing the same brush presets list as shown in Figure 1.52. You can then append or replace these brush presets by going to the panel fly-out menu shown below and selecting a new brush settings group from the list.

So far we have looked at the Brush options that are used to determine the brush shape and size, but if you click on any of the brush attribute settings shown in Figure 1.58, the brush presets list changes to reveal the individual brush attribute options (see Figure 1.59). The brush attributes include things like how the opacity of the brush is applied when painting, or the smoothness of the brush. You can therefore start by selecting an existing brush preset, modify it, as in the Figure 1.57 example, and then click on the Create new brush button at the bottom to define this as a new custom brush preset setting.

Figure 1.57 In this example, I selected an 'Aurora' brush preset and adjusted Size Jitter and Angle Jitter in the Shape Dynamics settings, linking both to the angle of the pen. I then set turquoise as the foreground color, purple for the background color and used a pen pressure setting to vary the paint color from the foreground to the background. I created the doodle shown here by twisting the pen angle as I applied the brush strokes.

Create new brush

Figure 1.58 If you open the Brushes panel, the default panel setting shows an Expanded View and lists the various brush presets in the right-hand section of the panel. If you click on any of the brush attributes in the list on the left, the right-hand section changes to reveal the various options settings (see Figure 1.59). If you open or go to the Brush Presets panel menu, you can select any of the brush settings listed here, which will then ask if you want to Append or Replace the current list of presets.

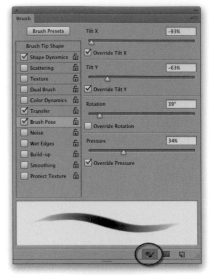

Figure 1.59 If you click on a brush attribute setting in the list on the left, the right-hand side of the panel displays the options that are associated with each attribute. Specific brush panel settings can be locked by clicking on the Lock buttons. If using a bristle tip brush shape, clicking the live brush tip preview button enables the preview shown here.

Brush Pose

The Brush Pose options allow mouse users to set a stylus pose that is applied while painting. If painting with, say, a Wacom device, enabling the checkboxes (like those shown checked in Figure 1.59) overrides any tablet data to set a fixed pose. To see how this works, try selecting a dynamic tip brush and enable the live brush tip preview (circled above). Brush Pose settings can be saved with Brush and Tool presets.

Brush panel options

The following notes and tips on working with the Brush panel will apply to most, but not all of the painting tools.

To create your own custom brush preset settings click on any of the brush attribute items that are listed on the left-hand side of the panel. The Jitter controls introduce some randomness into the brush dynamics behavior. For example, increasing the Opacity Jitter means that the opacity will respond according to how much pen pressure is applied and there is a built-in random fluctuation to the opacity that varies more and more as the jitter value is increased. Meanwhile, the Flow Jitter setting governs the speed at which the paint is applied. To understand how the brush flow dynamics work, try selecting a brush and quickly paint a series of brush strokes at a low and then a high flow rate. When the flow rate is low, less paint is applied, but as you increase the flow setting more paint is applied. Other tools like the dodge and burn toning tools use the terms Exposure and Strength, but these essentially have the same meaning as the opacity controls. The Shape Dynamics can be adjusted to introduce jitter into the size angle and roundness of the brush and the scattering controls allow you to produce broad, sweeping brush strokes with a random scatter, while the Color Dynamics let you introduce random color variation to the paint color. The Foreground/Background color control lets you vary the paint color between the foreground and background color, according to how much pressure is applied (see Figure 1.57). The Dual Brush and Texture Dynamics can introduce texture and more interactive complexity to the brush texture (it is worth experimenting with the Scale control in the Dual Brush options) and the Texture Dynamics can utilize different blending modes to produce different paint effects. The Transfer Dynamics allow you to adjust the dynamics for the build-up of the brush strokes – this relates particularly to the ability to paint using wet brush settings.

Pressure sensitive control

If you are using a pressure sensitive pen stylus, you will see additional options in the Brush panel that enable you to link the pen pressure of the stylus to how the effects are applied. You can therefore use these options to determine things like how the paint opacity and flow are controlled by the pen pressure or by the angle of tilt or rotation of the pen stylus. But note here that the tablet

pressure controls can also be controlled via the buttons in the
Options bar for the various painting tools (I've highlighted these
new tablet button controls in Figure 1.52).

Brush tool presets

When you have finished adjusting the Brush panel dynamics and
other settings, you can save combinations of the brush preset
shape/size, Brush panel attribute settings, plus the brush blending
mode (and brush color even) as a new Brush tool preset. To do this,
go to the Tool Presets panel and click on the New Preset button at
the bottom (see Figure 1.60). Or, you can mouse down on the Tool
Preset Picker in the Options bar and click on the New Brush setting
button. Give the brush tool preset a name and click OK to append
this to the current list. Once you have saved a brush tool preset,
you can access it at any time via the Tool Presets panel or via the
Tool Preset menu in the Options bar.

Mixer brush

The mixer brush allows you to paint more realistically in
Photoshop. With the mixer brush you can mix colors together
as you paint, picking up color samples from the image you are
painting on and set the rate at which the brush picks up paint from
the canvas and the rate at which the paint dries out. The mixer
brush can be used with either the bristle tips or with the traditional
Photoshop brush tips (now referred to as static tips) to produce
natural-looking paint strokes. The combination of the mixer brush
and bristle tip brushes provides a whole new level of sophistication
to the Photoshop paint engine. The only downside is that the user
interface has become even more complicated. The brush controls
and feedback are split between the Brush panel, the Brush Presets
panel, the Options bar and the live brush tip preview. It's not
particularly easy to pick up a brush and play with it unless you have
studied all the brush options in detail and you understand how the
user interface is meant to work. Fortunately, the Tool Presets panel
can help here and the easiest way to get started is to select one or
two of the new brush presets and experiment painting with these
brush settings to gain a better understanding of what the new brush
settings can do. In the meantime, let's take a look at the Options bar
settings for the mixer brush that's shown in Figure 1.61.

Wacom™ tablets

Photoshop is able to exploit all of the
pressure responsive built-in Wacom™
features. You will notice that as you alter
the brush dynamics settings in the Brush
panel, the brush stroke preview below
changes to reflect what the expected
outcome would be if you had drawn a
squiggly line that faded from zero to
full pen pressure (likewise with the tilt
and thumb wheel). This visual feedback
is extremely useful as it allows you to
experiment with the brush dynamics
settings in the Brushes panel and learn
how these affect the brush dynamics
behavior.

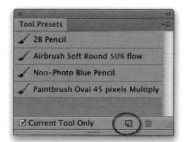

Figure 1.60 The Tool Presets panel. When
you click on the New Preset button (circled)
this opens the New Tool Preset dialog, where
you can save and name the current tool
settings as a new tool preset.

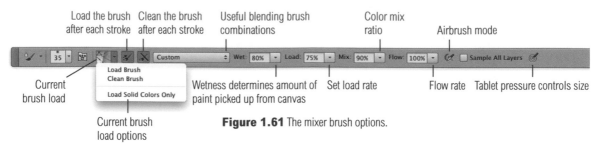

Load the brush after each stroke · Clean the brush after each stroke · Useful blending brush combinations · Color mix ratio · Airbrush mode

Load Brush
Clean Brush
Load Solid Colors Only

Current brush load

Current brush load options

Wetness determines amount of paint picked up from canvas · Set load rate · Flow rate · Tablet pressure controls size

Figure 1.61 The mixer brush options.

Figure 1.62 The Load swatch displays the main reservoir well color in the outer area and the pickup well color in the center. Clicking on the mixer brush Current brush load swatch launches the Photoshop Color Picker.

Wet/Mix/Flow numeric shortcuts

Typing in a number changes the Wetness value. Holding down the [⌥] [Shift] [alt] [Shift] keys while entering a number changes the Mix value. Lastly, holding down just the [Shift] key as you enter a number changes the Flow value. Note, you should type '00' to set any of the above values to zero.

Mixer brush presets

Sampled fill colors are retained whenever you switch brush tips or adjust the brush tip parameters. You can also include saving the main reservoir well and pickup well colors with a mixer brush tool preset.

The mixer brush tool has two wells: a reservoir and a pickup. The reservoir well color is defined by the current foreground color swatch in the Tools panel or by [⌥] [alt]-clicking in the image canvas area. This is the color you see displayed in the Load swatch preview. The pickup well is one that has paint flowing into it and continuously mixes the colors of where you paint with the color that's contained in the reservoir well. Selecting 'Clean Brush' from the 'Current brush load' options immediately cleans the brush and clears the current color, while selecting 'Load Brush' fills with the current foreground color again. The 'Load brush after each stroke' button does what it says, it tells the mixer brush to keep refilling the pickup well with color and therefore the pickup well becomes progressively contaminated with the colors that are sampled as you paint. The 'Clean brush after each stroke' button empties the reservoir well after each stroke and effectively allows you to paint from the pickup well only (Figure 1.62 shows an example of how the well colors are displayed in the Options bar).

The Paint wetness controls how much paint gets picked up from the image canvas. Basically, when the wetness is set to zero the mixer brush behaves more like a normal brush and deposits opaque color. As the wetness is increased so is the streaking of the brush strokes. The 'Set load rate' is a dry-out control. This determines how much paint gets loaded into the main reservoir well. With low load rate settings you'll get shorter brush strokes where the paint dries out quickly and as the load rate setting is increased you get longer brush strokes.

The Mix slider determines how much of the color picked up from the canvas that goes into the pickup well is mixed with the color stored in the main reservoir well. A high Mix ratio means more ink flows from the pickup to the reservoir well, while the Flow rate control determines how fast the paint flows as you paint. With a high Flow setting, more paint is applied as you paint. If you combine this with a low Load rate setting you'll notice how at a

high Flow setting the paint flows out quickly and results in shorter paint strokes. At a lower Flow rate you'll notice longer (but less opaque) brush strokes.

Bristle tip brush shapes

If you select one of the bristle tip brush shapes you can click on the Brush Tip Shape option in the Brush panel (Figure 1.64) to reveal the Bristle Qualities options. These brush tips can be used in conjunction with any of the Photoshop painting tools. When a bristle tip (as opposed to a traditional 'static' Photoshop brush tip) is selected you can also click the Bristle preview button (circled in Figure 1.64) to display the floating Bristle preview panel shown in Figure 1.63. As you adjust the slider controls in the Brush panel the Bristle preview provides visual feedback as to how this will affect the current bristle tip behavior.

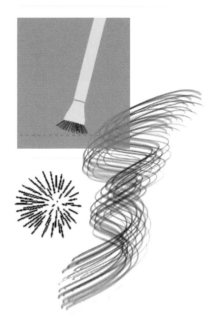

Figure 1.63 This shows the live brush preview, which can be enabled by clicking on the button circled in Figure 1.64. It can be toggled in size, moved around the screen, or closed. The Brush preview can also be turned on or off via the View/Show menu (or use ⌘ H ctrl H).

Dodge and burn tools

The dodge and burn tools were much improved in Photoshop CS4. However, you are still limited to working directly on the pixel data. If you do want to use the dodge and burn tools, I suggest you work on a copied pixel layer. Overall, I reckon you are better off using the Camera Raw adjustment tools to dodge and burn your images, or use the adjustment layers technique that is described in Chapter 5.

Figure 1.64 The Bristle tip Brush panel options. The Bristles slider determines the density of the number of bristles within the current brush size. The Length determines the length of the bristles relative to the shape and size of the selected brush. The Thickness determines the thickness of each bristle. The Stiffness controls the stiffness or resistance of the bristles. The Angle slider determines the angle of the brush position – this isn't so relevant for pen tablet users, but more so if you are using a mouse. Lastly, the Spacing slider sets the spacing between each stamp of the brush stroke.

Paint bucket tool (G)	
Gradient tool (G)	
Rectangle tool (U)	
Rounded rectangle tool (U)	
Elliptical tool (U)	
Polygon tool (U)	
Line tool (U)	
Custom shape tool (U)	

Aligned rendering and Snap to pixel

This is really something of more interest to designer users, but with Photoshop CS6, when creating a new shape or drawing a pen path, there is a new 'Align Edges' option in the Options bar that lets you force shapes or paths to align and snap to the underlying pixel grid. As I say, this is really useful for designers, but for photo editing work it's not so relevant.

Tools for filling

The various shape tools, including the line tool, are really of most use to graphic designers who wish to create things like buttons or need to add vector shapes to a design layout. In Figure 1.65, you can see an example of how a filled, custom shape vector layer was placed above a pixel layer that had been filled with a gradient.

The paint bucket tool is another type of fill tool and is a bit like a combination of a magic wand selection combined with an Edit ⇨ Fill using the foreground color. As much as I like to ignore the paint bucket, I can be proved wrong. Recently, photographer Stuart Weston showed me how he used the paint bucket tool to add small filled patches of color to a large composite fashion advertising image – I have to say, the final image did look very good.

The gradient tool will certainly be of interest to photographers. For example, you can use the Adjustment layer menu to add gradient fill layers to an image. Gradient fill layers can be applied in this way to create gradient filter type effects. However, you will also find that the gradient tool comes in use when you want to edit the contents of a layer mask. For example, you can add a black to white gradient to a layer mask to apply a graduated fade to the opacity of a layer.

Figure 1.65 In this example I added a radial gradient using a transparency to blue gradient. Above this I added a 35mm filmstrip custom shape layer filled with black.

Tools for drawing

If you want to become a good retoucher, then you are at some stage going to have to bite the bullet and learn how to use the pen tools. The selection tools are fine for making approximate selections, but as I have shown below in Figure 1.66, whenever you need to create precision selections or masks the pen and its associated path editing tools are essential.

The pen tool group includes the main pen tool, a freeform pen tool (which in essence is not much better than the lasso or magnetic lasso tools) plus modifier tools to add, delete or modify the path points. There are several examples coming up in Chapter 9 where I will show how to use the pen tools to draw a path.

Pen tool (P)

Freeform pen tool (P)

Add anchor point tool

Delete anchor point tool

Convert point tool

Path selection tool (A)

Direct selection tool (A)

Figure 1.66 If you need to isolate an object and create a cut-out like the one shown here, the only way to do this is by using the pen and pen modifier tools to first draw a path outline. You see, with a photograph like this, there is very little color differentiation between the object and the background and it would be very difficult for an auto masking tool to accurately predict the edges in this image. So I timed myself and it only took 8 minutes to draw the path outline that was used to create the cut-out shown on the right.

⊹	Move tool (V)
⊥	Crop tool (C)
⊞	Perspective Crop tool (C)
⊥	Clone Stamp (S)
⊞	Pattern Stamp (S)
⊘	Spot Healing brush (J)
⊘	Healing brush (J)
⊕	Patch tool (J)
✕	Content-Aware Move tool (J)
⊕	Red Eye tool (J)
⊿	Color Replacement tool (B)
⊿	Eraser (E)
⊿	Background Eraser (E)
⊿	Magic Eraser (E)

Image editing tools

Starting from the top, we have the move tool and below that the crop tool, which can be used to trim pictures or enlarge the canvas area. This tool has undergone some major changes, plus the break out of the perspective crop tool. You can read more about these in the Image editing essentials chapter.

The clone stamp tool has been around since the beginning of Photoshop and is definitely an essential tool for all kinds of retouching work. You can use the clone stamp to sample pixels from one part of the image and paint with them in another (as shown in Figure 1.67). The spot healing and healing brush tools can be used in almost exactly the same way as the clone stamp, except they cleverly blend the pixels around the edges of where the healing brush retouching is applied to produce almost flawless results. The spot healing brush is particularly clever because you don't even need to set a sample point: you simply click and paint over the blemishes you wish to see removed. This tool has been enhanced with a content-aware healing mode that allows you to tackle what were once really tricky subjects to retouch. The patch tool is similar to the healing brush except you first use a selection to define the area to be healed and this is now also joined by a content-aware move tool that allows you to either extend a selected area or move it and at the same time fill the initial selected area.

Providing you use the right flash settings on your camera it should be possible to avoid red eye from ever occurring in your flash portrait photographs. But for those times when the camera flash leaves your subjects looking like beasts of the night, the red eye tool provides a fairly basic and easy way to auto-correct such photos. Meanwhile, the color replacement brush is kind of like a semi-smart color blend mode painting tool that analyzes the area you are painting over and replaces it with the current foreground color, using either a Hue, Color, Saturation or Luminosity blend mode. It is perhaps useful for making quick and easy color changes without needing to create a Color Range selection mask first. The eraser tools are still there should you wish to erase the pixels directly, although these days it is more common to use layer masks to selectively hide or show the contents of a layer. The background eraser and magic eraser tools do offer some degree of automated erasing capabilities, but I would be more inclined to use the quick selection tool combined with a layer mask for this type of masking.

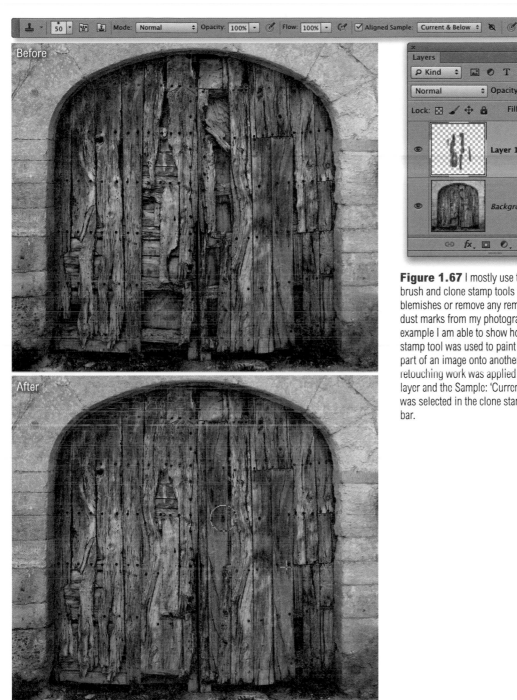

Figure 1.67 I mostly use the healing brush and clone stamp tools to retouch small blemishes or remove any remaining sensor dust marks from my photographs. In this example I am able to show how the clone stamp tool was used to paint detail from one part of an image onto another. Note how the retouching work was applied to an empty new layer and the Sample: 'Current & Below' option was selected in the clone stamp tool Options bar.

Blending modes

Layers can be made to blend with the layers below them using any of the 27 different blending modes that are in Photoshop. Layer effects/styles can be used to add effects such as drop shadows, gradient/pattern fills or glows to any layer, plus custom layer styles can be loaded from and saved to the Styles panel.

Drag and drop layers

You can drag and drop a file to a Photoshop document and place it as a new layer.

Working with Layers

Photoshop layers allow you to edit a photograph by building up the image in multiple layered sections, such as in the Figure 1.68 example below. A layer can be an image element, such as a duplicated background layer, a copied selection that's been made into a layer, or content that has been copied from another image. Or, you can have text or vector shape layers. You can also add adjustment layers, which are like image adjustment instructions applied in a layered form.

Layers can be organized into layer group folders, which will make the layer organization easier to manage, and you can also apply a mask to the layer content using either a pixel or vector layer mask. You will find there are plenty of examples throughout this book in which I show you how to work with layers and layer masks.

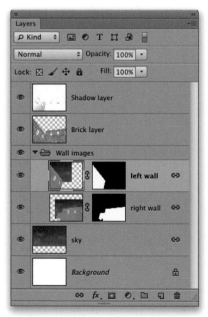

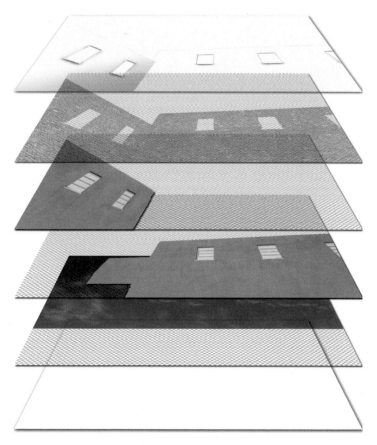

Figure 1.68 The above Layers panel view shows the layer contents of a typical layered Photoshop image and the diagram on the right shows how these layers are used to build the composite image.

Automating Photoshop

Why waste your time performing repetitive tasks when Photoshop is able to automate these processes for you? Using the Actions panel you can record steps in Photoshop as an action and use this to replay on other images. Figure 1.69 shows a screen shot of the Actions panel, where it currently displays an expanded view of the Default Actions set. As you can see from the descriptions, these actions can perform automated tasks such as adding a vignette to a photo or creating a wood frame edge effect. OK, these are not exactly the sort of actions you would use every day, but if you go to the panel fly-out menu and select Load Actions… you will be taken to the Photoshop CS6/Presets/Photoshop Actions folder. Here you will find lots of action sets that are worth installing.

To run an action, you will usually need to have a document already open in Photoshop and press the Play button. It is also quite easy to record your own custom actions, and once you get the hang of how to do this you can use the File ⇨ Automate ⇨ Batch… command to apply recorded actions to batches of images. You can also go to the File ⇨ Automate menu and choose 'Create Droplet…'. Droplets are like self-contained batch action operations located in the Finder/Explorer. All you have to do is drag an image file to a droplet to initiate a Photoshop action process (see Figure 1.70). I explain later in Chapter 13 how to automate Photoshop and make efficient use of actions.

By saving and loading actions it is easy to share your favorite Photoshop actions with other users – all you have to do is to double-click an action icon to automatically install it in the Actions panel, and if Photoshop is not running at the time, this will also launch the program.

Figure 1.69 The Actions panel.

Allow tool recording

In the Actions panel fly-out menu there is a new feature: Allow Tool Recording. When this is checked Photoshop CS6 now allows you to record things like brush strokes as part of an action. There are some limitations to this new feature, but providing the images you record on and play back the action on have the same pixel dimensions, it will work.

Figure 1.70 With Photoshop droplets you can apply a batch action operation by simply dragging and dropping an image file or a folder of images onto a droplet that has been saved to the Finder/Explorer.

Nudging layers and selections

The keyboard arrow keys can be used to nudge a layer or selection in 1 pixel increments, or 10 pixel increments with the *Shift* key held down. A series of nudges count as a single Photoshop step in history and can be undone with a single undo (⌘ Z *ctrl* Z) or a step back in history. Also, holding down the *Shift* key as you drag allows you to constrain the move direction to the horizontal, vertical or a 45° angle.

Move tool

The move tool can perform many functions such as move the contents of a layer, directly move layers from one document to another, copy layers, apply transforms, plus select and align multiple layers. In this respect the move tool might be more accurately described as a move/transform/alignment tool and in CS6 you'll now also see a heads up display that indicates how far you are moving something. The move tool can also be activated any time another tool is selected simply by holding down the ⌘ *ctrl* key (except for when the slice tools, hand tool, pen or path selection tools are selected). If you hold down the ⌥ *alt* key while the move tool is selected, this lets you copy a layer or selection contents. It is also useful to know that using ⌥ *alt* plus ⌘ *ctrl* (the move tool shortcut) lets you make a copy of a layer or selection contents when any other tool is selected (apart from the ones I just listed). If the Show Transform Controls box is checked in the move tool Options bar (Figure 1.71), a bounding box will appear around the bounds of the selected layer, and when you mouse down on the bounding box handles to transform the layer, the Options bar switches modes to display the numeric transform controls.

Figure 1.71 The move tool Options bar with the Auto-Select layer option checked. Note you can select Group or Layer from the pop-up menu here.

Auto layer/layer group selection

The move tool Options panel contains a menu that allows you to choose between 'Group' or 'Layer' auto-selection. When 'Layer' is selected, Photoshop only auto-selects individual layers. When 'Group' is selected, Photoshop can auto-select whole layer groups. If the move, marquee, lasso or crop tool are selected, a ⌘ ⌥ *ctrl* *ctrl* *alt* + right mouse-click selects a target layer based on the pixels where you click. When the move tool only is selected, ⌘ ⌥ *ctrl* *alt*-click selects a layer group based on the pixels where you click.

Layer selection using the move tool

When the move tool is selected, dragging with the move tool moves the layer or image selection contents (the cursor does not have to be centered on the object or selection, it can be anywhere in the image window). However, when the Auto-Select option is switched on (circled in Figure 1.71), the move tool can auto-select the uppermost layer (or layer group) containing the most opaque image data below the cursor – this can be useful when you have a large number of layers in an image. Multiple layer selection is also possible with the move tool, because when the move tool is in Auto-Select mode you can marquee drag with the move tool from outside the canvas area to select multiple layers, the same way as you can make a marquee selection using the mouse cursor to select multiple folders or documents in the Finder/Explorer (see Figure 1.72).

Where you have many layers that overlap, remember there is a contextual mode for the move tool that can help you target specific layers (use *ctrl* right mouse-click to access the contextual layer menu). Any layer with an opacity greater than 50% will show up in the contextual menu. This then allows you to select a specific layer from below the cursor.

Client: ET Nail Art

Figure 1.72 When the move tool is selected and the Auto-Select box is checked, you can marquee drag with the move tool from outside of the canvas area inwards to select specific multiple layers or layer groups. If the Auto-Select Layer option is deselected, you can instead hold down the ⌘ *ctrl* key to temporarily switch the move tool to the 'Auto-Select' mode.

Align/Distribute layers

When several layers are linked together, you can click on the Align and Distribute buttons in the Options bar as an alternative to navigating the Layer ⇨ Align Linked and Distribute Linked menus (see Chapter 9 for more about the Align and Distribute commands).

Layer selection shortcuts

You can at any time use the ⌘ �option A *ctrl* option A shortcut to select all layers. But note that the move tool layer selection method will not select any layers that are locked. For example, if you use the Auto-Select layer mode to marquee drag across the image to make a layer selection, the background layer will not be included in the selection.

Zoom tool (Z)

Hand tool (H)

Eyedropper tool (I)

Color Sampler tool (I)

Ruler tool (I)

Rotate View tool (R)

Notes tool (I)

Count tool (I)

Navigation and information tools

To zoom in on an image, you can either click with the zoom tool to magnify, or drag with the zoom tool, marqueeing the area you wish to inspect in close-up. This combines a zoom and scroll function in one (a plus icon appears inside the magnifying glass icon). To zoom out, just hold down the ⌥ *alt* key and click (the plus sign is replaced with a minus sign). You can also zoom in by holding down the Spacebar + the ⌘ key (Mac) or the *ctrl* key (PC). You can then click to zoom in and you can also zoom out by holding down the Spacebar + the ⌥ key (Mac) or the *alt* key (PC). This keyboard shortcut calls up the zoom tool in zoom out mode and you can then click to zoom out.

Zoom tool shortcuts

Traditionally, the ⌘ ⌥ *0* *ctrl* *alt* *0* shortcut is used to zoom to a 100% pixels view and the ⌘ *0* *ctrl* *0* shortcut is used to zoom out to a fit to view zoom view. Photoshop now also uses the ⌘ *1* *ctrl* *1* shortcut to zoom to 100%. This was first implemented in CS4 in order to unify the window document zoom controls across all of the Creative Suite applications. As a consequence of this, the channel selection shortcuts have been shifted along two numbers. ⌘ *2* *ctrl* *2* selects the composite channel, ⌘ *3* *ctrl* *3* selects the red channel, ⌘ *4* *ctrl* *4* the green channel and so on. The Tilde key has also changed use. Prior to CS4 ⌘ ~ *ctrl* ~ selected the composite color channels (after selecting a red, green or blue channel). It now toggles between open window documents. Another handy zoom shortcut is ⌘ *+* *ctrl* *+* to zoom in and ⌘ *−* *ctrl* *−* to zoom out (note the *+* key is really the *=* key). If your mouse has a wheel and Zoom with mouse wheel is selected in the preferences, you can use it with the ⌥ *alt* key held down to zoom in or out. If OpenGL is enabled you can carry out a continuous zoom by simply holding down the zoom tool (and use ⌥ *alt* to zoom out). If you have a recent MacPro Laptop or are using an Apple trackpad, Photoshop supports two-fingered zoom gestures such as drawing two fingers together to zoom in and spreading two fingers apart to zoom out.

Figure 1.73 You can use the Zoom tool Options bar buttons to adjust the zoom view. If OpenGL is enabled 'Scrubby Zoom' will be checked. This overrides the marquee zoom behavior – dragging to the right zooms in and dragging to the left zooms out.

Hand tool

When you view an image close-up, you can select the hand tool from the Tools panel (**H**) and drag to scroll the image, plus you can also hold down the Spacebar at any time to temporarily access the hand tool (except when the type tool is selected). The hand and zoom tools also have another navigational function. You can double-click the hand tool icon in the Tools panel to make an image fit to screen and double-click the zoom tool icon to magnify an image to 100%. There are also further zoom control buttons in the zoom tool Options bar, such as Fill Screen and Print Size (Figure 1.73).

Bird's-eye view

Another OpenGL option is the Bird's-eye view feature. If you are viewing an image in a close-up view, you can hold down the **H** key and, as you do this, if you click with the mouse, the image view swiftly zooms out to fit to the screen and at the same time shows an outline of the close-up view screen area (a bit like the preview in the Navigator panel). With the **H** key and mouse key still held down, you can drag to reposition the close-up view outline, release the mouse and the close-up view will re-center to the newly selected area in the image (see Figure 1.74).

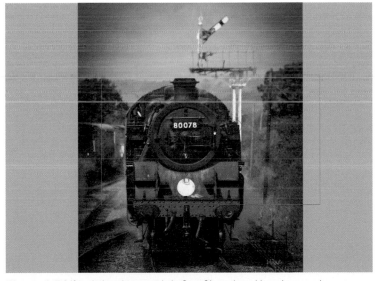

Figure 1.74 If a window document is in OpenGL mode and in a close-up view, you can hold down the **H** key and click with the mouse to access a birds eye view of the whole image. You can then drag the rectangle outline shown here to scroll the image and release to return to a close-up of the image centered around this new view.

Figure 1.75 This shows the OpenGL eyedropper wheel. The outer gray circle is included to help you judge the inner circle colors more effectively. The top half shows the current selected color and the bottom half, the previous selected color. The sample ring display can be disabled in the eyedropper options.

Flick panning

With OpenGL enabled in the Photoshop Performance preferences, you can also check the Enable Flick Panning option in the General preferences (see page 101). When this option is activated, Photoshop will respond to a flick of the mouse pan gesture by continuing to scroll the image in the direction you first scrolled, taking into account the acceleration of the flick movement. When you have located the area of interest just click again with the mouse to stop the image from scrolling any further.

Windows 7 Multi-touch support

If you are using Windows 7 operating system and have multi-touch aware hardware, Photoshop supports touch zoom in and out, touch pan/flicking as well as touch canvas rotation.

Eyedropper tool

The eyedropper tool can be used to measure pixel values directly from a Photoshop document, which are displayed in the Info panel shown in Figure 1.76. Photoshop also features a heads up display, which I describe in Figure 1.75. The color sampler tool can be used to place up to four color samplers in an image to provide persistent readouts of the pixel values, which is useful for those times when you need to closely monitor the pixel values as you make image adjustments. In Photoshop CS6 you can now sample the current layer and below as well as with no adjustments (see Figure 1.77).

Figure 1.76 The Info panel showing an eyedropper color reading, a measurement readout plus two color sampler readouts below.

Ruler tool

The ruler tool can be used to measure distance and angles in an image and again, this data is displayed in the Info panel. But note that the count tool is only available in the extended version and is perhaps more useful to those working in areas like medical research where, for example, you can use the count tool to count the number of cells in a microscope image.

Figure 1.77 The eyedropper tool has new sample options in the Options bar. You can now sample 'Current & Below', 'All Layers no Adjustments' and 'Current & Below no Adjustments'. Note that the sample size pop-up menu now also appears when using the various eyedropper tools, such as black point, white point eyedroppers in Levels and Curves.

Rotate view tool

If OpenGL is enabled in the Performance preferences, you can use the rotate view tool to rotate the Photoshop image canvas (as shown below in Figure 1.78). Being able to quickly rotate the image view can sometimes make it easier to carry out certain types of retouching work, rather that be forced to draw or paint at an uncomfortable angle. To use the rotate view tool, first select it from the Tools panel (or use the **R** keystroke) and click and drag in the window to rotate the image around the center axis. As you do this, you will see a compass overlay that indicates the image position relative to the default view angle (indicated in red). This can be useful when you are zoomed in close on an image. To reset the view angle to normal again, just hit the **esc** key or click on the Reset View button in the Options bar.

Rotate view shortcut

The rotate view tool uses the **R** keyboard shortcut, which (before CS4) was previously assigned to the blur/sharpen/sponge tool set. This has been generally accepted as a positive move, but you can if desired, use the Keyboard Shortcuts menu described on page 22 to reassign the keyboard shortcuts as you prefer.

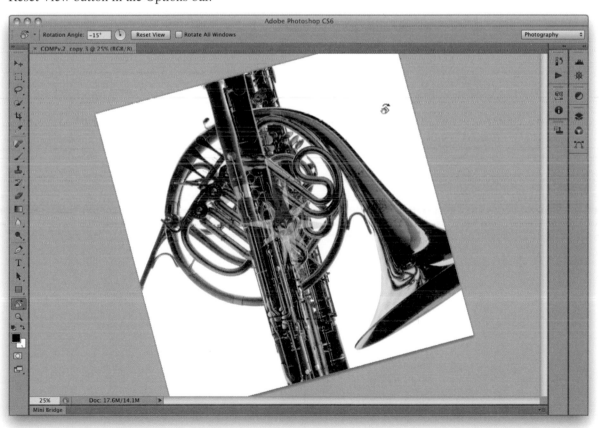

Figure 1.78 This shows the rotate view tool in action.

Photograph: Eric Richmond

Figure 1.79 The Notes panel.

Notes tool

The notes tool is handy for adding sticky notes to open images. Open note windows were removed in CS4 and Photoshop instead now uses a Notes panel (Figure 1.79) to store the recorded note messages. This method makes the notes display and management easy to control. I use this tool quite a lot at work, because when a client calls me to discuss a retouching job, I can open the image, click on the area that needs to be worked on and use the Notes panel to type in the instructions for whatever further retouching needs to be done to the image. If the client you are working with is also using Photoshop, they can use the notes feature to mark up images directly, which when opened in Photoshop can be inspected as shown in Figure 1.80 below.

Figure 1.80 This shows an example of the notes tool being used to annotate an image.

Screen view modes

In Figure 1.81 I have highlighted the Application bar screen view mode options which allow you to switch between the three main screen view modes. The standard screen view displays the application window the way it has been shown in all the previous screen shots and lets you view the document windows as floating windows or tabbed to the dock area. In Full Screen Mode with Menu Bar, the frontmost document fills the screen, while allowing you to see the menus and panels. Lastly, the Full Screen view mode displays a full screen view with the menus and panels hidden.

Full view screen mode

The Full Screen Mode with Menu Bar and Full Screen modes are usually the best view modes for concentrated retouching work. These allow full movement of the image, not limited by the edges of the document bounds. In other words, you can scroll the image to have a corner centered in the screen and edit things like path points outside the bounds of the document. Also note that the **F** key can be used to cycle between screen modes and **Shift F** to cycle backwards.

Figure 1.81 This shows examples of two of the three screen view modes for the Photoshop interface. Here you can see the Standard Screen Mode view (top) and Full Screen Mode with Menu Bar (bottom). The absolute Full Screen mode, which isn't shown here, displays the image against a black canvas and with the menus and panels hidden.

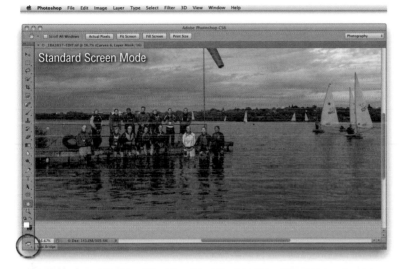

Saving presets as Sets

As you create and add your own custom preset settings, you can manage these via the Preset Manager. For example, this means that you can select a group of presets and click on the Save Set… button to save these as a new group of presets. Note that if you rearrange the order of the tool presets, the edited order will remain sticky when you next relaunch Photoshop.

Loading presets

If you double-click any Photoshop setting that is outside the Photoshop folder, this automatically loads the Photoshop program and appends the preset to the relevant section in the Preset Manager.

Preset Manager

The Preset Manager (Edit ⇨ Presets ⇨ Preset Manager) lets you manage all your presets from within the one dialog. This allows you to keep track of: Brushes, Swatches, Gradients, Styles, Patterns, Layer effect contours, Custom shapes and Tools (Figure 1.82 shows the Preset Manager used to manage the Tool presets). You can append or replace an existing set of presets via the Preset Manager options and the Preset Manager can also be customized to display the preset information in different ways, such as in the Figure 1.83 example, where I used a Large List to display large thumbnails of all the currently loaded Gradients presets.

Figure 1.82 You can use the Photoshop Preset Manager to load custom settings or replace them with one of the pre-supplied defaults.

Figure 1.83 Apart from being able to load and replace presets, you can choose how presets are displayed. In the case of Gradients, it's nice to to see a preview alongside each gradient.

History

The History feature was first introduced in Photoshop 5.0 and back then was considered a real breakthrough feature. This was because for the first time, Photoshop was able to offer multiple undos during a single Photoshop editing session. History can play a really important role in the way you use Photoshop, so I thought this would be the best place to describe this feature in more detail and explain how history can help you use Photoshop more efficiently.

As you work on an image, Photoshop is able to record a history of the various image states as steps and these can be viewed in the History panel (Figure 1.84). If you want to reverse a step, you can still use the conventional Edit ⇨ Undo command (\mathcal{H} Z $ctrl$ Z), but if you use the History panel, you can go back as many stages in the edit process as you have saved history steps.

The History panel

The History panel displays the sequence of Photoshop steps that have been applied during a Photoshop session and its main purpose is to let you manage and access the history steps that have been recorded in Photoshop. The history source column in the History panel will allow you to select a history state to sample from when working with the history brush (or filling from history). So, to revert to a previous step, just click on a specific history step. For example, in Figure 1.84 I carried out a simple one-step undo by clicking on the last but one history step.

One can look at history as a multiple undo feature in which you can reverse through up to 1000 image states. However, it is actually a far more sophisticated tool than just that. For example, there is a non-linear history option for multiple history path recording (see the History Options dialog in Figure 1.85). Non-linear history allows you to shoot off in new directions and still preserve all the original history steps. Painting from history can therefore save you from tedious workarounds like having to create more layers than are really necessary in order to preserve fixed image states that you can sample from. With history you don't have to do this and by making sensible use of non-linear history, you can keep the number of layers that are needed to a minimum.

To set the options for the History panel, mouse down on the fly-out menu and select History Options... (Figure 1.85). By default, history automatically creates an 'open' state snapshot each time

History brush (Y)

Art history brush (Y)

Figure 1.84 A previous history step can be selected by clicking on the history step name in the History panel. In its default configuration, you will notice how when you go back in history, the history steps that appear after the one that is selected will appear dimmed. If you have moved back in history, and you then make further edits to the image, the history steps after the selected history step will become deleted. However, you can change this behavior by selecting Allow Non-linear History in the History panel options (see Figure 1.85).

Figure 1.85 The History Options are accessed via the History panel fly-out menu. These allow you to configure things like the Snapshot and Non-linear history settings. I usually have Allow Non-Linear History option checked, as this enables me to use the History feature to its full potential (see page 66).

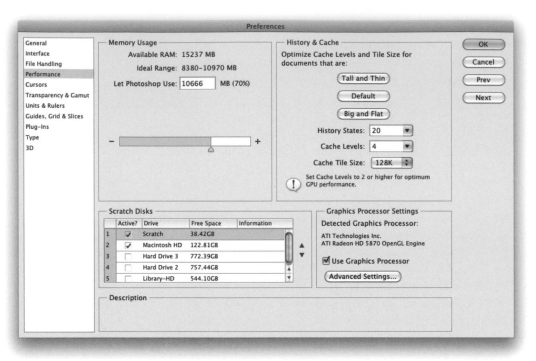

Figure 1.86 The number of recorded history states can be set via the History & Cache section of the Performance preferences dialog.

![Figure 1.87 image]

Figure 1.87 This shows the underlying tiled structure of a Photoshop image. This is a clue as to how history works as economically as possible. The history stores the minimum amount of data necessary at each step in Photoshop's memory. So if only one or two tile areas are altered by a Photoshop action, only the data change that takes place in those tiles is actually recorded.

you open an image and you can also choose to create additional snapshots each time an image is saved. Basically, Snapshots can be used to prevent history states from slipping off the end of the list and becoming deleted as more history steps are created (see page 65). 'Make Layer Visibility Changes Undoable' makes switching layer visibility on or off a recordable step in history, although this can be annoying when turning the layer visibility on or off prevents you from using undo/redo to undo the last Photoshop step.

History settings and memory usage

When the maximum number of recordable history steps has been reached, the earliest history step at the top of the list is discarded. With this in mind, the number of recorded histories can be altered via the Photoshop Performance preferences (Figure 1.86). Note that if you reduce the number of history states (or steps) that are allowed, any subsequent action will immediately cause all earlier steps beyond this new limit to be discarded.

Conventional wisdom would suggest that a multiple undo feature is bound to tie up vast amounts of scratch disk space to store all the previous image steps. However, proper testing of history indicates that this is not really the case. It is true that a series of global Photoshop steps may cause the scratch disk usage to rise, but localized changes will not. This is because the history feature makes clever use of the image cache tiling structure to limit any unnecessary drain on the memory usage. Essentially, Photoshop divides an image up into tiled sections and the size of these tiles can be set in the Performance preferences (see Chapter 2 for advice on how to optimize the cache tile size). Because of the way Photoshop images are tiled, the History feature only needs to memorize the changes that take place in each tile. Therefore, if a brush stroke takes place across two image tiles, only the changes taking place in those tiles needs to be updated (see Figure 1.87). If a global change takes place such as a filter effect, the whole of the image area is updated and the scratch disk usage rises accordingly. A savvy Photoshop user will want to customize the History feature to record a reasonable number of histories, while at the same time be aware of the need to change this setting if the history usage is likely to place too heavy a burden on the scratch disk. The history steps example discussed in Figure 1.88 demonstrates that successive histories need not consume an escalating amount of memory. After the first adjustment layer had been added, the successive adjustment layers had little impact on the scratch disk usage (as only the screen preview was being changed). The healing brush work only affected the tiled sections and by the time I got to the 'flatten image' stage the scratch disk/memory usage had begun to bottom out.

If the picture you are working with is exceptionally large, then having more than one undo can be both wasteful and unnecessary, so you should perhaps consider restricting the number of recordable history states. On the other hand, if multiple history undos are well within the scratch disk memory limits of your system, then make the most of them. If excessive scratch disk usage does prove to be a problem, the Purge History command in the Edit ⇨ Purge menu provides a useful way to keep the scratch disk memory usage under control. Above all, remember that the History feature is not just there as a mistake correcting tool, it has great potential for mixing composites from previous image states.

History stages	Scratch disk
Open file	1360 MB
Add new layer	1360 MB
Healing brush	1670 MB
Healing brush	1670 MB
Marquee selection	1610 MB
Feather selection	1630 MB
Inverse selection	1660 MB
Add adjustment layer	1700 MB
Modify adjustment layer	1700 MB
Flatten image	1630 MB

Figure 1.88 The accompanying table shows how the scratch disk usage can fluctuate during a typical Photoshop session. The image I opened here was 160 MB in size and 10 GB of memory was allocated to Photoshop. The scratch disk overhead is usually quite big at the beginning of a Photoshop session, but notice how there was little proportional increase in the scratch disk usage with each new history step.

Art history brush

The art history brush is something of an oddity. It is a history brush that allows you to paint from history but does so via a brush which distorts the sampled data and can be used to create impressionist type painting effects. You can learn more about this tool from the *Photoshop CS6 for Photographers Help Guide* that's on the book website.

Figure 1.89 A previous history state can be selected as the source for the history brush by going to the History panel and clicking in the box to the left of the history step you want to paint from using the history brush.

Filling from history

When you select the Fill... from the Edit menu there is an option in the Contents Use menu to choose 'History'.

History brush

The history brush can be used to paint from any previous history state and allows you to selectively restore image data as desired. To do this you need to leave the current history state as it is and select a source history state for the history brush by clicking in the box next to the history step you wish to sample from. In Figure 1.89 you can see how I had set the 'New Layer' history step as the history source (notice the small history brush icon where the box next to this is currently checked). I was then able to paint with the history brush from this previous history state, painting over the areas that had been worked on with the spot healing brush and use the history brush to restore those parts of the picture back to its previous, 'New Layer' history state.

Use of history versus undo

As you will have seen so far, the History feature is capable of being a lot more than a repeat Edit ⇨ Undo command. Although the History feature is sometimes described as a multiple undo, it is important not to confuse Photoshop history with the role of the undo command. For example, there are a number of Photoshop procedures that are *only undoable* through using the Edit ⇨ Undo command, like intermediate changes made when setting the shadows and highlights in the Levels dialog. Plus there are things which can be undone using Edit ⇨ Undo that have nothing to do with Photoshop's history record for an image. For example, if you delete a swatch color or delete a history state, these actions are only recoverable by using Edit ⇨ Undo. The undo command is also a toggled action and this is because the majority of Photoshop users like having the ability to switch quickly back and forth to see a before and after version of the image. The current combination of having undo commands and a separate History feature has been carefully planned to provide the most flexible and logical approach. History is not just an 'oh I messed up. Let's go back a few stages' feature, the way some other programs work; it is a tool designed to ease the workflow and provide you with extra creative options in Photoshop. A key example of this is the Globe Hands image that was created by Jeff Schewe. The story behind this image and it's influence on the History feature is told in Figure 1.91.

Snapshots

Snapshots are stored above the History panel divider and used to record the image in its current state so as to prevent this version of the image from being overwritten and for as long as the document is open and being edited in Photoshop. The default settings for the History panel will store a snapshot of the image in its opened state and you can create further snapshots by clicking on the Snapshot button at the bottom of the panel (see Figure 1.90). This feature is particularly useful if you have an image state that you wish to store temporarily and don't wish to lose as you make further adjustments to the image. There is no real constraint on the number of snapshots that can be added, and in the History panel options (Figure 1.85) you can choose to automatically generate a new snapshot each time you save the image (which will also be time-stamped). The Create New Document button (next to the Snapshot button) can be used to create a duplicate image state in a new document window and saved as a separate image.

Create new document Create new snapshot

Figure 1.90 To record a new snapshot, click on the Create New Snapshot button at the bottom of the History panel. This records a snapshot of the history at this stage. If you ⌥ *alt*-click the button, there are three options: Full Document, which stores all layers intact; Merged Layers, which stores a composite; and Current Layer, which stores just the currently active layer. Note if you have the Show New Snapshot dialog by Default turned on in the History panel options, the New Snapshot dialog appears directly, without you having to ⌥ *alt*-click the New Snapshot button. The adjacent Create New Document button can create a duplicate image of the active image in its current history state.

Figure 1.91 Photographer Jeff Schewe has had a long-standing connection with the Adobe Photoshop program and its development. The origins of the History feature can perhaps be traced back to a seminar where he used the Globe Hands image shown here to demonstrate his use of the Snapshot feature in Photoshop 2.5. Jeff was able to save multiple snapshots of different image states in Photoshop and selectively paint back from them. This was all way before layers and history were introduced in Photoshop. Chief Photoshop Engineer Mark Hamburg was suitably impressed by Jeff's technique and the ability to paint from snapshots became an important part of the History feature. Everyone had been crying out for a multiple undo in Photoshop, but when history was first introduced in Photoshop 5.0 it came as quite a surprise to discover just how much the History feature would allow you to do.

Non-linear history in use
On page 468 in Chapter 8 you can see
a practical example of how the history
feature might be used in a typical
Photoshop retouching session.

Non-linear history

The non-linear history option lets you branch off in several directions and experiment with different effects without needing to add lots of new layers. Non-linear history is not an easy concept to grasp, so the best way to approach this is to imagine a series of history steps as having more than one 'linear' progression, allowing the user to branch off in different directions in Photoshop instead of in a single chain of events (see Figure 1.92). Therefore, while you are working on an image in Photoshop, you have the opportunity to take an image down several different routes and a history step from one branch can then be blended with a history step from another branch without having to save duplicate files.

Non-linear history requires a little more thinking on your part in order to monitor and recall image states, but ultimately makes for a more efficient use of the available scratch disk space. Overall, I find it useful to have non-linear history switched on all the time, regardless of whether I need to push this feature to its limits or not.

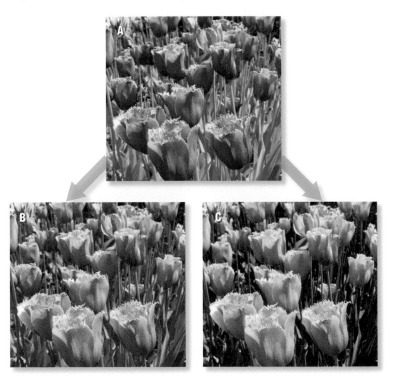

Figure 1.92 The non-linear history option allows you to branch off in different directions and simultaneously maintain a record of each history path up to the maximum number of history states that can be allowed. Shown here are three history states selected from the History panel: The initial opened image state (A), another with a Curves layer adjustment (B) and an alternative version (C) where I added a Black and White layer adjustment layer followed by a Curves adjustment layer to add a sepia tone color effect.

When files won't open

You can open an image file in Photoshop in a number of ways. You can use the Bridge program or Mini Bridge panel (which are described on pages 76–81), or you can simply double-click a file to open it. As long as the file you are about to open is in a file format that Photoshop recognizes, it will open in Photoshop and if the program is not running at the time this action should also launch Photoshop.

Every document file contains a header section, which among other things tells the computer which application should be used to open it. For example, Microsoft Word documents will (naturally enough) default to opening in Microsoft Word. Photoshop can recognize nearly all types of image documents regardless of the application they may have originated from, but sometimes you will see an image file with an icon for another specific program, like Macintosh Preview, or Internet Explorer. If you double-click these particular files, they will open in their respective programs. To get around this, you can follow the instructions described in Figure 1.93. Alternatively, you can use the File ⇨ Open command from within Photoshop, or you can drag a selected file (or files) to the Photoshop program icon, or a shortcut/alias of the program icon (Figure 1.94). In each of these cases this allows you to override the computer operating system which normally reads the file header to determine which program the file should be opened in. If you use Bridge as the main interface for opening image files in Photoshop, then you might also want to open the File Type Association preferences (that are described in Chapter 11) to check that the file format for the files you are opening are all set to open in Photoshop by default.

Yet, there are times when even these methods may fail and this points to one of two things. Either you have a corrupt file, in which case the damage is most likely permanent. Or, the file extension has been wrongly changed. It says .psd, but is it really a PSD? Is it possible that someone has accidentally renamed the file with an incorrect extension? In these situations, the only way to open it will be to rename the file using the *correct* file extension, or use the Photoshop File ⇨ Open command and navigate to locate the mis-saved image (which once successfully opened should then be resaved to register it in the correct file format).

There are various reasons why a file may have become corrupted and refuses to open. This will often happen to images that have been sent as attachments and is most likely due to a break during transmission somewhere, resulting in missing data.

Figure 1.93 The header information in some files may contain information that tells the operating system to open the image in a program other than Photoshop. On a Macintosh go to the File menu and choose File ⇨ Get Info and under the 'Open with' item, change the default application to Photoshop. On a PC you can do the same thing via the File Registry.

Figure 1.94 When files won't open up directly in Photoshop the way you expect them to, then it may be because the header is telling the computer to open them up in some other program instead. To force open an image in Photoshop, drag the file icon on top of the Photoshop application icon or an alias or shortcut thereof, such as an icon placed in the dock or on the desktop.

Graphic Converter

If you are still having trouble trying to open a corrupted file, the Graphic Converter program can sometimes be quite effective at opening mildly corrupted image files.

Save often

It goes without saying that you should always remember to save often while working in Photoshop. Hopefully, you won't come across many crashes when working with the latest Macintosh and PC operating systems, but that doesn't mean you should relax too much. The fact that Photoshop CS6 can now carry out automatic background saves is a real bonus, but there are still some pitfalls you need to be aware of.

Choosing File ⇨ Save always creates a safe backup of your image, but as with everything else you do on a computer, do make sure you are not overwriting the original with an inferior modified version. There is always the danger that you might make permanent changes such as a drastic reduction in image size, accidentally hit 'Save' and lose the original in the process. If this happens, there is no need to worry so long as you don't close the image. You can always go back a step or two in the History panel and resave the image in the state it was in before it was modified.

When you save an image in Photoshop, you are either resaving the file (which overwrites the original) or are forced to save a new version using the Photoshop file format. The determining factor here will be the file format the image was in when you opened it and how it has been modified in Photoshop. Over the next few pages I'll be discussing some of the different file formats you can use, but the main thing to be aware of is that some file formats do restrict you from being able to save things like layers, pen paths or extra channels. For example, if you open a JPEG format file in Photoshop and modify it by adding a pen path, you can choose File ⇨ Save and overwrite the original without any problem. However, if you open the same file and add a layer or an extra alpha channel, you won't be able to save it as a JPEG any more. This is because although a JPEG file can contain pen paths, it cannot contain layers or additional channels, so it has to be saved using a file format that is capable of containing these extra items.

I won't go into lengthy detail about what can and can't be saved using each format, but basically, if you modify a file and the modifications can be saved using the same file format that the original started out in, then Photoshop will have no problem saving and overwriting the original. If the modifications applied to an image mean that it can't be saved using the original file format it will default to using the PSD (Photoshop document) format and save the image as a new document via the Save As dialog

(Figure 1.95). You can also choose to save such documents using the TIFF or PDF format. In my view, both TIFF and PSD formats are a good choice here for saving any master image since these file formats can contain anything that's been added in Photoshop.

Essentially, there are four main file formats that can be used to save everything you might add to an image such as image layers, type layers, channels and also support 16-bits per channel. These are: TIFF, Photoshop PDF, the large document format, PSB and lastly the native Photoshop file format, PSD. I now mostly favor using the TIFF format when saving master RGB images.

When you choose File ⇨ Close All, if any of the photos have been modified, a warning dialog alerts you and allows you to close all open images with or without saving them first. For example, if you make a series of adjustments to a bunch of images and then change your mind, with this option you can quickly close all open images if you don't really need them to be saved.

Background Saving

The Background Save or Auto-Save is a recovery feature. In case of a crash it will allow you to recover data from any open files that you were working on which had been modified since opening. Note that this feature does not auto-save by overwriting the original file (which could lead to all sorts of problems). What Photoshop does is to auto-save copies of whatever you are working on in the background using the PSD format. In the event of a crash, the next time you launch Photoshop it will automatically open the most recent auto-saved copies of whatever you were working on. If you refer to page 106 in Chapter 2 you can read about how to configure the File Handling preferences to switch on this option and determine how frequently you wish to update the background save file.

Normal saves

As with all other programs, the keyboard shortcut for saving a file is: ⌘ S *ctrl* S . If you are editing an image that has never been saved before or the image state has changed (so that what started out as a flattened JPEG, now has layers added), this action will pop the Save As…dialog. Subsequent saves may not show the Save dialog. But if you do wish to force the Save dialog to appear to save a copy version, then use: ⌘ ⌥ S *ctrl* *alt* S .

Closing unchanged files (Mac)

On the Mac ⌥-clicking the Close button on one open image will close all the others that remain unchanged. Any others that have had changes will stop to ask whether you want to save the changes or not.

History saves

While there is now an Auto-Save feature in Photoshop CS6, it is still not possible to save a history of everything you did to an image. However, if you go to the Photoshop preferences you can choose to save the history log information of everything that was done to the image. This can record a log of everything that was done during a Photoshop session and can be saved to a central log file or saved to the file's metadata.

The other thing you can do is go to the Actions panel and click to record an action of everything that is done to the image. If you have the tool recording enabled, there is a reasonable chance that an action that can record things like brush strokes may be able to record a full record of what was done to an image while it was being edited in Photoshop.

Using Save As... to save images

If the image you are about to save has started out as, say, a flattened JPEG, but now has layers, this will force the Save As dialog shown in Figure 1.95 to appear as you save. However, you can also choose 'File ⇨ Save As…' (⌘ Shift S ctrl Shift S) any time you wish to save an image using a different file format, or if you want, you can save a layered image as a flattened duplicate. In the Save As dialog you have access to various save options and in the Figure 1.95 example I was able to select the JPEG format when saving a layered, edited image. As you can see, a warning triangle appears to alert you if Layers (or other non-compatible items) can't be stored when choosing JPEG. In these circumstances, incompatible features like this are automatically highlighted and grayed out in the Save As dialog, and the image is necessarily saved as a flattened version of the master.

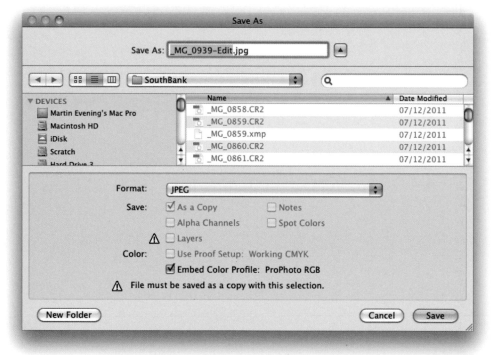

Figure 1.95 If the file format you choose to save in won't support all the components in the image such as layers, then a warning triangle alerts you to this when you attempt to save the document, reminding you that the layers will not be included. Note that the Mac OS dialog shown here can be collapsed or expanded by clicking on the downward pointing disclosure triangle to toggle the expanded folder view.

File formats

Photoshop supports nearly all the current, well-known image file formats. And for those that are not supported, you will find that certain specialized file format plug-ins are supplied as extras on the Photoshop application DVD. When these plug-ins are installed in the Plug-ins folder they allow you to extend the range of file formats that can be chosen when saving. Your choice of file format when saving images should be mainly determined by what you want to do with a particular file and how important it is to preserve all the features (such as layers and channels) that may have been added while editing the image in Photoshop. Some formats such as PSD and PSB are mainly intended for archiving master image files, while others, such as TIFF, are ideally suited for many types of uses and in particular, prepress work. Here is a brief summary of the main file formats in common use today.

Photoshop native file format

The Photoshop file format is a universal format and therefore a logical choice when saving and archiving your master files since the Photoshop (PSD) format will recognize and contain all known Photoshop features. There are a number of advantages to using PSD. Firstly, it can help you easily distinguish the master, layered RGB files from the flattened output files (which I usually save as TIFFs). Secondly, when saving layered images, the native Photoshop format is generally a very efficient format because it uses a run length encoding type of compression that can make the file size more compact, but without degrading the image quality in any way. LZW compression does this by compressing large areas of contiguous color such as a white background into short lengths of data instead of doggedly recording every single pixel in the image. The downside is that PSD is a poorly documented format. It arose at an early stage in Photoshop's development and remains, essentially, a proprietary file format to Adobe and Photoshop.

Smart PSD files

Adobe InDesign and Adobe Dreamweaver will let you share Photoshop format files between these separate applications so that any changes made to a Photoshop file will automatically be updated in the other program. This modular approach means that most Adobe graphics programs can integrate with each other seamlessly.

Maximum compatibility

Only the Photoshop, PDF, PSB and TIFF formats are capable of supporting all the Photoshop features such as vector masks and image adjustment layers. The PSD format has been supported in Photoshop for as long as I have been using the program, but, as I say, remains poorly documented and poorly implemented outside of Photoshop. This is the main reason why, for Photoshop (PSD) format documents to be completely compatible with other programs (such as Lightroom), you must ensure you have the 'Maximize PSD and PSB Compatibility' checked in Photoshop's File Handling preferences. The reason for this is because Lightroom is unable to read layered PSD files that don't include a saved composite within the file. If PSD images fail to be imported into Lightroom, it is most likely because they were saved with this preference switched off. Looking ahead to the future, it is difficult to say if PSD will be supported forever. What we do know though is that the TIFF file format has been around longer than PSD and is certainly a well-documented format and integrates well with all types of image editing programs. TIFF is currently at version 6.0 and it is rumored it's going to be updated to v 7.0 at some point in the near future. Meanwhile, even the Adobe engineers are suggesting that PSD is close to its end, and are now recommending the use of TIFF.

For those who prefer to edit their images in 16-bit, it always used to be frustrating when you would go to save an image as a JPEG copy, only to find that the JPEG option wasn't available in the Save dialog File Format menu. The reason for this is because 16-bit isn't supported by the JPEG format. When you choose Save As… for a 16-bit image, the JPEG file format is actually available as a save option, whereby Photoshop carries out the necessary 16-bit to 8-bit conversion as part of the JPEG save process. This allows you to quickly create JPEG copies without having to temporarily convert the image back to 8-bit. Note, however, that only the JPEG file format is supported in this way.

Large Document (PSB) format

The PSD and TIFF file formats have a 30,000 × 30,000 pixel dimensions limit, while the PSD file format has a 2 GB file size limit and the TIFF format specification has a 4 GB file size limit. You need to bear in mind here that most applications and printer RIPs can't handle files that are greater than 2 GB anyway and it is mainly for this reason that the above limits have been retained for all the main file formats used in Photoshop (although there are some exceptions, such as ColorByte's ImagePrint and Onyx's PosterShop, which can handle more than 2 GB of data).

The Large Document (PSB) file format is provided as a special format that can be used when saving master layered files that exceed the above limits. The PSB format has an upper limit of 300,000 × 300,000 pixels, plus a file size limit of 4 exabytes (that's 4 million terrabytes). This format is therefore mainly useful for saving extra long panoramic images that exceed 30,000 pixels in length, or when saving extra large files that exceed the TIFF 4 GB limit. You do have to bear in mind that only Photoshop CS or later is capable of reading the PSB format, and just like TIFF and PSD, only recent versions of Photoshop can offer full compatibility.

TIFF (Tagged Image File Format)

The main formats used for publishing are TIFF and EPS. Of the two, TIFF is the most universally recognized image format. TIFF files can readily be placed in QuarkXpress, InDesign and any other type of desktop publishing (DTP) program. The TIFF format is more open and unlike the EPS format, you can make adjustments within the DTP program as to the way a TIFF image will appear in print. As I mentioned earlier, it is also a well-documented format and set to remain as the industry standard format for archive work and publishing. Labs and output bureaux generally request that you save your output images as TIFFs, as this is the file format that can be read by most other imaging computer systems. If you are distributing a file for output as a print or transparency, or for someone else to continue editing your master file, it will usually be safer to supply the image using TIFF.

TIFFs saved using Photoshop 7.0 or later support alpha channels, paths, image transparency and all the extras that can normally be saved using the native PSD and PDF formats. Labs or service bureaux that receive TIFF files for direct output will

normally request that a TIFF file is flattened and saved with the alpha channels and other extra items removed. For example, earlier versions of Quark Xpress had a nasty habit of interpreting any path that was present in the image file as a clipping path.

Pixel order

The Photoshop TIFF format has traditionally saved the pixel values in an interleaved order. So if you were saving an RGB image, the pixel values would be saved as clusters of RGB values using the following sequence: RGBRGBRGB. All TIFF readers are able to interpret this pixel order. The Per Channel pixel order option saves the pixel values in channel order, where all the red pixel values are saved first, followed by the green, then the blue. So the sequence used is: RRRGGGBBB. Using the Per Channel order can therefore provide faster read/write speeds and better compression. Most third-party TIFF readers should support Per Channel pixel ordering, but there is a very slim chance that some TIFF readers won't.

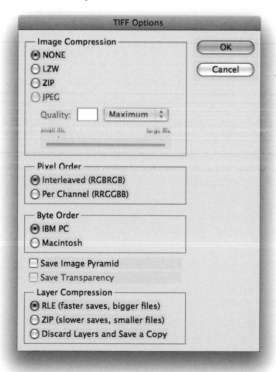

Figure 1.96 This dialog shows the save options that are available when you save an image as a TIFF.

Redundant formats

Note that the Filmstrip file format is no longer supported in Photoshop. The same applies to the PICT format as well. Photoshop is still able to read raster PICT files (though not QuickDraw PICTs), it just won't allow you to write to the PICT file format.

Photoshop CS6 TIFF additions

Photoshop CS6 now allows for more bit depths when saving TIFF files. BIGTIFF files can now also be read in Photoshop. The BIGTIFF format is a variant of the standard TIFF format that allows you to extend beyond the 4 GB data limit (see page 72). The BIGTIFF file format is designed to be backward compatible with older TIFF readers in as much as it allows such programs to read the first 4 GB data as normal. In order to read file data that exceeds this limit, TIFF readers need to be able to read the BIGTIFF format, which Photoshop CS6 can now do.

TIFF bit depths

Prior to Photoshop CS6, Photoshop could read TIFF files that contained an even number bit depth, such as 2, 4, 6, 8, 10, etc, but could not read TIFF files that had odd number bit depths, such as 3, 5, 7, 9. It is only really files that come from certain scientific cameras and medical systems that create such files. Anyway, Photoshop CS6 now allows such files to be read.

Byte order

The byte order can be made to match the computer system platform the file is being read on, but there is usually no need to worry about this and it shouldn't cause any compatibility problems.

Save Image Pyramid

The Save Image Pyramid option saves a pyramid structure of scaled-down versions of the full resolution image. TIFF pyramid-savvy DTP applications (and there are none I know of yet) will then be able to display a good quality TIFF preview, but without having to load the whole file.

TIFF compression options

An uncompressed TIFF will usually be about the same megabyte size as the figure you see displayed in the Image Size dialog box, but the TIFF format in Photoshop offers several compression options. LZW is a lossless compression option, where the image data is compacted and the file size reduced, but without any image detail being lost. Saving and opening takes longer when LZW is utilized so some clients request that you do not use it. ZIP is another lossless compression encoding that like LZW is most effective where you have images that contain large areas of a single color. JPEG image compression offers a lossy method that can offer even greater levels of file compression, but again be warned that this option can cause problems downstream with the printer RIP if it is used when saving output files for print. If there are layers present in an image, separate compression options are available for the layers. RLE stands for Run Length Encoding and provides the same type of lossless compression as LZW, and ZIP compression is as described above. Alternatively, you can choose Discard Layers and Save a Copy, which saves a copy version of the master image as a flattened TIFF.

Flattened TIFFs

If an open image contains alpha channels or layers, the Save dialog shown in Figure 1.95 indicates this and you can keep these items checked when saving as a TIFF. If you have 'Ask Before Saving Layered TIFF Files' switched on in the File Saving preferences, a further alert dialog will warn you that 'including layers will increase the file size' the first time you save an image as a layered TIFF.

Photoshop PDF

The PDF (Portable Document Format) is a cross-platform file format that was initially designed to provide an electronic publishing medium for distributing documents without requiring the recipient to have a copy of the program that originated the document. PDF files can be read in Adobe Acrobat or the free Adobe Reader ™ program, which will let others view documents the way they are meant to be seen, even though they may not have the exact same fonts that were used to compile the document.

Adobe PDF has now gained far wider acceptance as a reliable and compact method of supplying pages to printers, due to its color management features and ability to embed fonts, and compress images. It is now becoming the native format for Illustrator and other desktop publishing programs and is also gaining popularity for saving Photoshop files, because it can preserve everything that a Photoshop (PSD) file can. Adobe Reader™ is free, and can easily be downloaded from the Adobe website. But the full Adobe Acrobat™ program is required if you want to distill page documents into the PDF format and edit them on your computer.

Best of all, Acrobat documents are small in size and can be printed at high resolution. I can create a document in InDesign and export it as an Acrobat PDF using the Export command. Anyone who has installed the Adobe Reader program can open a PDF document I have created and see the layout just as I intended it to be seen, with the pictures in full color plus text displayed using the correct fonts. The Photoshop PDF file format can be used to save all Photoshop features such as Layers, with either JPEG or lossless ZIP compression and is backwards compatible in as much as it saves a flattened composite for viewing within programs that are unable to fully interpret the Photoshop CS6 layer information.

PDF security

The PDF security options allow you to restrict file access to authorized users only. This means that a password will have to be entered before an image can be opened in either Adobe Reader, Acrobat or Photoshop. You can also introduce a secondary password for permission to print or modify the PDF file in Acrobat. Note: this level of security only applies when reading a file in a PDF reader program and you can only password protect the opening of a PDF file in a program like Photoshop. Once opened,

PDF versatility

The PDF format in Photoshop is particularly useful for sending Photoshop images to people who don't have Photoshop, but do have the Adobe Reader™ or Macintosh Preview programs on their computer. If they have a full version of Adobe Acrobat™ they will even be able to conduct a limited amount of editing, such as the ability to edit the contents of a text layer. Photoshop is also able to import or append any annotations that have been added via Adobe Acrobat.

Placing PDF files

The Photoshop Parser plug-in allows Photoshop to import any Adobe Illustrator, EPS or generic single/multi-page PDF file. Using File ⇨ Place, you can select individual pages or ranges of pages from a generic PDF file, rasterize them and save them to a destination folder. You can also use File ⇨ Place to extract all or individual image/vector graphic files contained within a PDF document as separate image files (see Figure 1.98).

The PNG file format is one that is very popular for Web design and sometimes a useful substitute for the JPEG format. In Photoshop CS6 the PNG Save dialog (shown below in Figure 1.97) contains some new file save options. These allow you to choose between no compression or 'Smallest' compression.

Figure 1.97 The PNG Save dialog.

it will then be fully editable. Even so, this is still a useful feature to have, since PDF security allows you to prevent some unauthorized, first level access to your images. There are two security options: 40-bit RC4 for lower-level security and compatibility with versions 3 and 4 of Acrobat and 128-bit RC4, for higher security using Acrobat versions 5 or later. However, because the PDF specification is an open-source standard, some other PDF readers are able to bypass these security features and can open password-protected images! The security features are not totally infallible, but marginally better than using no security at all.

Figure 1.98 If you try to open a generic Acrobat PDF from within Photoshop by choosing File ⇨ Open, or File ⇨ Place, you will see the Import PDF or Place PDF dialog shown here. This allows you to select individual or multiple pages or selected images only and open these in Photoshop or place them within a new Photoshop document.

Adobe Bridge CS6

Bridge (Figure 1.99) is designed to provide you with an integrated way to navigate through the folders on your computer and complete compatibility with all the other Creative Suite applications. The Bridge interface allows you to inspect images in a folder, make decisions about which ones you like best, rearrange them in the content panel, hide the ones you don't like, and so on.

You can use Bridge to quickly review the images in a folder and open them up in Photoshop, while at a more advanced level, you can perform batch operations, share properties between files

Figure 1.99 The Bridge interface consists of three column zones used to contain the Bridge panel components. This allows you to customize the Bridge layout in any number of ways. For a complete overview of the components that make up the Bridge interface please refer to Chapter 11.

Return to Photoshop

As mentioned in the main text, you can toggle between Photoshop and Bridge by using ⌘ ⌥ O *ctrl* *alt* O keyboard shortcut. Once in Bridge you can use the same keyboard shortcut to return to Photoshop again, although to be more precise, this shortcut always returns you to the last used application. So if you had just gone to Bridge via Illustrator, the ⌘ ⌥ O *ctrl* *alt* O shortcut will in this instance take you from Bridge back to Illustrator again.

by synchronizing the metadata information, apply Camera Raw settings to a selection of images and use the Filter panel to fine-tune your image selections. It is very easy to switch back and forth between Photoshop and Bridge and one of the key benefits of having Bridge operate as a separate program is that Photoshop isn't fighting with the processor whenever you use Bridge to perform these various tasks. Bridge started as a file browser for Photoshop and has evolved over the last six versions of the Creative Suite to provide advanced browser navigation for all programs in the Creative Suite. Having said that, there isn't really much that's new in this latest version.

The Bridge interface

Bridge can be accessed from Photoshop by choosing File ⇨ Browse in Bridge... or by using the ⌘ ⌥ O *ctrl* *alt* O keyboard shortcut. You can also set the Bridge preferences so that Bridge launches automatically during the system login so that it is always open and ready for use. Bridge initially opens a new window pointing to the last visited folder location. You can have multiple Bridge windows open at once and this is useful if you want to manage files better by being able to drag them from one folder to another. Having multiple windows open also saves having to navigate back and forth between different folders. To make Bridge windows more manageable, you can click on the 'Switch to compact mode' button (circled in red in Figures 1.99 and 1.100) to toggle shrinking/expanding a Bridge window.

Figure 1.100 If you click on the Switch to compact mode button (circled in red in Figure 1.99), this shrinks the Bridge window to a compact, content panel only view like the one shown here, and if you click on the button again (circled here in red), this will return you to a full window view again. Note that compact Bridge windows are by default displayed in front of all other windows on the display, even when you are working in another program (you can turn this off by disabling this option via the compact Bridge window options menu, circled here in blue).

It makes sense to resize the Bridge window to fill the screen and if you have a dual monitor setup you can always have the Photoshop application window on the main display and the Bridge window (or windows) on the other. Image folders can be selected via the Folders or Favorites panels and the folder contents viewed in the content panel area as thumbnail images. When you click on a thumbnail, an enlarged view of the individually selected images can be seen in the Preview panel and images can be opened by double-clicking on the thumbnail. The main thing to be aware of is that you can have Bridge running alongside Photoshop without compromising Photoshop's performance and it is considered good practice to use Bridge in place of the Finder/Explorer as your main tool for navigating the folders on your computer system and opening documents. This can include opening photos directly into Photoshop, but of course, you can use Bridge as a browser to open up any kind of document: not just those linked to the Adobe Creative Suite programs. For example, Word documents can be made to open directly in Microsoft Word via Bridge.

Custom work spaces in Bridge

The Bridge panels can be grouped together in different ways and the panel dividers dragged, so for example, the Preview panel can be made to fill the Bridge interface more fully and there are already a number of workspace presets which are available to use from the top bar. In the Figure 1.101 example you can see Bridge being used with the Output workspace setting, which offers a special Output Preview panel for previewing print layouts directly in Bridge before you proceed to make a print.

Opening files from Bridge

There are a lot of things you can do in Bridge by way of managing and filtering images and other files on your computer. You will find a more detailed analysis of Bridge in Chapter 11. For now, all that you really need to familiarize yourself with are the Favorites and Folders panels and how you can use these to navigate the folder hierarchy. The Content panel is then used to inspect the folder contents and you can use the Preview panel to see an enlarged preview of the image (or images) you are about to open. Once photos have been selected, just double-click the images within the Content panel (not the Preview panel) to open them directly into Photoshop.

Slideshows

You can also use Bridge to generate slideshows. Just go to the View menu and choose Slideshow, or use the ⌘ L ctrl L keyboard shortcut. Figure 1.102 shows an example of a slideshow and instructions on how to access the Help menu.

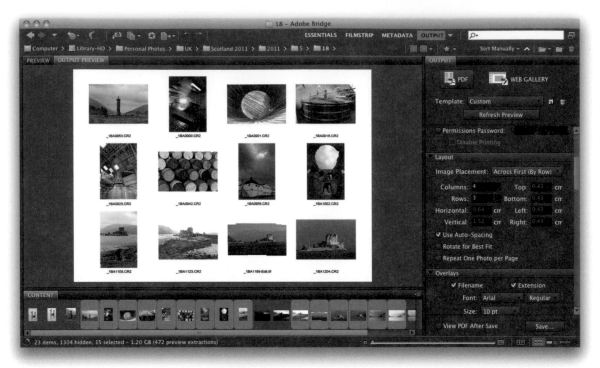

Figure 1.101 You can use the different workspaces to quickly switch Bridge layouts. This example shows the Output workspace in use, which one can use to edit print or Web gallery layouts.

Figure 1.102 You can use the Bridge application View ⇨ Slideshow mode to display selected images in a slideshow presentation, where you can make all your essential review and edit decisions with this easy-to-use interface (press the **H** key to call up the Slideshow shortcuts shown here).

Mini Bridge

The main Bridge program has a little cousin called Mini Bridge, which rather than being an alternative, standalone application, is something you add as a Photoshop extension panel (see sidebar). It can be viewed as an add-on feature for Bridge rather than a replacement as such. I see this as offering a simpler user interface for doing the types of things photographers need to do most. It provides a simplified interface for image browsing, but without offering refinement features such as keyword sorting, metadata editing, or Web and print output. While Mini Bridge is unlikely to replace all your main Bridge needs, it arguably allows you to browse more conveniently from within the Photoshop interface. Hopefully, it will encourage more Photoshop users to work with Bridge.

Launching Mini Bridge

To launch Mini Bridge you can go to the Window menu and choose Extensions ⇨ Mini Bridge. You can then open Mini Bridge via the File menu in Photoshop (providing the main Bridge program is also open in the background). To go direct to the main Bridge program, click on the Br button circled in Figure 1.103.

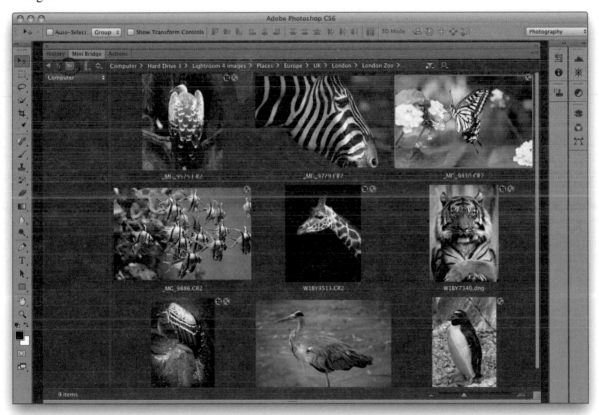

Figure 1.103 Mini Bridge is shown here as an open panel from it's default position docked to the bottom of the Application window.

Full Screen mode

If you click on the Full Screen mode button in Camera Raw (circled below in blue), you can quickly switch the Camera Raw view to Full Screen mode.

What's new in Camera Raw 7.0

Camera Raw 7.0 offers some further image processing refinements. In particular, there is now a new Process 2012 option in which the main Basic panel controls have been completely revised to provide more extensive editing capabilities for both raw and non-raw images. In fact, if you are familiar with the image editing controls in Adobe Revel for tablet devices, you'll already have seen how these work. The main Process 2012 sliders are also available as localized adjustments, along with new Temp and Tint adjustment controls. Lastly, the Tone Curve panel now also offers an RGB point curve editing option.

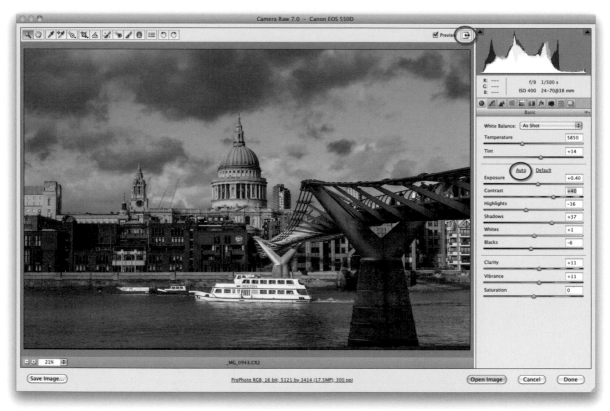

Figure 1.104 When you select a single raw image in Bridge, and double-click to open, you will see the Camera Raw dialog shown here. The Basic panel controls are a good place to get started, but as was mentioned in the text, the Auto button can often apply an adjustment that is ideally suited for most types of images. Once you are happy, click on the Open Image button at the bottom to open it in Photoshop.

Opening photos from Bridge via Camera Raw

If you double-click to open a raw or DNG image via Bridge, these will automatically open via the Camera Raw dialog shown in Figure 1.104, where Photoshop will host Camera Raw. Alternatively, if you choose File ⇨ Open in Camera Raw… via the Bridge menu, this will open the file in Camera Raw hosted by Bridge. The advantage of doing this is that it allows you to free up Photoshop to carry on working on other images. If you choose to open multiple raw images you will see a filmstrip of thumbnails appear down the left-hand side of the Camera Raw dialog, where you can edit one image and then sync the settings across all the other selected photos. There is also a preference setting in Bridge that allows you to open up JPEG and TIFF images via Camera Raw too.

The whole of Chapter 3 is devoted to looking at the Camera Raw controls and I would say that the main benefits of using Camera Raw is that any edits you apply in Camera Raw are non-permanent and this latest version in Photoshop CS6 offers yet further major advances in raw image processing. If you are still a little intimidated by the Camera Raw dialog interface, you can for now just click on the Auto button (circled in red in Figure 1.104). When the default settings in Camera Raw are set to Auto, Camera Raw usually does a pretty good job of optimizing the image settings for you. You can then click on the 'Done' or 'Open Image' button without concerning yourself too much just yet with what all the Camera Raw controls do. This should give you a good image to start working with in Photoshop and the beauty of working with Camera Raw is that you never risk overwriting the original master raw file (but do heed the warning in the sidebar about saving raw TIFF files). If you don't like the auto settings Camera Raw gives you, then it is relatively easy to adjust the tone and color sliders and make your own improvements upon the auto adjustment settings.

Saving from raw files

If you save an image that's been opened up from a raw file original, Photoshop will by default suggest you save it using the native Photoshop (PSD) file format. You are always forced to save it as something else and never to overwrite the original raw image. Most raw formats have unique extensions anyway like .crw or .nef. However, Canon did once decide to use a .tif extension for some of their raw file formats (so that the thumbnails would show up in their proprietary browser program). The danger here was that if you overrode the Photoshop default behavior and tried saving an opened Canon raw image as a TIFF, you risked overwriting the original raw file.

Photoshop code names

Nearly every version of the Photoshop beta program has traditionally contained a reference to a music track or a movie. Past honored music artists have included: Adrian Belew, William Orbit and Lou Reed.

Photoshop On-line

Photoshop On-line… is available from the Help menu and lets you access any late-breaking information along with on-line help and professional Photoshop tips. Photoshop help is also available as a PDF (there's a link in the upper right corner of the Help page).

Easter eggs

We'll round off this chapter with some of the hidden items that are in Photoshop. If you drag down from the system or Apple menu to select About Photoshop…, the splash screen reopens and after about 5 seconds the text starts to scroll telling you lots of stuff about the Adobe team who wrote the program, etc. Hold down ⌥ alt and the text scrolls faster. Last, but not least, you'll see a special mention to the most important Photoshop user of all… Now hold down ⌘ ctrl alt and choose About Photoshop… Here, you will see the Superstition beta test version of the splash screen (Figure 1.105). When the credits have finished scrolling, carefully ⌥ alt-click in the white space above the credits (and below Superstition) to see what are known as Adobe Transient Witticisms appearing one at a time above the credits. Being a member of the team that makes Photoshop has many rewards, but one of the perks is having the opportunity to add little office in-jokes in a secret spot on the Photoshop splash screen. It's a sign of what spending long hours building a new version of Photoshop will do to you. And if you are looking for the Merlin begone Easter egg, associated with the Layers panel options, well, Merlin is truly begone now!

Figure 1.105 The Superstition beta splash screen.

Chapter 2

Configuring Photoshop

n order to get the best performance out of Photoshop, you need to ensure that your computer system has been optimized for image editing work. When I first began writing the 'Photoshop for Photographers' series of books, it was always necessary to guide readers on how to buy the most suitable computer for Photoshop work and what hardware specifications to look for. These days I would say that almost any computer you buy is now capable of running Photoshop and can be upgraded later to run Photoshop faster. As always, I try to avoid making distinctions between the superiority of the Macintosh or PC systems. If you are an experienced computer user, you know what works best for you. I just so happen to mostly use a Mac and that is why nearly all the screen shots have been captured using the Mac system interface. The same argument would apply if I were mainly a Windows PC user. This shouldn't be a big deal.

64-bit processing support

It is well worth installing as much RAM memory as possible in your computer, as the RAM figures quoted here are the minimum recommended amounts. Personally, I would advise installing at least 4 GB RAM if you can. If you are working with a 32-bit operating system on a Windows platform you will only be able to install a 32-bit version of Photoshop CS6 and allocate up to 4 GB (less whatever the operating system frameworks take up, so effectively up to around 3.5 GB). However, 64-bit processing is now the new standard for the latest computer hardware and this is the only option supported on the Mac platform now. If you are running a 64-bit operating system, you can install a 64-bit version of Photoshop CS6, which offers the key benefit of letting you take advantage of having more than 4GB of RAM memory installed in your computer. This will have the potential to boost the speed for some operations (like the time it takes to open large documents).

For more information on this subject, check out Scott Byer's Adobe blog: http://tinyurl.com/yusmq9, as well as John Nack's coverage of this topic at: http://tinyurl.com/y7dnlgu.

What you will need

Today's entry level computers contain everything you need to get started running Photoshop, but here is a guide to the minimum system requirements for Macintosh and Windows system computers.

Macintosh

Photoshop CS6 can only be run on the latest Intel-based Macs running Mac OS 10.6 or later in 64-bit only. The minimum RAM requirement is 1 GB (but more RAM memory is recommended), plus Photoshop CS6 requires an estimated 2 GB of free hard disk space to install the program. You will also need a DVD-ROM drive and a computer display with at least a 1024 x 768 pixel resolution driven by a 16-bit (or greater) graphics card with at least 256 MB video RAM. All the current range of Apple Macintosh computers are capable of meeting these requirements, although with some of the older Intel Mac computers you may need to upgrade the video graphics card.

Windows

Photoshop CS6 can run on Intel Xeon, Xeon Dual, Centrino or Pentium 4 processors, and AMD equivalents running Windows® XP with Service Pack 3 or higher, as well as Windows® Vista with Service Pack 1, Windows 7 and it will be able to work with Windows 8. The minimum RAM requirement is 1 GB (but more is recommended) and Photoshop CS6 requires an estimated 1 GB of free hard disk space to install the program. You will also need a DVD-ROM drive and a computer display with at least 1024 x 768 pixel resolution driven by a 16-bit (or greater) graphics card with at least 256 MB video RAM. Almost any new PC system you buy should have no trouble meeting these requirements, but if you have an older computer system, do check that you have enough RAM memory and a powerful enough graphics card.

The ideal computer setup

Your computer working environment is important. Even if space
is limited there is much you can do to make your work area
an efficient place to work in. Figure 2.1 shows a typical, ideal
computer setup. Firstly, the walls in this office are painted neutral
gray with paint I was able to get from a local hardware store.
When dried and measured with a spectrophotometer, I found this
paint color to be almost perfectly neutral in color. The under shelf
lighting uses cool fluorescent strips that bounce off behind the
displays to avoid any light hitting the screens directly. Here, you
can see that I have a large, NEC LCD display hooked up to a tower
computer with an internal DVD drive. I have a Wacom graphics

Figure 2.1 This shows what I might regard as an ideal basic Photoshop setup. This
features a tower computer with plenty of RAM memory, a high quality calibrated display, a
graphics input tablet, a removable backup drive and a UPS device to protect against power
surges or cut-outs. The wall is painted neutral gray to absorb light and reduce the risk
of color casts affecting what is seen on the display. The lighting comes from a daylight
balanced tube which backlights the display. I usually have the light level turned down quite
low, in order to maximize the monitor viewing contrast.

Chip speed

Microchip processing speed is expressed in megahertz, but performance speed also depends on the chip type. A 2 GHz Pentium class 4 chip is not as fast as a 2 GHz Intel Core Duo processor. Speed comparisons in terms of the number of megahertz are only valid between chips of the same series. Many of the latest computers are also enabled with twin processors or more, although having extra cores is mainly beneficial when running certain types of filter operations. Another crucial factor is the bus speed, which refers to the speed of data transfer from RAM memory to the CPU (the central processing unit, i.e. the chip). CPU performance can be restricted by slow system bus speeds, so faster is definitely better, especially for Photoshop work where large chunks of data are being processed. More recently, Photoshop has sought to take advantage of OpenGL (and now Open CL) enabled video cards to speed up some aspects of Photoshop's image processing.

Eizo ColorEdge

Eizo have established themselves as offering the finest quality LCD displays for graphics use. The ColorEdge CG301 is the flagship model in the range. The 30" wide screen is capable of providing uniform screen display from edge to edge, encompasses the Adobe RGB gamut and comes with ColorNavigator calibration software that can be used with X-Rite calibration devices. This display is more expensive than most, but is highly prized for its color fidelity.

pad and pen to work with as an input device and also an external hard drive for backing up data to. As your requirements grow you will probably need to have more external drives and if you can afford it, I highly recommend working with two large displays side by side.

It is also important to choose an operator chair that is comfortable to sit in for long periods of time. Ideally you want a chair that has arm rests and adjustable seating positions so that your wrists can rest comfortably on the table top. The computer display monitor should be adjusted so that it is level with your line of sight, or slightly lower.

Once you start building an imaging workstation, you will soon end up with lots of electrical devices. While these in themselves may not consume a huge amount of power, do take precautions against too many power leads trailing from a single power point. To prevent damage or loss of data from a sudden power cut, I suggest you place an uninterruptible power supply unit (UPS) between your computer and the mains source. These devices can also smooth out any voltage spikes or surges in the electricity supply (see "Protecting the power supply" on page 100). In Figure 2.1 the computer and display are both connected to a power supply unit in the right-hand corner.

Choosing a display

The display is one of the most important components in your computer setup. It is what you will spend all your time looking at as you work in Photoshop and you really don't want to economize by buying a cheap display that is unsuited for graphics use. The only ones you can buy these days are liquid crystal displays (LCDs), which range in size from the small screens used on laptop computers to big 30" desktop displays. An LCD display contains a translucent film of fixed-size liquid crystal elements that individually filter the color of a backlit, fluorescent or LED light source. Therefore, the only hardware adjustment you can usually make is to adjust the brightness of the backlit screen. The contrast of an LCD is also fixed, but LCDs are generally more contrasty than CRT monitors ever were, which is not a bad thing when doing Photoshop work for print output.

Because LCDs are digital devices they tend to produce a more consistent color output, but they do still need to be calibrated and

profiled of course. Once profiled though, the display's performance should remain fairly consistent over a long period of time. On the other hand, with some displays there may be some variance in the image appearance depending on the angle from which you view the display, which means that the color output of an LCD may only appear correct when the display is viewed front on. This very much depends on the design of the LCD display unit and the worst examples of this can be seen with ultra-thin laptop screens. However, the evenness of output from high quality desktop LCD screens is certainly a lot more consistent these days. The higher grade LCD screens do feature relatively good viewing angle consistency, are not too far off from providing a neutral color at a D65 white balance, and won't fluctuate much in performance. As with everything else in life, you get what you pay for.

Video cards

The graphics card in your computer is what drives the display. It processes all the pixel information and converts it to draw the color image that's seen on the display. An accelerated graphics card can let you to do several things. It can allow you to run your display at higher screen resolutions, hold more image display view data in memory and can use the display profile information to finely adjust the color appearance. When more of the off-screen image data is able to be held in video memory the image scrolling is enhanced and this generally provides faster display refreshes. In the old days, computers would be sold with a limited amount of video memory and if you were lucky you could just about manage to run a small display in millions of colors. These days a computer is likely to be equipped with a good, high performance graphics card that is easily capable of meeting all your needs. A modern video card will typically have at least 256 MB of dedicated memory, which is enough to satisfy the minimum requirements for Photoshop CS6. However, with the advent of the latest OpenGL and OpenCL features in Photoshop, it is now worth considering video cards that were previously only necessary for gaming and 3D work. In a sidebar on the following page I outline some of the advantages these can bring. Also, check the Adobe Help site to find out which OpenGL and OpenCL video cards are designated as being compatible for Photoshop use.

NEC LCD3090

The NEC LCD3090 30" display has won a lot of praise from industry color gurus and is what I use as my main display. This display is a huge improvement upon the old, 30" Apple Cinema display which I now use as the secondary monitor. Meanwhile, Apple's passion for glossy displays means that their newer displays are actually worse than the old ones. I have found it impossible to calibrate the new iMac displays and make them useable for Photoshop image editing. The only viable solution has been to run a secondary display off the iMac I take on location, which kind of defeats the reason for having an iMac in the first place.

Support for 30-bit display output

Photoshop CS6 is able to support 30-bit displays (10-bits per channel) for improved bit-depth viewing provided that the monitor hardware, the graphic card and operating system, all support 30-bit. If so, Photoshop can render the video data into 30-bit buffers. The latest Windows operating systems are capable of supporting this fully. It is claimed that Mac OS X 10.7 (Lion) can do so too, though what the Lion operating system actually does is to dither the 30-bit video output to 24-bit (which isn't true 30-bit, but something slightly better than 24-bit). It is therefore only Windows users who can really take advantage of this feature.

OpenGL and OpenCL

The graphics processor can often fit more processing into its schedule due to its very high clockspeed. When allowed, it can give up some of its available cycles to help out the central processor unit (CPU) and provide additional processing power. The first implementation of this has been OpenGL, where OpenGL enabled cards can share certain graphics tasks (such as zoom and flick panning), freeing up the CPU. OpenCL does not confine itself to graphics, but can help with any computer-intensive task. Naturally, applications must be written specifically to take advantage of what OpenCL offers. So far, in Photoshop CS6 the added benefits of OpenCL only affect the performance of the Blur Tools. If you want to take advantage of what OpenGL and OpenCL can offer in Photoshop, it might be necessary to purchase a new video card. At the time of writing, there is a long list of video cards capable of providing OpenGL support in Photoshop CS6 for Mac OS X 10.6 (or later), Windows Vista and limited support for Windows 7. Adobe do list the GPU cards that are recommended for Photoshop use, but it is difficult though to point to any one group of cards and say these are best. The OpenGL performance in Photoshop is down to not just the card, but also the computer platform and operating system used.

Adding a second display

To run a second display you may need to buy an additional video graphics card that will provide a second video port. You'll then be able to contain all the Photoshop panels on the second screen and keep the main display area clear of clutter.

Display calibration and profiling

We now need to focus on what is the most important aspect of any Photoshop system: getting the display to show your images in Photoshop correctly and ensure that the display colors can be relied upon to match the print output. This basic advice should be self-evident, because we all want our images in Photoshop to be consistent from session to session and match in appearance when they are viewed on another user's system.

The initial calibration process should get your display close to an idealized state. The next step is to build a display profile that describes how well the display actually performs after it has been calibrated, which at a minimum describes the white point and chosen gamma. The more advanced LCD displays such as the Eizo ColorEdge and NEC LCD3090 do provide hardware calibration for a more consistent and standardized output, but the only adjustment you can make on most LCD displays is to adjust the brightness.

Calibration hardware

Let's now look at the practical steps for calibrating your display. First, get rid of any distracting background colors or patterns on the computer desktop. Consider choosing a neutral color theme for your operating system (the Mac OS X system has a graphite appearance setting especially for Photoshop users). If you are using a PC, go to Control Panels ⇨ Appearance & Personalization ⇨ Window Color and Appearance. I then suggest you choose the Graphite theme and adjust the Color Intensity slider as desired. This is all very subjective of course, but personally I think these adjustments improve the look of both operating systems.

The only reliable way to calibrate and profile your display is by using a hardware calibration system. Some displays, such as the LaCie range can be bought with a bundled hardware calibrator, but there are many other types of stand-alone calibration packages to consider. The ColorVision Monitor Spyder and Spyder2Pro Studio are affordable and are sold either with PhotoCal or the more advanced OptiCal software. Colorimeter devices can only be used to measure the output from a display. Unlike the more expensive spectraphotometers, you can't use them to measure print targets, but when it comes to profiling a display they are just as good.

1 An uncalibrated and unprofiled display cannot be relied on to provide an accurate indication of how colors should look.

2 The calibration process simply aims to optimize the display for brightness and get the luminance within a desired range.

3 The profiling process takes into account the target white balance and gamma. The profiling process also measures how a broad range of colors are displayed.

4 To create a profile of this kind you need a colorimeter device. A calibrator such as the X-Rite i1Display 2 or i1Photo with the i1Match or Profile Maker Professional software can be used, although there are now several other devices that are equally as good. Once calibrated and profiled, you will have a computer display that can be relied upon when assessing how your colors will reproduce in print.

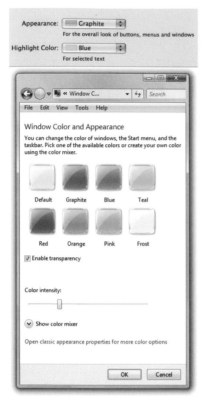

Figure 2.2 This shows the operating system Appearance options for Macintosh (top) and Windows Vista (bottom).

Figure 2.3 The X-Rite i1Photo is a popular spectrophotometer that can be used with the accompanying software, to calibrate and build an ICC profile for your display.

The X-Rite product range includes the i1 system, which is available in several different packages. The i1 Photo (Figure 2.3) is an emissive spectrophotometer that can measure all types of displays and build printer profiles too when used in conjunction with the ProfileMaker 5 or i1 Match software, while the EZ Color is a low cost colorimeter device bundled with the i1 Display 2 software. The newest product in their range is the ColorMunki Photo, which is an integrated calibration/profiling device that can work with everything, including LCD beamer projectors.

If all you are interested in is calibrating and profiling a computer display, there is no great advantage in choosing a spectrophotometer over the more economically priced colorimeter devices. Whatever you do, I certainly advise you to include a calibrator/software package with any display purchase.

The calibration/profiling procedure

Over the next few pages I have shown how to use the i1Match 3.6.2 software with an X-Rite monitor calibration device and described the steps that would be used for an advanced display calibration. Other calibration software packages will differ of course, but the basic principles should be similar to other software programs. The first step is to select the type of device you want to calibrate (in this instance, an LCD display) and then select the Basic or Advanced options.

White point

The white point information tells the video card how to display a pure white on the screen so that it matches a specific color temperature. Unlike the old CRT displays, it is not possible to physically adjust the white point of an LCD screen. For this reason, it is usually better to select the native white point option when calibrating an LCD display (as shown in Figure 2.4), rather than calibrate to a prescribed white point value. Remember that all colors are seen relative to what is perceived to be the whitest white in a scene and the eye naturally compensates from the white point seen on the display to the white point used by an alternative viewing light source (see accompanying sidebar on the white point setup).

Gamma

The gamma setting tells the video card how much to adjust the midtone levels compensation. You typically have three options to choose from here: 1.8, 2.2 or Native Gamma. Quite often you are told that PC users should use 2.2 gamma and Macintosh users should use 1.8 gamma. But 2.2 can be considered the ideal gamma setting to use regardless of whether you are on a Mac or a PC. You can build a correct display profile using a 1.8 gamma option, but 2.2 is closer to the native gamma of most displays. However, in Figure 2.4 you can see that I actually selected the Native Gamma option. Most LCD screens have a native gamma that is fairly close to 2.2 anyway, and if you choose 'native' rather than 2.2 you can create a satisfactory display profile without forcing the video card to stretch the display levels any more than is necessary.

Luminance

You need to make sure that the brightness of the LCD display is within an acceptable luminance range. The target luminance will vary according to which type of display you are using and a typical modern LCD display will have a luminance of 250 candelas m² or

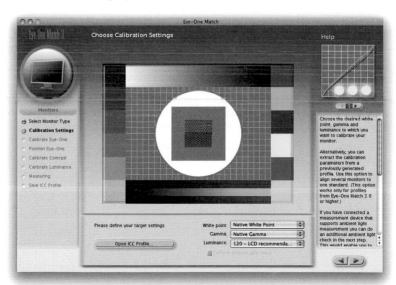

Figure 2.4 I like using the i1Match software because it is easy to set up and use. In this case, I wanted to calibrate and profile an LCD display. I set the white point and Gamma to 'Native' and the luminance to 120 candelas m², which is a recommended target setting for desktop LCD displays.

There is a lot of seemingly conflicting advice out there on how to set the white point in a calibration setup. In the days when CRT displays were popular there was a choice to be made between a 5000K and a 6500K white point for print work. My advice then was to use 6500K, since most CRT displays would run naturally at a white point of 6500K, although some people regarded 5000K as being the correct value to use for CMYK proofing work. In reality though, the whites on your display would appear far too yellow at this setting. 6500K may have been cooler than the assumed 5000K standard, but 6500K proved to be much better for image editing viewing. These days, most LCD displays have a native color temperature that is around 6000–7000K and it is now (mostly) considered best to choose the native white point when calibrating and profiling an LCD display.

The main thing to remember here is that your eyes adjust quite naturally to the white point color of any display, in the same way as your eyes constantly adjust to the fluctuations in color temperature of everyday lighting conditions. Therefore, your eyes will judge all colors relative to the color of the whitest white, so the apparent disparity of using a white point for the display that is not exactly the same as that of a calibrated viewing lightbox is not something you should worry about. As I say, when it comes to comparing colors, your eyes will naturally adapt as they move from the screen to a viewing lightbox.

Display gamma and brightness

Note that the gamma you choose when creating a display profile does not affect how light or dark an image will be displayed in Photoshop. This is because the display profile gamma only affects how the midtone levels are distributed. Whether you use a Mac or PC computer, you should ideally choose the native gamma or a gamma of 2.2.

The Macintosh 1.8 gamma option

The link between 1.8 gamma and the Macintosh system dates back to the early days of Macintosh computing when the only printer you could use with the Mac was an Apple black and white laser printer. At the time, it was suggested that the best way to match the screen appearance to the printer was to set the monitor gamma to 1.8. I once asked an engineer who designs display calibration software why they still included 1.8 gamma as an option and he replied that it's only there to comfort Mac users who have traditionally been taught to use 1.8. So now you know.

more at its maximum luminance setting, which is way too bright for image editing work in subdued office lighting conditions. A target of around 120–140 candelas m^2 is ideal for a desktop LCD display and for laptops, the ideal luminance to aim for is around 100–110 CD m^2.

It is important to note that as displays get older they do tend to lose brightness, which is one of the reasons why you will need to use a calibration device (like the X-Rite i1 Photo shown in Figure 2.3) to recalibrate the display from time to time. There may also come a point where the display becomes so dim that it can no longer be successfully calibrated or considered reliable enough for Photoshop image editing.

Device calibration and measurement

With the i1Match software you will be asked to calibrate the device (Figure 2.5) before proceeding to measure the brightness of the display (Figure 2.6). It is at this stage that the Luminance indicator appears and you can tweak the display brightness until the target luminance is reached.

The profiling process

When you click on the forward arrow button in Figure 2.6, i1Match will start flashing a series of colors on the screen, while the calibration device measures these. Once it has completed doing this, it generates a display profile named with the current date. All you have to do then is click OK to establish this as the new display profile to use so that it replaces the previous profile. You might also want to set a reminder for when the next monitor profile should be made. With LCD displays, regular calibration is not quite so critical and it will probably be enough for you to profile the display just once a month or so. Also, do you really need to hang on to your old display profiles? I recommend that you purge the Colorsync Profiles folder on your system of older display profiles to avoid confusion. All you really need is one good, up-to-date profile for each display.

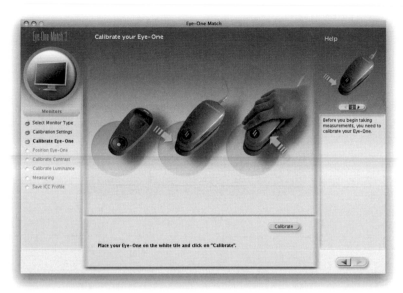

Figure 2.5 Here, i1Match asks you to calibrate the device, by placing it on the base unit to measure the white tile, before hanging the device over the screen.

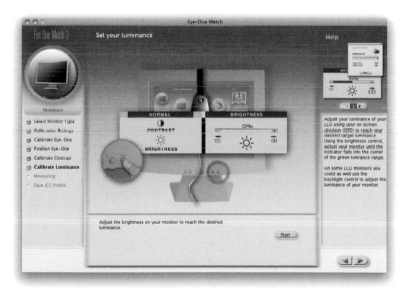

Figure 2.6 In this step you are asked to set the contrast to maximum (skip this step if calibrating an LCD) and then adjust the brightness. i1Match measures the current display brightness and shows you the measured value in a separate window. You can then adjust the display hardware brightness controls until you get a good match.

Is the display too bright?

These days, some LCD displays can be way too bright for digital imaging work. I recently tried to calibrate one of the new glossy Apple displays and measured a brightness of 250 candelas m² at the minimum brightness setting. Brand new LCD displays do lose their brightness after a 100 hours or so of use, which may make them become more useable. However, some of the new glossy displays appear to be incapable of revealing detail in the extreme highlight range. The thing is, these types of displays may look great for playing video games and watching TV, but they are not ideal for image editing work. This isn't just a problem with Apple, there are lots of unsuitable displays out there, which is why I now recommend purchasing a display that is specifically designed with digital image editing in mind.

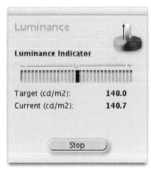

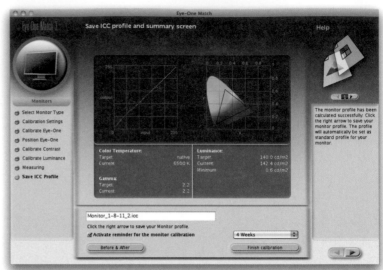

Figure 2.7 Finally, the i1Match software will start measuring a sequence of colors that are flashed up on the display and from this build an ICC profile of the display, which is automatically saved to the correct system folder, where it will be picked up by the system and referenced by Photoshop's color management system.

Do you want good color or just OK color?

Let me summarize in a few paragraphs why you should pay special attention to how your images are displayed in Photoshop and why good color management is essential.

These days the only real option is to buy a good quality LCD display that is designed for graphic use. Once you have chosen a good display you need to consider how you are going to calibrate and profile it. This is crucial and if done right it means you can trust the colors you see on the display when determining what the print output will look like. In the long run you are going to save yourself an awful lot of time and frustration if you calibrate and profile the display properly right from the start. Not so long ago, the price of a large display plus a decent video card would have cost a small fortune and display calibrators were considered specialist items. These days, a basic display calibration and profiling device can cost about the same as an external hard drive, so I would urge anyone setting up a computer system for Photoshop to put a display calibrator and accompanying software package high on their spending list.

All the display calibrator products I have tested will automatically place the generated display profile in the correct system folder so that you are ready to start working straight away in Photoshop with your display properly calibrated and with the knowledge that Photoshop automatically knows how to read the profile you have just created.

Color management settings

One of the very first things you should do after installing Photoshop is to adjust the color management settings. The default Photoshop Color Settings are configured using a general setting for the region you live in, which will be: North America, Europe or Japan. If you are using Photoshop for design work or photography, you will want to change this to a regional 'prepress' setting. Go to the Edit menu and select Color Settings, which opens the dialog shown in Figure 2.8. Next, go to the Settings menu and select one of the prepress settings. The individual prepress settings only differ in the default RGB to CMYK conversions that are used, and these

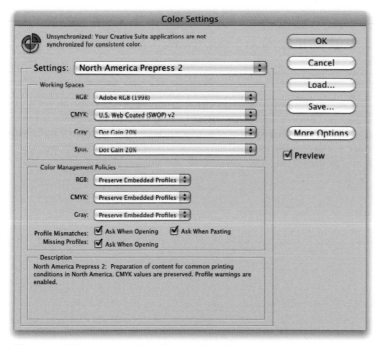

Figure 2.8 The Photoshop Color Settings. All the Photoshop color settings can be managed from within this single dialog (⌘ _Shift_ K _ctrl_ _Shift_ K) and shared with other Creative Suite applications (see Figure 2.9).

Eyeball calibration

Another option is to use a non-device calibration method, such as the Display Calibration Assistant that is part of the Mac OS X operating system. This is better than doing nothing, but is still not a proper substitute for proper hardware calibration and profiling. If you don't invest in a calibration/measuring device, your only other option is to load a canned profile for the display and keep your fingers crossed. This approach is better than doing nothing but rarely all that successful, so I would still urge you to consider buying a proper calibration device and software package.

CMYK prepress settings

The latest Europe prepress 3 setting utilizes the Coated FOGRA39 CMYK profile. This supersedes the former Coated FOGRA27 profile, though there may be some printers who will prefer the use of FOGRA27, so it is worth checking if you are asked to produce European CMYK conversions.

Color managing the print output

This leaves the question of how to profile the print output? Getting custom profiles built for your printer is a good idea, and it is a topic that I have covered in some detail in the Color Management PDF (available from the book website). However, calibrating and building a profile for your display is by far the most important first step in the whole color management process. Get this right and the canned profiles that came with your printer should work just fine. Follow these instructions and you should get a much closer match between what you see on the display and what you see coming out of your printer, although without doubt, a custom print profile will help you get even better results.

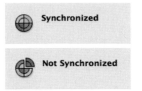

Figure 2.9 The pie chart icon in the Color Settings dialog tells you if the Color Settings have been synchronized across the Creative Suite or not.

will depend on the geographical area you are working in (I also suggest you check out the Color Management PDF on the book website to check you are using the right settings for a photography setup). So if you live and work in the US, choose North America Prepress 2 and you will mostly be fine with that setting. Please note that choosing a prepress setting changes the RGB working space from sRGB to Adobe RGB. This is a good thing to do if you intend editing RGB photographs in Photoshop (although I would personally recommend using ProPhoto RGB). The prepress settings also adjust the policy settings so as to preserve embedded profiles and alert you whenever there is a profile mismatch. I would also suggest you turn off the 'Ask When Opening' option in the Profile Mismatches section. This minimizes the number of times you are shown the profile mismatch warning dialog when working with image files that are in different color spaces. When you customize the color settings presets in this way, the preset menu will say 'Custom'. I suggest that you then save and name this preset so that these settings are easy to access in future.

Once this is done, the Color Settings will remain set until you change them. After that, all you need to worry about is making sure that the calibration and profile for your display are kept up-to-date. If you just take these recommended steps you won't need to worry too much more about the ins and outs of Photoshop color management until you are ready to. If you have purchased a previous edition of this book in the last ten years or so, you'll already have access to the chapter I wrote on color management. Nothing has changed really. If you would like to learn more and don't have one of the previous books you can download the chapter on color management from the book's website. Color management does not have to be intimidatingly complex and nor does it have to be expensive. So the question is, do you want good color or simply OK color? Or, to put it another way, can you afford not to?

Synchronizing the Color Settings

If you are using other programs that are part of the Adobe Creative Suite, such as Illustrator and InDesign, it is a good idea to keep the Color settings synchronized across all of these programs (see Figure 2.9). Once you have selected a desired color setting in Photoshop, I suggest you open Bridge and synchronize the Color Settings there too. This ensures that the same color settings are used throughout all the other programs in the Creative Suite.

Extras

An internal 16× or faster DVD/CD drive is usually fitted as standard in most computers. Devices such as a graphics tablet, external hard drive and other peripheral devices can be connected using one of the following interface connection methods.

USB is a universal interface connection for Mac and PC. The older USB 1 connection was regarded as being very slow, but the newer USB 2 interface connection is more universal and faster, especially for those working on a PC system. You can have up to 127 USB devices linked to a single computer and you can plug and unplug a USB device while the machine is switched on. FireWire (also known as the IEEE 1394 interface) has the potential to provide fast data transfer rates of 49 MB per second (faster still using the latest FireWire 800). Apple also has, in conjunction with Intel, a new proprietary interface called Thunderbolt, which offers data transfer speeds of up to 20 Gbits/s. It allows for both hard drives and displays, it can carry audio and when coupled with OpenCL and Open GL, points the way to increased performance.

Backing up your image data

The Mac and PC operating systems encourage you to place all your image files in the users 'Pictures' or 'My Pictures' folder. This might work fine if all you are shooting are JPEG snaps, but it is unlikely to suffice once you start capturing lots of raw images. So your first consideration should be to store your image files on hard drives that have plenty enough capacity to anticipate your image storage needs for at least the next year or two. The next thing you need to consider is how accessible is your image data? Suppose a power supply unit failure or some other glitch prevented you from turning on the computer? For this reason I find it is helpful to store important image data on drives that can easily be accessed and removed. One solution is to store your data on separate internal hard drives where the drive caddies can easily be swapped over to the internal bay of another computer. Or, you can store the data on external hard drive units that can simply be plugged in to another computer.

The next thing is to implement a backup strategy for your images and other important data files. For each main hard drive you should have at least one matching sized external hard drive that you can regularly back up the data to. These hard drives should be kept somewhere safe so that in case of a fire or theft you have access to recently backed up versions of all your essential data. One suggestion

Figure 2.10 Wacom™ pad and pen (Photoshop CS6 promises improved Wacom performance responsiveness).

Graphics tablets

I highly recommend you get a digitizing graphics tablet like the one shown in Figure 2.10. This is a pressure sensitive device, which makes it easier to draw with, and can be used alongside the mouse as an input device. Bigger is not necessarily better though. Some people like using the A4 sized tablets, while others find it easier to work with an A5 or A6 tablet. You don't have to move the pen around so much with smaller pads and these are therefore easier to use for painting and drawing. Once you have experienced working with a pen, using the mouse is like trying to draw while wearing boxing gloves! The latest Wacom Intuos™ range now features a cordless mouse with switchable pens and the Wacom Cintiq™ device is a combination of LCD monitor and digitizing pen pad. This radical new design will potentially introduce a whole new concept to the way we interact with the on-screen image. I don't know if it is going to be generally seen as the ideal way of working with photographs, but there are those who reckon it makes painting and drawing a more fluid experience.

Vampire power

Have you ever stopped to think how much electric power your computer workstation consumes, and of that how much is wasted? The statistics are quite alarming. Countries around the world have come up with different statistics, but it is estimated that between 7% and 13% of residential power is consumed by household appliances being left on standby mode. Of course, some of those items, such as security alarm systems, do have to be left on full-time standby mode full-time. In a typical office it is possible to accumulate a large number of electrical items, especially all the power bricks that are used to power individual hard drives and other computer accessories. It's a real problem and one that I have only partially managed to resolve by copying the data from a lot of my external drives onto bigger, single drive units and connecting all the lesser-used appliances to a switchable power strip.

Cloud storage

Cloud computing, including cloud storage, is becoming more widely used these days – look at the recent Adobe Revel program that was released last year. Most photographers tend to have storage requirements that run to at least several gigabytes and cloud storage is something that is often thought of as both pricey and slow. However, with plans to deliver broadband speeds at ever higher rates, we should see this becoming more of a realistic proposition for professional users.

is to have two external backup drives for each main drive. That way you can swap over the backup drives and continually have a secondary backup version stored permanently off-site or kept in a fire proof safe.

In the lifetime of the Photoshop program we have seen many different storage systems come and go: floppy disks, Syquests, Magneto Opticals… the list goes on. Although you can still obtain devices that are capable of reading these media formats, the question is, for how long? What will you do in the future if a specific hardware device fails to work? The introduction of recordable CD/DVD media has provided a reasonably consistent means of storage and for the last 16 years nearly all computers have been able to read CD and DVD discs. DVD drives have also evolved to provide much faster read/write speeds and DVD media may be able to offer increased storage space in the future. We are already seeing bigger disc media storage systems such as Blu-ray Disc make an impact. So how long will CD and DVD media remain popular and be supported by future computer hardware devices? More to the point, how long will the media discs themselves last? It is estimated that aluminium and gold CD discs could last up to 30 years, or longer, if stored carefully in the right conditions such as at the right temperature and away from direct sunlight, while DVD discs that use vegetable dyes may have a shorter life-span. I wouldn't bet on DVD or Blu-ray media providing a long-term archive solution, but even so, I reckon it is worth keeping extra backups of your data on such media. The one advantage write once media has over hard drive storage is that your data is protected from the prospect of a virus attack. If a virus were to infect your computer and damage your data files, a backup procedure might simply copy the damage over to the backup disks.

Protecting the power supply

It is inevitable that you will at some point suffer an interruption to the power supply. At least with Photoshop CS6, there is now an option to enable background saving, which can at least mitigate the worst consequence of a power failure: the loss of everything you have just been working on. Even so, it is not a good idea to let the computer be affected by a sudden loss of power or power surge. I therefore suggest you purchase a suitable Uninterruptible Power Supply Unit (UPS). You need to make sure that the unit you buy can handle the power demands of at least the main computer, display and powered hard drives. In my office I have my main computer setup powered via an APC Back-UPS ES-700 unit.

Photoshop preferences

The Photoshop preferences are located in the Edit menu in Windows and the Photoshop menu in OS X and these let you customize the various Photoshop functions. A new preference file is generated each time you exit Photoshop and deleting or removing this file will force Photoshop to reset all of its preference settings. The preference file is stored along with other program settings in the system level Preferences folder: Users/Username/Library/Preferences folder (Mac) or C:\Users\Username\App Data\Roaming\Adobe\Adobe Photoshop CS6\Adobe Photoshop CS6 Settings folder (PC).

After configuring the preference settings I suggest you make a duplicate of the Photoshop preference file after you have closed Photoshop and store it somewhere safe. Having ready access to a clean preference file can speed up resetting the Photoshop settings should the working preference file become corrupted.

Migrate settings

If you have older custom presets present on your system which aren't present in the current installation, the first time you launch Photoshop CS6 you will see a prompt message asking whether or not you want to transfer those presets? This allows you to migrate the older presets over to Photoshop CS6. Where the names of any presets conflict, presets from later versions will be given a higher priority. You can also carry out this task at any time after the first launch by choosing Edit ⇨ Presets ⇨ Migrate Presets, or by resetting your settings during launch. Similarly, you can choose the Export/Import Presets… option to export the current presets.

General preferences

Figure 2.11 The General preferences dialog.

Figure 2.12 When any paint or fill tool is selected, you can hold down the ⌘ ⌥ ctrl keys (Mac), or hold down the *alt* *Shift* keys and right-click (PC), to open the Heads Up Display Color Picker. The two main heads up display options are the Hue Strip (top) and the Hue wheel (bottom). These are available in different sizes from the HUD Color Picker menu.

When you open the preferences you will first be shown the General preferences (Figure 2.11). I suggest you leave the Color Picker set to Adobe (unless you have a strong attachment to the system Color Picker). Photoshop has a HUD (Heads Up Display) Color Picker options for selecting new colors when working with the eyedropper or paint tools (Figure 2.12). Note that the HUD Color Picker is only accessible when the Graphics Processor Settings are enabled (see page 111). In the Image Interpolation options the default is Bicubic, but you might like to choose the new Bicubic Automatic option instead (see page 319). If you need to override this setting you can always do so via the Image ⇨ Image Size dialog.

In the main Options section, 'Auto-Update Open Documents' can be used if you know you are likely to share files that are open in Photoshop but have been updated by another application. This used to be important when ImageReady was provided as a separate Web editing program to accompany Photoshop, but has less relevance now and can be left switched off. Only check the 'Beep When Done' box if you want Photoshop to signal a sound alert each time a task is completed. The 'Dynamic Color Sliders' option ensures that the colors change in the Color panel as you drag the sliders, so keep this selected. If you need to be able to paste the Photoshop clipboard contents to another program after you exit Photoshop then leave the 'Export Clipboard' box checked. Otherwise, I suggest you switch this off. The 'Use Shift Key for Tool Switch' option answers the needs of those users who wish to disable using the *Shift* key modifier for switching tools in the Tools panel with repeated keystrokes (see page 28). When the 'Resize Image During Place' preference item is checked, if you use File ⇨ Place… to place a photo in a document that is smaller than the placed image, the placed file is placed in a bounding box scaled to the dimensions of the target image. This can help speed up your workflow when pasting lots of documents, especially now that Photoshop allows you to drag and drop Photoshop compatible files to place them in an image. The 'Animated Zoom' option is another OpenGL only option, which is intended to provide smoother transitions on screen when using the ⌘ − ctrl − or ⌘ + ctrl + keys to zoom in or out. Also, check the 'Zoom Resizes Windows' option if you want the image window to shrink to fit whenever you use a keyboard zoom shortcut such as ⌘ − ctrl − or ⌘ + ctrl + . Then there is the 'Zoom with Scroll Wheel' option which enables you to zoom in and out using the

scroll wheel on a mouse (when this option is selected, holding down the `Shift` key makes the zoom operate quicker). Instead of selecting this option you can also hold down the `⌥` `alt` key to temporarily access the zoom wheel behavior. When the 'Zoom Clicked to Center' option is checked, the image zooms in centered around the point where you click, and the best way to understand the distinction between having this option on or off is to see what happens when you click to zoom in on the corner of a photo. When checked, the corner point of the photo will keep recentering as you zoom in. I discussed the 'Enable Flick panning' option earlier in Chapter 1, on page 56. This again is dependent on OpenGL being enabled for this option to take effect.

The 'Vary Round Brush Hardness on HUD Vertical Movement' is new to Photoshop CS6. This controls what happens when you have a painting tool selected and you hold down the `ctrl` `⌥` keys (Mac), or the `alt` key and right-click (PC) and drag. When this option is checked, dragging up or down varies the round brush hardness. When it is deselected, dragging up or down varies the brush opacity instead.

'Place or Drag Raster Images as Smart Objects' allows you to drag a Photoshop compatible file directly from the Finder/Explorer or from Bridge to place it as a new layer in an open document. 'Snap Vector Tools and Transforms to Pixel Grid' does just what it says.

A history log is useful if you wish to keep track of everything that has been done to an image and the History Log options let you save the history log directly in the image file metadata, to a saved text file stored in a pre-configured folder location, or both. Edit log items can be recorded in three modes. 'Sessions' records which files are opened and closed and when. The 'Concise' mode records an abbreviated list of which tools or commands were applied (also recording times). Both these modes can provide basic feedback that could be useful in a studio environment to monitor the time spent on a particular project and help calculate billing. The 'Detailed' mode records everything, such as the coordinates used to make a crop. This mode can be useful, for example, in forensic work.

You will often come across warning dialogs in Photoshop that contain a 'Don't Warn Me Again' checkbox. If you have at some stage clicked in these boxes to prevent a warning dialog appearing again you can undo this by clicking on the 'Reset All Warning Dialogs' button in the General preferences.

Resetting the preferences

If you hold down `⌘` `⌥` `Shift` `ctrl` `alt` `Shift` during startup cycle, this pops a dialog box that allows you to delete the current Photoshop preference file.

Scroll wheel zooming and track pad

If you check the 'Zoom with Scroll Wheel' option, this may also affect track pad gestures. For example, Mac computers make no differentiation between a mouse scroll wheel movement and a two-finger motion gesture on a track pad. It may be preferable to uncheck this if using the track pad for more straightforward navigation around an image, where inadvertent zooming would be annoying.

Mini Bridge interface settings

Note that the Appearance settings set here will affect the appearance of Mini Bridge, but not the main Bridge program, where the UI settings can be set separately.

Interface preferences

The Interface preferences are shown below in Figure 2.13. As you will have already gathered in Chapter 1, the Photoshop CS6 interface can be customized, allowing you to choose from one of four different panel brightness settings. These range from a light gray theme that is not too different from the previous 'classic' Photoshop interface, to three progressively darker themes. This is something that I discussed earlier in depth on page 6, where I pointed out how important it is to change the default interface settings in order to establish a suitable interface brightness and canvas color for photo editing work, and if you refer to the screen view modes shown on page 59, you'll see examples of two of the three main screen modes that are available in Photoshop. The outer canvas areas can be customized by selecting alternative colors from the Color menus. You can also adjust the border, which can be shown as a drop shadow, thin black line, or with the border style set to 'None'.

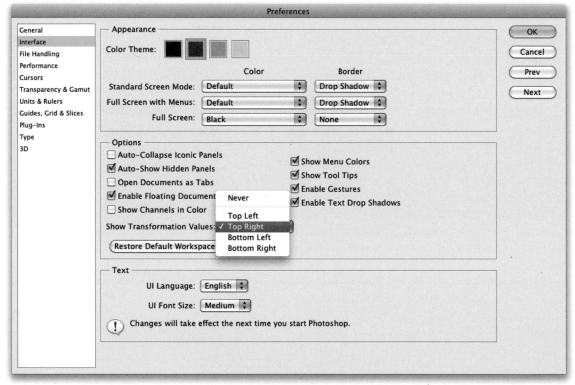

Figure 2.13 Interface preferences.

Now let's look at the Options section. The 'Auto-Collapse Iconic Panels' option allows you to open panels from icon mode and auto-collapse them back to icon mode again as soon as you start editing an image, while 'Auto Show Hidden Panels' reveals hidden panels on rollover.

When the 'Open Documents as Tabs' option is checked, new documents will open as tabbed documents, docked to a single document window in the Photoshop workspace. Uncheck this if you wish to restore the previous, floating document window opening behavior. When the 'Enable Floating Document Windows Docking' option is checked, this allows you to drag one window to another as a tabbed document (see page 12).

The 'Show Channels in Color' option is a somewhat redundant feature as it does not really help you visualize the channels any better. If anything it is a distraction and best left unchecked.

Photoshop allows you to create custom menu settings and use colors to highlight favorite menu items, but this particular feature can be disabled by unchecking the 'Show Menu Colors' option. When 'Show Tool Tips' is checked a tool tips box will appear for a few seconds after you roll over various items in the Photoshop interface. Tool tips are an excellent learning tool, but they can become irritating after a while, so you can use this checkbox to turn them on or off as desired. When 'Show Transformational Values' is checked you get to see the heads up display that you will have seen in earlier screen shots for things like the marquee tools.

The 'Enable Gestures' option is relevant if you are using a laptop computer or have a trackpad device connected to your computer. One of the things you can do with a trackpad is to set it up to respond to specific finger gestures. But this can be both a good or a bad thing: some users have found it rather distracting when carrying out Photoshop work and prefer to switch this option off.

The 'Enable Text Drop Shadows' option was also discussed earlier on page 9, where I mentioned how this option seems to be most useful when working with the two darker UI themes. If you switch it on when the lighter themes are selected, it can make the text appear less legible.

The 'UI text options' (user interface) settings allow you to choose an alternative UI language (if available) and UI text size. The default setting is 'Small' which most users will find plenty big enough. For those with very large, high resolution displays it can help to increase the UI text size (see sidebar).

Customizing the UI Font Size

LCD computer displays are getting bigger all the time and are only really designed to operate at their best when using the finest resolution setting. This can be great for viewing photographs, but the downside is that the application menu items are getting smaller and smaller. The UI (user interface) Font Size option allows you to customize the size of the smaller font menu items in Photoshop so that you don't have to strain your eyes to read them. For example, when using a large LCD screen, the Medium or Large font size option may make it easier to read the smaller font menu items from a distance.

Economical web saves

There are times though when you don't need previews. Web graphic files should be uploaded as small as possible without a thumbnail or platform-specific header information. If you use Save for Web, this removes the previews and keeps the output files compact in size.

File Handling preferences

In the File Handling preferences (Figure 2.14) you will normally want to include image previews when you save a file. It is certainly useful to have image thumbnail previews that are viewable in the system dialog boxes although the Bridge program is capable of generating large thumbnails regardless of whether a preview is present or not. Appending a file with a file extension is handy for knowing which format a document was saved in and is absolutely necessary when saving JPEG and GIF web graphics that need to be recognized in an HTML page. If you are exporting for the Web, you may want to check the 'Use Lower Case' option for appending files. However, instances of where servers trip up on upper case naming are fairly rare these days. The 'Save As to Original Folder' option is useful if you want this to be the default option. It makes sure that you are always able to save new versions of an image to the same folder as the original file came from. If this option is left unchecked, Photoshop shows you the last used folder location when you choose File ➪ Save As…

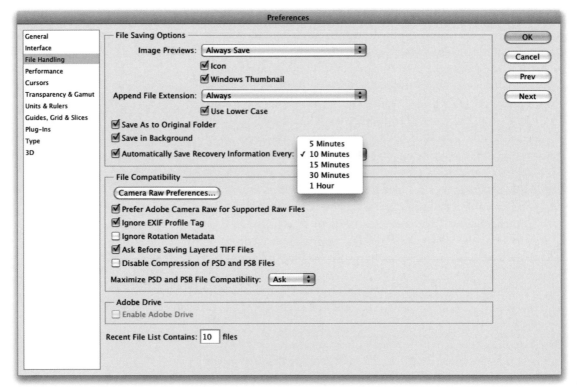

Figure 2.14 The File Handling preferences.

There is now the option to enable 'Save in Background'. This is an auto-recovery option that is switched on by default. When this is checked Photoshop auto-saves the documents you are working on to a special location using the PSD file format (this is so that everything you might add to a file is always included when auto-saving). Should you suffer a crash, the next time you open Photoshop you'll be given the opportunity to rescue any lost work. Also included here is an 'Automatically Save Recovery Information' option, where you can specify how regularly you would like Photoshop to update the recovery file.

Camera Raw preferences

If you click on the Camera Raw Preferences... button in the File Handling this will open the dialog shown in Figure 2.15. At the bottom are the JPEG and TIFF handling preferences where you have three options with which to decide how JPEG and TIFF images should be opened. The background story to all this is that Photoshop CS3 allowed for the first time for JPEG and TIFF images to open via Camera Raw, as if they were raw files. A number of people had misgivings about this, partly because of the potential confusion it might cause, but also because of the way it was implemented in Photoshop CS3. For example, you had the Photoshop File Handling preferences doing one thing plus another setting in the Bridge preferences and there was no simple way to summarize how these should be configured in order to get JPEG or TIFF images to open up via Camera Raw the way you expected. In fact, even fellow Photoshop experts were just as confused as everyone else as to how to manage the preference settings in these two different locations. To be honest, it was a bit of a mess, but things have been improved somewhat since then.

The Camera Raw preferences options are now fairly easy to understand and predictable in their behavior. If 'Disable JPEG (or TIFF) support' is selected this safely takes you back to the way things were before, where all JPEG or TIFF files open in Photoshop directly. If 'Automatically open all supported JPEGs (or TIFFs)' is selected, this causes all supported JPEGs (or TIFFs) to always open via Camera Raw. However, if 'Automatically open JPEGs (or TIFFs) with settings' is selected, Photoshop only opens JPEG or TIFF images via Camera Raw *if* they have previously been edited via Camera Raw. When this option is selected you

Version Cue Server and Adobe Drive

Adobe Version Cue® is a workgroup file management option that is included with the Creative Suite. Version Cue caters for those working in a networked environment, where two or more operators have shared network access to files that they will be working on using different programs within the Creative Suite. When a user 'checks out' a file, only he or she can edit it. The other users who have shared access to the files will only be able to make edit changes after the file has been checked back in. This precautionary file management system means that other users cannot overwrite a file while it is being edited. Version Cue now consists of two elements: the Version Cue Server and Adobe Drive. The Version Cue Server can be installed locally or on a dedicated computer and used to host Version Cue projects. Adobe Drive connects to the Version Cue servers, where the connected server appears as a hard drive in the Finder/Explorer as well as in the Open and Save As... dialog boxes.

Opening JPEGs in Camera Raw

So why should you want to open JPEGs (or TIFFs for that matter) in Camera Raw? This is useful if you shoot in JPEG mode and wish to use Camera Raw to process the JPEG masters (as you would a raw capture image) without actually editing the master files. This is because Camera Raw records all the edits as separate instructions. The same argument applies to opening TIFF files via Camera Raw, but the important thing to note here is that Camera Raw can only open flattened TIFFs and cannot open TIFFs that contain saved layers. The main reason why it might be useful to use Camera Raw to open a TIFF image is if you want to process TIFF scan images via Camera Raw to take advantage of things like the capture sharpening controls in the Detail panel section.

have the option in Bridge to use a double-click to open a JPEG directly into Photoshop, or use ⌘ R ctrl R to force JPEGs to open via Camera Raw. Note that when you edit a JPEG or TIFF in Camera Raw in this way, the next time you use a double-click to open, the file will now default to opening via Camera Raw.

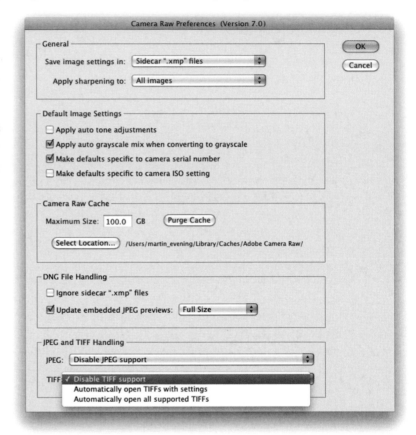

Figure 2.15 This shows the Camera Raw preferences dialog with the JPEG and TIFF handling options at the bottom.

Back in the main Photoshop File Handling preferences dialog, the 'Prefer Adobe Camera Raw for Supported Raw Files option' always launches Adobe Camera Raw as your favored raw processor when opening a proprietary raw file. Some cameras may embed an sRGB profile tag in the EXIF metadata of a JPEG capture file (where the profile used isn't a correct sRGB profile

anyway). If you check the 'Ignore EXIF Profile Tag' option, Photoshop ignores this particular part of the metadata and reads from the (correct) embedded profile data instead. The 'Ignore Rotation Metadata' option allows you to ignore any rotation settings applied via Camera Raw and will open such files without any rotation.

TIFF and PSD options

A TIFF format file saved in Photoshop 6.0 or later can contain all types of Photoshop layer information and a flattened composite is always saved in a TIFF. If you then place a layered TIFF image in a page layout, only the flattened composite will be read by the program when the page is finally converted to print. Some people argue that there are specific instances where a layered TIFF might trip up a print production workflow, so it might be safer to never save layers in a TIFF, but you know, there are a large number of Photoshop users who successfully use layered TIFFs when saving master images. My advice is not to be put off including layers. When the 'Ask Before Saving Layered TIFF Files' option is checked, Photoshop presents you with an option to either flatten or preserve the layers when saving a layered image as a TIFF. If this is unchecked, then the layer information is saved regardless and you'll see no warning dialog.

However, standard Photoshop PSD files created in Photoshop CS6 are not going to be 100% compatible if they are likely to be read by someone who is using an earlier version of Photoshop and this has always been the case with each upgrade of the program. Setting the Maximize PSD and PSB Compatibility to 'Always' allows you to do the same thing as when saving a flattened composite with a TIFF. This option ensures that a flattened version of the image is always included with the saved Photoshop file and the safe option is to keep this checked. For example, if you include a Smart Object layer, the Photoshop file will not be interpreted correctly when read by Photoshop CS or earlier unless you maximize the compatibility of the saved PSD. In these circumstances if Photoshop is unable to interpret an image it will present an alert dialog. This will warn that certain elements cannot be read and offer the option to discard these and continue, or to read the composite image data. Discarding the unreadable data will allow another user to open your image, but when opened it

Layered files in a DTP layout

Adobe InDesign allows you to place Photoshop format (PSD) files in a page layout, but if you do so, the Maximize Backwards Compatibility option must be checked in the File Handling preferences (in order to generate a flattened composite). If you use layered TIFF, PSD (or Photoshop PDF) files in your page layout workflow, you can modify the layers in Photoshop and the page design image preview will immediately be updated. This way you don't run the risk of losing synchronization between the master image that is used to make the Photoshop edits and a flattened version of the same image that is used solely for placing in the layout. If you want to 'round trip' your images this way, TIFF is the more universally recognized file format. The downside is that you may end up with bloated files and these can significantly increase the file transmission times. It so happens that nearly all the image files used in the production of this book have been placed as layered TIFF RGB files, which allows me to edit them easily in Photoshop. Keeping the files as layered RGBs is perfect at the text editing stage, but the final TIFF files that are used to go to press are all flattened CMYK TIFFs.

will be missing all the elements you added and most likely look very different from the file you intended that person to receive. If on the other hand they click the 'Read Composite Data' button and a composite was saved, the image will open using a flattened composite layer which looks the same as the image you created and saved. If no composite was created, they will just see a white picture and a multi-language message saying that no composite data was available.

Maximizing PSD compatibility lets images load quicker in Bridge and another crucial factor is that Lightroom is only able to read layered PSD files that have this option turned on. If there is no saved composite, Lightroom won't be able to import it.

If you set the preference here to 'Ask when saving', Photoshop will display a "Don't show this message again" message in the Maximize Compatibility warning dialog, which will appear after you choose to save an image using the PSD file format (See Figure 2.16). If the Maximize Compatibility option is checked, the default from now on will be to 'Always' maximize compatibility. If the option is unchecked, it will be set to 'Never' from now on. Lastly, you can choose to 'Disable Compression of PSD and PSB files'. These file formats normally include a lossless form of compression which helps keep the saved file size down. Disabling this won't improve the image quality, but may reduce the time it takes to save and will only affect 16-bit or 32-bit images. Having said that, efforts have been made in CS6 to optimize the read/write times for PSD and PSB files.

Figure 2.16 The Photoshop Format Options dialog.

Recent File list

The Recent File list refers to the number of image document locations that are remembered in the Photoshop File ⇨ Open Recent submenu. You might want to set this to the maximum limit allowed which is 30.

Performance preferences

Improvements have been made to the multi-threading in Photoshop CS6. This has resulted in better performance when carrying out the following: Warp, Puppet Warp, Liquify, Crop, Adaptive Wide angle corrections and painting. The Performance preferences section (Figure 2.17) lets you configure all the things that influence how efficiently Photoshop is able to run on your computer. The memory usage can be set using a sliding percentage scale and you will notice how Photoshop provides a hint as to what the ideal range should be for your particular computer. The History & Cache section now includes a Cache Tile Size option and buttons to help you configure the ideal settings here. In the Scratch Disks section you can drag to rearrange the currently available disk volumes in order of priority and lastly, the Graphics Processor Settings allow you to enable the graphics processor if your video card allows it.

Restart to activate preferences

Some Photoshop preferences only take effect after you quit and restart the program. For example, the Scratch Disk preference settings in the Performance preferences (see Figure 2.17) only come into effect after a restart, while the Graphics Processor settings only come into effect after you open or create a new window in Photoshop.

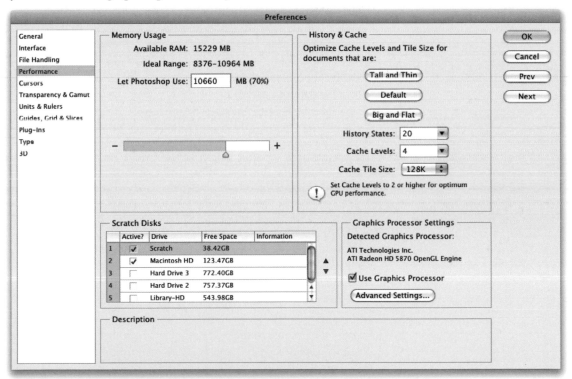

Figure 2.17 The Performance preferences, where you can configure the Memory Usage, History, Cache, Scratch Disks and Graphic Processor settings. Note that in the Scratch Disks section you can check which volumes to use as scratch disks. Highlight a particular disk, then use the arrows to move it up or down the list; tick it to make it active.

Speed and efficiency test

To help evaluate the performance efficiency of your computer setup, here is a really useful weblink to a site hosted by a company called Retouchartists.com: retouchartists.com/pages/speedtest.html. From there you can download a test file which contains a sample image and a Photoshop action that was created by Alex Godden. All you have to do is time how long it takes for the action to complete to gauge and compare how fast your computer is running. You can then compare your speed test results with those of other Photoshop users.

Figure 2.18 You can monitor how efficiently Photoshop is running by getting the Info panel options to display an Efficiency readout. If the efficiency reading drops below 100% this means that Photoshop is having to rely on the designated scratch disk as a virtual memory source.

Memory usage

The amount of RAM memory you have installed determines how efficiently you can work in Photoshop. Each time you launch Photoshop a certain amount of RAM memory is set aside for use by the program. How much depends on the amount that is set in the Memory Usage section, expressed as a percentage of the total amount of RAM that is available for Photoshop to use. The figure you see in the Memory Usage section is just the RAM that's reserved for Photoshop (although the RAM you set aside for Photoshop can be shared by other applications when it is not actively being used by Photoshop). Adobe recommend that you allocate a minimum of 1 GB RAM memory, which means that if you allow an additional 200 MB of RAM for the operating system, you will need to have at least 1.5 GB of RAM installed. If you also take into account the requirements of other programs and the likelihood that newer operating systems may need even more memory, it is safer to suggest you actually need a minimum of 2 GB RAM memory in total. Don't forget that you will also need to allow some RAM memory to run Adobe Bridge at the same time as Photoshop. In any case, most computers sold these days come with at least 4 GB of RAM.

The Memory Usage section therefore provides a guide for the ideal RAM setting for your computer and indicates what the ideal range should be. On a Windows system the default setting is 50% of the total available RAM and on a Mac it is 70% (since Photoshop CS5 the figure shown here is now more accurate). Note that if the memory is set too high Photoshop may end up competing with the operating system for memory and this can slow performance, although as I mentioned earlier, the memory assigned to Photoshop is freed up whenever Photoshop is not running. You can always try allocating 5% above the recommended upper limit, relaunch Photoshop and closely observe the efficiency status bar or Info panel Efficiency readout (Figure 2.18). Anything less than 100% indicates that Photoshop is running short of physical memory and having to make use of the scratch disk space. If you allocate too high a percentage, this can compromise Photoshop's efficiency. So the trick is to find the optimum percentage before you see a drop in performance. You may find the speed test described in the sidebar is a useful tool for gauging Photoshop performance.

32-bit and 64-bit RAM limits

The amount of RAM that is available to Photoshop is obviously dependent on the total amount of RAM memory that's installed on your computer. If you run Photoshop on a Windows computer with a 32-bit operating system that has 4 GB or more of RAM installed, a maximum of 3 GB of RAM can be allocated to Photoshop. Even if you are hit by the 4 GB RAM limit on a 32-bit system and you have more than 4 GB memory installed, the RAM above 4 GB can also be used by the operating system as a cache for the Photoshop scratch data. So although you can't allocate this extra memory directly, installing extra memory can still help boost Photoshop's performance on a 32-bit system.

Providing you have the latest 64-bit enabled hardware and a 64-bit computer operating system, you can install or run Photoshop in 64-bit mode. In fact, Macintosh users can now only install a 64-bit program and must therefore be using a 64-bit enabled Macintosh to run Photoshop CS6. The main advantage 64-bit brings is increased RAM memory access beyond the 4 GB physical limit. In terms of speed you won't necessarily find a 64-bit version of Photoshop to be that much faster than a 32-bit version, except for when you are working with very large files or carrying out memory-intensive operations.

History & Cache

In the History & Cache section the default number of History States is 20. You can set this to any number you like from 1–1000, but remember that the number of histories you choose does have a bearing on the scratch disk usage.

The Cache Level settings affect the speed of the screen redraws. Whenever you are working with a large image, Photoshop uses a pyramid type structure of lower resolution cached versions of the full resolution picture. Each cached image is a quarter scale version of the previous cache level and is temporarily stored in memory to provide speedier screen previews. Basically, if you are viewing a large image on screen in 'Fit to screen' display mode, Photoshop uses a cache level that is closest to the fit to screen resolution to provide a screen refresh view of any edit changes you make at this viewing scale. The cached screen previews can therefore provide you with faster screen redraws and larger images can benefit from using a higher cache level, since a higher setting

RAM memory upgrades

Most PCs and Macs use DIMMs (Dual In-line Memory Modules). The specific RAM memory chips may vary for each type of computer, so check carefully with the vendor that you are buying the right type for your particular machine. RAM memory used to cost a small fortune, but these days the price of RAM is almost inconsequential. If you have four RAM slots on your machine, you should easily be able to install 4 ×1 GB RAM or 4 × 2 GB RAM memory chips, which will give you 4 or 8 GB of installed RAM. A good suggestion is to install an absolute minimum of 1 GB of RAM per processing core on your computer, while the ideal balance is more like 2 GB of RAM per core. If you aim for 4 GB of RAM per core, you will see significant benefits with certain memory-intensive filter operations. For all other types of operations the speed benefits are not quite so dramatic.

Assigning scratch disks at startup

If you hold down the ⌘ ⌥ ctrl alt keys as you launch Photoshop, this will pop the Disk options on the screen and allow you to add or change the Scratch Disk settings.

Cache tile size and batch processes

There are certain types of Photoshop operations (such as a Radial Blur filter) that can make heavy demands on the computer hardware, utlilizing nearly all of your processors. If you raise the cache tile size in the Performance preferences to 1024 or 1028K this means the data to be processed is divided into bigger chunks and this in turn can make a big improvement to batch processing times. The optimum choice of tile size here will depend on whether you are using an Intel or AMD processor.

provides faster screen redraws, but at the expense of sacrificing the quality of the preview. This is because a lower resolution cache preview is not as accurate as when viewing an image at an 'actual pixels' view.

The optimization buttons can help you set the Cache Levels to an appropriate value. If you mostly work on small images such as Web design layouts, which are small in pixel dimension size, but may contain lots of complex layers, you'll gain better performance by clicking the 'Tall and Thin' button to set the Cache Levels to 2. If you mostly work with large images, but not quite so many layers, you can click on the 'Big and Flat' button to set the Cache Levels to 5, although you may wish to override this and set the cache levels even higher than this.

The Cache Tile Size can be adjusted according to what is the most appropriate setting for the type of work you do. There used to be an optional Bigger Tiles plug-in that you could install in order to boost Photoshop performance when editing large images. This has now been done away with and the tiling options are now incorporated into the Performance preferences. The Cache Tile Size can be set anywhere from 128K–1024K, and tests suggest the optimum settings to choose from are 128K/1024K for the newer Intel processors and 132K/1028K for AMD processors. For image editing work with large photo-sized documents where throughput, i.e. image size, is more of a consideration, it is better to choose a larger Cache Tile Size here.

Scratch disks

Photoshop can utilize the free hard disk space that's allocated in the Scratch Disks section as an extension of RAM memory. Photoshop always makes the most efficient use of the real RAM memory and tries to keep as much RAM as possible free for memory-intensive calculations. Low-level data like the 'last saved' version of the image is stored in the scratch disk memory giving priority to the current version and last undo versions being held in RAM. Normally, Photoshop uses all the available free RAM as buffer memory in which to perform real-time calculations and mirrors the RAM memory contents on the scratch disk. Photoshop does this whenever there is a convenient opportunity to do so. For example, after you open a new image you may notice some disk activity as Photoshop writes from the RAM memory buffer

to the scratch disk. Photoshop then continually looks for ways to economize the use of RAM memory, writing to the hard disk in the background whenever there are periods of inactivity. Scratch disk data is also compressed when it is not in use (unless an optional plug-in extension that prevents this has been loaded at startup).

When Photoshop exhausts its reserves of RAM memory, it is forced to use the extra space on the scratch disk as a source of virtual memory and this is where you will start to see a major slowdown in efficiency. When the Efficiency indicator (Figure 2.18) drops below 100% this means that the RAM buffer is full and Photoshop is now relying exclusively on the hard disk scratch disk space as a memory reserve. This is because the Photoshop calculations are limited to the read/write speeds of the primary scratch disk, followed by the secondary disk, and so on. Should you experience a temporary slowdown in performance you might want to purge Photoshop of any excess data that's temporarily held in memory. To do this, choose Edit ⇨ Purge and select Undo, Clipboard, Histories or All.

The primary scratch disk should ideally be one that is separate to the disk that's running the operating system and Photoshop. It is no good partitioning the main disk volume and designating an empty partition as the scratch disk, because the disk drive head will simply be switching back and forth between different sectors of the same disk as it tries to do the job of running the computer system and provide scratch disk space. For optimal image editing, you ideally want the scratch disk to be a fast, separate disk volume with a minimum of 20–40 GB of free space and as free as possible of any disk fragmentation. Having said that, with the latest SSD drives there are no moving parts. They are also very fast compared with normal hard drives and it is possible to partition a main SSD hard drive, allocating a portion of this as a scratch disk. Note also the instructions in Figure 2.19 that describe how to alter the scratch disk settings during startup.

Scratch disk performance

With all this reliance on the scratch disk (or multiple scratch disks) to read/write data from the RAM memory buffer, the hard disk performance of the scratch disk plays an important role in maintaining Photoshop efficiency. There is provision in Photoshop for as many as four scratch disks. Each individual scratch file

Scratch disk checks

When you launch Photoshop it checks to see how much hard disk space is free for scratch disk usage and if for any reason you have less scratch disk space than RAM memory space, the RAM memory will be restricted by the amount of scratch disk space that is available.

Move don't copy

To copy selections and layers between documents, use the drag and drop method with the move tool. This saves on memory usage and also preserves the current clipboard contents.

Scratch disk usage and history

The scratch disk usage will vary according to how many history states you have set in the History and Cache section and also how you use Photoshop. Generally speaking, Photoshop stores a version of each history state, but it does not always store a complete version of the image for each history state. As was explained in Chapter 1, the History feature only needs to save the changes made in each image tile. So if you carry out a series of brush strokes, the history only stores changes made to the altered image tiles. For this reason, although the scratch disk usage increases as you add more history steps, in practice the usage does not increase in such large chunks, unless you were to perform a series of global filter changes.

Figure 2.19 If you hold down the ⌘ ⌥ ctrl alt keys during the startup cycle as you launch Photoshop, this reveals the Scratch Disk Preferences dialog, allowing you to configure the Scratch Disk options during startup.

created by Photoshop can be a maximum of 2 GB and Photoshop can keep writing scratch files to a scratch disk volume until it becomes full. When the primary scratch disk runs out of room to accommodate all the scratch files during a Photoshop session, it then starts writing scratch files to the secondary scratch disk, and so on. This makes for more efficient and faster disk usage. Let's now look at the important factors that affect the speed of the scratch disk.

Interface connection

Most modern Macs and PCs have IDE, ATA or SATA drives as standard. A fast internal hard disk is adequate for getting started, but for better performance, you should really install a second internal or external hard drive and have this dedicated as the primary scratch disk (make this the number one scratch disk in the Performance preferences). Your computer will most likely have the choice of a USB or FireWire connector for linking external devices. USB 2 offers a much faster connection speed than the old USB 1, while FireWire (IEEE 1394) is regarded as being faster still. With USB or Firewire you can hot swap a drive between one computer and another. This is particularly useful when you wish to shuttle very large files around quickly. With the advent of FireWire 800 we are now seeing an appreciable improvement in data transfer speeds. And as I mentioned at the beginning of this chapter, the latest Macintosh computers now feature a Thunderbolt interface capable of transfer rates up to 500 Gbits/s. Note though that it is the data transfer and not the data access time that is the measure of disk speed to look out for.

Hard drive speed

Most desktop computers use internal drives which run at 7200 rpm and you can easily find spare internal drives that run at this speed or faster. For example, there are drives that even run at 10,000 or 15,000 rpm, but these are hard to come by and are expensive, plus they are more limited in disk capacity. Laptop computers usually have slower hard drives fitted as standard (typically 5400 rpm). It may therefore be worth checking if you can select a faster speed hard drive as a build-to-order option. External SATA drives (eSATA) are now regarded as faster than Firewire 800 and are available, sometimes as multiport drives like the LaCie d2 series. In theory these are better. And of course, there are now the SSD drives, which offer very fast read/write speeds.

RAID setups

RAID stands for Redundant Array of Independent Disks, and a simple way to explain RAID is that it allows you to treat multiple drives as a single drive volume to provide either increased data integrity, capacity, transfer rates or fault-tolerance compared with a single volume. How it does this depends on the RAID level you choose. You need a minimum of two disks to configure a RAID system and most off-the-shelf RAID solutions are sold as a bay dock that can accommodate two or more drives with a built-in RAID controller. A RAID disk can be connected via internal SCSI or using an external FireWire (IEEE 1394) 400/800 connection.

RAID 0 (striping)

A RAID 0 setup is an ideal choice for use as a Photoshop scratch disk. With a RAID 0 setup, two or more drives are striped together to create a single large volume drive. For example, if two 400 GB drives are striped using a RAID 0 setup you will end up with a single 800 MB volume. RAID 0 is useful where you require fast hard drive access speeds, because the drive access speed increases proportionally to the number of drives that are added. So, if you have a 2 x 400 GB drive RAID 0 system, the hard drive access speed should be two times that of a single 800 GB drive. A RAID 0 setup can offer faster speeds, but will be less reliable, since if one drive fails, all the stored data is lost on the combined volume.

RAID 1 (mirroring)

A RAID 1 setup stores duplicate data across two drives. This means that if you have, say, two 400 GB drives configured in a RAID 1 setup, the data on one drive is mirrored on the other and the total drive capacity will be equal to that of a single drive (in this case, 400 GB). RAID 1 systems are used as a way to protect against sudden drive failure since if one drive fails, a mirror copy of that data can immediately be accessed from the other drive and if you replace the defunct drive with a new one, the RAID 1 system rebuilds a copy of the data on the new drive. A RAID 1 setup offers greater security but the downside is that RAID 1 read/write speeds are slower. This is because the RAID 1 system has to constantly back up the data between one drive and the other.

It used to be the case that software-created RAIDs such as the one included with the Mac OS X Disk Utilities program were a lot slower than a dedicated system. True, the read/write speeds from a software RAID will still be somewhat slower than a true dedicated RAID system since a software RAID will be stealing some of your computer processor cycles, but these days the speed loss is not as bad as it used to be. For example, a software-driven internal striped RAID 0 can bring about a 45% increase in disk access speed. Overall I recommend that if you do choose to go down the internal RAID route, you use a dedicated device with a RAID controller.

Figure 2.20 A RAID system drive setup contains two or more drives linked together that can provide either faster disk access or more secure data backup.

Internal RAID

You can fit an internal RAID system with a do-it-yourself kit consisting of two internally mounted drives and a RAID controller card. This should not be too challenging to install yourself, but if you are in any doubt about whether you are capable of doing this then you should get a qualified computer specialist to install such a system in your computer. The advantage of an internal RAID is that it is always there whenever you turn the computer on and is an economical solution compared with buying an external RAID drive setup. Most PC tower computer systems should have plenty of free hard drive bays, which will make it fairly easy for you to install internal RAID. An internal RAID setup will definitely speed up the time it takes Photoshop to read and write data to the scratch disk. However, if you have more hard drives running simultaneously this will mean more power consumption, which in turn can generate extra heat and possibly more noise too. Be warned that this heat may cause problems for the cooling system in your computer and put extra strain on the internal power supply unit.

External RAID

External RAID hard drive units (Figure 2.20) are not overly expensive and you can easily buy a ready assembled bay dock with a couple of drives and a built-in RAID controller that can be configured for RAID 0. The speed will be governed not just by the number of drives making up the RAID but also by the speed of the cable connection. Most RAID systems these days will connect to the computer via a FireWire 400/800 or SATA connection, which may again require a special card in order to connect to the computer (for now). At this time of writing it seems that computers in the future are more likely to support SATA as standard. My own personal experience has led me to be rather wary of relying on SATA. I have had two SATA RAID units fail or have problems maintaining a connection to the computer. For this reason I have chosen to stick with FireWire 800, and even this isn't completely reliable on the Mac OS X system.

Graphics Processor settings

OpenGL enabled video cards are able to offload processor-intensive activity from the CPU to the video card's GPU (Graphics Processing Unit). An OpenGL card also uses its own onboard RAM to lessen the burden on the CPU and this can result in

faster overall video performance. Photoshop is able to detect the graphics card used by your computer and whether it has a built-in Graphics Processor Unit (GPU) capability. If so, you can then check the 'Use Graphics Processor' option to make full use of the graphics processor memory on the card. As was explained earlier, in Chapter 1, this preference setting affects images opened in Photoshop on a per-window document basis.

The main advantages of enabling the graphics processor are: smooth views when using odd number viewing percentages, image rotation, flick panning, smooth animated zooms, the bird's-eye view zoom-out feature, Puppet Warp, applying transforms plus a pixel grid display at view magnifications greater than 500%. In Photoshop CS6 16-bit and 32-bit images should also redraw faster when viewed at a 50% magnification or lower. And, where cards are OpenCL enabled, this can improve performance when using the Blur Tools filters in Photoshop CS6. Note, the advanced graphic processing is only available on later operating systems (which are basically the ones that are required anyway to run Photoshop CS6).

If you click on the Advanced Settings... button this opens the Advanced Graphics Processor Settings dialog shown in Figure 2.21, where you will want to check 'Use Graphics Processor to Accelerate Computation' option. There are three drawing mode levels: Basic, Normal and Advanced. The Advanced option aims to give you the maximum benefit from the graphics processing, but if the screen redraws appear to work less smoothly than desired you can select the Normal or Basic modes instead. Checking the Anti-alias Guides and Paths option can help improve the visibility of pen paths and guides.

Cache pyramid structure

If you have the Use Graphics Processor option switched off, or your video card does not support OpenGL, you may sometimes notice how layered Photoshop images are not always displayed with complete accuracy at anything other than the 100% magnification. For example, if you have added a pixel layer that has a sharp edge, you might see a line appear along the edges when it is viewed at smaller viewing percentages. This is simply the image cache at work and nothing to worry about – it is speeding up the display preview at the expense of accuracy. If you have to work on an image (without OpenGL) at a less than 100% magnification, then do make sure the magnification is a wholly divisible number of 100%. In other words, it is better to work at 50%, 25% or 12.5% magnification, rather than at 66% or 33%. Note also that the number of cache levels will affect the structure of a TIFF file when the 'Save Image Pyramid' option is selected (see Figure 1.96 on page 73).

Figure 2.21 The Advanced Graphics Processor Settings dialog. This offers three drawing mode levels: Basic, Normal and Advanced.

Figure 2.22 This is an example of the brush cursor using the Full Size Brush Tip mode with Show Crosshair in Brush Tip.

Cursors preferences

We now come to the Cursors preferences (Figure 2.23). The painting cursors can be displayed as a painting tool icon, a precise crosshair or with the default setting, which shows an outline of the brush shape at its 'most opaque' size in relation to the image magnification. When the Normal brush tip is selected, the brush cursor size represents the boundary of the brush shape up to where the brush opacity is 50% or denser in opacity. You can also choose to display a Full Size brush tip, indicating the entire outer edge reach of a soft edged brush. This represents the complete brush area size and it is debatable whether this improves the appearance of the painting cursors or not (see Figure 2.22). The 'Show Crosshair in Brush Tip' option allows you to display a crosshair inside the brush size cursor. In the Other Cursors section, the Standard option represents all the other tools using a standard tool icon. I suggest you change this to the Precise setting, because this will make it easier for you to target the placement of certain tools such as the crop tool or clone stamp.

Figure 2.23 The Display & Cursors preferences.

The *Caps Lock* key can be used to toggle the cursor display. When the Standard paint cursor is selected, the *Caps Lock* toggles between a Standard and Precise cursor view. When the Precise or a brush size paint cursor option is selected, the *Caps Lock* toggles between a Precise and a brush size cursor view. When the Standard cursor mode is selected for all other cursors, the *Caps Lock* toggles between the Standard and Precise cursor views.

Transparency & Gamut

The Transparency & Gamut settings (Figure 2.24) determine how the transparent areas in an image are represented on the screen. If a layer contains transparency and is viewed on its own with the background layer visibility switched off, the transparent areas are normally shown as a checkerboard pattern. The display preferences let you decide how the checkerboard grid size and colors are displayed. If you go to the preferences shown here you can select different grid sizes and colors, but you can also select None. When this is selected the transparent areas are displayed as solid white.

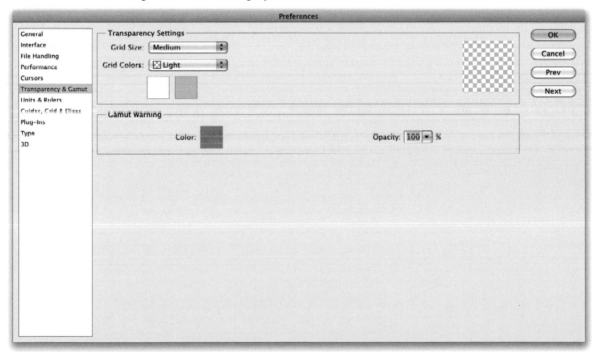

Figure 2.24 The Transparency display settings are editable. You have a choice of Transparency display settings: None, Small, Medium or Large grid pattern, and a choice of different grid colors.

Figure 2.25 This shows the Photoshop Color Picker with a gamut warning applied.

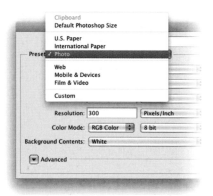

Figure 2.26 The New Document Preset Resolution settings will have a bearing on the resolution used when selecting a new document preset from the File ⇨ New Document dialog. In this example, if I were to select the U.S. Paper, International Paper or Photo preset, the file resolution would be set to whatever the Print Resolution is in the Units & Rulers preferences.

Color Picker gamut warning

The gamut warning can be switched on via the View menu (⌘ Shift Y ctrl Shift Y) and uses whatever color has been set in the Transparency & Gamut preferences. The gamut warning alerts you to any colors that will be out of gamut after a conversion is made from, say, RGB to CMYK, or whichever color space is currently loaded in the View ⇨ Proof Setup menu. The default overlay color is a neutral gray at 100% opacity, but I suggest reducing the opacity to make the gamut warning appear as a semi-transparent overlay. So, if you are working on an image in RGB mode and you choose View ⇨ Gamut Warning, Photoshop highlights these out-of-gamut colors with a color overlay. The gamut warning is, in my view, a rather crude instrument for determining whether colors are in gamut or not, since a color that is only slightly out of gamut will be highlighted as strongly as a color that is hugely out of gamut. A good quality graphics display coupled with a custom proof setup view mode is a much more reliable guide. Note that if you have the Photoshop Color Picker dialog open, you can choose View ⇨ Gamut Warning to apply a gamut warning overlay to the Color Picker colors (see Figure 2.25).

Units & Rulers

You can use the Units & Rulers preferences section to set the Ruler measurements (inches or centimeters, etc.) and the units used. Note that as well as using the preferences options shown here, the measurement units can also be changed via the Info panel submenu or by *ctrl* right mouse-clicking on a ruler to open the contextual menu (you can also double-click the ruler bar as a shortcut for opening the preference window shown in Figure 2.27).

The New Document Preset Resolution options allow you to decide what the default pixel resolution should be for print output or screen display work whenever you select a preset from the File ⇨ New Document dialog (Figure 2.26). The Screen Resolution has typically always been 72 ppi. But there is no real significance to the resolution that is set here if an image is only destined to appear in a Web page design. Web browser programs are only concerned with the physical number of pixels an image has and the resolution setting actually has no relevance. The Print Resolution setting is more useful as this does have an important bearing on what size an image will eventually print.

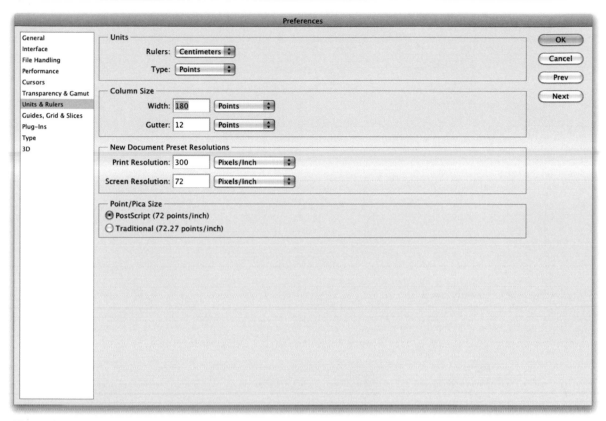

Figure 2.27 The ruler units can be set in pixels, inches, cm, mm, points, picas or as a percentage. The percentage setting is ideal for recording actions that you wish to apply proportionally at any image size.

Guides, Grid & Slices

The Guides, Grid & Slices preferences (Figure 2.28) let you decide the colors to use for the Guides, Smart Guides, Grid and Slices. Both Grid and Guides can be displayed as solid or dashed lines, with the added option of dotted lines for the Grid. The number of Grid subdivisions can be adjusted to suit whatever project you are working on and the Slice options include a Line Color style and whether the Slice Numbers are displayed or not.

Figure 2.29 shows an example of the selection edges made visible from the View ⇨ Show menu, as well as a smart guide highlighting the alignment of a layer.

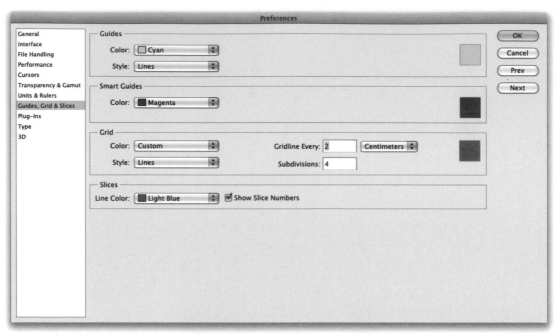

Figure 2.28 The Guides, Grid & Slices preferences.

Figure 2.29 The View ⇨ Show menu options include Layer Edges. When this is selected the currently selected layer or layers will be indicated with a rectangular color edge border. The Smart Guides option is useful as a visual aid for aligning layer elements. The Smart Guides (shown here in pink) will flash on and off to indicate when a layer element is aligned to other layers in the image.

Plug-ins

The Plug-ins folder will automatically be recognized by Photoshop so long as it resides in the same application folder. Figure 2.30 shows how you can also choose an Additional Plug-ins Folder that may be located in another application folder, such as Adobe Bridge, so that these plug-ins can in effect be shared with Photoshop. To do this click on the Choose… button to locate the additional plug-ins folder.

In the Filters section the 'Show all Filter Gallery groups and names' option is left switched off. When checked, this allows you to see the full range of non-GPU effects filters. I suspect most photographers will be happy to leave this option disabled.

Photoshop can now install what are known as Extensions panels (such as the Configurator panel described on page 27). If the 'Load Extensions Panels' option is checked this will load all the installed panels on start-up. Furthermore, if the 'Allow Extensions to Connect to the Internet' option is checked, this allows such panels to connect over the Internet, allowing them to access new content plus any important panel updates. This is obviously essential for those Extensions panels that need to be connected to the Internet in order for them to work.

Plug-ins folder location

The location of the standard Plug-ins folder, where the standard set of shipping plug-ins are installed, has been moved. On Windows, the Plug-ins folder is now located in the Program Files\Adobe\ Adobe Photoshop CS6\Required. On Mac, it is located in the Applications/Adobe Photoshop CS6/Required directory. There is still a Plug-ins directory inside the Adobe Photoshop CS6 program directory. This is now used for placing third-party plug-ins, extension Panels, or any optional plug-ins that have been distributed outside the full installer. This means that you can now more easily disable loading all the plug-ins that are in the Plug-ins and Additional Plug-ins directories on a per session basis. To do this hold down the *Shift* key at launch. This will show a message asking if you would like to skip loading optional and third-party plug-ins.

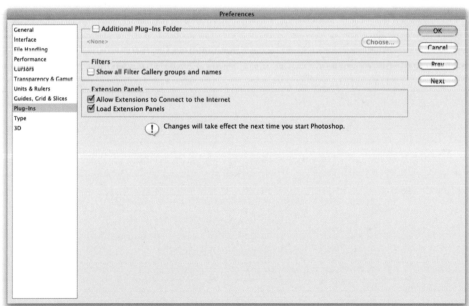

Figure 2.30 The Plug-ins preferences.

Figure 2.31 Photoshop presents the font lists using a WYSIWYG menu listing.

Type preferences

Lastly, we come to the Type preferences (Figure 2.32), which are mainly of importance to graphics users rather than photographers. We could all do with smart quotes I guess, but the smart quotes referred to here is a preference for whether the text tool uses vertical quotation marks or rounded ones that are inverted at the beginning and end of a sentence. The 'Enable Missing Glyph Protection' option will switch on automatic font substitution for any missing glyph fonts (those swirly graphic font characters). The 'Show Font Names in English' option will be of more significance to non-English language users, as it allows them the option to display the font names in English, as an alternative to their own native language.

Figure 2.32 The Type preferences.

Type tool initialization

When you select the type tool for the first time during a Photoshop session, there will be a brief pause in which Photoshop initializes the type tool engine. If the type tool was selected when you last closed Photoshop, the initialization process will happen during the start-up cycle.

Ensuring the preferences are saved

Once you have configured your preferences and got everything set up just the way you want, it is a good idea to Quit and restart Photoshop. This then forces Photoshop to save these preferences as it updates the preference file.

Chapter 3

Camera Raw Image Processing

n the 15 or so years that I have been writing this series of books, the photography industry has changed out of all recognition. When I first began writing about Photoshop, most photographers were shooting with film cameras, getting their pictures scanned, and only a few professionals were shooting with high-end digital cameras. In the last decade the number of photographers who shoot digitally has grown to the point where it is the photographers who shoot film who are now in the minority. I therefore reckon that the vast majority of photographers reading this book will be working with pictures that have been shot using a digital SLR or high-end digital camera that is capable of capturing files in a raw format that can be read by Adobe Camera Raw in Photoshop. This is why I have devoted a whole chapter (and more) to discussing Camera Raw image processing.

From light to digital

The CCD or CMOS chip in your camera converts the light hitting the sensor into a digital image. In order to digitize the information, the signal must be processed through an analog-to-digital converter (ADC). The ADC measures the amount of light hitting the sensor at each photosite and converts the analog signal into a binary form. At this point, the raw data simply consists of image brightness information coming from the camera sensor. The raw data must somehow be converted and it is here that the raw conversion method used can make a huge difference to the quality of the final image output. Digital cameras have an on-board microprocessor that is able to convert the raw data into a readable image file, which in most cases will be in a JPEG file format. The quality of a digital image is therefore primarily dependent on the lens optics used to take the photograph, the recording capabilities of the CCD or CMOS chip and the analog-to-digital converter, but it is the raw conversion process that matters most. If you instead choose to process the raw data on your computer, you have much greater control than is the case if you had let your camera automatically guess the best raw conversion settings to use.

Camera Raw advantages

Although Camera Raw started out as an image processor exclusively for raw files, it has, since version 4.0, also been capable of processing any RGB image that is in a JPEG or TIFF file format. This means that you can use Camera Raw to process any image that has been captured by a digital camera, or any photograph that has been scanned by a film scanner and saved as an RGB TIFF or JPEG. Camera Raw allows you to work non-destructively and anything you do to process an image in Camera Raw is saved as an instruction edit and the pixels in the original file are never altered. In this respect, Camera Raw treats your master files as if they were your negatives and you can use Camera Raw to process an image in any way that you like without ever altering the original.

The new Camera Raw workflow

When Camera Raw first came out it was regarded as a convenient tool for processing raw format images, without having to leave Photoshop. The early versions of Camera Raw had controls for applying basic tone and color adjustments, but Camera Raw could never, on its own, match the sophistication of Photoshop. Because of this, photographers would typically follow the Camera Raw workflow steps described in Figure 3.1. They would use Camera Raw to do all the 'heavy lifting' work such as adjusting the white point, exposure and contrast and from there output the picture to Photoshop, where they would carry out the remaining image editing.

Camera Raw 7 in Photoshop CS6 offers far more extensive image editing capabilities and it is now possible to replicate in Camera Raw some of the things which previously could only have been done in Photoshop. The net result of all this is that you can (and should) use Camera Raw as your first port of call when preparing any photographic image for editing in Photoshop. Let's be clear, Camera Raw does not replace Photoshop. It simply enhances the workflow and offers a better set of tools to work with in the early stages of an image editing workflow. Add to this what I mentioned earlier about being able to work with JPEG and TIFF images, and you can see that Camera Raw is a logical place for any image to begin its journey through Photoshop.

If you look at the suggested workflow listed in Figure 3.2 you will see that Camera Raw 7 now has everything you need to

optimize and enhance a photograph. It can also be argued that if you use Camera Raw to edit your photographs, this replaces the need for Photoshop adjustments such as Levels, Curves and Hue/ Saturation. To some extent this is true, but as you will read later in Chapter 5, these Photoshop adjustment tools are still relevant for fine-tuning the images that have been processed first in Camera Raw, especially when you want to edit your photos directly or apply certain kinds of image effects that require the use of adjustment layers or additional image layers.

⇨ Set the white point
⇨ Apply a fine-tuned camera calibration adjustment
⇨ Set the highlight and shadow clipping points
⇨ Adjust the brightness and contrast
⇨ Adjust the color saturation
⇨ Compensate for chromatic aberrations and vignetting
⇨ Apply basic sharpening and noise reduction
⇨ Apply a crop
⇨ Open images in Photoshop for further image editing

Figure 3.1 Camera Raw 1 offered a limited but useful range of image adjustments, and this remained unchanged through to version 3.0 of Camera Raw.

⇨ Set the white point
⇨ Apply a Camera Profile camera calibration adjustment
⇨ Apply a Lens Profile calibration adjustment
 (correct for lens distortion chromatic aberrations and vignetting)
⇨ Set the overall Exposure brightness
⇨ Enhance the highlight detail using Highlights slider
⇨ Enhance the shadow detail using Shadows slider
⇨ Fine-tune the highlight and shadow clipping points
⇨ Adjust the midtone contrast (Clarity)
⇨ Fine-tune the Tone Curve contrast
⇨ Fine-tune the color saturation/vibrance plus HSL color
⇨ Retouch spots using the clone or heal brush
⇨ Make localized adjustments (i.e. adjustment brush, graduated filter)
⇨ Apply capture sharpening and noise reduction
⇨ Apply a crop and/or a rotation
⇨ Open images in Photoshop for further image editing

Figure 3.2 Camera Raw 7 has now extended the list of things that can be done to an image at the Camera Raw editing stage.

Camera Raw support
Camera Raw has kept pace with nearly all the latest raw camera formats in the compact range and digital SLR market, but only supports a few of the higher-end cameras such as the Hasselblad, Leaf, Leica and Phase One cameras. Camera Raw currently offers support for over 350 raw camera formats, including most of the leading models, and is updated regularly every three months or so. As I mentioned here, you can also use Camera Raw to open JPEG and TIFF files. It is an RGB editor, so is designed to edit in RGB. However, CMYK files can be opened via Camera Raw, but will be converted to RGB upon opening. For the full list, go to: www. adobe.com/products/photoshop/extend. html.

Camera Raw size limits

Camera Raw can now open images up to 65,000 pixels in any dimension up to 512 megapixels.

Figure 3.3 The camera's on-board processor is used to generate the low resolution JPEG preview image that appears in the LCD screen. The histogram is also based on this JPEG preview and therefore a poor indicator of the true exposure potential of a raw capture image.

Does the order matter?

When you edit an image in Camera Raw it does not matter which order you apply the adjustments in. The lists shown in Figures 3.1 and 3.2 are presented as just one possible Camera Raw workflow. So for example, you could refer to the list of steps in Figure 3.2 and start by applying the crop and work your way through the remainder of the list backwards. However, you are best advised to start with the major adjustments first, such as setting the white point and Exposure in the Basic panel before going on to fine-tune the image using the other controls.

Raw capture

If you are shooting with a professional digital back, digital SLR, or an advanced compact digital camera, you will almost certainly have the capability to shoot using the camera's raw format mode. The advantages of shooting raw as opposed to JPEG mode are not always well understood. If you shoot using JPEG, the files are compressed by varying amounts and this file compression enables you to fit more captures on to a single card. Some photographers assume that shooting in raw mode simply provides you with uncompressed images without JPEG artifacts, but there are other, more important reasons why capturing in raw mode is better than shooting with JPEG. The main benefit is the flexibility raw gives you. The raw file is like a digital negative, waiting to be interpreted any way you like. It does not matter about the color space or white balance setting that was used at the time of capture, since these can all be set later in the raw processing. You can also liken capturing in raw mode to shooting with negative film, since when you shoot raw you are recording a master file that contains all the color information that was captured at the time of shooting. To carry the analogy further, shooting in JPEG mode is like taking your film to a high street photo lab, throwing away the negatives and then making scans from the prints. If you shoot JPEGs, the camera is deciding automatically at the time of shooting how to set the white balance and tonal corrections, often clipping the highlights and shadows in the process. In fact, the camera histogram you see on the camera LCD is based on the JPEG interpretation capture data regardless of whether you are shooting in raw or JPEG mode (see Figure 3.3).

When shooting raw, all you need to consider is the ISO setting and camera exposure. But this advantage can also be seen by some to be its biggest drawback; since the Camera Raw stage adds to the overall image processing, this means more time has to be spent working on the images, plus there will be an increase in the file size of the raw captures and download times. For these reasons, news photographers and others may find that JPEG capture is preferable for the kind of work they do.

It's 'raw' not 'RAW'

This is a pedantic point, but raw is always spelt using lower case letters and never all capitals, which would suggest that 'raw' was some sort of acronym, like JPEG or TIFF, which it isn't.

JPEG capture

When you shoot in JPEG mode, your options are more limited since the camera's on-board computer makes its own automated decisions about how to optimize for tone, color, noise and sharpness. When you shoot using JPEG or TIFF, the camera is immediately discarding up to 88% of the image information that's been captured by the sensor. This is not as alarming as it sounds, because as you'll know from experience, you don't always get a bad photograph from a JPEG capture. But consider the alternative of what happens if you shoot using raw mode. The raw file is saved to the memory card without being altered by the camera. This allows you to work with all 100% of the image data that was captured by the sensor. If you choose to shoot in JPEG capture mode you have to make sure that the camera settings are absolutely correct for things like the white balance and exposure. There is some room for maneuver when editing JPEGs, but not as much as you get when editing raw files. In JPEG mode, your camera will be able to fit more captures onto a card, and this will depend obviously on the capture file size and compression settings used. However, it is worth noting that at the highest quality setting, JPEG capture files are sometimes not that much smaller than those stored using the native raw format. What you will find though is that the burst capture rate is higher when shooting in JPEG mode and for some photographers, such as those who cover sports events, speed is everything.

Editing JPEGs and TIFFs in Camera Raw

Not everyone is keen on the idea of using Camera Raw to open non-raw images. However, the Camera Raw processing tools are so powerful and intuitive to use that why shouldn't they be available to work on other types of images? The idea of applying further

Adobe Photoshop Lightroom

The Adobe Photoshop Lightroom program is designed as a raw processor and image management program for photographers. It uses the exact same Adobe Camera Raw color engine that is used in Photoshop, which means that raw files that have been adjusted in Lightroom can also be read and opened via Camera Raw in Photoshop or Bridge. Having said that, there are compatibility issues to be aware of whereby only the most recent version of Camera Raw will be able to fully interpret the image processing carried out in Lightroom and vice versa. Lightroom does have the advantage of offering a full range of workflow modules designed to let you edit and manage raw images all the way from the camera import stage through to Slideshow, Book, Print or Web output. There is no differentiation made between a raw or non-raw file, and with the latest Process 2012, the same default settings are applied when a photo is first imported. When you choose to open a Lightroom imported, non-raw file (a JPEG, TIFF or maximum compatibility PSD) into Photoshop, Lightroom gives you the option to apply or not apply Lightroom edited image adjustments.

Camera Raw processing may seem redundant in the case of JPEGs, but despite these concerns, Camera Raw does happen to be a good JPEG image editor. So from one point of view, Camera Raw can be seen as offering the best of all worlds, but it can also be seen as a major source of confusion (is it a raw editor or what?)

Perhaps the biggest problem so far has been the implementation rather than the principle of non-raw Camera Raw editing. Earlier in Chapter 2, I made the point that opening JPEGs and TIFFs via Camera Raw was made unnecessarily complex in Photoshop CS3, but following the changes made in Photoshop CS4, this issue has been mostly resolved. The Camera Raw file opening behavior for non-raw files is now much easier to configure and anticipate (see "Camera Raw preferences" on page 107 for the full details).

On the other hand, if you look at the Lightroom program, I think you'll find that the use of Camera Raw processing on non-raw images works very well indeed (I explain the Lightroom approach to non-raw editing in a separate PDF that's on the book website). It has to be said that editing non-raw files in Lightroom is much easier to get to grips with, since Lightroom manages to process JPEGs quite seamlessly (see sidebar).

Alternative Raw processors

While I may personally take the view that Camera Raw is a powerful raw processor, there are other alternative raw processing programs photographers can choose from. Some camera manufacturers supply their own brand of raw processing programs which either come free with the camera or you are encouraged to buy separately. Other notable programs include Capture One (www.phaseone.com/en/software.aspx), which is favored by a lot of professional shooters, Bibble (www.bibblelabs.com), DxO Optics Pro (www.dxo.com) and Apple's Aperture which can also be seen as a rival for Adobe's own Lightroom program. If you are using some other program to process your raw images and are happy with the results you are getting then that's fine. Even so, I would say that the core message of this chapter still applies, which is to use the raw processing stage to optimize the image so that you can rely less on using Photoshop's own adjustment tools to process the photograph afterwards. Overall it makes good sense to take advantage of the non-destructive processing in Camera Raw to freely interpret the raw capture data in ways that can't be done using Photoshop alone.

A basic Camera Raw/Photoshop workflow

The standard Camera Raw workflow should be kept quite simple. Select the photo you wish to edit and double-click the thumbnail in Bridge to open it in Camera Raw. Or, you can use the ⌘ R ctrl R shortcut to open in Camera Raw via Bridge (this is discussed later on page 150). In the example shown over the next few pages, I mainly used the Basic panel controls to adjust the white balance, and make some initial tone edits. With these basic adjustments it is possible to produce a well-balanced color master image that can then be edited in Photoshop, where layers and filters can be added as necessary. Any special effects or black and white conversions are best applied at the end in Photoshop (as shown in Step 5).

1 In this first step I opened a window in Bridge, selected a raw photo that I wished to edit and double-clicked on the highlighted thumbnail to open it via Camera Raw in Photoshop.

2 This shows the photograph opened via the Camera Raw dialog hosted in Photoshop, where I clicked 'Auto' (circled) to apply the Camera Raw Auto settings.

3 I was then able to use the Basic panel controls to optimize the tone, color and contrast. Once I was happy with the way the image looked I clicked the Open Image button (circled) to continue editing it in Photoshop.

4 Opening the image from Camera Raw rendered a pixel image version of the raw file that could then be edited in Photoshop using all the tools that Photoshop has to offer.

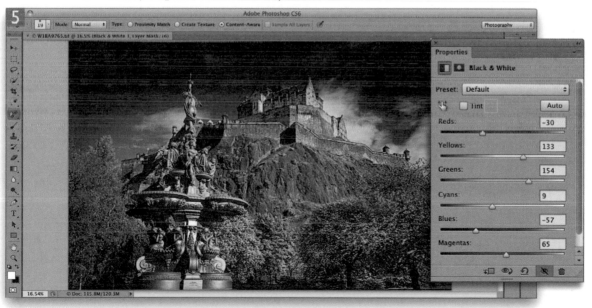

5 In this step I added a Black & White adjustment layer to the top of the layer stack. This allowed me to preserve the color data in the retouched image and retain the ability to switch this conversion on or off.

135

Forward compatibility for raw files

Adobe's policy is to provide on-going Camera Raw support throughout the life of a particular Photoshop product. This means if you bought Photoshop CS5, you will have been provided with free Camera Raw updates up until version 6.7. Once a new Photoshop program comes out, Camera Raw support is continued for those new customers only. Consequently, you are obliged to upgrade your version of Photoshop if you wish to take advantage of the support offered for new cameras. However, you won't be completely blocked off from doing so. If you refer to the end of this chapter you can read about the free DNG Converter program that is always released at the same time as any Camera Raw updates. What you can do is use DNG Converter to convert any supported raw camera format file to DNG. When you do this, the DNG file can then be read by any previous version of Camera Raw.

Camera Raw support

Camera Raw won't 'officially' interpret the raw files from every digital camera, but over 350 different raw formats are now supported and Adobe is committed to providing intermittent free Camera Raw updates that will always include any new camera file interpreters as they become available. This generally happens about once every three months and sometimes sooner if a significant new camera is released. It is probably no coincidence that Thomas Knoll, who is a Canon EOS 1Ds user, always happens to have a new Camera Raw update for the 1Ds soon after a new model comes out! Camera Raw updates don't usually include new features, although the Camera Raw 4.1 update for Photoshop CS3 was unique in that it offered a whole new refined approach to image sharpening. There is always a chance this might happen again, but for the most part, Camera Raw updates are provided in order to offer additional camera support, and/or improved integration with Lightroom. For example, a Camera Raw 4.5 update was released so that Photoshop CS3 users could read raw files that had been edited in Lightroom 2 using features that were then new to Camera Raw.

Now understand that while not all raw camera file formats are supported, this is in no way the fault of Adobe. Certain camera manufacturers have, in the past, done things like encrypt the white balance data, which makes it difficult for anyone but themselves to decode the raw image data. The Camera Raw team have always done their best to make Camera Raw compatible with the latest digital cameras, but sometimes there have been obstacles which aren't directly Adobe's fault.

DNG compatibility

The DNG file format is an open standard file format for raw camera files. DNG is a file format that was devised by Adobe and there are already a few cameras such as Leica, Ricoh and Hasselblad H2D cameras that can shoot directly to DNG, plus there are now quite a few raw processor programs that can read DNG, including Camera Raw and Lightroom of course. Basically, DNG files can be read and edited just like any other proprietary raw file format and it is generally regarded as a safe file format to use for archiving your digital master files. For more about the DNG format I suggest you refer to pages 260–264 at the end of this chapter.

Getting raw images into Photoshop

There was a time, not so long ago, when one would simply scan a few photographs, put them in a folder and double-click to open them up in Photoshop. These days most photographers are working with large numbers of images and it is therefore important to be able to import and manage those images efficiently. With Photoshop 7, Adobe introduced the File Browser, which was like an alternative open dialog interface that was built in to the Photoshop program. The File Browser offered a superior way to manage your images, allowing you to preview and manage multiple images at once. The File Browser was then superseded by Bridge, which was supplied as a separate program and included as part of the CS2 Creative Suite.

As image browser programs go, Bridge's main advantage is that you have ready access to Photoshop. You can open up single or multiple images and apply batch operations all directly from within Bridge. If you compare Bridge with other browser programs, it has enough basic functionality to suit most photographers' needs, although it has to be said that Bridge has yet to provide the full functionality that professional photographers have come to rely on in other programs, such as those which are dedicated to the task of managing large numbers of photographs (such as Lightroom or Aperture).

Image ingestion

The first thing we should look at is how to get the images from the camera and on to the computer, such as when shooting with a studio setup like the one shown in Figure 3.4. This process is usually referred to as 'image ingestion', which is not a particularly elegant phrase, but it's how some people like to describe the image import process.

Bridge features a Photo Downloader utility program that makes the downloading process easier to carry out than was the case in earlier versions of Bridge. Over the next few pages I have outlined all the steps that are required when working with the Photo Downloader. It so happens that I mostly use Lightroom to import my photos, so for comparison purposes I have provided a PDF on the book website where I show an example of how to use the Lightroom program to import captured images to the computer ready for Lightroom and Photoshop editing.

Figure 3.4 Here is a typical studio setup where I have a laptop computer (plus a separate LCD display) stationed close to the actual shooting area, ready to process the captured images from the shoot. With the setup shown here I am able to import images either via a card reader or by shooting tethered.

Importing images via Photo Downloader

EOS_DIGITAL

1 To begin with I inserted a camera card into the computer via a card reader. The card should mount on the desktop, or appear in the My Computer window, as a newly mounted volume.

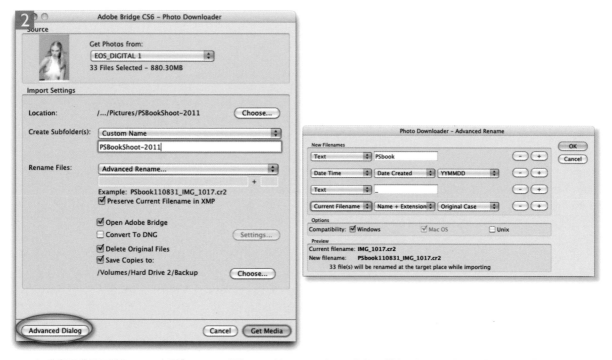

Figure 3.5 The subfolder naming options.

2 The next thing was to launch Bridge CS6 and choose File ➪ Get Photos from Camera... This opened the Photo Downloader dialog shown here, where I could start by selecting where to download the files from (in this instance, the EOS_Digital camera card). Next, I chose a location to download the photos to. Here, I selected the Pictures folder. I then selected 'Custom Name' from the Create Subfolder(s) menu (see Figure 3.5) and typed in a name for the shoot import (this name is appended to the Location setting to complete the file path). I then went on the Rename Files menu, selected the Advanced Rename... option and configured the rename settings as shown above. If the 'Delete Original Files' option is checked, Photo Downloader gives you the option to delete the files from the camera card once they have been successfully downloaded to the computer. I then checked the Save Copies to: option and clicked on the Choose... button to locate a backup folder to save the backup files to.

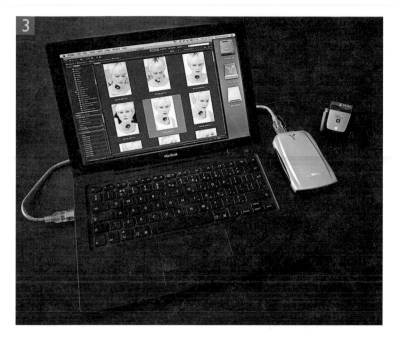

For as long as they remain in one location only, your camera files are vulnerable to loss. This is especially true when they only exist on the camera card, which can easily get lost or the data could become corrupted. This is why it is always a good idea to get the camera files off the card and safely stored on a computer hard drive as soon as possible. Not only that, it is also a good idea to make a backup of the camera files as you do so. Note that Bridge will apply the settings setup in the Photo Downloader to the files that are copied to the main folder location. But, the files that are copied to the backup location will be plain clone copies of the original camera files. The backup copy files will not be renamed (as are the main import files). This is a good thing because should you make a mistake during the rename process you will always retain a backup version of the files just as they were named when captured by the camera. Basically, backup files are like an insurance policy against both a drive failure as well as any file renaming mix-ups.

Copy to main import folder location

EOS_DIGITAL

Computer Hard Drive

Copy to backup folder location

Backup Hard Drive

3 Lets review the Photo Downloader settings that have been applied so far. The camera card contained the images I wished to import and the Photo Downloader settings had so far been configured to copy these files to the primary disk location (which in this instance would be the computer hard drive), and at the same time make a backup copy of all the files to a secondary location (in this case, a backup hard drive). With the setup shown here, I was able to use Photo Downloader to make renamed copies of the files to the principal drive/folder location and, if desired, convert the files to DNG as I did so. With this type of configuration I would end up with two copies of each image: one on the main computer and one on the backup drive.

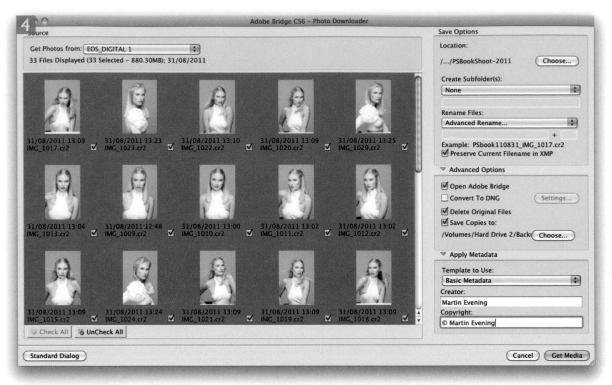

Do not rename files
Today's Date (yyyymmdd)
Shot Date (yyyymmdd)
Shot Date (yyddmm)
Shot Date (ddmmyy)
Shot Date (ddmm)
Shot Date (yyyyddmmm)
Shot Date (ddmmmyyyy)
Custom Name
✓ Shot Date (yyyymmdd) + Custom Name
Shot Date (yyddmm) + Custom Name
Shot Date (ddmmyy) + Custom Name
Shot Date (ddmm) + Custom Name
Shot Date (yyyyddmmm) + Custom Name
Shot Date (ddmmmyyyy) + Custom Name
Custom Name + Shot Date (yyyymmdd)
Custom Name + Shot Date (yyddmm)
Custom Name + Shot Date (ddmmyy)
Custom Name + Shot Date (ddmm)
Custom Name + Shot Date (yyyyddmmm)
Custom Name + Shot Date (ddmmmyyyy)
Same as Subfolder Name
Advanced Rename...

Figure 3.6 Here are the options for the Rename Files menu, highlighted in the dialog above.

4 I then clicked on the Advanced dialog button in the bottom left corner (circled in Step 2). This revealed an expanded version of the Photo Downloader dialog, which allowed me to see a grid preview of all the images I was about to import from the card. I could now decide which images were to be imported by clicking on the thumbnail checkboxes to select or deselect individual photos. You can also use the Check All and Uncheck All buttons in the bottom left of the dialog to select or deselect all the thumbnails at once.

The Rename Files section allowed me to choose a renaming scheme from the options shown in Figure 3.6. Which you should choose here will depend on what works best for you, and this is a topic I will explore in greater detail in the Image Management chapter. In this example I chose to rename using the shoot date followed by a custom shoot name. I could see how the renaming would work by inspecting the Example filename below, where, as you can see, the imported files were automatically renumbered beginning from the start number entered here. If you check the Preserve Current Filename in XMP, this gives you the option to use the Batch Rename feature in Bridge to recover the original filename at a later date.

The Advanced Options lets you decide what happens to the imported images after they have been renamed. You will most likely want to check the Open Adobe Bridge option so that Bridge displays the image download folder contents as the images are being imported. In the Apply Metadata section you can also choose a pre-saved metadata template (see Chapter 11) and enter your author name and copyright information. This is then automatically embedded in the metadata of all the files as they are imported.

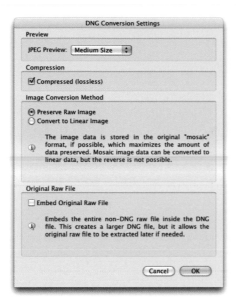

5 If the Convert to DNG option is selected, this can be used to convert raw images to the DNG file format as they are imported. For some people it can be useful to carry out the conversion straight away, but be warned that this will add to the time it takes to import all the photos. If you click on the Settings… button (next to the Convert to DNG option in Photo Downloader) this opens the DNG Conversion Settings dialog shown here. If you select the Medium Size JPEG Preview option, this will generate a standard size preview for the imported pictures – there is no point in generating a full size preview just yet since you may well be changing the camera raw settings soon anyway, so to get reasonably fast imports it is better to choose 'Medium Size'. Check the Compressed option if you would like smaller file sizes (note that this uses lossless compression and does not risk degrading the image quality). In the Image Conversion Method section I suggest you don't choose 'Convert to Linear Image', but choose 'Preserve Raw Image' as this keeps the raw data in the DNG in its original state. And lastly, you can choose to embed the original raw data (along with the DNG data) in the DNG file, but I would advise against this unless you really need to preserve the proprietary raw file data.

Converting to DNG
To read more about converting proprietary raw files to DNG and the conversion settings shown here, please refer to pages 260–264 at the end of this chapter.

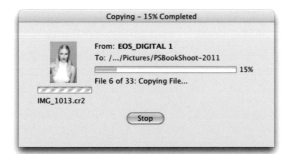

6 After I clicked on the Get Photos button in the Photo Downloader dialog, the images started to download from the card to the disk location specified in the Save Options in Step 4. The above progress dialog showed me how the download process was proceeding.

Deleting camera card files

It isn't actually necessary to delete the files from the camera card first, because formatting a card in the camera will delete everything that is on the card anyway. Formatting the card is good housekeeping practice as this helps guard against future file corruptions occurring with the card. However, I find that if I am in the midst of a busy shoot it is preferable to get into a routine of deleting the files before you put the card back in the camera. Otherwise I am always left with the nagging doubt: 'Have I downloaded all the files on this card yet? Is it really safe to delete everything on this card?'

7 Because the 'Open Adobe Bridge' option had been selected, once all the photos were downloaded, Bridge opened a new window to display the imported photos that were now in the selected download images folder.

8 Also, because the 'Delete Original Files' option was selected, the above warning dialog appeared once the downloads to the primary destination folder (and backup folder) were complete. This step conveniently cleared the camera card of all the images that were stored on it and prepared it for reuse in the camera. Be warned that this step bypasses any opportunity to confirm if you really want to delete these files. Once you click 'Yes', the files will be permanently removed from the card. When I put a card back in the camera I usually reformat it anyway before shooting a fresh batch of photos to that card (see sidebar: Deleting camera card files).

Tethered shoot imports

There is no direct support for tethered shooting in Bridge CS6, but if Bridge were able to do so, it would have to offer tethered support for many if not all the cameras that Camera Raw already supports. Enabling full tethered shoot functionality is difficult enough to do for one camera let alone several hundred. This is why those software programs that do offer tethered shooting, such as Capture One and Bibble, only do so for a narrow range of popular digital SLR cameras. However, it is possible to shoot in tethered mode with Bridge, but it all depends on the capabilities of your camera and whether it has a suitable connection socket and if the supplied camera software allows you to download files directly to the computer. Many cameras (especially digital SLR cameras) will most likely come with some kind of software that allows you to hook your camera up to the computer via a FireWire (IEEE 1394), USB 2 or Ethernet cable (Figure 3.7). If you are able to download files directly to the computer, then Bridge can monitor that folder and this gives you a next best solution to a dedicated software program that is designed to operate in tethered mode.

The only drawback to shooting tethered is that the camera must be wired up to the computer and you don't have complete freedom to wander around with the camera. If you have a wireless communication device then it may be possible to shoot in a direct import mode to the computer, without the hassle of a cable, but at the time of writing, wireless shooting isn't particularly speedy when shooting raw files with a typical digital SLR.

Over the next few pages I have described a method for shooting in tethered mode with a Canon EOS camera, using the EOS Utility program that ships with most of the Canon cameras. This program lets you download camera files as they are captured, to a designated watched folder. Nikon owners will find that Nikon Capture NX2 includes a Camera Control component that allows you to do the same thing as the Canon software and establishes a watched folder to download the images to. The latest version of Nikon Capture supports all the latest D Series cameras. Alternatively, you might want to consider buying Bibble Pro 5 software from Bibble Labs (www.bibblelabs.com). Bibble Pro does not cost as much as Nikon Capture. It enables tethered shooting with a wide variety of digital cameras and, again, allows you to establish a watched folder for the downloaded images, which you can monitor using Bridge CS6.

Figure 3.7 Here is a photograph taken of me at work in the studio, shooting in tethered mode.

Which utility?

One of the problems with the Canon system is the way the utility programs have been named and updated with succeeding generations of cameras. First of all there was EOS Viewer Utility and now EOS Utility, which have both interacted with a program called EOS Capture. On top of this you also have to make sure that you are using the correct version of 'utility' software for your camera. It would help if there were just one program that was updated to work with all Canon cameras.

Which transfer protocol?

Nikon and Canon systems both offer FTP and PTP transfer protocols. Make sure you select the right one, as failure to do so can result in an inability to get tethered shooting to work. This information can be found in the camera manufacturer's manual for your camera model.

Tethered shooting via Canon EOS Utility

EOS Utility

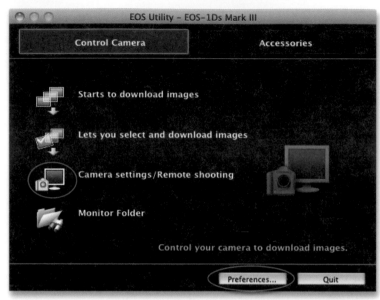

1 To begin with, I made sure the camera was tethered to the computer correctly and was switched on, I then launched EOS Utility and clicked the Preferences button (circled in orange) to open the Preferences dialog shown in Step 2 below.

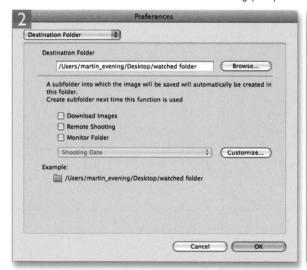

2 In the Destination Folder section, I clicked on the Browse... button and selected a destination folder that the camera captures were to be downloaded to. This could be an existing folder, or a new folder, such as the 'watched folder' selected here. Meanwhile, in the Linked Software section, I set the 'Software to link' to as 'None'.

 3 I also needed to establish a file renaming scheme. It is possible to carry out the file renaming in Bridge afterwards, but establishing this beforehand can save time and helps reduce the risk of error if it's applied automatically as the files are captured. In this example, I selected the Shooting Date+Prefix+Number file naming scheme and set the start count number to '1'.

4 I then clicked OK to the Camera Settings in Step 3 and clicked on the Camera Settings/ Remote shooting option circled in blue in Step 1. This opened the Camera control window shown here, where I could configure the camera settings remotely. As soon as this window appeared I was ready to start shooting.

Lightroom conflict

If you are also running Lightroom, the one thing to watch out for here is that the watched folder you select in Step 2 does not conflict with a watched folder that is currently being monitored by Lightroom. If this is the case, you will need to disable the auto-import feature in Lightroom first before using it to import photos that can be viewed via Bridge.

Auto renumbering

When you select a numbering option in the File Name section, the numbering will keep on auto-updating until such time as you change the file prefix name. This is useful to know because it means that if you were to lose a camera connection or switch the camera off between shoots, the EOS Utility program knows to continue the file renaming of the import files from the last number used.

Remote shooting controls

As soon as the Camera control window appears you know that you have succeeded in establishing a tethered connection and are ready to start shooting. This can be done by pressing the shutter on the camera, or alternatively, you can use the EOS Capture utility to capture the photos remotely from the computer by clicking on the large round button (circled in orange in Step 4). You can also use this window to adjust the camera settings by selecting any of the status items in the window and use the left/right keyboard arrow keys to navigate between the various mode options and use the up/down keys to increase or decrease the individual settings.

5 As I started shooting, the EOS Utility enabled the import of the camera files directly into the watched folder I had established in Step 1 and renamed them (as configured in Step 2). All I needed to do now was point Bridge at the same watched folder as was configured in the EOS Utility preferences and I would see the pictures appear in Bridge directly. Of course, if you are shooting continuously in the studio or on location with a setup like this, then you will most likely wish to see the newest pictures appear first at the top of the content area in the Bridge window. To do this, I went to the View menu and ensured the Ascending Order item in the Sort menu was deselected (as shown in the screen shot on the left). Having done this, the files would now be sorted in reverse order with the most recent image appearing at the top.

When you have finished shooting in tethered mode, you will either need to move the files from the watched folder and place them elsewhere, or rename the folder. The main thing to be aware of here is that every time you start a new shoot, you will either want to choose a new job folder to download the photos to, or move the files from this folder to a new location and make sure that the watched folder you are linking to has been emptied. Of course, you could always create an Automator workflow action (Mac) or VB script (Windows PC) that allowed you to press a button to do the transfer and clearing of the watched folder.

Importing images via other programs

Figure 3.8 highlights some of the various methods that can be used for importing images. There is no one program that can do everything perfectly, but of these, I would say that Capture One is the only program capable of ticking all the essential boxes (as long as your camera is supported). Ingestamatic and ImageIngester are great little utility programs that can provide a fast and robust import workflow. These are both currently available as demo versions from the link on the right. The newest versions allow you to download from up to 8 cards simultaneously. They can also provide raw file verification, apply default Camera Raw settings and incorporate GPS tagging.

Ever since Adobe Photoshop Lightroom made its first appearance, I have been using it in the studio and on location to import images from cards as well as when shooting in tethered mode. To show you how I do this, I have included a PDF on the book website that demonstrates how I use Lightroom to import new photos into the computer. I should mention though that I do still use Bridge for various other browsing tasks. For example, it would be difficult to manage a project such as this without using Bridge to manage the files that are used in the book.

Ingestamatic and ImageIngester

The Ingestamatic™ and ImageIngester™ utilities have been designed by Marc Rochkind and are aimed at photographers who shoot raw files, and who need to ingest hundreds of images from a typical shoot. You can download demos of both from the following link:

http://basepath.com/site/.

	Direct integration with Bridge	File renaming	Full auto renumbering	Secondary backup of data	Convert to DNG	Import settings saved for concurrent imports	Tethered shooting	Preview and pre-selection of import files
Photo Downloader in Bridge	✓	✓	✓	✓	✓	✓		✓
Tethered shooting via Bridge	✓						✓*	
DNG Converter		✓	✓		✓	✓		
Lightroom Import Photos		✓	✓	✓	✓	✓	✓	✓
ImageIngester Standard		✓	✓	✓	✓	✓		
Capture One		✓	✓	✓	✓	✓	✓	✓

Figure 3.8 In this table I have compared the features that are available when using some of the various methods for importing camera images into the computer. As you can see, there is no one perfect solution out there that will let you do everything (although Lightroom and Capture One tick all the important boxes). Lightroom does now include the ability to shoot tethered, but does not provide as extensive support or as many options as some of the other methods of tethered shooting.

* In these instances, tethered shooting is only possible if done in conjunction with a camera manufacturer's import software.

TWAIN origins

On a side note here, the name TWAIN was originally arrived upon as a reference to Rudyard Kipling's 'The Ballad of East and West', in which he writes: '…and never the twain shall meet…'. An alternative explanation is that it's an acronym for 'Technology Without An Interesting Name'.

Import Images from Device (Mac only)

This isn't a raw capture feature, but while we are on the subject of importing images I did want to draw attention here to something that's new in Photoshop CS6. Import Images from Device lets you interact with scanner devices and import images from a scanner directly into Photoshop (although you do need to install the appropriate driver and configure the scanner before you can scan images in this way). The impetus for this device is the fact that TWAIN 64-bit drivers are pretty scarce, and this new feature does at least offer some extra features that TWAIN can't offer, such as support for networked scanners and cropping and rotation of images on import. This does at least give Macintosh users a simple interface control for importing photos from their desktop scanners.

Figure 3.9 This shows Import Images from Device with a scanner device selected.

When a supported scanner device is selected from the Devices menu, you'll see options like those shown in Figure 3.9, where I selected the Manual option in the Image Correction menu (circled). This revealed the extra image adjustment controls that were available for this scanner. As you can see, what you have here is fairly basic and advanced users will most likely prefer to stick with dedicated scanner software such as Vuescan or SilverFast. There is though an option to 'Detect Separate items', which works the same way as the Crop and Straighten command from the File ⇨ Automate submenu. At the bottom are two radio buttons, which allow you to choose whether to import files as new image documents, or to place as a new layer in the frontmost document.

Import Images from Device does more though than just allow you to connect to desktop scanner devices. You can also import files from a connected digital camera, or a card reader. If you have an iSight camera connected to your computer, you can even use it to take photos. In Figure 3.10 you can see that I had a smart phone connected to the computer and could use Import Photos from Device to import the photos I had stored on it.

Scanning to layers

When you choose 'Create new layer in frontmost document', the scanned image will be placed as a Smart Object layer. If you have 'Detect Separate Items' checked and this means you are going to be making multiple scans, you will need to commit each layer before the following scanned layer can be placed. If not, an alert will appear: 'Cannot create new layer while current layer is active. Double-click layer to deactivate.' Click OK to get rid of the alert message. However, if you do not commit the placed layer in time, you will lose all further scanned images, though copies will be saved to the usual designated scan folder.

Closing the Import Images dialog

The 'Import Images from Device' dialog always remains open after you have made a scan. This is so that it remains on standby for making further scans. You can close it either by clicking on the Close button, or use the ⌘ W ctrl W shortcut.

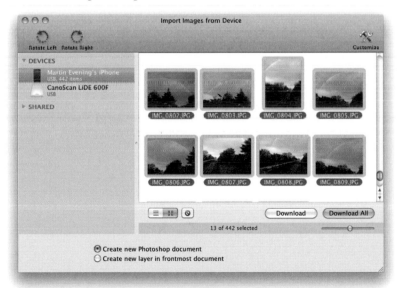

Figure 3.10 This shows Import Images from Device with a smart phone device selected. Note that the Rotate Right and Rotate Left icons are dimmed when importing images from a scanner but are enabled when importing images from a camera.

Closing Bridge as you open

If you hold down the ⌥ *alt* key as you double-click to open a raw image, this closes the Bridge window as you open the Camera Raw dialog hosted by Photoshop.

Installing updates

Adobe release regular Camera Raw updates which keep Camera Raw up-to-date and compatible with the latest upcoming cameras. The update process is fairly straight forward. There are standard installers for Mac and PC that automatically update Camera Raw for you rather than require you to manually search for the correct folder location to copy the plug-in to. Note that whenever there is an update to Camera Raw there will also be an accompanying update for the Lightroom program as well as for Adobe DNG Converter.

Basic Camera Raw image editing

Working with Bridge and Camera Raw

The mechanics of how Photoshop and Bridge work together are designed to be as simple as possible so that you can open single or multiple images or batch process images quickly and efficiently. Figure 3.11 summarizes how the file opening between Bridge, Photoshop and Camera Raw works. Central to everything is the Bridge window interface where you can browse, preview or make selections of the images you wish to process. The way most people are accustomed to opening images is to select the desired thumbnail (or thumbnails) and open using one of the following three methods: use the File ⇨ Open command, use a double-click, or use the ⌘ O ctrl O shortcut. The way things are set up in Bridge, all of the above methods will open a selected raw image (or images) via the Camera Raw dialog hosted by Photoshop. If the image is not a raw file, it will open in Photoshop directly. Alternatively, you can use File ⇨ Open in Camera Raw… or use the ⌘ R ctrl R shortcut to open images via the Camera Raw dialog hosted by Bridge. This allows you to perform batch processing operations in the background without compromising Photoshop's performance. If the 'Double-click edits Camera Raw Settings in Bridge' option is deselected in the Bridge General preferences, *Shift* double-clicking allows you to open an image or multiple selections of images in Photoshop directly, bypassing the Camera Raw dialog.

Opening single raw images via Photoshop is quicker than opening them via Bridge, but when you do this Photoshop does then become tied up managing the Camera Raw processing and this will prevent you from doing any other work in Photoshop. The advantage of opening via Bridge is that Bridge can be used to process large numbers of raw files in Camera Raw, while freeing up Photoshop to perform other tasks. You can then toggle between the two programs. For example, you can be processing images in Camera Raw while you switch to working on other images that have already been opened in Photoshop.

Regarding JPEG and TIFF images, Camera Raw can be made to open these as if they were raw images, but please refer to page 166 for a summary of the JPEG and TIFF handling behavior in Camera Raw.

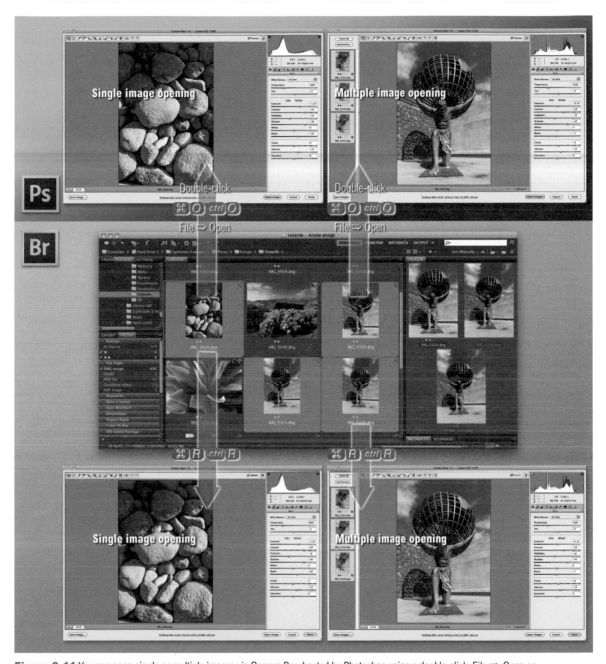

Figure 3.11 You can open single or multiple images via Camera Raw hosted by Photoshop using a double-click, File ⇨ Open or ⌘ O ctrl O. Photoshop is ideal for processing small numbers of images. If you use ⌘ R ctrl R, Bridge hosts the single or multiple Camera Raw dialog. Opening via Bridge is better suited for processing large batches of images in the background.

Camera Raw tools

🔍 Zoom tool (Z)
Use as you would the normal zoom tool to zoom the preview image in or out.

✋ Hand tool (H)
Use as you would the normal hand tool to scroll a magnified preview.

🖋 White balance tool (I)
The white balance tool is used to set the White Balance in the Basic panel.

🖋 Color sampler tool (S)
This allows you to place up to nine color sampler points in the preview window (note that these are temporary and are not stored in the XMP data).

🔧 Target adjustment tool (T)
This allows you to use the cursor to mouse down on an image and apply targeted image adjustments, dragging the cursor up or down.

🔲 Crop tool (C)
The crop tool can apply a crop setting to the raw image which is applied when the file is opened in Photoshop.

📐 Straighten tool (A)
Use this tool to drag along a horizontal or vertical line to apply a 'best fit', straightened crop.

🖌 Spot removal (B)
Use to remove sensor dust spots and other blemishes from a photo.

👁 Red eye removal tool (E)
For removing red eye from portraits shot using on-camera direct flash.

🖌 Adjustment brush (K)
Use this brush tool to paint in localized adjustments.

📋 Graduated filter (G)
Use the graduated filter to apply graduated localized adjustments.

☰ ACR preferences (⌘ ctrl–K)
Opens the Adobe Camera Raw preferences dialog.

↺ Rotate counterclockwise (L)
Rotates the image 90° counter clockwise.

↻ Rotate clockwise (R)
Rotates the image 90° clockwise.

General controls for single file opening

Whenever you open a single image, you will see the Camera Raw dialog shown in Figure 3.12 (which in this case, shows Camera Raw hosted via Bridge). The status bar shows which version of Camera Raw you are using and the make of camera for the file you are currently editing. In the top left section you have the Camera Raw tools (which I have listed on the left) and below that is the image preview area where the zoom setting can be adjusted via the pop-up menu at the bottom. The initial Camera Raw dialog displays the Basic panel control settings and in this mode the Preview checkbox allows you to toggle global adjustments that have been made in Camera Raw on or off. Once you start selecting any of the other panels, the Preview toggles only the changes that have been made within that particular panel.

The histogram represents the output histogram of an image and is calculated based on the RGB output space that has been selected in the Workflow options. As you carry out Basic panel adjustments, the shadow and highlight triangles in the histogram display will indicate the shadow and highlight clipping. As either the shadows or highlights get clipped, the triangles will light up with the color of the channel or channels that are about to be clipped and if you click on them, will display a color overlay (blue for the shadows, red for the highlights) to indicate which areas in the image are currently clipped.

At the bottom are the Show Workflow Options, which when clicked will open the Workflow Options dialog shown in Figure 3.13. The destination color space should ideally match the RGB workspace setting established in the Photoshop color settings, and I would suggest setting the bit depth to 16-bits per channel, as this ensures a maximum number of levels are preserved when the image is opened in Photoshop. The file size setting lets you open images using smaller or larger pixel dimensions than the default capture file size (these size options are indicated by + or − signs) and the Resolution field lets you set the file resolution in pixels per inch or per centimeter, but note that the value selected has no impact on the actual pixel dimensions of the image.

In Photoshop CS6, the default Camera Raw dialog takes up more room than former versions. To allow for small screen sizes you can now adjust the dialog size to allow scrolling of the panels, thus allowing the dialog to still fit smaller screen displays.

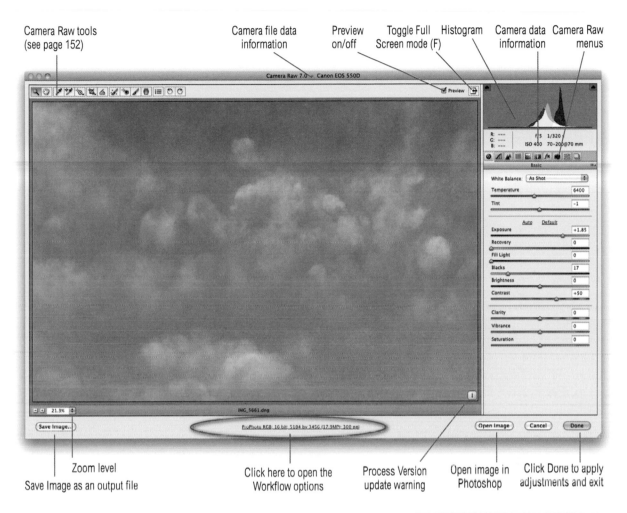

Camera Raw tools (see page 152)

Camera file data information

Preview on/off

Toggle Full Screen mode (F)

Histogram

Camera data information

Camera Raw menus

Save Image as an output file

Zoom level

Click here to open the Workflow options

Process Version update warning

Open image in Photoshop

Click Done to apply adjustments and exit

Figure 3.12 This shows the Camera Raw dialog (hosted by Bridge), showing the main controls and shortcuts for the single file open mode. You can tell if Camera Raw has been opened via Bridge, because the 'Done' button is highlighted. This is an 'update' button that you click when you are done making Camera Raw edits and wish to save these settings, but without opening the image.

If you click on the Workflow options (circled), this opens the Workflow Options dialog shown in Figure 3.13, where you can adjust the settings that determine the color space the image will open in, the bit-depth, cropped image pixel dimensions plus resolution (i.e. how many pixels per inch). You can also choose here to sharpen the rendered image for print or screen output. These options are relevant if you are producing a file to go directly to print or for a website. If you intend carrying out any type of further retouching then leave this set to 'None'. Lastly, there is an option to open in Photoshop as a Smart Object (see page 156).

Figure 3.13 The workflow options let you set the color space and pixel dimensions etc. At the bottom are also options that allow you to apply screen or print output sharpening.

Figure 3.14 After editing an image via the Camera Raw dialog, you will see a settings badge appear in the top right corner of the image thumbnail (circled). This indicates that an image has been edited in Camera Raw.

Figure 3.15 If there is a process version conflict when selecting multiple files, there will be the option to convert all the selected files to the process version that's applied to the most selected image.

Full size window view

The Toggle Full screen mode button (*F*) can be used to expand the Camera Raw dialog to fill the whole screen, which can make Camera Raw editing easier when you have a bigger preview area to work with. Click this button again to restore the previous Camera Raw window size view.

General controls for multiple file opening

If you have more than one photo selected in Bridge, you can open these all up at once via Camera Raw. If you refer back to Figure 3.11, you can see a summary of the file opening behavior, which is basically as follows. If you double-click, or use File ⇨ Open (⌘ *O* *ctrl* *O*) this opens the multiple image Camera Raw dialog hosted via Photoshop (as shown in Figure 3.16) and if you choose File ⇨ Open in Camera Raw… or ⌘ *R* *ctrl* *R*, this opens the multiple image Camera Raw dialog hosted via Bridge.

The multiple image dialog contains a filmstrip of the selected images running down the left-hand side of the dialog and you can select individual images by clicking on the thumbnails in the filmstrip, or use the Select All button to select all the photos at once. You can also make custom selections of images via the filmstrip using the *Shift* key to make continuous selections, or the ⌘ *ctrl* key to make discontinuous selections of images. Once you have made a thumbnail selection you can then navigate the selected photos by using the navigation buttons in the bottom right section of the Preview area to progress through them one by one and apply Camera Raw adjustments to the individual selected images. The Synchronize… button then allows you to synchronize the Camera Raw settings adjustments across all the images that have been selected, based on the current 'most selected' image. This will be the thumbnail that's highlighted with a blue border. When you click on the Synchronize… button, the Synchronize dialog (Figure 3.17) lets you choose which of the Camera Raw settings you want to synchronize. You can learn more about this and how to synchronize Camera Raw settings on page 255, as well as how to copy and paste Camera Raw settings via Bridge.

Once a photo has been edited in Camera Raw you will notice a badge icon appears in the top right corner of the Bridge thumbnail (Figure 3.14), which indicates this photo has had Camera Raw edit adjustments applied to it.

Select all images

Synchronize settings

Mark for deletion (X)

Preview on/off

Warning triangle warns that the image preview has not refreshed completely yet

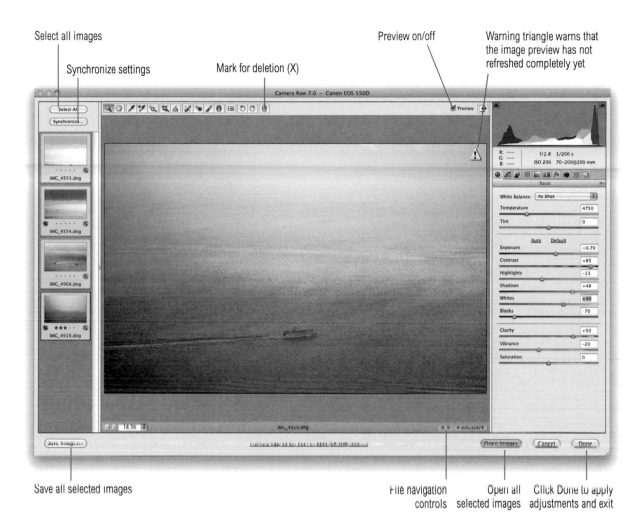

Save all selected images

File navigation controls

Open all selected images

Click Done to apply adjustments and exit

Figure 3.16 Here is a view of the Camera Raw dialog in the multiple file open mode, hosted in Photoshop (you can tell because the Open Images button is highlighted here). This screen shot shows a filmstrip of opened images on the left where all four of the opened images are currently selected and the bottom image (highlighted with the blue border) is the one that is 'most selected' and displayed in the preview area. Camera Raw adjustments can be applied to the selected photos one at a time, or synchronized with each other, by clicking on the Synchronize settings button. This opens the Synchronize dialog shown in Figure 3.17. Because images may now have different process versions, if you select multiple photos that use different process versions, the Basic panel will show a message like the one shown in Figure 3.15, requiring you to update the selected photos to the process version applied to the most selected image. Note that if you hold down the ⌥ *alt* key as you do so, this will bypass the Synchronize dialog options and synchronize everything.

Figure 3.17 The Synchronize dialog.

Opening raw files as Smart Objects

One of the top requests we hear for Photoshop, is "Can we have Camera Raw style adjustment layers?" It's a nice idea, but sadly unworkable as most of the Basic panel Camera Raw adjustments simply can't be applied as layers (in the same way as filters can't be applied as adjustment layers). What we can do though is to use the Smart Objects feature in Photoshop, which means it is possible to place raw images as Smart Object layers. These are like independent images within an image that can be processed independently and non-destructively.

In the case of Camera Raw, Smart Object opening is almost like a hidden feature, but once discovered can lead to all sorts of interesting possibilities. There are two ways you can go about this. You can click on the Workflow options link highlighted in Figure 3.18 to open the Workflow Options dialog and select the 'Open in Photoshop as Smart Objects' option. If checked, whenever you click on the Open Image button, this will make *all* Camera Raw processed images open as Smart Object layers in Photoshop. The other option is to simply hold down the Shift key as you click on the 'Open Image' button.

Let's now look at a practical example in which I opened two raw images as Smart Object layers and was able to merge them as a composite image in Photoshop.

Figure 3.18 If you click on the Workflow options link (circled above), this opens the Workflow Options dialog, where you can check the 'Open in Photoshop as Smart Objects' option. Alternatively, hold down the Shift key as you click the 'Open Image' button.

1 In this first step, I opened a raw image of a building and held down the *Shift* key as I clicked on the 'Open Image' button, to open it as a Smart Object layer in Photoshop.

2 In this next step I selected a new image, this time a photo of a sky, and again, held the *Shift* key as I clicked on the 'Open Image' button, to open this too as a Smart Object layer.

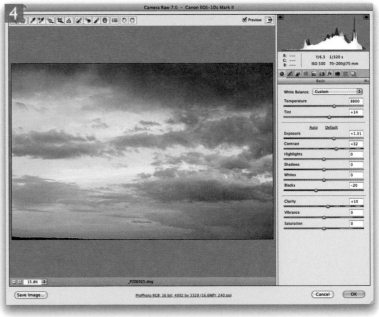

3 In Photoshop I dragged the Smart Object layer of the sky across to the Smart Object layer image of the building, to add it as a new layer. I then made a selection of the outline of the building and applied it as a layer mask to create the merged photo shown here.

4 Because both of these layers were raw image Smart Objects, I was able to double-click the top layer thumbnail (circled in orange in Step 3 above) to open the Camera Raw dialog and edit the settings. In this case I decided to give the sky more of a sunset color balance.

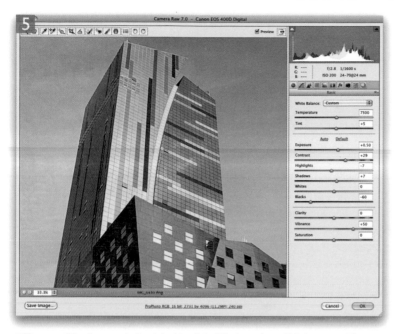

5 The same thing happened when I double-clicked the lower layer. This too opened the raw image Smart Object layer via Camera Raw and allowed me to warm the colors and add more contrast to the building.

6 This shows the Photoshop image with the revised Smart Object layers. The thing to bear in mind here is that all edits made to the Smart Object layers are completely non-destructive.

Saving images via Camera Raw

If you hold down the ⌥ [alt] key as you click on the Save… button, this will bypass the Save dialog box and save the image (or images) using the last used Save Options settings. This is handy if you want to add file saves to a queue and continue making more edit changes in the Camera Raw dialog.

Saving a JPEG as DNG

Although it is possible to save a JPEG or TIFF original as a DNG via Camera Raw it is important to realize that this step does not actually allow you to convert a JPEG or TIFF file into a raw image. Once an image has been rendered as a JPEG or TIFF it cannot be converted back into a raw format. Saving to DNG does though allow you to use DNG as a container format for a JPEG or TIFF. For example, this means that you can now store a Camera Raw rendered preview alongside the JPEG or TIFF data, which will be portable when sharing such files with other (non Camera-Raw aware) programs. Also, now that one can save using a lossy DNG format, on this level at least, there are advantages to saving JPEGs using DNG.

Resolving naming conflicts

A save operation from Camera Raw will auto-resolve any naming conflicts so as to avoid overwriting any existing files in the same save destination. This is important if you wish to save multiple versions of the same image as separate files and avoid overwriting the originals.

Saving photos from Camera Raw

When you click on the Save Image… button you have the option of choosing a folder destination to save the images to and a File Naming section to customize file naming. In the Format section you can choose which file format to use when rendering a pixel version from the raw master. These options include: PSD, TIFF, JPEG or DNG. If you have used the crop tool to crop an image in Camera Raw, the PSD options allow you to Preserve the cropped pixels by saving the image with a non-background layer (in Photoshop you can use Image ⇨ Reveal All should you wish to revert to an uncropped state). The JPEG and TIFF format saves provide the usual compression options and if you save using DNG you can convert any raw original to DNG, but see the sidebar about saving JPEGs and TIFFs as DNG. The file save processing is then carried out in the background, allowing you to carry on working in Bridge or Photoshop (depending on which program is hosting Camera Raw at the time) and you'll see a progress indicator (circled in Figure 3.19) showing how many photos there are left to save.

Figure 3.19 Clicking on the Save Image… button opens the Save Options dialog shown here. After configuring the options and clicking 'Save', you will see a status report next to the Save Image button that shows how many images remain to be processed. For more about the new DNG save options, see page 260 at the end of this chapter.

The histogram display

The Camera Raw Histogram provides a preview of how the Camera Raw output image histogram will look after the image data has been processed and output as a pixel image (such as a TIFF, PSD or JPEG). The histogram appearance is affected by the tone and color settings that have been applied in Camera Raw, but more importantly, it is also influenced by the RGB space selected in the Workflow options (see Figure 3.20). It can therefore be quite interesting to compare the effect of different output spaces when editing a raw capture image. For example, if you edit a photo in an RGB space like ProPhoto or Adobe RGB and then switch to sRGB, you will most likely see some color channel clipping in the histogram. Such clipping can then be addressed by readjusting the Camera Raw settings to suit the smaller gamut RGB space. This exercise is particularly useful in demonstrating why it is better to output your Camera Raw processed images using either the ProPhoto or Adobe RGB color spaces.

Digital camera histograms

Some digital cameras provide a histogram display that enables you to check the quality of what you have just shot. This too can be used as an indication of the levels captured in a scene. However, the histogram you see displayed is usually based on a JPEG capture image. If you are shooting in JPEG mode, that's what you are going to get. If you prefer to shoot using raw mode, the histogram you see on the back of the camera will not provide an accurate guide to the true potential of the image you have captured (see also, Figure 3.3 on page 130).

Figure 3.20 This shows how to access the workflow options, plus an example of how the Camera Raw histogram may vary depending on which color space is selected.

Deleting images

As you work with Camera Raw to edit your shots, the *Delete* key can be used to mark images that are to be sent to the trash. This places a big red X in the thumbnail, which can be undone by hitting *Delete* again.

Image browsing via Camera Raw

In a multiple view mode, the Camera Raw dialog can be used as a 'magnified view' image browser. You can match the magnification and location across all the selected images to check and compare details, inspect them in a sequence and apply ratings to the selected photos.

Selecting rated images only

If you *alt*-click on the 'Select All' button, this selects the rated images only. This means that you can use star ratings to mark the images you are interested in during a 'first pass' edit and then use the above shortcut to make a quick selection of just the rated images.

1 If you have a large folder of images to review, the Camera Raw dialog can be used to provide a synchronized, magnified view of the selected pictures. The dialog is shown here in a normal window view, but you can click on the Full Screen mode button (circled) to expand the dialog to a Full screen view mode.

2 Here, I selected the first image in the sequence and clicked on the Select All button. I then used the zoom tool to magnify the preview. This action synchronized the zoom view used for all the selected images in the Camera Raw dialog, plus I was able to use the hand tool to synchronize the scroll location for the selected photos.

3 Once this had been done I could deselect the thumbnail selection and start inspecting the photos. This could be done by clicking on the file navigation controls (circled) or by using the keyboard arrow keys to progress through the images one by one. I could then mark my favorite pictures by using the usual Bridge shortcuts: *⌘ >* *ctrl >* progressively increases the star rating for a selected image; *⌘ <* *ctrl <* progressively decreases the star rating.

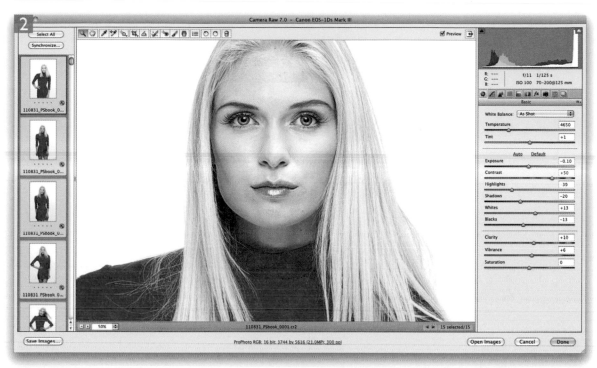

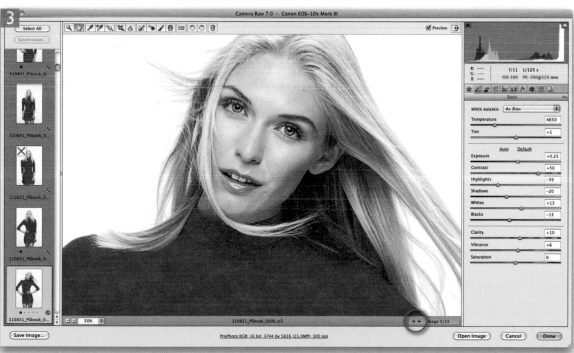

XMP sidecar files

Camera Raw edit settings are written as XMP metadata and this data is stored in the central Camera Raw database on the computer and can also be written to the files directly. In the case of JPEG, TIFF and DNG files, these file formats allow the XMP metadata to be written to the XMP space in the file header. However, in the case of proprietary raw file formats such as CR2 and NEF, it would be unsafe to write XMP metadata to incompletely documented file formats. To get around this, Camera Raw writes the XMP metadata to XMP sidecar files that accompany the image in the same folder and stay with the file when you move it from one location to another via Bridge.

Camera Raw preferences

The Camera Raw preferences (Figure 3.21) can be accessed via the Photoshop/Bridge menu (Mac) or Edit menu (PC). While the Camera Raw dialog is open you can use ⌘ K ctrl K to open the Camera Raw preferences, or click on the Camera Raw Preferences... button in Photoshop's File Handling preferences.

Let's look at the General section first. In the 'Save image settings' section I suggest you choose 'Sidecar ".xmp" files'. TIFF, JPEG and DNG files can store the XMP data in the header, but if the XMP data can't be stored internally within the file itself, this forces the image settings to be stored locally in XMP sidecar files that accompany the image files (see also page 252).

Should you wish to preview adjustments with the sharpening turned on, but without actually sharpening the output the 'Apply sharpening to' option can be set to 'Preview images only'. This is because you might want to use a third-party sharpening program in preference to Camera Raw. However, with the advent of Camera Raw's improved sharpening, you will most likely want to leave this set to 'All images' to make full use of Camera Raw sharpening.

Figure 3.21 Camera Raw preferences dialog.

Default Image Settings

In the Camera Raw preferences Default Image Settings section, you can select 'Apply auto tone adjustments' as a Camera Raw default. When this is switched on, Camera Raw automatically applies an auto tone adjustment to new images it encounters that have not yet been processed in Camera Raw, while any images you have edited previously via Camera Raw will remain as they are. The 'Apply auto grayscale mix when converting to grayscale' option refers to the HSL/Grayscale controls, where Camera Raw can apply an auto slider grayscale mix adjustment when converting a color image to black and white. The next two options can be used to decide, when setting the camera default settings, if these should be camera body and/or ISO specific (see page 189).

Camera Raw cache

When photos are rendered using the Camera Raw engine, they go through an early stage initial rendering and the Camera Raw cache stores a cache of this data so that when you next reopen an image that has data stored in the cache, it renders the photo quicker in the Camera Raw dialog. The 1 GB default setting is rather conservative. If you have enough free hard disk space available, you may want to increase the size limit for the cache, or choose a new location to store the central preview cache data. If you increase the limit to, say, 20 GB or more, you should expect to see an improvement in Camera Raw's performance.

DNG file handling

Camera Raw and Lightroom both embed the XMP metadata in the XMP header space of a DNG file. There should therefore be no need to use sidecar files to read and write XMP metadata when sharing files between these two programs. However, some third-party programs may create sidecar files for DNG files. If 'Ignore sidecar "xmp" files' is checked, Camera Raw will not be sidetracked by sidecar files that might accompany a DNG file and cause a metadata conflict.

However, there are times where it may be useful to read the XMP metadata from DNG sidecar files. For example, when I work from a rental studio I'll have a computer in the studio with all the captured files (kept as standard raws) and a backup/shuttle disk to take back to the office at my house from which I

Camera Raw cache

Whenever you open an image in Camera Raw, it builds full, high quality previews direct from the master image data. In the case of raw files, the early stage processing includes the decoding and decompression of the raw data as well as the linearization and demosaic processing. All this has to take place first before getting to the stage that allows the user to adjust things like the Basic panel adjustments. The Camera Raw cache is therefore used to store the unchanging, early stage raw processing data that is used to generate the Camera Raw previews so that the early stage raw processing can be skipped the next time you view that image. If you increase the Camera Raw cache size, more image data can be held in the cache. This in turn results in swifter Camera Raw preview generation when you reopen these photos. Also, because the Camera Raw cache can be utilized by Lightroom, the cache data is shared between both programs. Since version 3.6, the Camera Raw cache files have been made much more compact. This means that one can now cache a lot more files within the limit set in the Camera Raw preferences.

can copy everything to the main computer there. If I make any further ratings edits on this main machine, the XMP metadata is automatically updated as I do so. It then only takes a few seconds to copy just the updated XMP files across to the backup disk, replacing the old ones. Back at the studio I can again copy the most recently modified XMP files back to the main computer (overwriting the old XMP files). The photos in Bridge will then appear updated. So, if in the meantime the files on the studio computer happen to have been converted to DNG, it's important that the 'Ignore sidecar "xmp" files' option be now left unchecked, otherwise the imported xmp files will simply be ignored.

DNG files have embedded previews that represent how the image looks with the current applied Camera Raw settings. When 'Update embedded JPEG previews' is checked, this forces the previews in all DNG files to be continually updated based on the current Camera Raw settings, overriding previously embedded previews. It's important to point out here though that DNG previews created by Camera Raw can only be considered 100% accurate when viewed by other Adobe programs such as Lightroom or Bridge and even then, they must be using the same version of Camera Raw. While DNG is a safe format for the archiving of raw data, other DNG compatible programs that are not made by Adobe, or that use an earlier version of Camera Raw, will not always be able to read the Camera Raw settings that have been applied using the latest version of Camera Raw or Lightroom.

JPEG and TIFF handling

If 'Disable JPEG (or TIFF) support' is selected, all JPEG (or TIFF) files will always open in Photoshop directly. If 'Automatically open all supported JPEGs (or TIFFs)' is selected, this causes all supported JPEGs and TIFFs to always open via Camera Raw. However, if 'Automatically open JPEGs (or TIFFs) with settings' is selected, Photoshop will only open a JPEG or TIFF via Camera Raw if it has previously been edited via Camera Raw. When this option is selected you have the option in Bridge to use a double-click to open a JPEG directly into Photoshop, or use ⌘ R ctrl R to force JPEGs to open via Camera Raw. But note that when you edit the Camera Raw settings for that JPEG, the next time you use a double-click to open, it will default to opening via Camera Raw.

Camera Raw cropping and straightening

You can crop an image in Camera Raw before it is opened in Photoshop, but note that the cropping is limited to the bounds of the image area only. The crop you apply in Camera Raw is updated in the Bridge thumbnail and preview, and applied when the image is opened in Photoshop. However, if you save a file out of Camera Raw using the Photoshop format, there is an option to preserve the cropped pixels so you can recover the hidden pixels later. Meanwhile, the Camera Raw straighten tool can initially be used to measure a vertical or horizontal angle and apply a minimum crop to the image, which you can then resize accordingly.

A useful tip I learnt from Bruce Fraser was how you can use the Custom Crop menu option that's highlighted in Figure 3.23 to create a custom crop size using whatever units you like (Figure 3.22) and save this as a custom size output that matches the size required for a specific layout, or one that exceeds the standard output sizes available in the Workflow Options.

To remove a crop, open the image in the Camera Raw dialog again, select the crop tool and choose 'Clear Crop' from the Crop menu. Alternatively, you can hit *Delete* or simply click outside of the crop in the gray canvas area.

Figure 3.22 This shows the Custom Crop settings that can be accessed via the Crop Tool menu (Figure 3.23). The crop units can be adjusted to crop according to the 'Ratio' (the default option) or by pixels, inches or centimeters. In this example I set a custom pixel size that enabled me to render files at a larger pixel size than the maximum size currently allowed.

Figure 3.23 The Camera Raw Crop Tool menu includes a range of preset crop proportions. You can also add your own custom presets by clicking on Custom… (see Figure 3.22).

How to straighten and crop

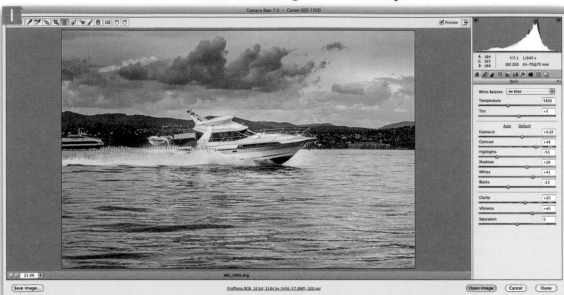

1 To straighten this photograph, I selected the straighten tool from the Camera Raw tools and dragged with the tool to follow the line that I wished to have appear straight.

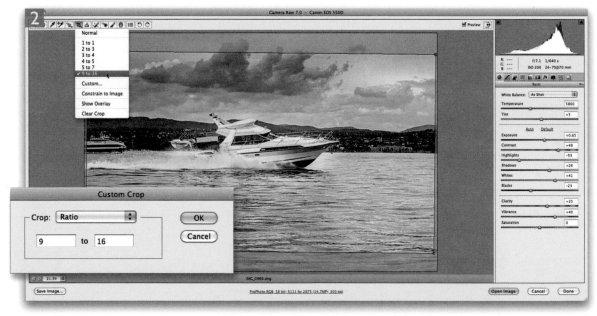

2 This action straightened the image. I could then click on the crop tool to access the Crop Tool menu and choose a crop ratio preset, or click on Custom… to create a new setting.

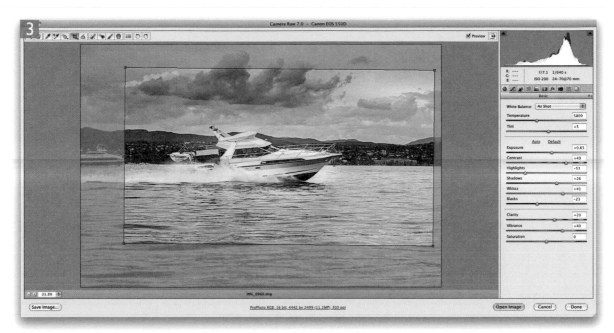

3 After creating and selecting a new custom 16:9 crop ratio setting, I dragged one of the corner handles to resize the crop bounding box as desired.

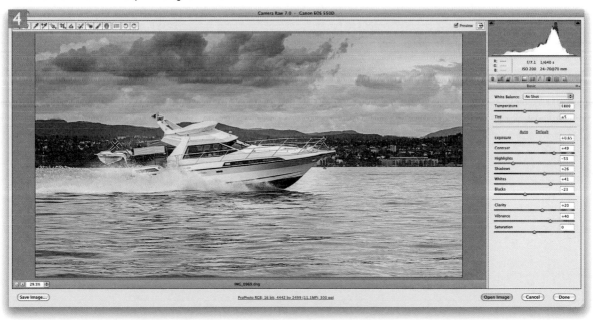

4 Finally, I deselected the crop tool by clicking on one of the other tools (such as the hand tool). This reset the preview to show a fully cropped and straightened image.

Figure 3.24 The Camera Raw Basic panel controls.

Figure 3.25 WhiBal™ cards come in different sizes and are available from RawWorkflow.com.

Basic panel controls

The Basic panel (Figure 3.24) is where you carry out the main color and tone edits to an image. Most photos can be improved by making just a few Basic panel edits.

White balance

Let's start with the white balance controls. These refer to the color temperature of the lighting conditions at the time a photo was taken and essentially describe the warmth or coolness of the light. Quartz-halogen lighting has a warmer color and a low color temperature value of around 3,400 K, while daylight has a bluer color (and a higher color temperature value of around 6,500 K). If you choose to shoot in raw mode it does not matter how you set the white point setting on the camera because you can always decide later which is the best white balance setting to use.

Camera Raw cleverly uses two color profile measurements for each of the supported cameras, one made under tungsten lighting conditions and another made using daylight balanced lighting. From this data, Camera Raw is able to extrapolate and calculate the white balance adjustment for any color temperature value that falls between these two white balance measurements, as well as calculating the more extreme values that go beyond either side of these measured values.

The default white balance setting normally uses the 'As Shot' white balance setting that was embedded in the raw file metadata at the time the image was taken. This might be a fixed white balance setting that you had selected on your camera, or it could be an auto white balance that was calculated at the time the picture was shot. If this is not correct you can try mousing down on the White Balance pop-up menu and select a preset setting that correctly describes which white balance setting should be used. Alternatively, you can simply adjust the Temperature slider to make the image appear warmer or cooler and adjust the Tint slider to balance the white balance green/magenta tint bias.

Using the white balance tool

The easiest way to set the white balance manually is to select the white balance tool and click on an area that is meant to be a light gray color (Figure 3.26). Don't select an area of pure white as this may contain some channel clipping and this will produce a

skewed result (which is why it is better to sample a light gray color instead). You will also notice that as you move the white balance tool across the image, the sampled RGB values are displayed just below the histogram, and when you click to set the white balance, these numbers should appear even.

There are also calibration charts such as the X-Rite ColorChecker chart, which can be used in carrying out a custom calibration, although the light gray patch on this chart is regarded as being a little on the warm side. For this reason, you may like to consider using a WhiBal™ card (Figure 3.25). These cards have been specially designed for obtaining accurate white point readings under varying lighting conditions.

Color temperature

Color temperature is a term that links the appearance of a black body object to its appearance at specific temperatures, measured in kelvins. Think of a piece of metal being heated in a furnace. At first it will glow red but as it gets hotter, it emits a red, then yellow and then a white glow. Indoor tungsten lighting has a low color temperature (a more orange color), while sunlight has a higher color temperature and emits a bluer light.

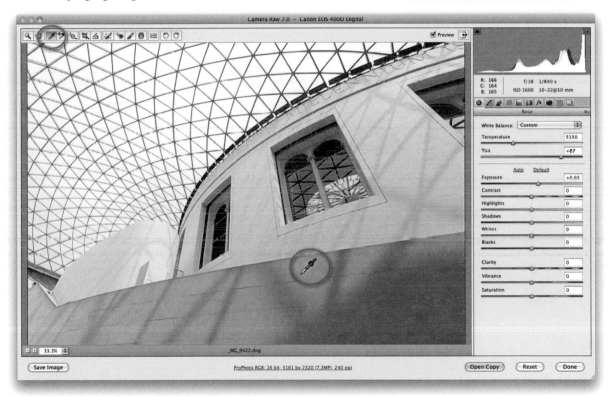

Figure 3.26 To manually set the white balance, select the white balance tool (circled) to locate what should be a light gray neutral area and click to update the white balance.

Camera Raw 4.1 and later

In the main body text I stated that the Camera Raw processing remained more or less exactly the same from version 1.0 through to Camera Raw 5.0. There was one aspect to Camera Raw behavior though that changed slightly. When Camera Raw 4.1 was released a certain amount of noise reduction became integral to the Camera Raw demosaic process. This displeased some users who preferred things the way they were prior to this. In Camera Raw 6.0 or later the Process 2003 rendering reverted to pre-Camera Raw 4.1 behavior with the noise reduction removed again. Consequently, Process 2003 will match pre Camera Raw 4.1 processing exactly, but images that have previously been processed in Camera Raw 4.1– 5.7 may appear slightly less sharp when using Process 2003 in Camera Raw 6.0 or later. You can compensate for this by adding 15–25% extra Luminance noise reduction in the Detail panel. But bear in mind that this only applies should you wish to preserve an image in the Process 2003 state. I assume that most readers will want to update such images to Process 2010 or 2012 rather than keep them in Process 2003.

Process Versions

Version 1.0 of Camera Raw was first released in late 2002 as an optional plug-in for Photoshop 7.1. Between then and October 2008, with the release of Camera Raw 5 in Photoshop CS4, Camera Raw underwent many changes. Later versions had the benefit of more tools to play with, such as Recovery, Fill Light, Clarity, Vibrance and localized adjustments, but the underlying demosaic processing remained (almost) unchanged. An image that had been processed in Camera Raw 1.0 could be opened in Camera Raw 5.0 and still look the same. With Camera Raw 6.0 in Photoshop CS5, Adobe completely revised the way raw data was demosaiced, plus they also updated the noise reduction and sharpening, as well as fine-tuning the Recovery and Fill Light controls. It was therefore necessary to draw a line between the old and new-style processing and this resulted in the need for 'process versions'. In Camera Raw 6.0 you could use the Process 2003 rendering to preserve the Develop settings in all your legacy files (raw, TIFF or JPEG) more or less exactly as they were (see sidebar on Camera Raw 4.1). You could then use the newer Process 2010 rendering to update your older files to the new processing method and take full advantage of the much-improved image processing capabilities in this latest version of Camera Raw. Process 2010 was also applied by default to all newly-imported photos.

Now with Camera Raw 7.0 in Photoshop CS6 we have yet another new process version: Process 2012. This time the change is just as radical. We now have a new set of Basic panel tone adjustment slider controls where the line-up includes: Exposure, Contrast, Highlights, Shadows, Blacks and Whites. Some of the names remain the same, but the Process 2012 sliders all behave quite differently compared to Process 2003/2010. I'll be explaining how these work shortly, but there are important reasons why it was felt necessary to introduce such changes. Firstly, Camera Raw has evolved a lot since it was first introduced. Initially, the Basic panel had just four tone control sliders: Exposure, Blacks, Brightness and Contrast. To this was added the Recovery and Fill Light sliders, by which time there was quite a bit of overlap between each of these sliders and the effect they would have on an image. For example, the Exposure, Recovery and Fill Light sliders all handled the highlights and shadows somewhat differently, but they would also have an effect on the image midtones and hence, the overall brightness. Yes, there was the Brightness slider that could

be used to adjust the midtones, but there was also confusion in some users' minds over the role of Brightness versus the Exposure slider. The other thing that could be said was wrong with the old set of tone controls was the lack of symmetry between highlight and shadow adjustments. Those of you who are familiar with Process 2003/2010 Camera Raw processing will know that small incremental adjustments to the Blacks slider have a much more pronounced effect on an image compared with an Exposure or Recovery adjustment. The new Process 2012 Basic panel tone sliders attempt to address these problems. The Exposure slider is slightly different in that it is now more of a midtones brightness slider rather than a highlight clipping adjustment. The Highlights and Shadows sliders have a more symmetrical response and can be used to adjust the shadow and highlight tones while leaving the midtones more or less unchanged (to be adjusted by Exposure). The Contrast slider can now be regarded as being more important as it can be used to compress or expand the entire tonal range, and the Blacks and Whites sliders allow you to fine-tune the black and white clipping at the extreme ends of the tonal range.

Another thing Process 2012 addresses is the discrepancy in the Camera Raw tone settings between raw and non-raw images. Previously, raw images would default to a Blacks setting of 5, a +50 Brightness and +25 Contrast. For non-raw files such as JPEGs and TIFFs, the equivalent default settings were all zero. With Process 2012 the default settings are now identical for both raw and non-raw files alike. Apart from removing the mystery as to why these settings had to be different, it is now possible to share and synchronize settings between raw and non-raw images more effectively. Lastly, the tone controls have been revised with an eye to the future and provide the ability to handle high dynamic range images. It isn't possible yet to process 32-bit images directly in Camera Raw and there aren't that many cameras out there that can effectively capture high dynamic range scenes using a single capture, but the Process 2012 controls have been planned with this in mind as a future possibility.

Whenever you edit a photo that's previously been edited in an earlier version of Camera Raw using Process 2003 or Process 2010, an exclamation mark button will appear in the bottom right corner of the preview (Figure 3.27) to indicate this is an older Process Version image. Clicking on the button updates the file to Process 2012, which then allows you to take advantage of

High contrast image processing

The redesign of the tone controls means that contrasty images of high dynamic range scenes can be processed more effectively. As camera manufacturers focus on better ways to capture high dynamic range scenes, the raw image processing tools will need to offer the flexibility to keep up with such developments.

Camera Raw rendering times

With Camera Raw 6, the Process 2010 rendering was more sophisticated than Process 2003 and, as a result of this, increased the amount of processing time that was required to render individual images. In some circumstances this could result in longer output processing times, such as when saving images or opening them in Photoshop. With Process 2012 for Camera Raw 7, this too has implications that will affect the image processing. At the same time, improvements have been made to the way the data is cached and read, which should make Camera Raw 7 processing overall faster.

Figure 3.27 This shows the Process Version update warning triangle. Note that you can ⌥-click (Mac), *alt*-click (PC) to bypass the subsequent warning dialog.

Figure 3.28 The Process Version setting can be accessed via the Camera Calibration panel.

Figure 3.29 The Process 2012 tone adjustment controls.

the latest image processing features in Camera Raw. Or, you can go to the Camera Calibration panel and select the desired Process Version from the Process menu shown in Figure 3.28. Here you can update to Process 2012 by choosing 2012 (Current). Should you wish to do so you can use this menu to revert to a previous Process 2010 or Process 2003 setting. Note that Camera Raw will attempt to match the legacy settings as closely as possible when updating to Process 2012.

The Process 2012 tone adjustment controls

Now that I have outlined the new changes in Process 2012, let's look at the Basic panel tone adjustment controls in more detail (Figure 3.29). You can adjust the sliders described here manually, plus you can click on the Auto button to auto-set the slider settings. Note that in this edition of the book I only discuss the new Process 2012 controls. If you want to know how to master the Process 2003/2010 controls, don't despair though – there is a 24-page PDF guide on Process 2010 image processing that you can download from the book website.

Exposure

With Process 2003 and 2010, as you adjusted the Exposure, Fill Light or Brightness sliders these would have an overlapping effect on an image's appearance and could all affect the midtones in different ways. Consequently an adjustment made to any one of these sliders could affect the overall image brightness. With Process 2012, there is now only one control for adjusting the overall brightness and that is the Exposure slider, which is essentially a blend of the old, 2003/2010 Exposure and Brightness sliders.

The adjustment units remain the same, ranging from −4.00 to +4.00, but apart from that everything about this slider is now different. Previously you would think of adjusting Exposure to set the highlight clipping point and perhaps adjust the Exposure in conjunction with the Fill Light slider to find an ideal combination that applied an appropriate Exposure level of brightness while retaining sufficient detail in the extreme highlights. You can still hold down the ⌥ *alt* key as you drag the Exposure slider to see a threshold preview that indicates any highlight clipping, but I would urge you to rethink the way you work with the Exposure slider. Consider it primarily as an 'Exposure brightness' adjustment. If you now try to preserve clipping using the Exposure

slider you'll quite possibly end up with an overdark image that you can't fully lighten with the Basic panel sliders alone. What you want to do now is to concentrate on the midtones rather than the highlights as you adjust the Exposure slider and use the Contrast, Highlights and Whites sliders to adjust the highlight clipping.

The Exposure slider's behavior is also dependent on the image content. Previously, with Process 2003/2010, as you increased the Exposure the highlights would at some point 'hard clip'. Also, as you increased the Exposure slider further, there was a tendency for color shifts to occur in the highlights as one or more color channels began to clip. With Process 2012, as you increase Exposure there is more of a 'soft clipping' of the highlights as the highlight clipping threshold point is reached. Additional increases in Exposure behave more like a Process 2010 Brightness adjustment in that the highlights roll off smoothly instead of being clipped. As you further increase Exposure you will of course see more and more pixels mapping to pure white, but overall, such Exposure adjustments should result in smoother highlights and reduced color shifts.

Contrast

The Process 2012 Contrast slider also behaves slightly differently now. With any contrast type adjustment there is a midpoint and as you increase the contrast the tones on one side get darker and the other lighter. As you reduce contrast the opposite happens. With Process 2003/2010 the midpoint was always fixed (see Figure 3.30). With Process 2012 the midpoint varies slightly according to the content of the image. So with low key images the midpoint shifts slightly more to the left and with high key images, it shifts more to the right. Consequently, the Contrast slider behavior adapts slightly according to the image content and should allow you to better differentiate the tones in the tone areas that predominate.

Basically, you need to think of the Exposure slider as the control for establishing the midtone brightness and the Contrast slider as the control for setting the amount of contrast around that midpoint. By working with just these two sliders you can fairly quickly get to a point where you have an image with more or less the right brightness and contrast. Everything you do from there on with the remaining sliders is about fine-tuning this initial outcome. Highlights and Shadows help you reveal more tone detail either side of the Exposure midpoint and Whites and Blacks allow you (where required) to fine-tune the white and black clipping points.

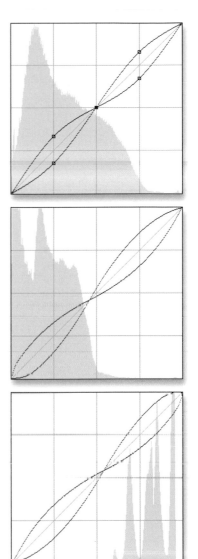

Figure 3.30 The Contrast slider in Process 2012 works slightly differently to its Process 2010 counterpart. It now automatically varies the midpoint setting depending on the image content. In the top Curve diagram the Process 2010 midpoint is locked in the center. With Process 2012 the midpoint can shift left or right depending on whether you are processing a low key or high key image.

Extreme Highlights/Shadows

As you play around with the new controls you'll notice that the Highlights and Shadows adjustments have the potential to apply quite strong corrections when bringing out detail in the shadow and highlight areas. If you prefer a more natural look then you are advised to keep your adjustments within the ± 50 range. As you go beyond this, Camera Raw uses a soft edge tone mapping method to compress the tonal range. This technique is similar to that used when converting high dynamic range images to low dynamic range versions, such as when using the HDR Toning adjustment in Photoshop or the Photomatix program. As you increase the amounts applied in the Highlights or Shadows sliders you will start to get more of an 'HDR effect' type look, though this will be nothing like as noticeable as the obvious halo effects associated with a typical HDR processed image. These are promising signs of how Camera Raw may one day function as a high dynamic range image editor.

Going in the other direction it is now possible to apply negative Shadows adjustments to darken the shadows – this can be useful where you wish to darken just the shadows to add more contrast. Similarly, you can apply positive Highlights adjustments in order to lighten the whites in images where the highlight tones need extra lifting.

The Highlights and Shadows controls also inform the Whites and Blacks how much tonal compression or expansion has been applied and the Whites and Blacks controls adjust their ranges automatically taking this into account.

One of the things that tends to confuse some people is the fact that as well as the Contrast adjustment in the Basic panel there is also a separate Tone Curve panel that can be used to adjust contrast. Basically, The Tone Curve panel sliders are useful for fine-tuning the image contrast *after* you have adjusted the main Contrast slider. Note that increasing the contrast does not produce the same kind of unusual color shifts that you sometimes see in Photoshop when you use Curves. This is because the Camera Raw processing manages to prevent such hue shifts when you pump up the contrast.

Highlights and Shadows

The Highlights and Shadows sliders should be regarded as the 'second-level' tone adjustment controls that you apply after you have adjusted the Exposure and Contrast. Highlights and Shadows are essentially improved versions of Recovery and Fill Light. The important things to note here is that they work exactly the same, but from opposite ends of the tonal scale. They are also symmetrical in behavior and their range extends just slightly beyond the midtone region. A Highlights adjustment won't affect the dark areas and similarly, a Shadows adjustment won't affect the light areas. So, by using these two sliders it is easier to work on the shadow and highlight regions independently without affecting the overall image brightness. This is because the midtones will mostly remain unchanged, where they can be better governed by an Exposure slider adjustment. Overall, this is a better way of working because it is now clearer which control it is you need to grab when adjusting the highlights or shadows and the results are better too. For example, with Process 2003/2010, a Recovery adjustment to restore more detail in the highlights would quickly flatten out and soften the highlight tones. A Fill Light adjustment would have a much bolder effect on the shadows, but would also be influenced by the Blacks setting, which in turn would affect how far into the midtones a Fill Light adjustment would lighten. The new process 2012 setup with the Highlights and Shadows sliders is now more consistent and easier to use.

You can also hold down the ⎇ `alt` key as you drag a slider to see a threshold preview, which indicates any highlight or shadow clipping. I would say that a threshold preview analysis at this stage is 'helpful' rather than essential.

Whites and Blacks

The Whites and Blacks sliders can be used to fine-tune the extremes of the tonal range. In most instances it should be possible to achieve the look you are after using just the first four sliders, namely: Exposure, Contrast, Highlights and Shadows. Should you find it necessary to further tweak the highlight and shadows, you can use the Whites and Blacks sliders to precisely determine how much the shadows and highlights should be clipped, while preserving the overall tonal relationships in the image. These controls do offer less range. This is because they are primarily intended for fine-tuning the endpoints after the overall tonal relationships in the image have been established. As with the Highlights and Shadows sliders, you can hold down the [⎇] [alt] key as you drag a slider to see a threshold preview and this will indicate any highlight or shadow clipping. At this stage a threshold preview analysis can be particularly useful. You can also rely on the highlight clipping indicator (discussed on page 180) to tell you which highlights are about to be clipped. It should be noted here that the direction of the Blacks slider adjustment is reversed in Process 2012 and the old zero value for the Blacks slider is now equivalent to a +25 adjustment. Previously you had a scale of 0–5, but you can now work with a scale of +25–0, and it is now easier to fine-tune a blacks clipping adjustment. Also, the Blacks range is automatically calculated on an image by image basis (see sidebar).

Suggested order for the Basic panel adjustments

The first step should be to set the Exposure to get the overall image brightness looking right. After that you will want to use the Contrast slider to set the contrast. You can judge this visually on the display and maybe also reference the Histogram to see what type of Contrast adjustment would be appropriate. After that, use the Highlights and Shadows sliders to fine-tune the highlight and shadow regions. By this stage you should be almost there. Only if you feel it is necessary to improve the image further should it be necessary to adjust the Whites and Blacks sliders as well.

You might initially like to limit some of your adjustments so that you only apply negative Highlights, positive Shadows and positive Blacks slider adjustments. Working in this constrained fashion will allow you to work more within Process 2003/2010 limits. This may help you gain a better understanding of the Process 2012 controls until you are more comfortable with them.

Extreme Whites/Blacks

Working with the Whites and Blacks sliders you can correct for extreme highlights and shadows by adjusting them to reveal more detail. But you can also push them the other way in order to decrease shadow or highlight detail. For example, you might want to apply a positive Whites adjustment to deliberately blow out certain highlights. And you might also want to use a negative Blacks adjustment in order to make a dark background go completely black. See also the section on localized adjustments and how it is useful to apply such corrections via the adjustment brush. Note that images where the Blacks slider has been run up the scale using Process 2003/2010 will most likely appear somewhat different after a conversion. The new Process 2012 Blacks slider tends to back off quite a bit.

Auto-calculated Blacks range

Previously, in Process 2003/2010, it was not always possible to crush the Blacks completely when editing a low contrast image. This was because the Blacks range was fixed. In Process 2012, the Blacks range is auto-calculated based on the image content. This means that when editing a low contrast image, such as a foggy or hazy, distant landscape, the Blacks range adapts so that you should always be able to crush the darkest tones in the image. Also, the Blacks adjustment will become increasingly aggressive as you get closer to a −100 value. This means that you gain more range when processing such images, but at the expense of some precision.

Highlight recovery technology

Camera Raw features an internal technology called 'highlight recovery'. This is designed to help recover luminance and color data in the highlight regions whenever the highlight pixels are partially clipped. In other words, when one or more of the red, green and blue channels are partially clipped, but not all three channels are affected. Initially, the highlight recovery process looks for luminance detail in the non missing channel or channels and uses this to build luminance detail in the clipped channel or channels. This may be enough to recover the missing detail in the highlights. After that Camera Raw also applies a darkening curve to the highlight region only, and in doing so brings out more detail in the highlight areas. Note that this technology is designed to work for raw files only, although JPEG images can sometimes benefit too (but not so much).

Process 2012 has taken this further to provide improved highlight color rendering, which preserves the partial color relationships as well as the luminance texture in the highlights. You should now find that highlight detail is rendered better. There is also less tendency for color detail to quickly fade to neutral gray and better preservation of the highlight detail.

Preserving the highlight detail

The Exposure slider's response correlates quite well with the way film behaves and you should also find that the latest Process 2012 provides you with about an extra stop of exposure latitude compared to editing with the Process 2003/2010 Exposure slider. As you apply basic adjustments in Camera Raw, you will want to make the brightest parts of the photo go to white so the highlights are not too dull. At the same time though, you will want to ensure that important highlight detail is always preserved. This means taking care not to clip the highlights too much, since this might otherwise result in important highlight detail being lost when you come to make a print. You therefore need to bear in mind the following guidelines when deciding how the highlights should be clipped.

Where you should set the highlight clipping point is really dependent on the nature of the image. In most cases you can adjust the Highlights, followed by the Whites slider so that the highlights just begin to clip and not worry about losing any important highlight detail. If the picture you are editing contains a lot of delicate highlight information then you will want to be careful when setting the highlight point so that the brightest whites in the photo are not too close to the point where the highlights become clipped. The reason for this is all down to what happens when you ultimately send a photo to a desktop printer or convert an image to CMYK and send it to press to be printed. Most photo inkjet printers are quite good at reproducing highlight detail at the top end of the print scale, but at some point you will find that the highest pixel values do not equate to a printable tone on paper. Basically, the printer may not be able to produce a dot that is light enough to print successfully. Some inkjet printers use light colored inks such as a light gray, light magenta and light cyan to complement the regular black, gray, cyan, magenta, yellow ink set and these printers are better at reproducing feint highlight detail. CMYK press printing is a whole other matter. Printing presses will vary of course, but there is a similar problem where a halftone dot may be too small for any ink to adhere to the paper. In all the above cases there is an upper threshold limit where the highlight values won't print. So, when you are adjusting the Highlights and Whites sliders, it is important to examine the image and ask yourself if the highlight detail matters or not.

Some pictures may contain subtle highlight detail (such as in Figure 3.31), where it is essential to make sure the important highlight tones don't get clipped. Other images may look like the example over the page in Figure 3.32. Here, the light reflecting off a shiny metal surface creates bright, specular highlights and the last thing you need to concern yourself with is preserving the highlight detail. I would say that most images contain at least a few specular highlights and it is only where you have a photo like the one shown below, in Figure 3.31, where you have to pay particular attention to ensure the brightest highlights aren't totally clipped.

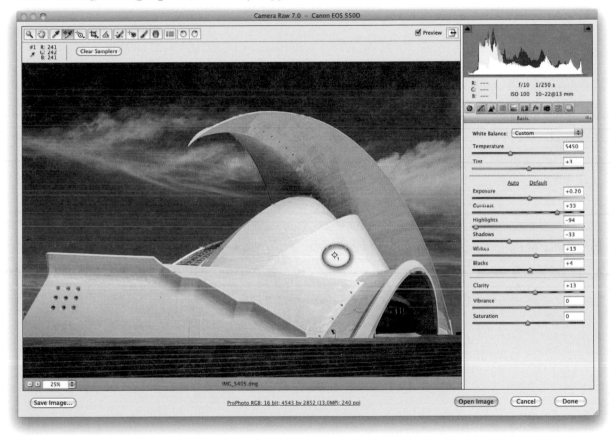

Figure 3.31 In this example it was important to preserve the delicate highlight tones in the Auditorio de Tenerife building. To be absolutely sure that I didn't risk making the highlight detail areas too bright, I placed a color sampler (circled) over an area that contained important highlight detail. This allowed me to check that the RGB highlight value did not go too high. In this case I knew that with a pixel reading of 241,242,241, the highlight tones in this part of the picture would print fine using almost any print device.

White backdrops

For studio shots with a white background, you usually want the backdrop to reproduce as white. If you do this with the lighting you need to ensure the lighting ratios are balanced so that important detail in the subject highlights isn't clipped. It is best not to overexpose the white background exposure too much at the capture stage. One can always force the background tones to white when editing in Camera Raw by applying a positive Highlights and/or Whites adjustment (or edit the image in Photoshop).

When to clip the highlights

As I say, you have to be careful when judging where to set the highlight point. If you clip too much then you risk losing important highlight detail. However, what if the image contains bright specular highlights, such as highlight reflections on shiny metal objects? The Figure 3.32 image has specular highlights which contain no detail. It is therefore safe to clip these highlights, because if you were to clip them too conservatively you would end up with dull highlights in your prints. In this case the aim is for the shiny reflections to print to paper white. So when adjusting the Highlights and Whites slider for a subject like this, you would use the Exposure slider to visually decide how bright to make the photo and not be afraid to let the specular highlights blow out to white when adjusting the Highlights and Whites sliders.

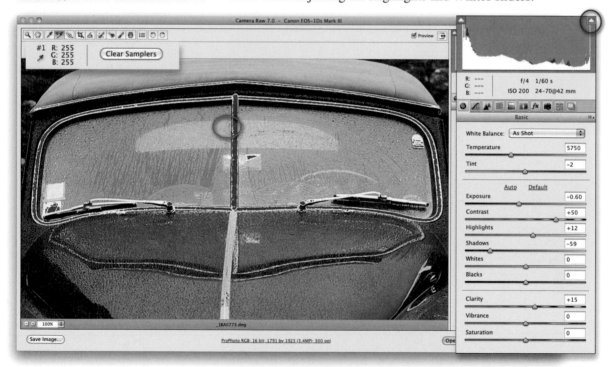

Figure 3.32 The highlights in this photograph contain no detail, so there is no point in trying to preserve detail in the shiny areas as this would needlessly limit the contrast. One can safely afford to clip the highlights in this image without losing important image detail and as you can see here, the color sampler over the shiny reflection (circled in orange) measures a highlight value of 255,255,255. With images like this it is OK to let the highlights burn out. Note that the highlight clipping warning is checked (circled in red) and the colored overlay in the preview image indicates where there is highlight clipping.

How to clip the shadows

Setting the black clipping point is, by comparison, a much easier thing to do. Put aside any concerns you might have about matching the black clipping point to a printing device, I'll explain how that works over the next two pages. Blacks slider adjustments are simply about deciding where you want the shadows to clip. The default setting is now 0 and this will usually be about right for most images. With some images, where the initial clipping appears too severe, you may want to ease the clipping off by dragging the Blacks slider more to the right, but it is inadvisable to lighten the Blacks too much. Some photos, such as the one shown below in Figure 3.33, can actually benefit from a heavy black clipping so that the dark areas print to a solid black.

Hiding shadow noise

Raising the threshold point to where the shadows start to clip is one way to add depth and contrast to your photos. It can also help improve the appearance of an image that has very noisy shadows.

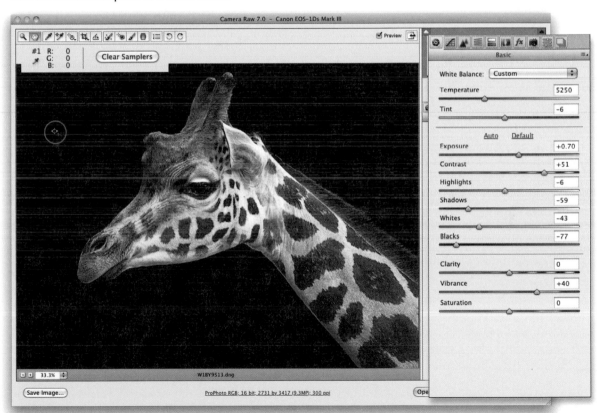

Figure 3.33 In this picture you can see that the Blacks in this photo are well and truly clipped. This is because I deliberately wanted to force any shadow detail in the backdrop to a solid black. As you can see, the color sampler over the backdrop in this picture (circled) showed an RGB reading of 0,0,0.

Is it wrong to set levels manually?

All I am suggesting here is that it is an unnecessary extra step to use Photoshop to set the black output levels to anything higher than the zero black after you have already set the black clipping at the Camera Raw editing stage (or have done so in Photoshop). If you do set the black output levels manually to a setting that is higher than zero you won't necessarily get inferior print outputs, providing that is, you set the black levels accurately and don't set them any higher than is needed. And there's the rub: how do you know how much to set the output levels, and what if you want to output a photo to more than one type of print paper? You see, it's easier to let Photoshop work this out for you automatically. Some picture libraries are quite specific about how you set the output levels, but their suggested settings are usually very conservative and unlikely to result in weak shadows when printed to most devices. It is therefore probably better to oblige the libraries and just give them what they ask for, rather than fight them over the logic of their arguments. The only time when you may need to give special consideration to setting the shadows to anything other than zero is when you are required to edit an already converted CMYK or grayscale file that is destined to go to a printing press, where the black output levels have been set incorrectly. However, if you use Photoshop color management properly you are unlikely to encounter such problems.

Shadow levels after a conversion

You will sometimes come across advice saying that the output levels for the black point in an RGB image should be set to something like 20,20,20 (for the Red, Green, Blue RGB values). The usual reason given for this is because anything darker than, say, a 20,20,20 shadow value will reproduce in print as a solid black. Just to add to the confusion, different numbers are suggested for the output levels: one person suggests using 10,10,10, while another advises you use 25,25,25. In all this you are probably left wondering how to set the Blacks slider in Camera Raw, since you can only use it to clip the black input levels and there is no control for setting the black output levels so that they match these suggested output settings.

This is one of those areas where the advice given is more complex than it needs to be. It is well known that because of factors such as dot gain, it has always been necessary to make the blacks in a digital image slightly lighter than the blackest black (0,0,0,) before outputting it to print. As a result of this, in the early days of digital imaging, the only way to get a digital image to print correctly was to *manually* adjust the output levels so that the black clipping point matched the print device. Back then, if you set the levels to 0,0,0, RGB, the blacks would print too dark and you would lose detail in the shadows. Therefore the solution was to set the output levels point to a value higher than this (such as 20,20,20 RGB), so that the blacks in the image matched the blackest black for the print device. These are the historical reasons for such advice, because the black levels had to be adjusted differently for each type of print output including CMYK prepress files.

For the last 14 years or so, Photoshop has had a built-in automated color management systems that's designed to take care of the black clipping at the output stage. The advice these days is therefore quite simple: you decide where you want the blackest blacks to be in the picture and clip them to 0,0,0, RGB (as discussed on the previous page). When you save the image out to Photoshop as a pixel image and send the image data to the printer, the Photoshop or print driver software automatically calculates the precise amount of black clipping adjustment that is required for each and every print/paper combination. In the Figure 3.34 example you can see how the black clipping point for different print papers is automatically compensated when converting the

data from the edited image to the profile space for the printing paper. Don't just take my word, it is easy to prove this for yourself. Open an image (almost any will do), set the Channel display in the Histogram panel to Luminosity and refresh the histogram to show the most up-to-date histogram view (you do this by clicking on the yellow warning triangle in the top right corner). Once you have done this go to the Edit menu, choose Convert to Profile and select a CMYK or RGB print space. You'll need to refresh the histogram display again, but once you have done so you can compare the before and after histograms and check what happens to the black clipping point.

Original histogram – ProPhoto RGB

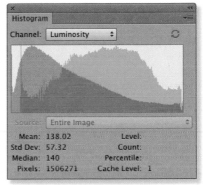

Innova Fibraprint glossy paper

Figure 3.34 The Histogram panel views on the right show (top) the original histogram for this ProPhoto RGB image. The middle histogram shows a comparison of the image histogram after converting the ProPhoto RGB data to a print profile space for Innova Fibraprint glossy paper printed to an Epson 4800 printer. The print output histogram is overlaid here in green and you can see how the black levels clipping point has been automatically indented. The bottom example shows a standard CMYK conversion to the US Web coated SWOP profile, colored green so that you can compare it more easily with the before histogram. Again, the black clipping point is moved inwards to avoid clogging up the shadow detail. Please note that the histograms shown here were all captured using the Luminosity mode since this mode accurately portrays the composite luminance levels in each version of the image.

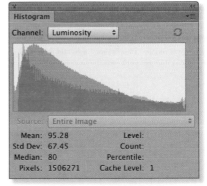

US Web coated SWOP CMYK

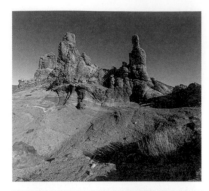

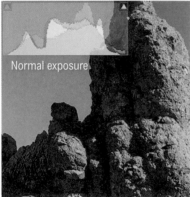

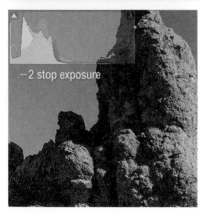

Figure 3.35 This shows the difference the exposure can make in retaining shadow information. The darker the exposure, the fewer discreet levels that can be captured via the camera sensor. This will result in poorly recorded shadow detail.

Digital exposure

Compared with film, shooting with a digital camera requires a whole new approach to determining what the optimum exposure should be. With film you tended to underexpose slightly for chrome emulsions (because you didn't want to risk blowing out the highlights). With negative emulsion film it was considered safer to overexpose as this would ensure you captured more shadow detail and thereby recorded a greater subject tonal range.

When capturing raw images on a digital camera it is best to overexpose as much as it is safe to do so before you start to clip the highlights. Most digital cameras such as digital SLRs and even the raw-enabled compacts are capable of capturing 12 bits of data, which is equivalent to 4096 recordable levels per color channel. As you halve the amount of light that falls on the chip sensor, you potentially halve the number of levels that are available to record an exposure (see Figure 3.36). Let us suppose that the optimum exposure for a particular photograph at a given shutter speed is f16. This exposure makes full use of the chip sensor's dynamic range and consequently there is the potential to record up to 4096 levels of information. If one were then to halve the exposure to f22, you would only have the ability to record up to 2048 levels per channel. It would still be possible to lighten the image in Camera Raw or Photoshop to create an image that appeared to have similar contrast and brightness. But (and it's a big but), that one stop exposure difference has immediately lost you half the number of levels that could potentially be captured using a one stop brighter exposure. The image is now effectively using only 11 bits of data per channel instead of 12. This is true of digital scanners too. Perhaps you may have already observed how difficult it can be to rescue detail from the very darkest shadows, and how these can end up looking posterized. Also, have you ever noticed how much easier it is to rescue highlight detail compared with shadow detail when using the Shadows/Highlights adjustment? This is because far fewer levels are available to define the information recorded in the darkest areas of the picture and these levels are easily stretched further apart as you try to lighten the shadows. This is why posterization is always much more noticeable in the shadows (see Figure 3.35). It also explains why it is important to target your digital exposures as carefully as possible so that you capture the brightest exposures possible, but without the risk of blowing out the highlight detail.

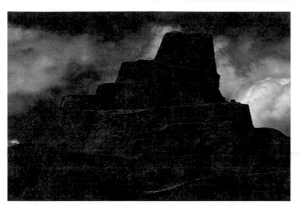 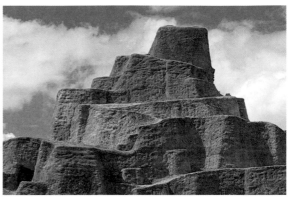

Figure 3.36 If you could inspect a raw capture image in its native, linear gamma state, it would look something like the image shown top left. Notice that the picture is very dark and is lacking in contrast. During the raw conversion process, a gamma curve correction is applied when converting the linear data so that the processed image matches the way we are used to viewing the relative brightness in a scene. The picture top right shows the same image after a basic raw conversion. As a consequence of this, the more brightly exposed areas will preserve the most tonal information and the shadow areas will end up with fewer levels. A typical CCD sensor can capture up to 4096 levels of tonal information. Half these levels are recorded in the brightest stop exposure range and the recorded levels are effectively halved with every stop decrease in exposure. The digital camera exposure is therefore quite critical. Ideally, you want the exposure to be as bright as possible so that you make full use of the Levels histogram, but at the same time be careful to make sure the highlights don't get clipped.

Camera histograms

As I have mentioned already in this book, the histogram that appears on a compact camera or digital SLR screen is unreliable for anything other than JPEG capture. This is because the histogram you see there is usually based on the camera-processed JPEG and is not representative of the true raw capture. The only way to check the histogram for a raw capture file is to open the image via a raw processing program such as Camera Raw or Lightroom.

How Camera Raw Interprets the raw data

Camera sensors have a linear response to light and unprocessed raw files therefore exist in a 'linear gamma space'. Human vision on the other hand interprets light in a non-linear fashion, so one of the main things a raw conversion has to do is to apply a gamma correction to the original image data to make the correctly exposed, raw image look the way our eyes would expect such a scene to look. The preview image you see in the Camera Raw dialog presents a gamma corrected preview of the raw data, while the adjustments you apply in Camera Raw are in fact being applied directly to the raw linear data. The reason I mention this is to illustrate one aspect of the subtle but important differences between the tonal edits that can be made in Camera Raw to raw files and those that are applied in Photoshop where the images have already been 'gamma corrected'. Note that in the case of non-raw files, Camera Raw has to temporarily convert the image to a linear RGB space to carry out the image processing calculations.

Basic panel image adjustment procedure

1 Here you can see the starting point for this image where the Basic panel settings have all been set to their default values.

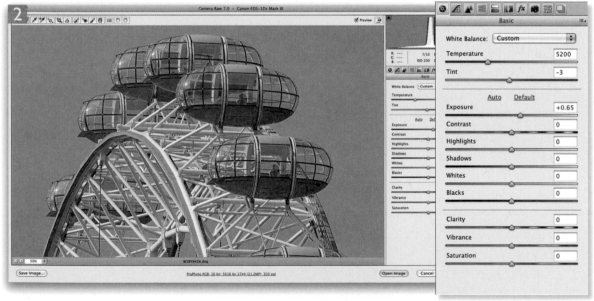

2 To begin with I used the white balance tool to adjust the white point. I then used the Exposure slider to adjust the midtone brightness and lighten the image.

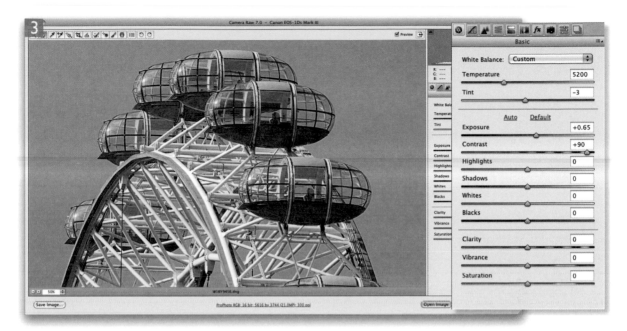

3 Next, I adjusted the Contrast to increase the contrast in the photo. You'll notice that I needed to apply quite a strong increase here.

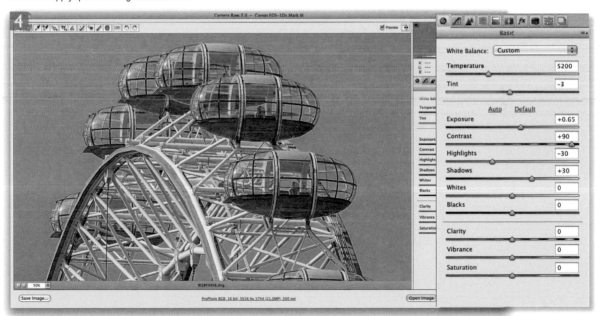

4 Here you can see that I reduced the Highlights to restore more detail in the highlight areas and increased the Shadows to lift the darker areas.

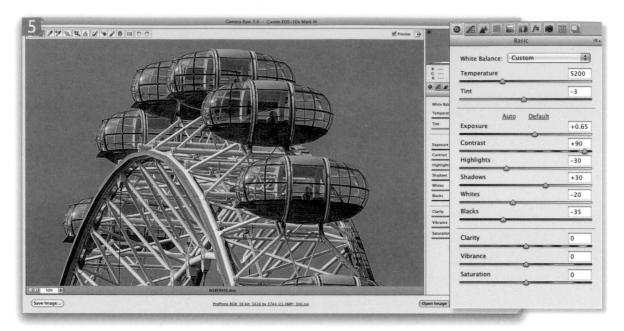

5 In this step I reduced both the Whites and Blacks sliders to fine-tune the white and black clipping points.

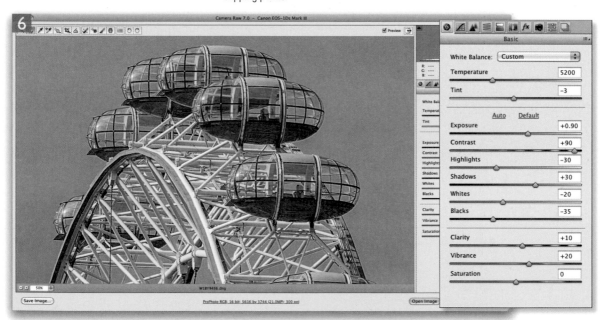

6 Finally, I readjusted the Exposure to rebalance the overall brightness of the photo, plus I added some positive Clarity and Vibrance.

Auto tone corrections

Camera Raw has the useful ability to apply auto tone corrections. To do this, just click on 'Auto' (⌘ U ctrl U) in the Camera Raw dialog (circled in Figure 3.37). An auto tone adjustment will affect the Exposure, Contrast, Highlights, Shadows, Whites and Blacks and is to some extent affected by the white balance setting. This is also noticeable when making auto grayscale adjustments. Here too, the white balance settings have an impact. If you adjust the Temp and Tint white balance controls in the Basic panel and then select the Convert to Grayscale box in the HSL/Grayscale panel, as shown in Step 2 on page 407 (with Auto enabled), you will see the Grayscale sliders readjust according to the white balance settings. Auto tone adjustments work really well on most images, such as outdoor scenes and naturally-lit portraits, but works less well on photographs that have been shot in the studio under controlled lighting conditions. In these instances it is best not to use Auto.

Camera-specific default settings

The Default Image Settings section of the Camera Raw preferences allows you to make any default settings camera-specific. If you go to the Camera Raw fly-out menu options shown in Figure 3.38, there is an option that allows you to 'Save New Camera Raw Defaults' as the new default setting to be used every time Bridge or Camera Raw encounters a new image. On its own, this menu item allows you to create a default setting based on the current Camera Raw settings and apply this to all subsequent photos (except where you have already overridden the default settings). However, if the 'Make defaults specific to the camera serial number' option is selected in the Camera Raw preferences, selecting 'Save New Camera Raw Defaults' only applies this setting as a default to files that match the same camera serial number. Similarly, if the 'Make defaults specific to camera ISO setting' option is checked, this allows you to save default settings for specific ISO values. And when both this and the previous option are checked, you can effectively have in Camera Raw multiple default settings that take into account the combination of the camera model and ISO setting. You do have to be careful how you go about using the 'Save New Camera Defaults' option. When used correctly you can cleverly set up Camera Raw to apply appropriate default settings for any camera and ISO setting. However, it is all too easy to make a

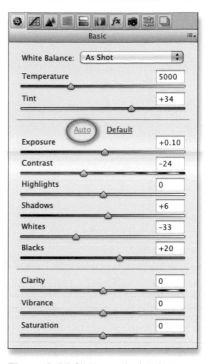

Figure 3.37 Clicking on the Auto button applies an auto adjustment to the Basic panel settings in Camera Raw. This auto-adjusts the Exposure, Contrast, Highlights, Shadows, Whites and Blacks settings. You can also use *Shift*+double-click to apply an auto setting to individual sliders.

mistake, or worse still, select the 'Reset Camera Defaults' option and undo all your hard work!

The main thing to watch out for is that you don't include too many Camera Raw adjustments (such as the HSL/Grayscale panel settings) as part of a default setting. One approach is to open a previously untouched image, apply a Camera Calibration panel adjustment plus, say, a Lens Profile correction setting and save this as a camera-specific default. You might find it useful to adjust the Detail panel noise reduction settings for an image shot at a specific ISO setting and save this as a 'Make defaults specific to camera ISO setting'. Or, you might like to check using both Camera Raw preference options and setup defaults for different ISO settings with specific cameras.

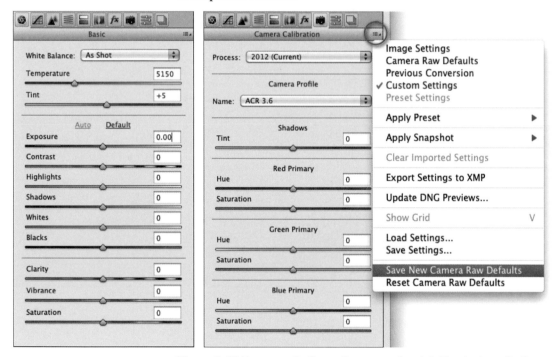

Figure 3.38 You can use the Camera Raw menu option circled here to choose the 'Save New Camera Raw Defaults'. This saves all the current Camera Raw settings as a default setting according to how the preferences are set in Figure 3.19. The important thing to bear in mind here is to ensure the Basic panel settings have all been set to their defaults first.

Clarity

The Clarity slider is the first of three 'Presence' controls in Camera Raw. Adding Clarity to a photo can be thought of as adding sharpness, but it is more accurate to say that Clarity is 'adding localized, midtone contrast'. In other words, the Clarity slider can be used to build up the contrast in the midtone areas by effectively applying a soft, wide radius unsharp mask type of filter. Consequently, when you add a positive Clarity adjustment, you will notice increased tonal separation in the midtone areas. By applying a small positive Clarity adjustment you can therefore increase the local contrast across narrow areas of detail and a bigger positive Clarity adjustment increases the localized contrast over broader regions of the photo. Positive Clarity adjustments now utilize the new tone mapping logic that is employed for the Highlights and Shadows sliders. As a result of this halos either side of a high contrast boundary edge should appear reduced.

How much Clarity should you add?

All photos can benefit from adding a small amount of Clarity. I would say, a +10 value works well for most pictures. However, you can safely add a maximum Clarity adjustment if you think a picture needs it (such as in the Figure 3.39 example shown below). But note that in terms of strength, a maximum Clarity adjustment is now roughly double what it was in Process 2010.

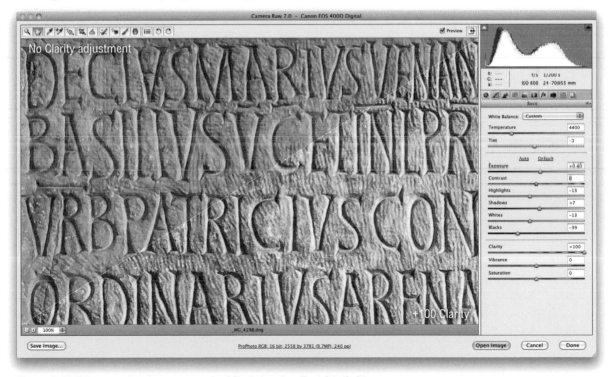

Figure 3.39 This screen shot shows an example of Clarity in action. The left half of the Camera Raw preview shows how the photo looked before Clarity was added and the right half of the preview shows Clarity being applied using a maximum +100 value.

Negative clarity

Just as you can use a positive clarity adjustment to boost the
midtone contrast, you can also apply a negative clarity adjustment
to soften the midtones. There are two uses that come to mind here.
Clicio Barroso and Ettore Causa suggested that a negative clarity
adjustment could be useful for softening skin tones in portrait and
beauty shots (see Figure 3.40). This works great if you use the
adjustment brush tool (discussed on pages 235–245) to apply a
negative clarity in combination with a sharpening adjustment. The
other idea I had was to use negative clarity to simulate a diffusion
printing technique that used to be popular with a lot of traditional
darkroom printers. In Figure 3.41 you can see examples of a before
and after image where I used a maximum negative clarity to soften
the midtone contrast to produce a kind of soft focus look. You will
also find that this technique works particularly well with photos
that have been converted to black and white. Note that negative
Clarity adjustments remain unchanged and don't use the new tone
mapping logic.

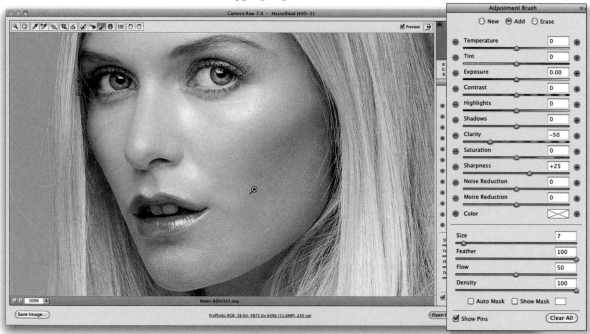

Figure 3.40 This shows the results of an adjustment brush applied using the
combination of a −50 Clarity effect with a +25 Sharpness effect to produce the skin
softening look achieved here. I applied this effect a little stronger than I would do normally
in order to really emphasize the skin softening effect.

Figure 3.41 This shows a before version (top) and an after version (below), where I applied a −100 Clarity adjustment.

Negative vibrance and saturation

Not all of us want to turn our photographs into super-colored versions of reality. So it is worth remembering that you can use the Vibrance and Saturation sliders to apply negative adjustments too. If you take the Saturation down to -100, this converts an image to monochrome, but lesser negative Saturation and Vibrance adjustments can be used to produce interesting pastel-colored effects.

Vibrance and Saturation

The Saturation slider can be used to boost color saturation, but extreme saturation adjustments will soon cause the brighter colors to clip. However, the Vibrance slider can be used to apply what is described as a non-linear color saturation adjustment, which means colors that are already brightly saturated in color remain relatively protected as you boost the vibrance, whereas the colors that are not so saturated receive a greater saturation boost. The net result is a saturation control that allows you to make an image look more colorful, but without the attendant risk of clipping those colors that are saturated enough already. Try opening a photograph of some brightly colored flowers and compare the difference between a Vibrance and a Saturation adjustment to see what I mean. The other thing that is rather neat about the Vibrance control is that it has a built-in skin tone protection filter which does rather a good job of not letting the skin tones increase in saturation as you move the slider to the right. In Figure 3.42, I set the Vibrance to +55, which boosted the colors in the dress, but without giving the model too 'vibrant' a suntan.

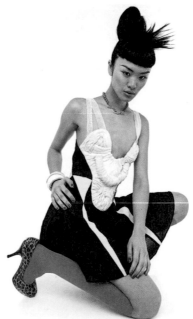

Model: Kelly @ Zone

Figure 3.42 Boosting the colors using the Vibrance control in the Basic panel.

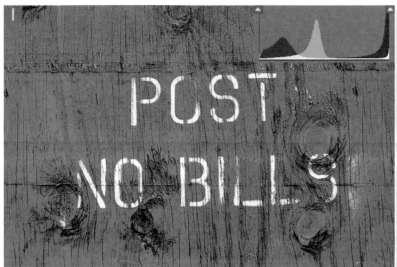
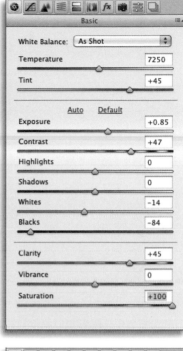

1 In this example you can see what happens if you choose to boost the saturation in a photo using the Saturation slider only to enrich the colors. If you look at the histogram you will notice how the blue channel is clipped. This is what we should expect, because the Saturation slider in Camera Raw applies a linear adjustment that pushes the already saturated blues off the histogram scale.

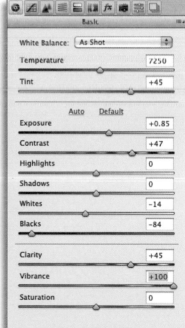

2 Compare what happens when you use the Vibrance slider instead. In this example you will notice how none of the blue channel colors are clipped. This is because the Vibrance slider boosts the saturation of the least saturated colors most, tapering off to a no saturation boost for the already saturated colors. Hence, there is no clipping in the histogram.

Linear contrast in Process 2012

The default Tone Curve for Process 2003/2010 applies a Medium Contrast curve, whereas the Process 2012 default is now 'Linear'. However, the Linear setting in Process 2012 actually applies the same Tone Curve kick to the shadows as the old Medium Contrast setting. Adobe simply recalibrated the underlying tone curve settings in Process 2012 so that Medium Contrast is now the new 'Linear' starting point. The important thing here is that the starting point in Process 2003/2010 and Process 2012 is actually the same. It's only the names and how the Tone Curve is represented in the Point Curve editor mode that have changed.

Tone Curve panel

The Tone Curve panel offers a fine-tuning contrast control that can be applied in addition to the tone and contrast adjustments made in the Basic panel. There are two modes of operation available here: parametric and point. We'll look at the parametric controls first. The starting point is a straight curve, though in actual fact, the underlying tone curve does actually apply a small amount of contrast (see sidebar). When editing a Tone Curve in parametric mode you use the Tone Curve panel slider controls to control the curve shape. This is essentially a more intuitive method to work with, plus you can also use the target adjustment tool (T) in conjunction with the parametric sliders to adjust the tones in an image. Note that you can use the T shortcut as a toggle action to access and use the Tone Curve target adjustment tool while editing in the Basic panel. Here is an example of how to edit the Tone Curve in the parametric editor mode.

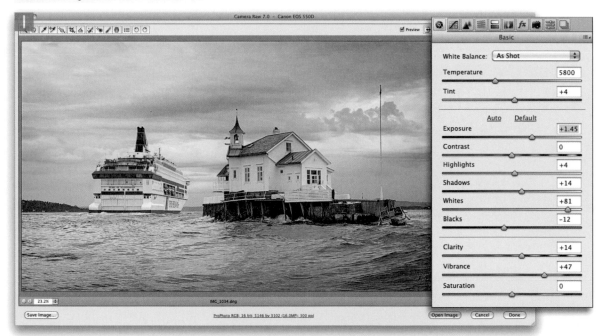

1 In this first example, the image tones were adjusted using the Basic panel controls to produce an optimized range of tones that were ready to be enhanced further. I could have used the Contrast slider to adjust contrast, but the Tone Curve panel provides a simple yet effective interface for manipulating the image contrast.

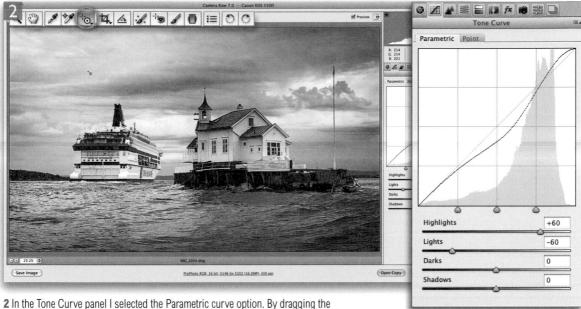

2 In the Tone Curve panel I selected the Parametric curve option. By dragging the Highlights slider to the right and the Lights slider to the left, I was able to increase the contrast in the sky. One can also apply these adjustments by selecting the target adjustment tool (circled) and then clicking and dragging up or down on target areas of the image.

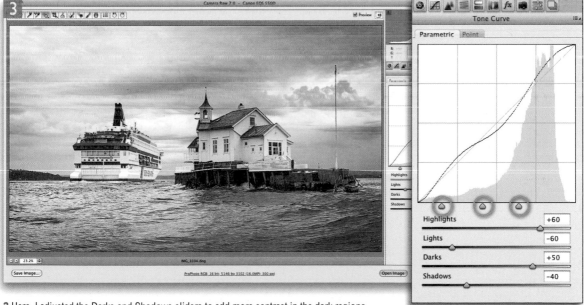

3 Here, I adjusted the Darks and Shadows sliders to add more contrast in the dark regions of the photograph. In addition to this, I fine-tuned the scope of adjustment for the Tone Curve sliders by adjusting the positions of the three tone range split points (circled).

Figure 3.43 The Tone Curve panel, shown here in Point Curve editor mode with the default Linear tone curve setting.

Figure 3.44 The Tone Curve panel, shown here with the Standard channel selected.

Point Curve editor mode

In the Point Curve editor mode, you can manipulate the shape of the Tone Curve as you would with the Curves adjustment in Photoshop. As I mentioned on the previous page, the default curve shape in Process 2012 is now 'Linear', which is actually the same as the old Medium Contrast curve. If you want, you can use the Point Tone Curve panel mode to apply a stronger contrast base curve setting. Regardless of any adjustments you have already made in the parametric mode, the curve shape that's shown here uses the Curve setting selected from the Curve menu in Figure 3.43 as the starting point curve shape. I suppose you could say that the way the Tone Curve panel represents curves in Camera Raw is kind of the same as having two Curves adjustment layers one on top of the other in Photoshop. In fact, if you also take into account the effect of the Contrast slider in the Basic panel, you effectively have three curves adjustments to play with. To edit the point tone curve, just click on the curve line to add points and drag to adjust the overall curve shape. You can edit curve points just like in Photoshop. When a point is selected, use the keyboard arrow keys to move the point around. To select a new existing point, use _ctrl_ _→_ to select the next point up and use _ctrl_ _Shift_ _→_ to select the next point down. You can delete a selected point by hitting the _Delete_ key, or drag a point off to the side of the curve graph. Also, if you hold down the _⌘_ _ctrl_ key while hovering the cursor over the image preview, you can see exactly where a tone will fall on the curve, and you can use _⌘_ _ctrl_-click to place a point on the curve. Lastly, use the _Shift_ key to select multiple points on the curve.

RGB Curves

When working in Process 2012, you will now see a Channel menu, which allows you to edit either 'Standard' (the composite channel view) or the individual red, green or blue channels. This allows you to apply fine-tuned color corrections in Camera Raw (Figure 3.44). There are a lot of color adjustment controls already in Camera Raw, so this is to some extent duplicating functionality that is available elsewhere. Even so, RGB curves do allow you to apply some quite unique kinds of adjustments, such as those seen in Figures 3.45 and 3.46. You can use it to apply strong color casts, you can correct images with mixed lighting and you can also use it to achieve split tone effects that go beyond what can be achieved in the Split Toning panel alone.

Figure 3.45 This shows two different RGB point tone curve adjustments. In the middle, a correction to cool the highlights and warm the shadows and on the right, an adjustment where I deliberately applied a strong red/yellow cast.

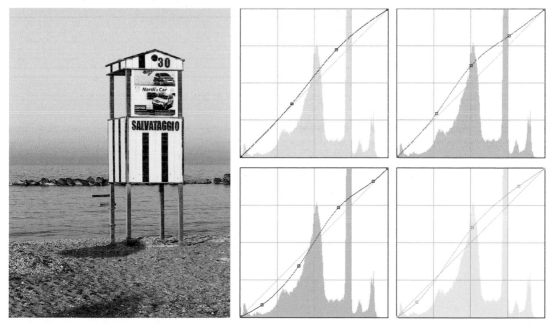

Figure 3.46 In this example I desaturated the image, taking the Saturation slider in the Basic panel to −100. I then applied the point tone curve adjustments shown here to apply a multi-color split toning effect.

Correcting a high contrast image

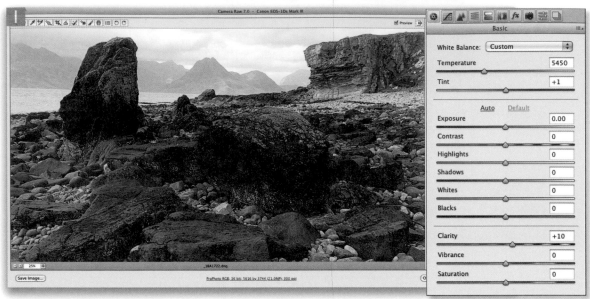

1 This photograph has a wide subject brightness range, and is shown here opened in Camera Raw using the default Process 2012 settings.

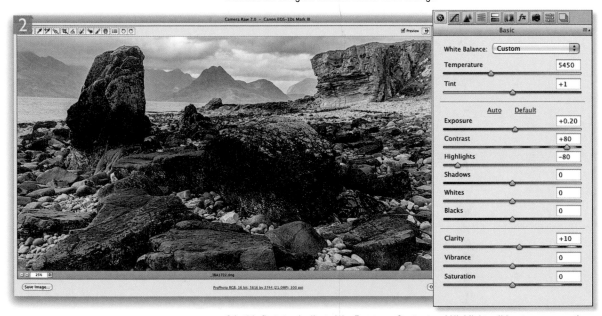

2 In this first step I adjusted the Exposure, Contrast and Highlights sliders to compress the tonal range. This resulted in more detail being seen in the sky.

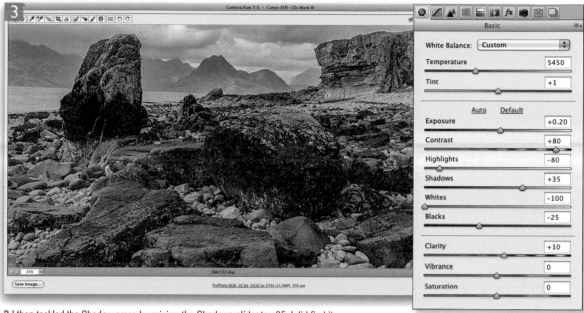

3 I then tackled the Shadow areas by raising the Shadows slider to +35. I did find it necessary to fine-tune the whites and blacks clipping points. As you can see, I reduced the Whites slider to −100 and the Blacks slider to −25.

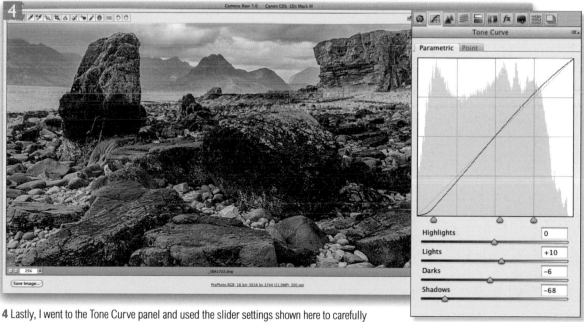

4 Lastly, I went to the Tone Curve panel and used the slider settings shown here to carefully add more contrast to the photograph where it was needed most.

Camera Raw Detail panel

In case you are wondering, the following chapter contains a major section on working with the Detail panel.

HSL color controls

The choice of color ranges for the HSL sliders is really quite logical when you think about it. We may often want to adjust skin tone colors, but skin tones aren't red or yellow, but are more of an orange color. And the sea is often not blue but more of an turquoise color. Basically, the hue ranges in the HSL controls are designed to provide a more applicable range of colors for photographers to work with.

HSL/Grayscale panel

The HSL controls provide eight color sliders with which to control the Hue, Saturation and Luminance. These work in a similar way to the Hue/Saturation adjustment in Photoshop, but are in many ways better, because based on my own experience I find these controls are more predictable in their response. In Figure 3.47 I used the Luminance controls to darken the blue sky and add more contrast in the clouds, plus I lightened the grass and trees slightly. Try doing this using Hue/Saturation in Photoshop and you will find that the blue colors tend to lose saturation as you darken the luminosity. You will also notice that instead of using the traditional additive and subtractive primary colors of red, green, blue, plus cyan, magenta and yellow, the color slider controls in the HSL panel are based on colors that are of more actual relevance when editing photographic images. For example, the Oranges slider is useful for adjusting skin tones and Aquas allows you to target the color of the sea, but without affecting the color of a sky.

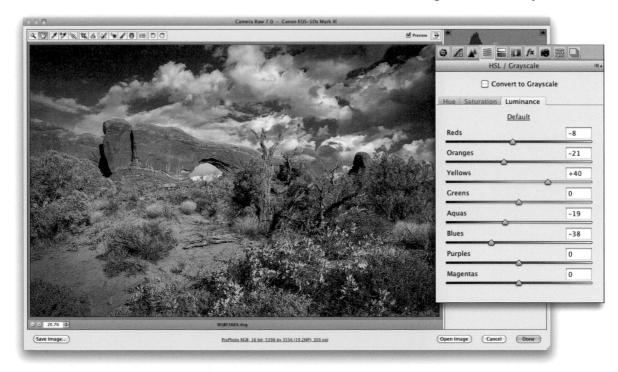

Figure 3.47 In this example, the Luminance sliders in the HSL/Grayscale panel were used to darken the sky and also to lighten the yellows.

Recovering out-of-gamut colors

Figure 3.48 highlights the problem of how the camera you are shooting with is almost certainly capable of capturing a greater range of colors than can be displayed on the monitor or seen in print. Just because you can't see them doesn't mean they're not there! Although a typical monitor can't give a true indication of how colors will print, it is all you have to rely on when assessing the colors in a photo. The HSL Luminance and Saturation sliders can therefore be used to reveal hidden color detail (see Figure 3.49).

Figure 3.48 This diagram shows a plot of the color gamut of an LCD monitor (the solid shape in the center) compared to the actual color gamut of a digital camera. Assuming you are using a wide gamut RGB space such as Adobe RGB or better still, ProPhoto RGB, the colors you are able to edit will almost certainly extend beyond what can be seen on the display.

Tech note

The previews shown here are not simple screen grabs, but were mocked up using fully processed ProPhoto RGB images. You can judge the effectiveness of this adjustment by how well the lower one reproduces in print.

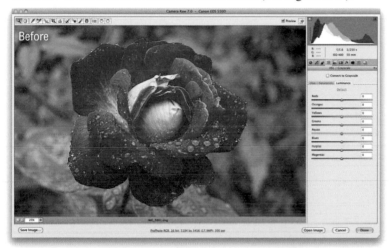

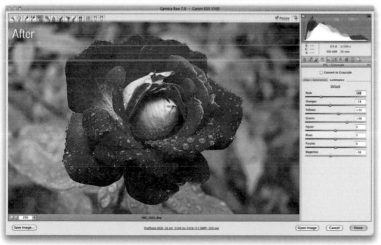

Figure 3.49 In the 'before' screen shot view the pink rose appeared flat. I then applied a negative luminance adjustment to darken the red, orange and magenta colors to produce the improved 'after' version.

Grayscale conversions

To find out about how to apply grayscale conversions in Camera Raw, please refer to pages 406–409 in the Black and White chapter.

Emulating Hue/Saturation behavior

In Photoshop's Hue/Saturation dialog, there is a Hue slider that can be used to apply global hue shifts. This can be useful if you are interested in shifting all of the hue values in one go. With Camera Raw you can create preset HSL settings where all the Hue sliders are shifted equally in each direction. Using such presets you can quickly shift all the hues in positive or negative steps, without having to drag each slider in turn.

Adjusting the hue and saturation

The Hue sliders in the HSL/Grayscale panel can be used to fine-tune the hue color bias using each of the eight color sliders. In the Figure 3.50 example, I adjusted the Reds hue slider to make the reds look less magenta and more orange. In other words, this is a useful HSL/Grayscale panel tip for improving the look of snapshot pictures taken with a compact digital camera, where the skin tones can often look too red.

The Saturation sliders allow you to decrease or increase the saturation of specific colors. In the Figure 3.51 example you can see how I was able to use these to knock back specific colors so that everything in the photograph ended up looking monochrome, except for the red guitar in the foreground. Of course, I could have used the adjustment brush to do this, but adjusting the Saturation sliders offers a really quick method for selectively editing the colors in this way. As with the Tone Curve, you can also use the target adjustment tool to pin-point the colors and tones you wish to adjust.

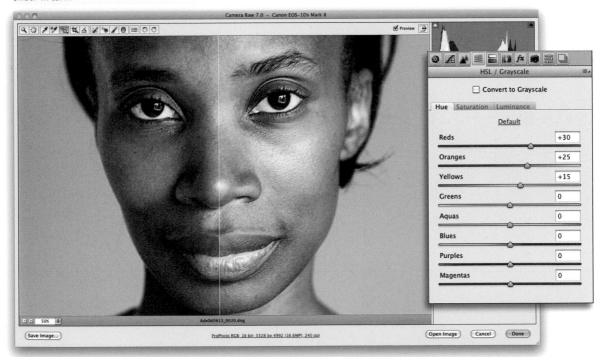

Figure 3.50 Here, I used a combination of a positive Reds, Oranges and Yellows Hue adjustments to make the skin tones look less reddish.

Figure 3.51 In this example, I have shown the before version (top) and a modified version (below), where I used the HSL/Grayscale panel Saturation sliders to selectively desaturate some of the colors in this scene. This can be done manually, or by using the target adjustment tool (circled) to target specific colors and drag downwards to desaturate.

Figure 3.52 This shows the Manual Lens Corrections controls.

Figure 3.53 This shows the 'Constrain to Image' item in the Crop menu.

Lens Corrections panel

The Lens Corrections panel controls (Figure 3.52) can be used to help correct some of the optical problems that are associated with digital capture.

Perspective corrections

In the Manual tab section of the Lens Corrections panel you'll see the Transform controls. The Distortion slider can be used to apply geometric distortion adjustments. These can be applied independently of a distortion correction that might have been applied by enabling a lens profile correction in the Profile tab section. The Vertical slider can be used to apply keystone corrections. For example when photographing tall buildings it will usually be necessary to point the camera upwards, which can lead to converging verticals in the picture. The Horizontal slider can similarly be used to correct for horizontal shifts in perspective, such as when a photo has been captured from a viewpoint that is not completely 'front on' to the camera. Note that you can use the V key to toggle showing/hiding a grid overlay. The Rotate slider allows you to adjust the rotation of the transform adjustment (which is not exactly the same as rotating the image). While it is possible to use the Rotate slider here to straighten a photo, I suggest that you should primarily use the straighten tool do make this type of correction first. Finally, there is the Scale slider. This allows you to adjust the image scale. As you reduce the Scale amount the outer image area will appear as an undefined gray padded area (see Step 3 on page 215). Camera Raw does not offer any options for filling in the gray padded areas itself. However there is a way you can do this in Photoshop when retouching an image and you need to 'fill in' the edges (see page 530). When you select the crop tool, you'll notice there is a 'Constrain to Image' option in the menu (see Figure 3.53). This allows you, if you prefer, to constrain any applied crop to the visible areas only of the image, excluding the gray padded areas.

Lens Vignetting control

With certain camera/lens combinations you may see some brightness fall-off occur towards the edges of the picture frame. This is a problem you are more likely to encounter with wide angle lenses and you may only notice this particular lens deficiency if the

subject contains a plain, evenly-lit background. The Lens Vignetting Amount slider can be used to correct for this by lightening the corners relative to the center of the photograph, while the Midpoint slider can be used to offset the rate of fall-off. As you increase the Midpoint value, the exposure compensation is accentuated more towards the outer edges.

Vignetting is not always a result of the lens used. In the studio I am fond of shooting with extreme wide angle lenses and the problem here is that it's often difficult to get the backdrop evenly lit in all four corners. In these kinds of situations I find it sometimes helps to use the Lens Vignetting slider to compensate for the fall-off in light towards the corners of the frame by lightening the edges (as shown in Figure 3.54 below).

UV filters and edge detail

Fixing a UV filter over the lens is generally considered a good way to filter out the UV light when photographing outdoors, plus it can also offer a first line of defence against the lens getting damaged. However, this is not such a good idea with wide angle or wide angle zoom lenses, since the light entering the lens from the extreme edges is forced to go through the UV filter at an angle. This can cause the image to degrade more at the edges of the frame since the light is refracted as it passes through the filter glass.

Figure 3.54 This is an example of the Lens Vignetting sliders being used to compensate for light fall-off on a studio backdrop, to produce a more even-balanced white.

1 Here is an example of a photograph shot with a wide angle lens, where lens vignetting can be seen in the corners of the frame.

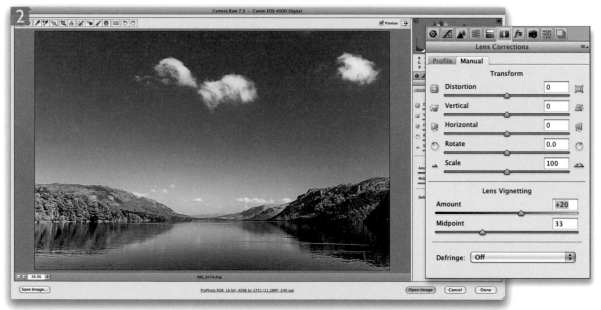

2 In this example, I used the Lens Corrections panel to compensate for the Vignetting. I set the Amount slider to +20 and adjusted the Midpoint to fine-tune the correction. The aim here was to obtain an even exposure at the corners of the photograph.

Defringe

The Defringe options (see Figure 3.52) provide an extra level of defringing in addition to the manual slider adjustments. To be honest, the Highlight Edges and All Edges settings usually have a very subtle effect, but if you are going to use this, I would suggest choosing the All Edges option as it can also sometimes help clean-up stubborn color fringes. Basically, you are unlikely to see much impact or benefit when using the Defringe controls in conjunction with Process 2012.

Automatic lens corrections

I began this section on the Lens Corrections panel by showing you how to use the manual correction sliders because this seemed the best way to introduce you to what these controls do and why you would need to use them. With Camera Raw 6.1 or later you will notice that the Lens Corrections panel defaults to showing you the Profile tab mode that's shown in Figure 3.55, allowing you to apply instant auto lens correction adjustments. This can be done to any image, providing there is a matching lens profile in the lens profile database that was installed with Photoshop and Camera Raw. If the lens you are using is not included in the camera lens profile database, you will need to use a custom lens profile. I'll come on to this shortly, but if we assume there are lens profiles available for the lenses you are shooting with, it should be a simple matter of clicking the 'Enable Lens Profile Corrections' box to apply auto lens corrections to any selected photo. When you do this you should see the 'Make' of the lens manufacturer, the specific lens 'Model' and lens 'Profile' (which will most likely be the installed 'Adobe' profile) appear in the boxes below. If these don't show up, then you may need to first select the lens manufacturer brand from the 'Make' menu, then the specific lens 'Model' and lastly, the desired lens profile from the 'Profile' menu. It is important to appreciate here that some camera systems will capture a full-frame image, while compact SLR range cameras have smaller-sized sensors which make use of a smaller area of the lens's total coverage area. The Adobe lens profiles have mostly all been built using cameras that have full-frame sensors. Therefore, from a single lens profile it is possible to calculate the appropriate lens correction adjustments to make for all other types of cameras in that manufacturer's range where the sensor size is smaller than

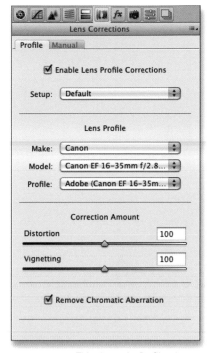

Figure 3.55 This shows the Profile tab Lens Corrections controls.

Chromatic Aberration

Lens profiles actually describe three aspects of a lens correction: Distortion, Vignetting and Chromatic Aberration. When Process 2012 is selected in Photoshop CS6 you see just the Distortion and Vignetting sliders. The chromatic aberration data is ignored and the chromatic aberration distortion is handled separately by checking the 'Remove Chromatic Aberration' option. This carries out an 'analysis' method of correction, rather than using the data in the profile. When Process 2003 or 2010 is selected you will see the third slider, allowing you to enable and adjust the chromatic aberration that's applied as part of correction.

a full-frame. Also note that when processing raw images, Camera Raw will prefer to use lens profiles that have also been generated from raw capture files. This is because the vignette estimation and removal has to be measured directly from the raw linear sensor data rather than from a gamma-corrected JPEG or TIFF image.

An auto lens correction will consist of two main components: a 'Distortion' correction to correct for barrel or pin-cushion geometric distortion and a 'Vignetting' correction (as I described earlier). The Amount sliders you see here allow you to fine-tune an auto lens correction. So for example, if you wanted to have a lens profile correction correct for the lens vignetting, but not correct for, say, a fisheye lens distortion, you could drag the Distortion slider all the way to the left. On the other hand, if you believe an auto lens correction to be too strong or not strong enough, you can compensate the correction amount by dragging either of these sliders left or right.

The default option in the Setup menu will say 'Default'. This instructs Camera Raw to automatically work out what is the correct lens profile to use based on the available EXIF metadata contained in the image file, or use whatever might have been assigned as a 'default' Lens Corrections to use with a particular lens (see below). The 'Custom' option will only appear if you choose to override the auto-selected default setting, or you have to manually apply the appropriate lens profile. As you work with the automatic lens profile corrections feature on specific images you will also have the option to customize the Lens Corrections settings and use the Setup menu to select the 'Save new Defaults…' option. This will allow you to set new Lens Correction settings as the default to use when an image with identical camera EXIF lens data settings is selected. After you do this the Setup menu will in future show 'Default' as the selected option in the Setup menu.

Accessing and creating custom lens profiles

If you don't see any lens profiles listed for a particular lens, you have two choices. You can either make one yourself using the Adobe Lens Profile Creator program, or locate a custom profile that someone else has made. The Adobe Lens Profile Creator program is available free from the labs.adobe.com website, along with full documentation that explains how you should go about photographing one of the supplied Adobe Lens Calibration

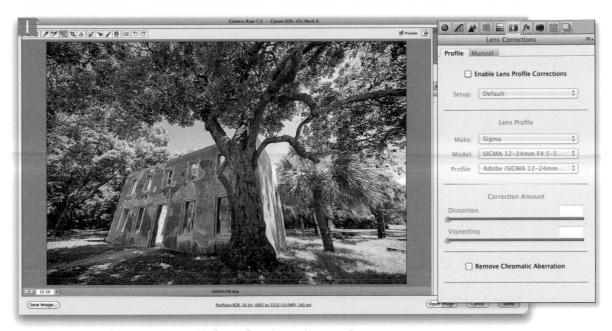

1 Here is an example of a photograph opened in Camera Raw where no lens corrections have been applied yet.

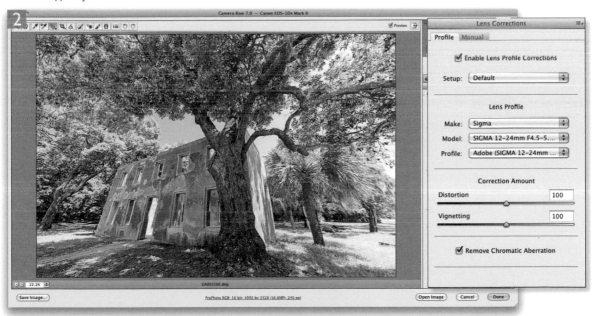

2 In this step I checked the 'Enable Lens Profile Corrections' and 'Remove Chromatic Aberration' boxes to automatically correct the image.

Where lens profiles are kept

Custom lens profiles created via Adobe Lens Profile Creator 1.0 should be saved to the following locations: Library/Application Support/Adobe/Camera Profiles/Lens Correction/1.0 (Mac), C: \Application Data\Adobe\CameraRaw\ LensProfiles\1.0 (PC).

Lateral chromatic aberration

The sensors in the latest digital SLRs and medium format camera backs are able to resolve a much finer level of detail than was possible with film. As a consequence of this any deficiencies in the lens optics can be made even more apparent. Therefore, where some color wavelengths are focused at different points, you may see color fringes around the high contrast edges of a picture. This can be particularly noticeable when shooting with wide angle lenses (especially when they are being used at wider apertures), where you may well see signs of color fringing toward the edges of the frame. There is also another type of chromatic aberration known as 'longitudinal chromatic aberration', which describes the inability of lenses to focus different colors at the exact same distance, and is harder to correct. Fortunately, most of the color fringing problems we see are due to latitudinal chromatic aberration and this is easy enough to fix by scaling the individual color channels that make up the composite color image so that what could be thought of as the 'color misregistration' towards the edges of the frame is corrected.

charts and generate custom lens profiles for your own lenses. It really isn't too difficult to do yourself once you have mastered the basic principles. If you are familiar with the Lens Correction filter in Photoshop (see page 602) you will know how easy it is to access shared custom lens profiles that have been created by other Photoshop customers (using the Adobe Lens Profile Creator program). Unfortunately, the Lens Corrections panel in Camera Raw doesn't provide a shared user lens profile option, so whether you are creating lens profiles for yourself or wishing to install supplied lens profiles, you will need to reference the directory path lists shown in the 'Where lens profiles are kept' sidebar. Once you have added a new lens profile to the Lens Correction or LensProfiles folder, you will need to quit Photoshop and restart before any newly added lens profiles appear listed in the Automatic Lens Corrections panel profile list.

Note that any images that are missing their EXIF metadata cannot be processed directly using lens profile corrections feature. However, if you save a lens profile corrections setting as a Camera Raw preset, it is kind of possible to apply such adjustments to any images that are missing the EXIF metadata by applying this preset via Camera Raw.

Chromatic aberrations

If you inspect an image closely towards the edge of the frame area, you may notice some color fringing, which will be most apparent around areas of high contrast. This is mainly a problem you get with cheaper lens optics, but it can occur even with a good lens when photographing brightly colored subjects. To correct for chromatic aberrations you'll need to click on the Profile tab in the Lens Corrections panel and check the 'Remove Chromatic Aberration' box. As I explained earlier in a sidebar on page 209, when using Process 2012, the chromatic aberration data contained in a lens profile is ignored and Camera Raw carries out an auto correction based on an analysis of the image. As you can see in the Figure 3.56 example, this new approach to removing chromatic aberrations appears to work really well. One of the added advantages of this approach is that one can process images where a non-centrally-aligned lens has been used. For example, photographs shot using a tilt/shift lens with the central axis tilted can now be more effectively corrected.

Figure 3.56 The top screen shot shows a 200% close-up view of an image where you can see strong color fringing around the strong contrast edges. In the lower version I used an automatic Chromatic Aberration correction to remove the color fringes.

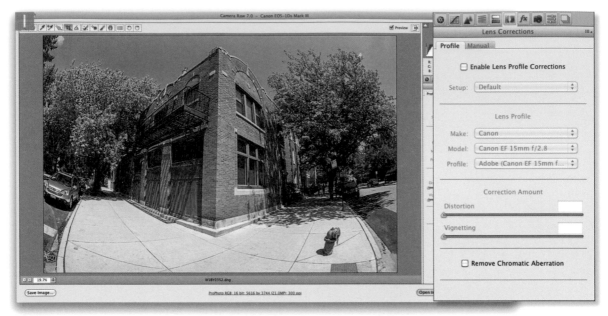

1 In this initial step you can see an example of a photograph that was shot using a 15 mm fisheye lens, where there is a noticeable curvature in the image.

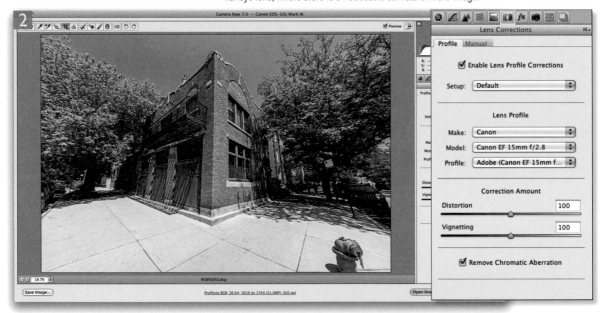

2 In the Lens Corrections panel I simply checked the Enable Lens Profile Corrections box to apply an auto lens correction to the photograph. In this instance I left the two Correction Amount sliders at their default 100% settings.

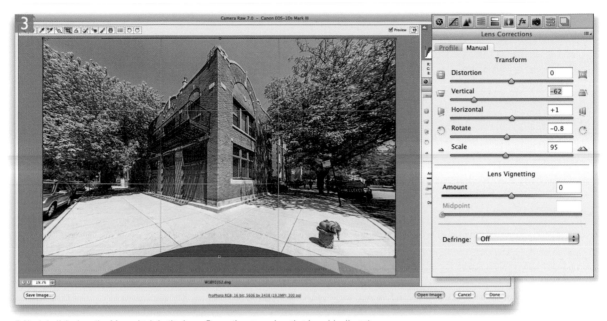

3 Next, I clicked on the Manual tab in the Lens Corrections panel so that I could adjust the Vertical transform slider to correct for some of the keystone distortion in this photo. I also adjusted the Horizontal slider slightly, rotated the transform adjustment 0.8 degrees anti-clockwise and adjusted the Scale slider to zoom out and reveal more of the image.

4 Finally, I opened the photo in Photoshop CS6 and used the Content-Aware Fill feature to fill in the gray padded area at the bottom (there is an example of how to do this shown on page 530).

Combined effects

Now that we have Post Crop Vignetting controls as well as the standard Lens correction vignette sliders, you can achieve even more varied results by combining different combinations of slider settings, whether a photo is cropped or not.

Effects panel
Post Crop Vignetting control

A lot of photographers have got into using the Lens Vignetting controls as a creative tool for darkening or lightening the corners of their pictures. The only problem here is that the lens vignetting can only be applied to the whole of the image frame area. However, you can also use the Post Crop Vignetting sliders to apply a vignette relative to the cropped image area. This means you can use the Lens Vignetting controls for the purpose they were intended (to counter any fall-off that occurs towards the edges of the frame) and use the Post Crop Vignette sliders in the Effects panel as a creative tool for those times when you deliberately wish to lighten or darken the edges of a photo via Camera Raw. The Post Crop Vignetting Amount and Midpoint sliders work identically to the Lens Vignetting controls, except in addition to this, you can adjust the Roundness and the Feathering of the vignette adjustment.

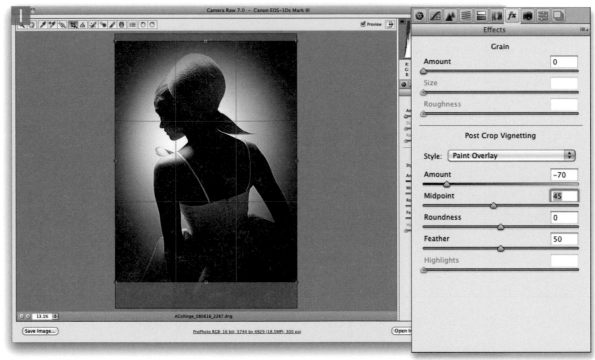

Client: Andrew Collinge Hair & Beauty.
Hair by Andrew Collinge artistic team,
Make-up: Liz Collinge.

1 In this first example I applied a −70, darkening vignette offset with a +45 Midpoint setting. This adjustment was not too different from a normal Lens Vignetting adjustment, except it was applied to the cropped area of an image.

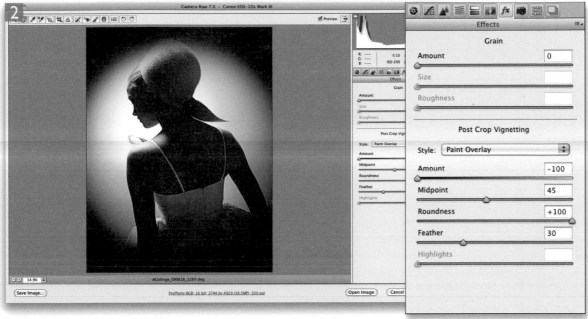

2 In this next version, I adjusted the Roundness slider to make the vignette shape less elliptical and adjusted the Feather slider to make the vignette edge harder.

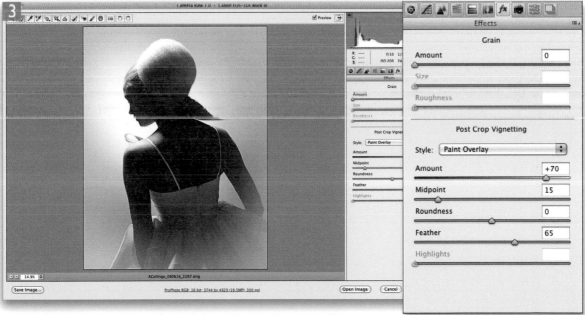

3 For this final version, I applied a +100 vignette Amount to lighten the corners of the cropped image, combined with a low Midpoint and a soft Feather setting.

Post Crop Vignette style options

So far I have just shown you the options for the Paint Overlay vignette style option. It wasn't named as such before, since this was the only Post Crop Vignette mode available in previous versions (Camera Raw 5 or earlier). When first introduced, some people were quick to point out that the Post Crop Vignetting wasn't exactly the same as a Lens Correction Vignette effect. You

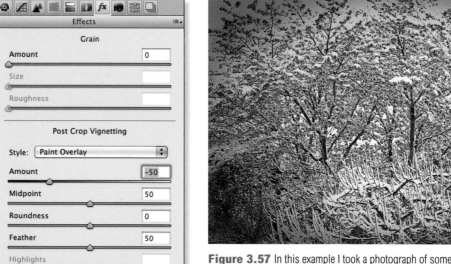

Figure 3.57 In this example I took a photograph of some snow-covered tree branches. Shown here is the before version (top) and one where I had applied a standard Paint Overlay style Post Crop Vignette using the settings shown here.

can see for yourself in the Figure 3.57 example how the Paint Overlay vignette applies a soft contrast, hazy kind of effect. This wasn't to everyone's taste (although I didn't particularly mind it) and so Camera Raw 6 or later now offer you two alternative post crop editing modes which more closely match the normal Lens Correction edit mode, yet offer extra scope for adjustment. Where people were once inclined to use the Lens Correction sliders as a creative tool (because the Paint Overlay Post Crop effect was a bit wishy-washy), they should now think of the Lens Correction panel as being for lens corrections only and use the Post Crop Vignetting sliders in the Effects panel to add different kinds of vignette effects. So let's now look at the new post-crop options.

In the Paint Overlay mode example (Figure 3.57), the Post Crop effect blends either a black or white color into the edges of the frame depending on which direction you drag the Amount slider. The two new 'Priority' modes produce an effect that is now more similar to the Lens Correction effect since the darkening or lightening is created by varying the exposure at the edges. Of the two, the Color Priority (Figure 3.58) is usually the more gentler as this applies the Post Crop Vignette *after* the Basic panel Exposure adjustments, but *before* the Tone Curve stage. This minimizes color shifts in the darkened areas, but it can't perform any highlight recovery when you darken the edges.

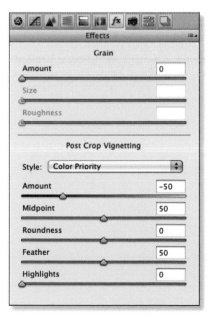

Figure 3.58 This shows an example of a darkening post-crop vignette adjustment in which the Color Priority style was used.

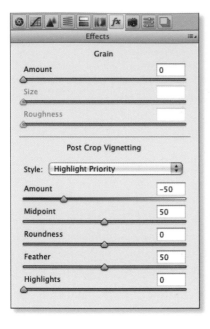

The Highlight Priority style (see Figure 3.59) tends to produce more dramatic results. This is because it applies the Post Crop Vignette *prior* to the Exposure adjustment. It has the benefit of allowing better highlight recovery, but this can lead to color shifts in the darkened areas.

Figure 3.59 This shows an example of a darkening Post Crop Vignette adjustment in which the Highlight Priority style was used.

Highlights slider

You will notice there is also a 'Highlights' slider, which can be used to further modify the effect. In Paint Overlay mode, the Highlights slider has no effect on the image. In the two new priority modes the Highlights slider is only active when applying a negative Amount setting and as soon as you increase the Amount to apply a lightening vignette, the Highlights slider is disabled. As you can see in the Figure 3.60 and 3.61 examples, increasing the Highlights amount allows you to boost the highlight contrast in the vignetted areas, but the effect is only really noticeable in subjects that feature bright highlights. Here it had the effect of lightening the snow-covered branches in the corners of the image, taking them back more to their original exposure value. In these examples the difference is quite subtle, but I find that the Highlights slider usually has the greatest impact when editing a Color Priority Post Crop Vignette.

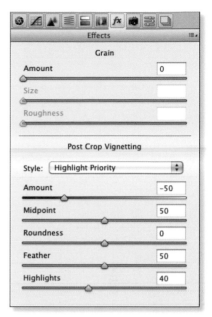

Figure 3.60 In this example I applied a Highlight Priority Post Crop Vignette style and added a 40% Highlights adjustment to the Highlight Priority vignette. In this instance, the Highlights slider adjustment applied a fairly subtle change to the appearance of this Post Crop Vignette effect.

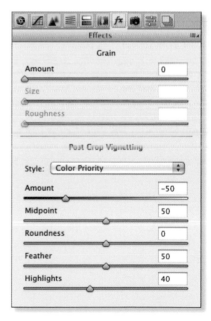

Figure 3.61 In this example I applied a Color Priority Post Crop Vignette style and added a 40% Highlights adjustment to the Color Priority vignette. If you compare this with the above example in Figure 3.60, you can see how a Highlights slider adjustment can have a more substantial effect on the Post Crop Vignette adjustment in Color Priority mode.

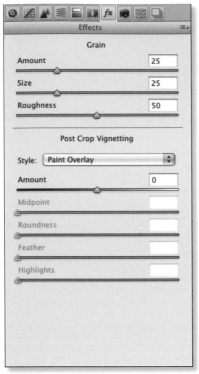

Figure 3.62 The Effects panel showing the Grain sliders.

Adding Grain effects

The Effects panel also contains Grain controls (Figure 3.62). The Amount slider determines how much grain is added, while the Size slider controls the size of the grain particles. The default setting is 25 and dragging to the left or right allows you to decrease or increase the grain particle size. Note here that if the Size slider is set any higher than 25, then a small amount of blur is applied to the underlying image. This is done so that the image can blend better with the grain effect. The exact amount of blur is also linked to the Amount setting; the higher the Amount, the more blur that's applied. The Roughness slider controls the regularity of the grain. The Default value is 50. Dragging to the left makes the grain pattern more uniform, while dragging to the right can make the grain appear more irregular. Basically, the Size and Roughness sliders are intended to be used in conjunction with the Amount slider to determine the overall grain effect. In Figure 3.63 you can see a before and after example of a grain effect being applied to a photo in Camera Raw.

The most obvious reason for including these new sliders is so that you can deliberately add a grain effect and give your photos a film-like look. However, if this is your aim you will probably need to apply quite a strong setting in order for the grain effect to be noticeable in print. Even then, this will only work effectively if you are producing a large-sized print output. The thing is, if you apply a grain effect while looking at the image at a 1:1 view and then make, say, a 10 x 8 print, the grain effect will mostly be lost due to the downsizing of the image data. Where images are going to be downsized even further to appear on the Web, a grain effect is unlikely to be noticed at all.

It is also possible to use the Grain sliders to add subtle amounts of noise which can be used to disguise ugly image artifacts that can't otherwise be eradicated from the image. Having said this, it is possible to end up needlessly fretting about what you can see on screen at a 1:1 or a 200% view when the detail you are analyzing will be diffused by the print process. Therefore tiny artifacts you see at a 100% view or higher shouldn't really be worth getting all that concerned about. A low Amount setting will allow you to add a fine amount of noise to a photo and this might well look even more pleasing as you add extra micro detail to a photo. In all honesty though, adding some extra fine grain is still only 'creating

the illusion' of an improved image. What you see close-up on the screen won't have much actual bearing on the detailedness of the final print. This is really something that should mainly be reserved for problem photos that can't be fixed with the new noise reduction sliders in the Detail panel (see page 296). In other words, where you have an image that contains really noticeable artifacts, you can try using the Grain sliders to cover these up, but I wouldn't recommend overdoing this too much. As you might have gathered, I'm not that enamored with this new feature. One of the main reasons I prefer shooting with digital cameras is because of the lack of grain you get in the captures.

The micro detail effect

It has been suggested that some raw converter programs have already been adding small amounts of grain by default in order to add micro detail to the image processing, which, as I say in the main text, it is only creating the illusion of better image quality. Camera Raw doesn't do this by default, but gives you the opportunity to experiment.

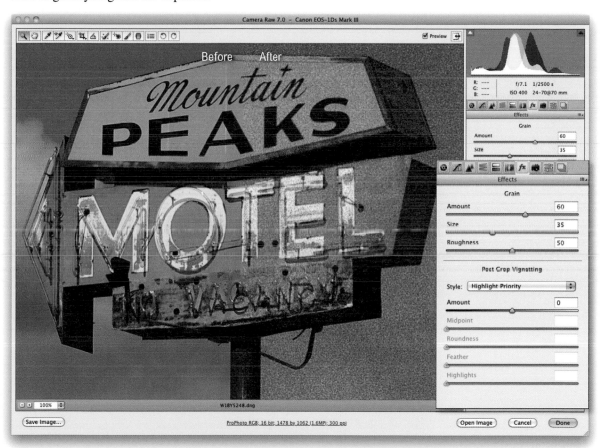

Figure 3.63 This shows a before and after example of a grain effect applied to a photo.

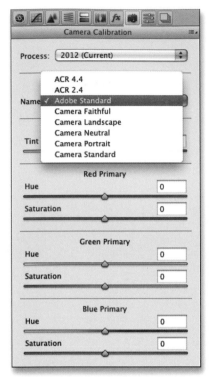

Figure 3.64 The Camera Calibration panel controls can be used to set the desired Process Version and fine-tune the Camera Raw color interpretation. The Camera Profile setting at the top can offer a choice of camera profile settings. These include legacy settings such as ACR 4.3, etc. The recommended default setting to use now is 'Adobe Standard'.

ACR compatible cameras

The list of cameras that are compatible with the latest version of Camera Raw can be found at the Adobe website by following this link: www.adobe.com/products/photoshop/cameraraw.html.

Camera Calibration panel

The Camera Calibration panel (Figure 3.64) lets you do two things. It allows you to choose which Process Version to use when rendering a raw file and also lets you select an appropriate camera profile. As I explained earlier, if you click on the warning triangle that appears in the bottom right corner of the preview section you can update an image from Process 2003 or 2010 to the latest Process 2012. You can therefore use the Camera Calibration panel to update the Process Version used or reverse this process and select an older Process Version should you need to.

Everyone wants or expects their camera to be capable of capturing perfect colors whether they really need to or not. What is perfect color though? Some photographers may look at a JPEG version of an image and judge everything according to that, while others, who shoot raw, may prefer the default look they get from a particular raw processing program. Apart from anything else, is the display you are using actually capable of showing all the colors your camera can capture?

Camera Raw is the product of much camera testing and raw file analysis, carried out by the Camera Raw team. By selecting the most appropriate camera profile in the Camera Calibration panel you can ensure you get the most accurate (or most suitable) color from your camera. Test cameras were used to build a two-part profile of each camera sensor's spectral response under standardized tungsten and daylight balanced lighting conditions. From this, Camera Raw is able to calculate a pretty good color interpretation under these specific lighting conditions, and also extrapolate beyond these across a full range of color temperatures. This method may not be as accurate as having a proper profile built for your camera, but realistically, profiling a camera is something that can only be done where the light source conditions are always the same.

New Camera Raw profiles

You have to bear in mind that many of the initial default Camera Raw profiles were achieved through testing a limited number of cameras. It was later discovered that there could be a discernible variation in color response between individual cameras. As a result of this a wider pool of cameras were evaluated and the default profile settings were updated for certain makes of camera and in

some cases newer versions of the default camera profiles were provided. This is why you will sometimes see extra profiles listed that refer to earlier builds of Camera Raw, such as ACR 2.4 or ACR 3.6, etc. (see sidebar on 'New camera profile availability'). More recently, Eric Chan (who works on the Camera Raw engineering team) managed to improve many of the standard ACR profiles as well as extend the range of profiles that can be applied via Camera Raw. In Camera Raw 5 or later, the 'Adobe Standard' profile is now the new default and this and the other profiles you see listed in the Profile menu options are the result of improved analysis as well as an effort to match some of the individual camera vendor 'look settings' associated with JPEG captured images.

Although 'Adobe Standard' is now the recommended default camera profile, it has been necessary to preserve the older profiles such as ACR 3.6 and ACR 4.4, since these need to be kept in order to satisfy customers who have relied on these previous profile settings. After all, it wouldn't do to find that all your existing Camera Raw processed images suddenly looked different because the profile had been updated. Therefore, in order to maintain backward compatibility, Adobe leave you the choice of which profiles to use. If you are happy to trust the new 'Adobe Standard' profile, then I suggest you leave this as the default starting point for all your raw conversions. The difference you'll see with this profile may only be slight, but I think you will find this still represents an improvement and should be left as the new default.

Camera look settings profiles

The other profiles you may see listed are designed to let you match some of the camera vendor 'look settings'. The profile names will vary according to which camera files you are editing, so for Canon cameras Camera Raw offers the following camera profile options: Camera Faithful, Camera Landscape, Camera Neutral, Camera Portrait as well as a Camera Standard option. Nikon users may see Mode 1, Mode 2, Mode 3, Camera Landscape, Camera Neutral, Camera Portrait and Camera Vivid profile options. In Figure 3.66 you can see an example of how these can compare with the older ACR and Adobe Standard profiles.

The 'Camera Standard' profile is rather clever because Eric has managed here to match the default camera vendor settings for some of the main cameras that are supported by Camera Raw.

New camera profile availability
Not all the Camera Raw supported cameras have the new profiles. These are mainly done for Canon, Nikon and a few Pentax and Leica models. So, you may not see a full list of profile options for every Camera Raw compatible camera, just the newer and most popular camera models.

Figure 3.65 X-Rite ColorChecker charts can be bought as a mini chart or the full-size chart you see here.

Embedding custom profiles

If you create a custom camera profile for your camera and apply this to any of the images you process through Camera Raw, you need to be aware that the custom profile component can only be read if that camera profile exists on the computer that's reading it. If you transfer a raw file that's been processed in Camera Raw to another computer it will look to see if the same camera profile is in the 'CameraProfiles' folder. If it isn't, it will default to using the Adobe Standard profile. Which leads me to point out an important solution to this problem, which is to convert your raw files to DNG. The current DNG spec allows for camera profiles to be embedded within the file and thereby removes the dependency on the host computer having a copy of the custom camera profile used.

By choosing the Camera Standard profile you can get the Camera Raw interpretation to pretty much match exactly the default color renderings that are applied by the camera manufacturer software. This means that if you apply the Camera Standard profile as the default setting in the Camera Calibration panel, Camera Raw applies the same kind of default color rendering as the camera vendor's software and will also match the default camera JPEG renderings. For years, photographers have complained that Camera Raw in Bridge and Lightroom changed the look of their photos soon after downloading. The initial JPEG previews they saw that they liked would quickly be replaced by a different Camera Raw interpretation. When Camera Standard profile is selected you won't see any jumps in color as the Camera Raw processing kicks in. This is because, as I say, Camera Raw is now able to match the JPEG rendering for certain supported cameras.

Custom camera profile calibrations

While the Adobe Standard profiles are much improved, they have still been achieved through testing a limited number of cameras. You can, however, create custom standard camera profiles for individual camera bodies. Creating a custom camera calibration profile does require a little extra effort to set up, but it is worth doing if you want to fine-tune the color calibration for each individual camera you shoot with. This used to be done by adjusting the Camera Calibration panel sliders, but is now mainly done through the use of camera profiles. However, the sliders do have their uses still, as I'll explain shortly.

In the early days of Camera Raw I used to shoot an X-Rite ColorChecker chart and visually compared the shot results with a synthetic ColorChecker chart and adjusted the Camera Calibration panel sliders to achieve a best match. It was all very complex! Fortunately there is now an easier way to calibrate your camera equipment. You will still need to capture an X-Rite ColorChecker chart (Figure 3.65). These can easily be ordered on-line and will probably cost you around $100. You then need to photograph the chart with your camera in raw mode. It is important that the chart is evenly lit and exposed correctly. The best way to do this is to use two studio lights in a copy light setup, or failing that, use a diffuse light source. Apart from that it does not matter what other camera settings are used, although I would recommend you shoot at a low ISO rating.

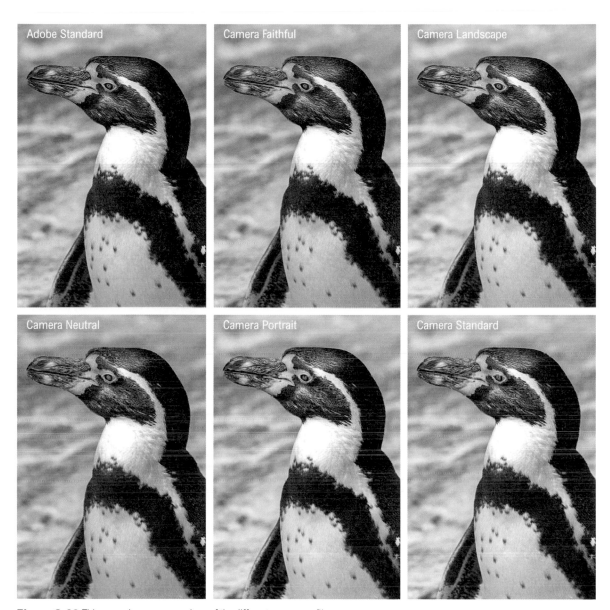

Figure 3.66 This page shows a comparison of the different camera profiles one can now choose from and the effect these will have on the appearance of an image, which in this case was shot using a Canon EOS 1Ds MkIII camera.

Camera profiles and white balance

In the step-by-step example shown here I recommend creating a camera profile using a standard strobe flash lighting setup. This lets you calibrate the camera sensor for the studio lights you normally shoot with. The camera profile measurements can vary slightly for pictures that are shot using different white balance lighting setups. It is for this reason the DNG Profile Editor allows you to measure and generate camera profiles in the same way as the Camera Raw team do. For example, if you shoot the ColorChecker chart once with a lighting setup at a measured white balance of 6500 K and again at a white balance of 3400 K, you can measure these two charts using the DNG Profile Editor to create a more accurate custom camera profile.

DNG Profile Editor

In the quest to produce improved camera profiles, a special utility program called DNG Profile Editor was used to help re-evaluate the camera profiles supplied with Camera Raw and produce the revised camera profiles. You can get hold of a copy of this program by going to the labs.adobe.com website and doing a search for 'DNG Profiles'. At the time of writing it is currently in version beta 3 and available as a free download. There are a number of things you can do with this utility, but its main strength is that it allows you to create custom calibration profiles for individual cameras. You see, while the default camera profiles can be quite accurate, there may still be a slight difference in color response between your particular camera and the one Adobe used to test with. For this reason you may like to run through the following steps to create a custom calibration for your camera sensor.

GretagMacbeth™ ColorChecker Color Rendition Chart

1 As I showed in Figure 3.65, you'll first need to photograph an X-Rite ColorChecker chart. I suggest you shoot this against a plain, dark backdrop and make sure it is evenly lit from both sides, and, for the utmost accuracy, is illuminated with the same strobe lights that you normally work with. It is also a good idea to take several photos and bracket the exposures slightly. If the raw original isn't exposed correctly you'll see an error message when trying to run the DNG Profile Editor. The other thing you'll need to do is to convert the raw capture image to the DNG format, which you can do using Adobe DNG Converter (see page 264).

2 The next step is to launch DNG Profile Editor. Go to the File menu and choose File ⇨ Open DNG Image… Now browse to locate the DNG image you just edited and click Open. The selected image appears in a separate window. Go to the Base Profile menu and select the Adobe Standard profile for whichever camera was used to capture the ColorChecker chart.

3 Now click on the Chart tab (circled) and drag the four colored circles to the four corner swatches of the chart. If you are just measuring the one chart, select the Both color tables option and click on the Create Color Table… button. If you are recording two separately shot targets at different white balance settings, use this menu to select the appropriate color table.

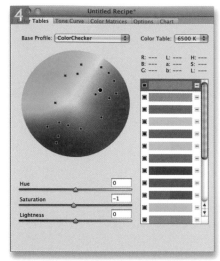

4 The camera profile generation process is pretty much instantaneous. Once this has been done you can then go to the Edit menu and choose File ⇨ Export (name of camera) Profile, or use the ⌘ E ctrl E shortcut and rename the profile as desired.

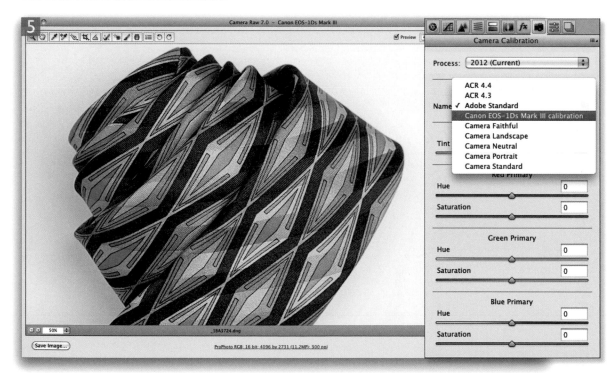

5 Custom camera profiles are saved to a default user folder but won't appear visible in the Camera Calibration panel profile list until you next launch Photoshop or Bridge and open a raw image via Camera Raw. Once you have done this you can select the newly created camera profile and apply it to any photos that have been shot using this camera.

6 Here is an extra tip which is worth carrying out. You can save the camera profile selected in the Camera Calibration panel as a custom Camera Raw preset. In the example shown here I went to the Camera Raw Presets panel, clicked on the New preset button (circled) and in the New Preset dialog shown here, selected the Camera Calibration subset setting, so that only the Camera Calibration option was checked. Once I had done this I now had a camera profile preset setting that could easily be applied to any other photographs that had been shot with the same camera. One can also easily apply a setting like this via the Bridge Edit ⇨ Develop settings submenu.

Clearing the retouching work

You can remove individual retouch circles by selecting them and hitting the *Delete* key. Or, you can click on the 'Clear All' button to delete all retouch circles.

Turning off the preview

You can use the Preview option to toggle showing/hiding the spot removal retouching (also using the *H* key).

Overlapping the spots

In the absence of an elliptical spot removal tool you can still be clever when removing irregular shaped marks. First, apply two spot removal circles side by side and afterwards, edit one of the spots and move the destination circle so that it overlaps the first.

Spot removal tool

You can use the spot removal tool (*B*) to retouch spots and blemishes. Whenever the spot removal tool is active you will see the Spot Removal options appear in the panel section on the right (Figure 3.67). From here you can choose between Heal and Clone type retouching and ideally you should work on the image at a 100% magnification. In Clone mode, the tool behaves like a cross between the spot healing brush and clone stamp tool in Photoshop. It carries out a straightforward clone of the image with a soft feathered edge circle and automatically selects the area to sample from. In Heal mode, the tool behaves like a cross between the spot healing and normal healing brush in Photoshop, where a straight-forward click auto-selects an area to sample from and blends the sampled data with the surrounding data outside the spotting circle. If you then click to select a spot circle you can adjust the destination and/or source point circles. In either case, you can click to select an applied clone circle and use the 'Type' menu to switch from one mode to the other. With both the Clone

Figure 3.67 This screen shot shows the retouch tool in action, with explanations of how to apply and modify the retouch spot circles.

and Heal modes you have the option to adjust the radius of the spot removal tool as well as the opacity. You can use the [] keys to tweak the radius, but it is usually simpler to follow the instructions in Figure 3.67 and drag with the cursor instead. The Opacity slider allows you to lower the opacity setting should you wish. You can also click on the 'Show Overlay' box or use the *H* key to toggle showing and hiding the circles so that you can view the retouched image without seeing the retouch circles.

Synchronized spotting with Camera Raw

You can synchronize the spot removal tool across multiple photos. Make a selection of images in Bridge and open them up via Camera Raw (as shown in Figure 3.68). Now click on the Select All button. This selects all the photos and if you now use the spot removal tool, you can retouch the most selected photo (the one shown in the main preview), and the spotting work will be automatically updated to all the other selected images.

Keeping the sensor clean
Dust marks are the bane of digital photography and ideally you want to do as much as you can to avoid dust or dirt getting onto the camera sensor. I have experimented with various products and find that the Sensor Swabs used with the Eclipse cleaning solution from Photographic Solutions Inc (www. photosol.com) are reliable products. I use these from time to time to keep the sensors in my cameras free from marks.

Figure 3.68 Here is an example of the Camera Raw dialog being used to carry out synchronized spotting.

Hiding the red eye rectangles

As with the spot removal tool, you can click on the 'Show Overlay' box to toggle showing and hiding the rectangle overlays (or use the **H** key).

Red eye removal

The remove red eye tool is useful for correcting photos that have been taken of people where the direct camera flash has caused the pupils to appear bright red. To apply a red eye correction, select the red eye removal tool and drag the cursor over the eyes that need to be adjusted. In the Figure 3.69 example I dragged with the mouse to roughly select one of the eyes. As I did this, Camera Raw was able to detect the area that needed to be corrected and automatically adjusted the marquee size to fit. The Pupil Size and Darken sliders can then be used to fine-tune the Pupil Size area that you want to correct as well as the amount you want to darken the pupil by. You can also revise the red eye removal settings by clicking on a rectangle to reactivate it, or use the *Delete* key to remove individual red eye corrections. If you don't like the results you are getting, you can always click on the 'Clear All' button to delete the red eye retouching and start over again.

Figure 3.69 Here is an example of the remove red eye tool in action.

Localized adjustments

The adjustment brush and graduated filter tools can be used to apply localized edits in Camera Raw. As with the spot removal and red eye removal tools, you can revise these edits as often as you like. But these are more than just dodge and burn tools – there are a total of 12 effects to choose from, as well as an Auto Mask option.

Adjustment brush

When you select the adjustment brush tool (**K**) the tool options shown in Figure 3.70 will appear in the panel section on the right with the 'New' button selected (you can also use the **K** key to toggle between the Adjustment Brush panel and the main Camera Raw panel controls). Below this are the sliders you use to configure the adjustment brush settings before you apply a new set of brush strokes.

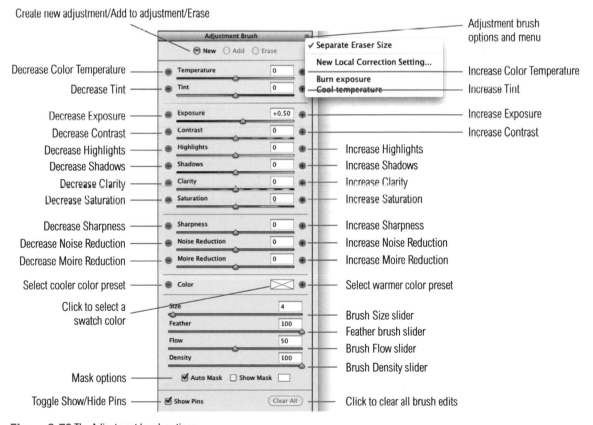

Create new adjustment/Add to adjustment/Erase

Adjustment brush options and menu

Decrease Color Temperature — Increase Color Temperature
Decrease Tint — Increase Tint
Decrease Exposure — Increase Exposure
Decrease Contrast — Increase Contrast
Decrease Highlights — Increase Highlights
Decrease Shadows — Increase Shadows
Decrease Clarity — Increase Clarity
Decrease Saturation — Increase Saturation
Decrease Sharpness — Increase Sharpness
Decrease Noise Reduction — Increase Noise Reduction
Decrease Moire Reduction — Increase Moire Reduction
Select cooler color preset — Select warmer color preset
Click to select a swatch color
Brush Size slider
Feather brush slider
Brush Flow slider
Brush Density slider
Mask options
Toggle Show/Hide Pins
Click to clear all brush edits

Figure 3.70 The Adjustment brush options.

Hiding and showing brush edits

You can use the Preview button in the Camera Raw dialog to toggle showing and hiding all Adjustment brush edits.

Figure 3.71 The outer edge of the adjustment brush cursor represents the overall size of the brush, while the inner circle represents the softness (feathering) of the brush relative to the overall brush size.

Initial Adjustment brush options

To apply a brush adjustment, click on the New brush button at the top of the panel and then select the effect options you wish to apply by using either the plus or minus buttons or the sliders. For example, clicking on the Exposure plus button increases the exposure setting to +0.50 and clicking on the negative button sets it to −0.50 (these are your basic dodge and burn settings). The effect buttons therefore make it fairly easy for you to quickly create the kind of effect you are after. Remember, you can only select one effect setting at a time using the buttons, but if you use the slider controls you can fine-tune the adjustment brush effect settings and combine multiple effects in a single setting.

Brush settings

Below this are the brush settings. The Size slider adjusts the brush radius, plus you can use the ⦗ ⦘ keys to make the brush smaller or larger. It is also possible to resize a brush on screen. If you hold down the *ctrl* key (Mac) or use a right-mouse click (Mac and PC), you can drag to resize the cursor before you start using it to retouch the image. The Feather slider adjusts the softness of the brush and you can also use the *Shift* ⦘ keys to make the brush edge softer and *Shift* ⦗ to make the brush harder. Note that these settings are reflected in the cursor shape shown in Figure 3.71. The Flow slider is a bit like an airbrush control. If you select a low Flow setting, you can apply a series of brush strokes that successively build to create a stronger effect. As you brush back and forth with the brush, you will notice how the paint effect gains opacity, and if you are using a pressure-sensitive tablet such as a Wacom™, the Flow of the brush strokes is automatically linked to the pen pressure that you apply. The Density slider determines the maximum opacity for the brush. This means that if you have the brush set to 100% Density, the flow of the brush strokes can build to a maximum density of 100%. If on the other hand you reduce the Density, this limits the maximum brush opacity to a lower opacity value. For example, if you lower the Density and paint over an area that was previously painted at a Density of 100%, you can paint with the adjustment brush to reduce the opacity in these areas and if you reduce the Density to 0%, the adjustment brush acts like an eraser tool.

Adding a new brush effect

We are now ready to start painting. When you click on the image preview, a pin marker is added and the Adjustment Brush panel shows that it is now in 'Add' mode (Figure 3.72). As you start adding successive brush strokes, these are collectively associated with this marker and will continue to be so, until you click on the 'New' button and click to create a new pin marker with a new set of brush strokes. The pin markers therefore provide a tag for identifying groups of brush strokes. You just click on a pin marker whenever you want to add or remove brush strokes, or need to re-edit the brush settings that were applied previously. If you want to hide the markers you can do so by clicking on the Show Pins box to toggle showing/hiding the pins, or use the Ⓗ key shortcut.

Localized adjustment strength

Localized adjustments have the same full strength as the global adjustments. But note that all the effects have linear incremental behavior except for the Temp, Tint, Highlights, Shadows and Clarity adjustments. These have non-linear incremental behavior, which means that they only increase in strength by 75% relative to the previous localized adjustment each time you add a new pin group.

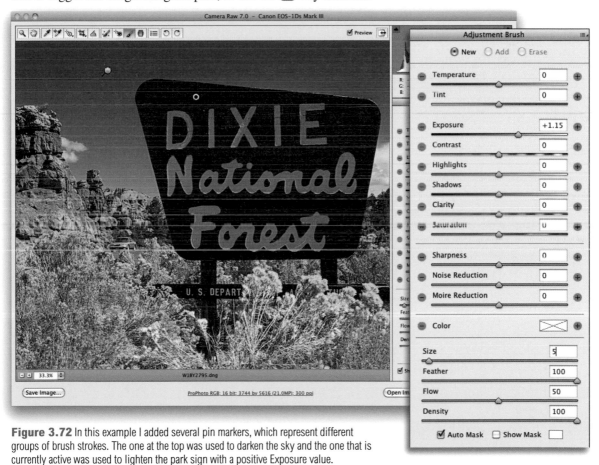

Figure 3.72 In this example I added several pin markers, which represent different groups of brush strokes. The one at the top was used to darken the sky and the one that is currently active was used to lighten the park sign with a positive Exposure value.

Undoing and erasing brush strokes

As you work with the adjustment brush, you can undo a brush stroke or series of strokes using the undo command (⌘ Z ctrl Z).

Previewing the mask more clearly

Sometimes it is useful to initially adjust the settings to apply a stronger effect than is desired. This lets you judge the effectiveness of your masking more clearly. You can then reduce the effect settings to reach the desired strength for the brush strokes.

Resetting the sliders

Double-clicking a slider arrow pointer resets it to zero, or to its default value.

Editing brush adjustments

To edit a series of brush strokes, just click on an existing pin marker to select it (a black dot appears in the center of the pin). This takes you into the 'Add' mode, where you can add more brush strokes or edit the current brush settings. For example, in Step 2 (opposite), I might have wanted to drag the Exposure slider to darken the selected brush group more. You might also want to erase portions of a brush group, which you can do by clicking on the Erase button at the top of the Adjustment Brush panel, where you can independently edit the brush settings for the eraser mode (except for the Density slider which is locked at zero). Alternatively, you can hold down the ⌥ alt key to temporarily access the adjustment brush in eraser mode. When you are done editing, click on the New button to return to the New adjustment mode, where you can now click on the image to add a new pin marker and a new set of brush strokes.

Previewing the brush stroke areas

If you click on the 'Show Mask' option, you'll see a temporary overlay view of the painted regions (Figure 3.73). The color overlay represents the areas that have been painted and can also be seen as you roll the cursor over a pin marker.

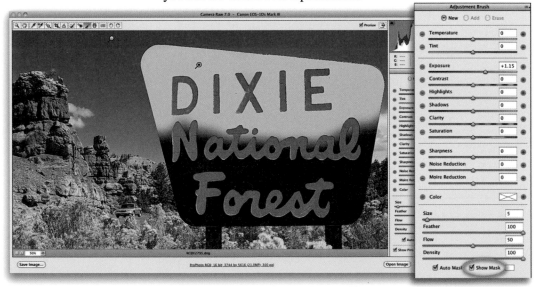

Figure 3.73 In this screen view, the 'Show Mask' option is checked and you can see an overlay mask for the selected brush group. Click on the swatch next to it if you wish to choose a different color for the overlay display.

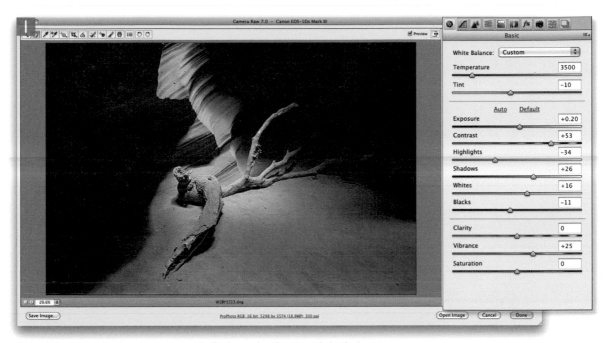

1 Here is a photograph where I had adjusted the Basic panel settings to optimize the image.

2 I then added a new brush group to lighten the shadows.

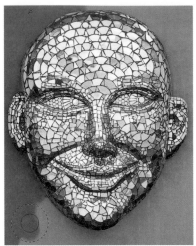

Figure 3.74 Quite often, you only need to click on an area of a picture with the color you wish to target and drag the adjustment brush in auto mask mode to quickly adjust areas of the picture that share the same tone and color.

Auto masking

At the bottom of the Adjustment Brush panel is the Auto Mask option and when this is switched on it cleverly masks the image at the same time as you paint. It does this by analyzing the colors in the image where you first click and then proceeds to apply the effect only to those areas with the same matching tone and color (Figure 3.74). It does this on a contiguous selection basis. For example, in the steps shown here, I dragged with the adjustment brush in auto mask mode on the egg in the middle to desaturate the color. While the Auto Mask can do a great job at auto selecting the areas you want to paint, at extremes it can lead to ugly 'dissolved pixel' edges. This doesn't happen with every photo, but it's something to be aware of. The other thing to watch out for is a slow-down in brush performance. As you add extra brush stroke groups, the Camera Raw processing takes a knock anyway, but it gets even worse when you apply a lot of auto mask brushing. It is therefore a good idea to restrict the number of adjustment groups to a minimum.

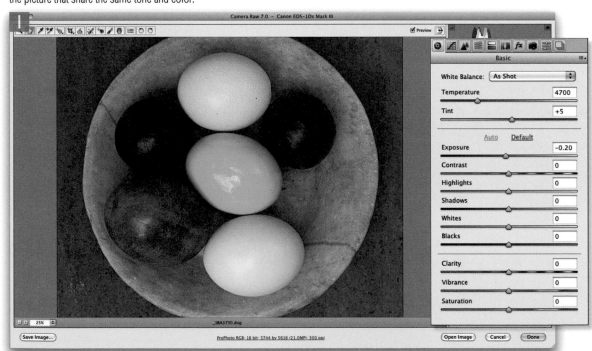

1 This shows a still life subject with just the Basic panel corrections applied.

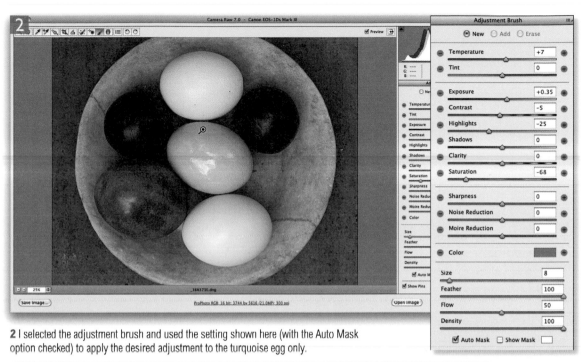

2 I selected the adjustment brush and used the setting shown here (with the Auto Mask option checked) to apply the desired adjustment to the turquoise egg only.

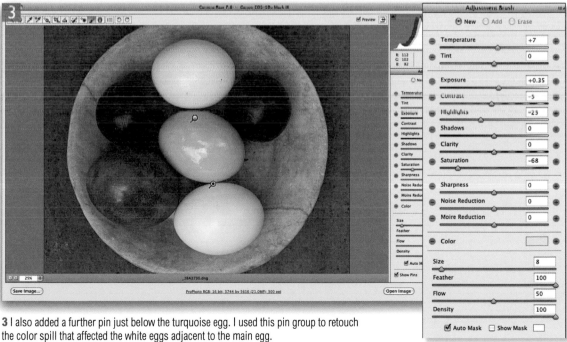

3 I also added a further pin just below the turquoise egg. I used this pin group to retouch the color spill that affected the white eggs adjacent to the main egg.

Darkening the shadows

With Process 2012 we now have a lot more tools at our disposal when making localized adjustments. I wanted to focus here though on the Shadows slider. In many ways the Shadows adjustment is a bit like the Fill Light control that is available in Process 2010. As you raise the Shadows amount you can selectively lighten the shadow to midtone areas. Conversely, you can apply a negative amount in order to darken the shadows more. I see this as being particularly useful in situations like the one shown here, where you can use this type of regional adjustment to make a dark backdrop darker and clip to black.

Also, with the Highlights slider you can use negative amounts to apply localized adjustments to selectively darken the highlight areas and you can also use positive amounts to deliberately force highlight areas to clip to white. Therefore, you can use a positive Highlights adjustments to deliberately blow out some of the highlights in an image.

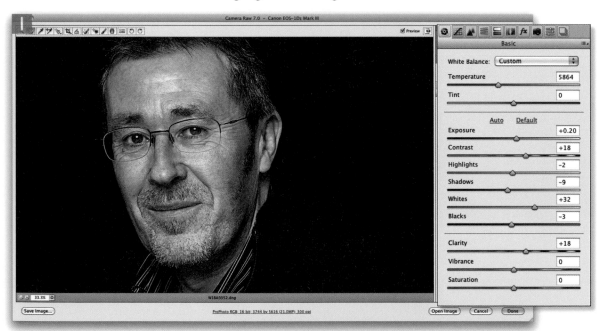

1 For this portrait I photographed my subject against a dark backdrop, which I wished to have appear black in the final image. As you can see, after carrying out preliminary Basic panel adjustments, there was still some detail showing in the backdrop.

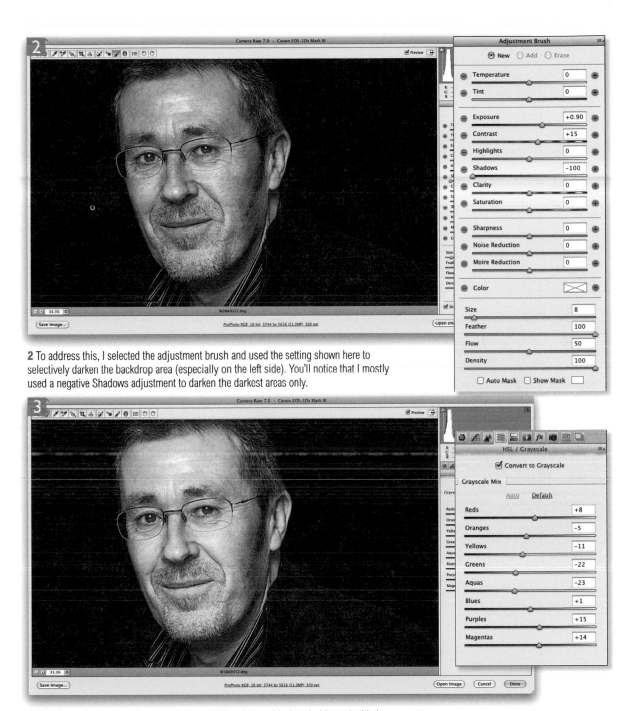

2 To address this, I selected the adjustment brush and used the setting shown here to selectively darken the backdrop area (especially on the left side). You'll notice that I mostly used a negative Shadows adjustment to darken the darkest areas only.

3 Here is the final version, in which I converted the photo to black and white and added a split tone effect.

Adjustment brush speed

The fact that you can apply non-destructive localized adjustments to a raw image is a clever innovation, but this type of editing can never be as fast as editing a pixel image in Photoshop. This example demonstrates how it is possible to get quite creative with the adjustment brush tool. In reality though it can be extremely slow to carry out such complex retouching with the adjustment brush, even on a fast computer.

Hand-coloring in Color mode

The adjustment brush tool can also be used to tint black and white images and this is a technique that works well with any raw, JPEG or TIFF image that is in color. This is because the auto mask feature can be used to help guide the adjustment brush to colorize regional areas that share the same tone and color. In other words, if the underlying image is in color, the auto mask has more information to work with. To convert the image to black and white, you can do what I did here and take the Saturation slider in the Basic panel all the way to the left. Alternatively, you can go to the HSL panel and set all the Saturation sliders to −100. The advantage of doing this is that you then have the option of using the HSL panel Luminance sliders to vary the black and white mix (see Chapter 6). After desaturating the image you simply select the adjustment brush and click on the color swatch to open the Color Picker dialog and choose a color to paint with.

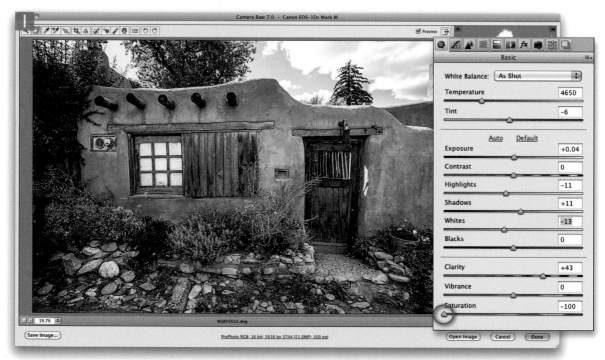

1 The first step was to go to the Basic panel and desaturate the colors in the image by dragging the Saturation slider all the way to the left.

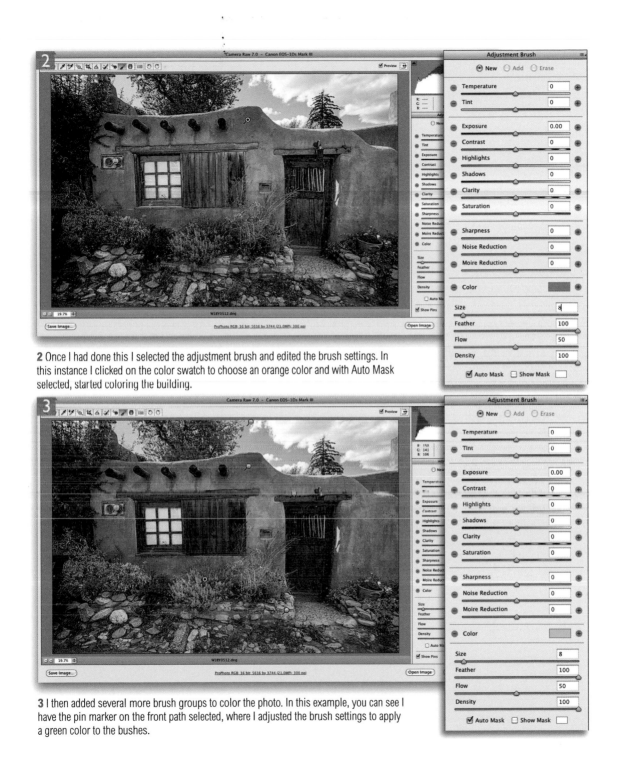

2 Once I had done this I selected the adjustment brush and edited the brush settings. In this instance I clicked on the color swatch to choose an orange color and with Auto Mask selected, started coloring the building.

3 I then added several more brush groups to color the photo. In this example, you can see I have the pin marker on the front path selected, where I adjusted the brush settings to apply a green color to the bushes.

Toggle the main panel controls

You can use the **G** key to toggle between the Graduated Filter panel and the main Camera Raw panel controls.

Resetting the sliders

As with the Adjustment brush options, double-clicking a slider arrow pointer resets it to zero, or to its default value.

Angled gradients

As you drag with the graduated filter you can do so at any angle you like and edit the angle afterwards. Just hover the cursor over the red or green line and click and drag. If you hold down the *Shift* key you can constrain the angle of rotation to 45° increments.

Graduated filter tool

Everything that has been described so far with regards to working with the adjustment brush more or less applies to working with the graduated filter (Figure 3.75), which allows you to add linear graduated adjustments. To use the graduated filter tool, click in the photo to set the start point (the point with the maximum effect strength), drag the mouse to define the spread of the graduated filter, and release to set the minimum effect strength point. There is no midtone control with which you can offset a graduated filter effect and there are no graduated filter options other than 'linear'.

Graduated filter effects are indicated by green and red pin markers. The green dashed line represents the point of maximum effect strength and the red dashed line represents the point of minimum effect strength. The dashed line between the two points indicates the spread of the filter and you can change the width by dragging the outer pins further apart and move the position of the gradient by clicking and dragging the central line.

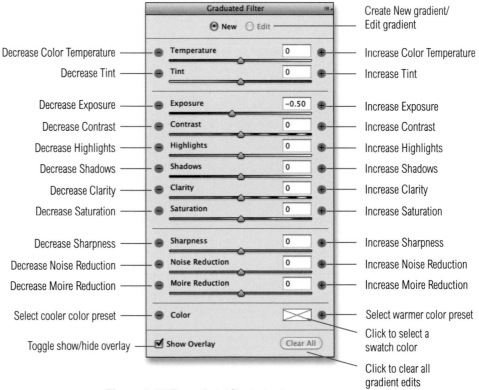

Figure 3.75 The graduated filter tool options.

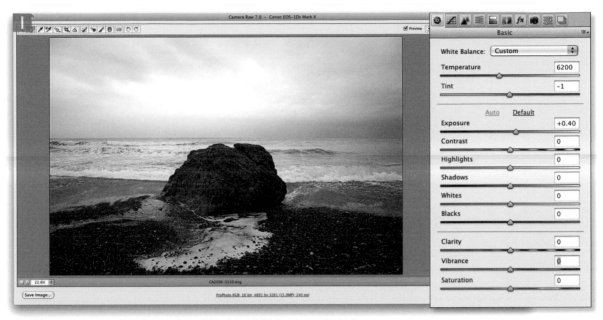

1 In this screen shot you see an image where all I had done initially was to optimize the Exposure and Contrast.

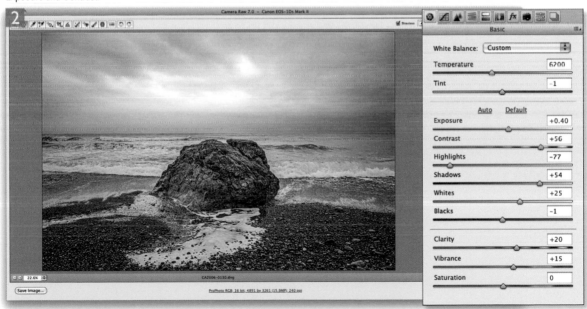

2 With the Process 2012 controls there is a lot that you can do to a photo like this just by adjusting the Highlights and Shadows sliders to reveal more detail in the sky and the rock in the foreground.

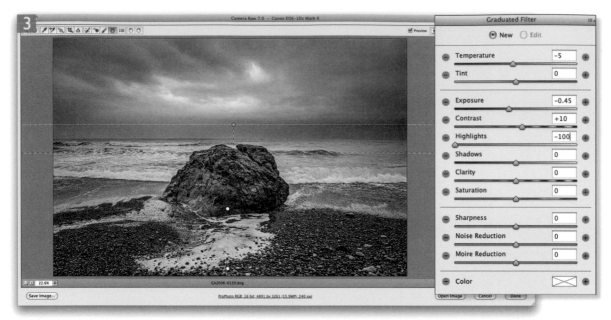

3 I then added a couple of graduated filter effects. With the main one you see here I decreased the Exposure and Highlights and added a little more Contrast to the sky.

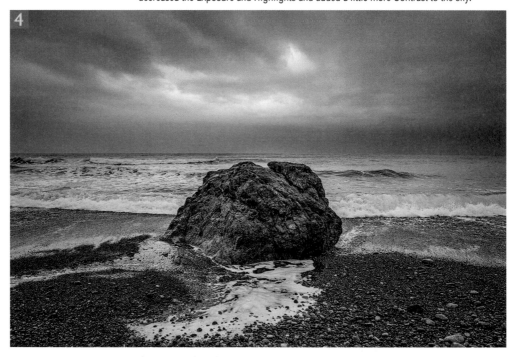

4 Here is the final Camera Raw processed version.

Color temperature adjustments

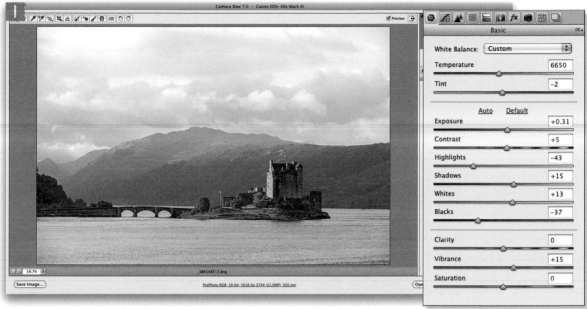

1 This photograph was taken just after sunrise with a nice warm light hitting the side of the castle.

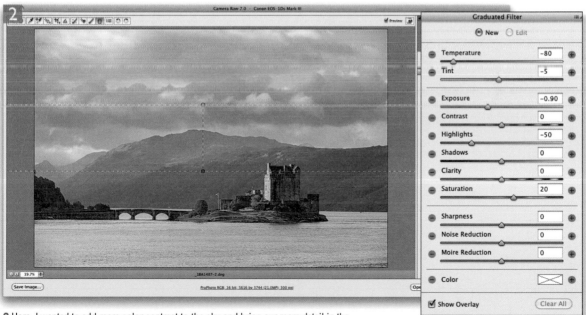

2 Here, I wanted to add more color contrast to the sky and bring our more detail in the clouds. I selected the graduated filter tool and applied the settings shown here to the sky.

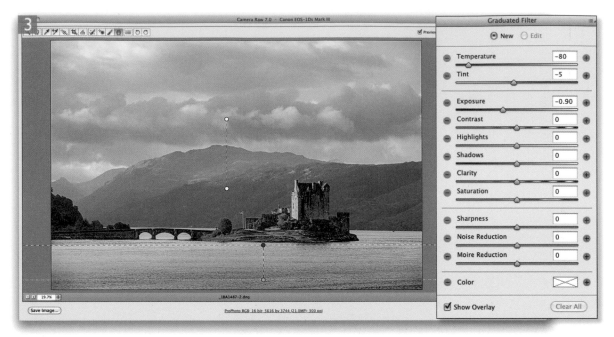

3 I also added a further graduated filter to the bottom of the image. Here, I wanted to darken the bottom and add more contrast.

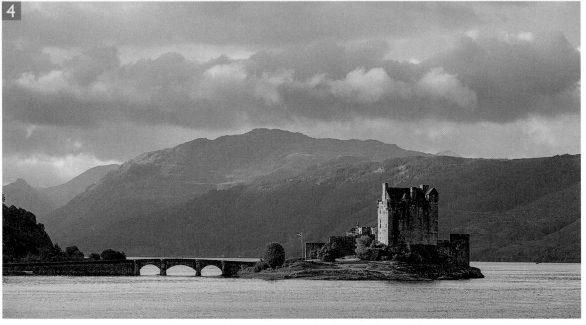

4 This shows the final version where I also boosted the Vibrance slightly.

Camera Raw settings menu

If you mouse down on the Camera Raw menu (circled in Figure 3.76) this reveals a number of Camera Raw settings options. 'Image Settings' is whatever the Camera Raw settings are for the current image you are viewing. This might be a default setting or it might be a custom setting you created when you last edited the image in Camera Raw. 'Camera Raw Defaults' resets the default settings in all the panels and applies whatever the white balance setting was at the time the picture was captured. 'Previous Conversion' applies the Camera Raw settings that were applied to the previously saved image.

If you proceed to make any custom changes while the Camera Raw dialog is open, you'll also see a 'Custom Settings' option. Whichever setting is currently in use will be shown with a check mark next to it and below that is the 'Apply Preset' submenu that let's you quickly access any pre-saved presets (which you can also do via the Presets panel that is discussed on page 253 onwards).

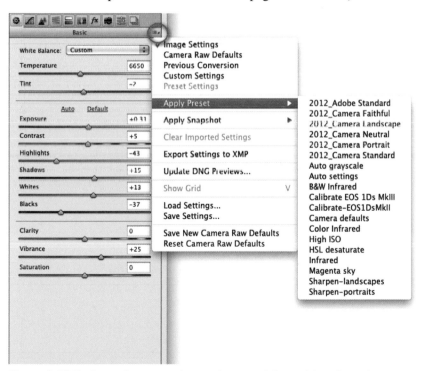

Figure 3.76 The Camera Raw menu options can be accessed via any of the main panels by clicking on the small menu icon that's circled here.

The Camera Raw database

The Camera Raw preferences gives you the option to save the XMP metadata to the Camera Raw database or to the XMP sidecar files (or the XMP space in the file header). If you choose to save to the Camera Raw database, all the Camera Raw adjustments you make will be saved to this central location only. An advantage of this approach is that it makes it easier to back up the image settings. All you have to do is ensure that the database file is backed up, rather than the entire image collection.

On a Mac, the Adobe Camera Raw Database file is stored in: username/Library/ Preferences. On Windows it is stored in: Username\AppData\Roaming\Adobe\ CameraRaw. However, if you are working with Bridge and Lightroom, Lightroom will not be able to pick up any changes made to an image using Camera Raw via Photoshop or Bridge. You then have two options. You either have to remember to select the photos first in Camera Raw and choose 'Export Settings to XMP', or forget about saving image settings to the Camera Raw database and ensure that the 'Save image settings to XMP sidecar files' option is selected in the Camera Raw preferences.

Figure 3.77 When 'Update DNG Previews' is selected you can force update the JPEG previews in a DNG file, choosing either a Medium Size or Full Size preview. You can also chose to 'Embed Fast Load Data'.

Export settings to XMP

If you refer to the Camera Raw preferences shown in Figure 3.21 on page 164, there is an option to save the image settings either as sidecar ".xmp" files, or save them to the 'Camera Raw database'. If the 'sidecar ".xmp" files' option is selected, the image settings information is automatically written to the XMP space in the file header. This is what happens for most file formats, including DNG. In the case of proprietary raw files such as CR2s or NEFs, it would be unsafe for Camera Raw to edit the header information of an incompletely documented file format. To get around this the settings information is stored using XMP sidecar files, which share the same base file name and accompany the image whenever you use Bridge or Lightroom to move a raw file from one location to another. Storing the image settings in the XMP space is a convenient way of keeping the image settings data stored locally to the individual files instead of it being stored only in the central Camera Raw database. If 'Save image settings in Camera Raw database' is selected in the Camera Raw preferences you can always use the 'Export Settings to XMP' option from the Camera Raw options menu (Figure 3.76) to manually export the XMP data to the selected images. For example, if you are editing a filmstrip selection of images and want to save out the XMP data for some images, but not all, you could use the 'Export Settings to XMP' menu command to do this (see also the sidebar).

Update DNG previews

DNG files can store a JPEG preview of how the processed image should look based on the last saved Camera Raw settings. If you refer again to the Camera Raw preferences (Figure 3.21), there is an option to 'Update embedded JPEG previews'. When this is checked, the DNG JPEG previews are automatically updated, but if this option is disabled in the Camera Raw preferences you can manually update the JPEG previews by selecting 'Update DNG Previews…' from the Camera Raw options menu (Figure 3.76). This opens the Update DNG Previews dialog shown in Figure 3.77.

Load Settings... Save Settings...

These Camera Raw menu options allow you to load and save pre-created XMP settings. Overall, I find it preferable to click on the New Preset button in the Preset panel (discussed opposite) when you wish to save a new Camera Raw preset.

Camera Raw defaults

The 'Save New Camera Raw Defaults' Camera Raw menu option creates a new default setting based on the current selected image. Note that these defaults are also affected by the 'Default Image Settings' that have been selected in the Camera Raw preferences (see "Camera-specific default settings" on page 189).

Presets panel

The Presets panel is used to manage saved custom Camera Raw preset settings.

Saving and applying presets

To save a preset, you can go to the Camera Raw fly-out menu and choose Save Settings… Or, you can click on the Add Preset button in the Presets panel (circled in Figure 3.78) to create a new Camera Raw preset. A preset can be one that is defined by selecting all the

New Camera Raw defaults

The Save New Camera Raw Defaults option will make the current Camera Raw settings sticky every time from now on when Camera Raw encounters a new file. This includes images processed by Bridge. So for example, if you were working in the studio and had achieved a perfect Camera Raw setting for the day's shoot, you could make this the new Camera Raw default setting. All subsequent imported images will use this setting by default. At the end of the day you can always select 'Reset Camera Raw defaults' from the Camera Raw options menu to restore the default Camera Raw camera default settings.

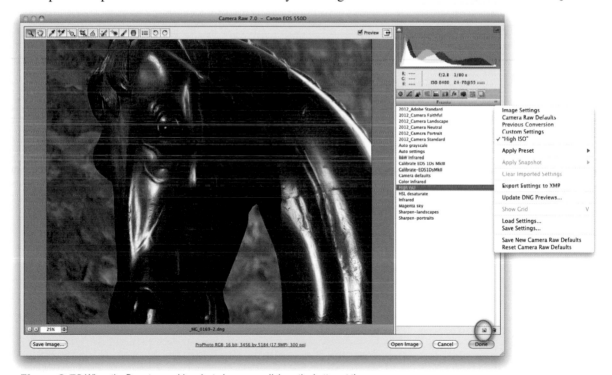

Figure 3.78 When the Presets panel is selected, you can click on the button at the bottom (circled) to add Camera Raw settings as a new preset. In this example I saved a High ISO preset using the New Preset settings shown in Figure 3.79. You can also use the Load Settings… and Save Settings… menu options to load and save new presets.

Camera Raw preset wisdom

Before you save a Camera Raw preset, it is important to think carefully about which items you need to include in a preset. When saving presets it is best to save just the bare minimum number of options. In other words, if you are saving a grayscale conversion preset, you should save the Grayscale Conversion option only. If you are saving a camera body and ISO-specific camera default, you might want to save just the Camera Calibration and Enable lens profile correction settings. The problem with saving too many attributes is that although the global settings may have worked well for one image, there is no knowing if they will work as effectively on other images. It is therefore a good idea to break your saved presets down into smaller chunks.

Camera Raw settings, or it can be one that is made up of a subset of settings (as shown in Figure 3.79). Either way, a saved preset will next appear listed in the Presets panel as well as in the Apply Preset menu (Figure 3.76). Just click on a setting to apply it to an image. To remove a preset setting, go to the Presets panel, select it and click the Delete button at the bottom, next to the Add new preset button (see Figure 3.78).

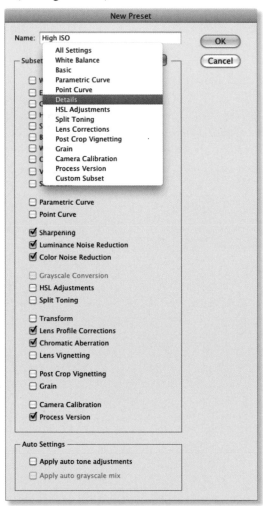

Figure 3.79 The New Preset dialog can be accessed by clicking on the New Preset button (circled in Figure 3.78). You can choose to save All Settings to record all the current Camera Raw settings as a preset. You can select a sub setting selection such as: Basic, or HSL Adjustments, or you can manually check the items that you want to include in the subset selection that will make up a saved Camera Raw preset.

Copying and synchronizing settings

If you have a multiple selection of photos in the Camera Raw dialog you can apply synchronized Camera Raw adjustments to all the selected images at once. For example, you can ⌘ *ctrl*-click or *Shift*-click to make an image selection via the Filmstrip, or click on the Select All button to select all images. Once you have done this any adjustments you make to the most selected photo are simultaneously updated to all the other photos too. Alternatively, if you make adjustments to a single image, then include other images in the Filmstrip selection and click on the Synchronize… button, this pops the Synchronize dialog shown in Figure 3.80. Here you can select the specific settings you wish to synchronize and click OK. The Camera Raw settings will now synchronize to the currently selected image. You can also copy and paste the Camera Raw settings via Bridge. Select an image and choose Edit ⇨ Develop Settings ⇨ Copy Camera Raw Settings (⌘ ⌥ *C* *ctrl* *alt* *C*). Then select the image or images you wish to paste the settings to and choose Edit ⇨ Develop Settings ⇨ Paste Camera Raw Settings (⌘ ⌥ *V* *ctrl* *alt* *V*).

Figure 3.80 When the Synchronize options dialog box appears you can select a preset range of settings to synchronize with or make your own custom selection of settings to synchronize the currently selected images.

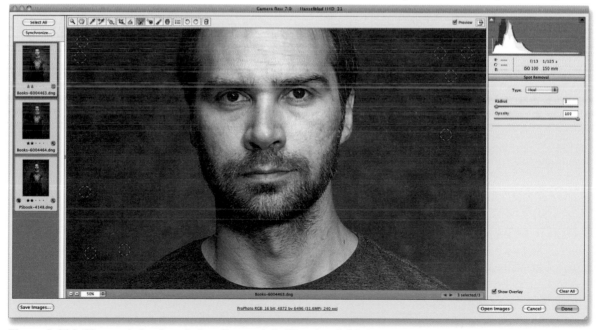

Figure 3.81 In this example, I made a selection of images via the Filmstrip and clicked the Synchronize… button, which opened the dialog shown in Figure 3.80.

Figure 3.82 If there is a process version conflict when selecting multiple files, there will be the option to convert all the selected files to the process version that's applied to the most selected image.

Copying and pasting settings

Whenever you copy Camera Raw settings, Camera Raw utilizes the Basic panel settings associated with the process version of the selected image, and automatically includes the process version of the image in the copy settings. You can override this by disabling the Process Version box. But as you will gather from what's written here, it is inadvisable not to include the process version when synchronizing or copying settings.

Synchronizing different process versions

The Synchronize command will work as described, providing the photos you are synchronizing all share the same process version. If you have a mixture of process version images selected, the Basic panel will appear as shown in Figure 3.82, highlighting the fact that the selected images have differing, incompatible process versions. What happens next when you synchronize depends on whether you have the Process Versions box checked or not. If checked, it synchronizes the selected photos converting them to the process version of the most selected photo and updates them accordingly. If unchecked, it synchronizes just those settings that are common to the process versions that are applied to the selected images and ignores all the others (see Figure 3.83). Be aware that such synchronizations can produce unexpected-looking results. In any case, converting Process 2012 images to Process 2010 with the Process Version box checked can also produce unpredictable results.

Legacy presets

If the Process Version box is checked when saving a preset (see Figure 3.79), the process version is included when applying the preset to other images. If the photos you apply this preset to share the same process version, no conversion takes place, but if they don't share the same process version they'll have to be converted. If the Process Version box isn't checked when you create a preset, things again become more unpredictable. In this situation no process version is referenced when applying the preset. Therefore, if you apply a Process 2010 preset (without including the process version) to a Process 2012 image, settings such as Recovery or Fill Light won't be translated. Similarly, if you apply a Process 2012 preset (without including the process version) to a Process 2010 photo, settings like Highlights and Shadows won't be recognized either.

Older presets that don't contain Basic or Tone Curve panel adjustments (other than White Balance, Vibrance and Saturation) will still work OK when applied to Process 2012 images. Where legacy presets do contain Basic or Tone Curve panel settings, they'll only continue to work effectively on images that share the same process version. Therefore, when creating new presets it is important to check the Process Version box. When you do this, if the image you apply the preset to has the same process version, nothing happens – the preset is applied as normal. If it has a different process version a conversion is carried out.

Synchronize Process 2010 to Process 2012 master **Synchronize Process 2012 to Process 2010 master**

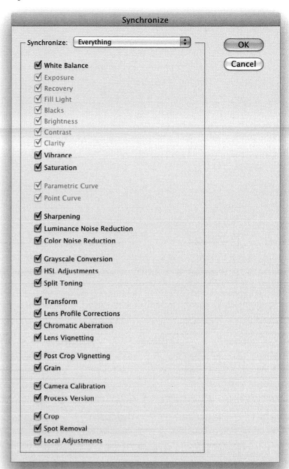

Figure 3.83 If there is a process version mismatch when synchronizing settings, the Process Version box determines what will happen. If checked, those photos with differing process versions will be updated to match the process version of the most selected image. If you attempt to synchronize Process 2010 images to a Process 2012 master, the adjustments that are new in Process 2012: Exposure, Contrast, Highlights, Shadows, Blacks, Whites, Clarity and Tone Curve will be applied by default, which is why the boxes next to the above settings are all checked and dimmed (meaning you can't edit them). Similarly, if you attempt to synchronize Process 2012 images to a Process 2010 master, the Exposure, Recovery, Fill Light, Blacks, Brightness, Contrast, Clarity and Tone Curve adjustments will be checked by default. If you deselect the Process Version box the above process version-specific settings will be disabled completely. When this is done only those settings that can be synchronized (without applying a process version conversion) will be synchronized, which in turn can lead to unpredictable results.

Lightroom snapshots

Snapshots can also be created in
Lightroom and as long as you save
and update the metadata to the file
(in Lightroom), these can be read in
Camera Raw. Similarly, snapshots
applied in Camera Raw can also be read
in Lightroom. The only limiting factor
is whether the Develop settings are
compatible between your current version
of Camera Raw and Lightroom.

Working with Snapshots

As you work in Camera Raw you can save favorite Camera Raw
settings as snapshots via the Snapshots panel. The ability to save
snapshots means that you are not limited to applying only one type
of Camera Raw rendering to an image. By using snapshots you can
easily store multiple renderings within the image file's metadata
and with minimal overhead, since the Camera Raw snapshots you
save will only occupy a small amount of file space. I find snapshots
are extremely useful and I use them a lot whenever I wish to
experiment with different types of processed looks on individual
images, or save in-between states.

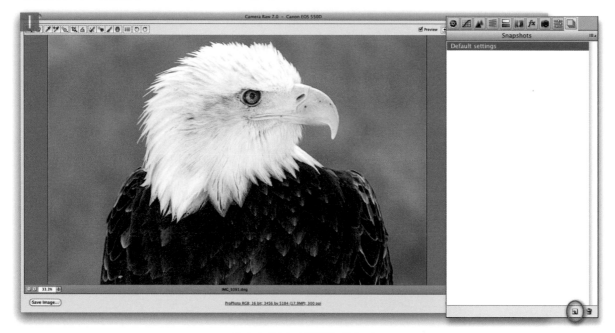

1 The Snapshots panel can be used to store multiple versions of Camera Raw settings.
When you visit this panel you may sometimes see a snapshot called 'Import', which will be
the setting that was first applied to the photo at the time it was imported. What you can do
here is make adjustments to the photo using the Camera Raw controls and use this panel
to create new saved snapshots. To begin with I clicked on the Add New Snapshot button
(circled) to save this setting as a snapshot called 'Default settings'.

2 I then adjusted the Camera Raw settings to create an optimized adjustment and saved this as an 'Optimized edit' snapshot.

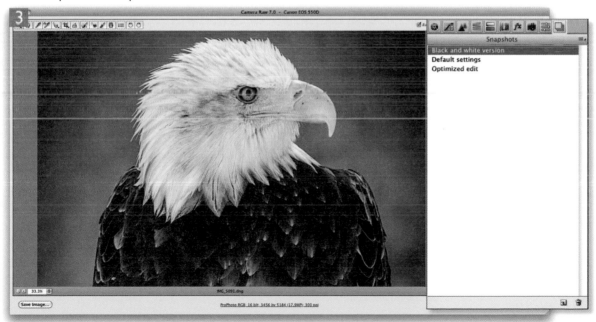

3 Finally, I created a black and white version and saved this too as a snapshot.

Raw compatibility and DNG adoption

Fifteen years ago, Adam Woolfitt and myself conducted a test report on a range of professional and semi-professional digital cameras. Wherever possible, we shot using raw mode. I still have a CD that contains the master files and if I want to access those images today I am, in some cases, going to have to track down a computer capable of running Mac OS 8.6, in order to load the camera manufacturer software that will be required to read the data! If that is a problem now, what will the situation be like in another 15 years' time? Over the last few years DNG has been adopted by many of the mainstream software programs such as Phase One Media Pro 1, Capture One, Portfolio and Photo Mechanic. At this time of writing, there are Hasselblad, Leica, Pentax, Ricoh, Casio and Samsung cameras that support DNG as a raw capture format option. You might also like to visit the www.openraw. org site where you can join the Open Raw discussion group and read the results of their 2006 raw survey.

DNG file format

In the slipstream of every new technology there follows the inevitable chaos of lots of different new standards competing for supremacy. Nowhere is this more evident that in the world of digital imaging. In the last 15 years or so, we have seen many hundreds of digital cameras come and go along with other computer technologies such as Syquest disks and SCSI cables, and in that time I have probably encountered well over a hundred different raw format specifications. It would not be so bad if each camera manufacturer were to adopt a raw format specification that could be applied to all the cameras they produced. Instead we've seen raw formats evolve and change with each new camera model that has been released and those changes have not always been for the better.

The biggest problem is that with so many types of raw formats being developed, how reliable can any one raw format be for archiving your images? It is the proprietary nature of these formats that is the central issue here. At the moment, all the camera manufacturers appear to want to devise their own brand of raw format. As a result of this if you need to access the data from a raw file, you are forced to use *their* brand of software in order to do so. Now, while the camera manufacturers may have excelled in designing great hardware, the proprietary raw processing software they have supplied with those cameras has mostly been quite basic. Just because a company builds great digital cameras, it does not follow that they are going to be good at designing the software that's needed to read and process the raw image data.

The DNG solution

Fortunately there are third-party companies who have devised ways to process some of these raw formats, which means that you are not always limited to using the software that comes with the camera. Adobe is the most obvious example here of a company who are able to offer a superior alternative, and at this time of writing, Camera Raw can recognize the raw formats from over 350 different cameras.

The DNG (digital negative) file format specification came about partly as a way to make Adobe's life easier for the future development of Camera Raw and make Adobe Photoshop compatible with as many cameras as possible. DNG is a well

thought out file format that is designed to accommodate the many different requirements of the proprietary raw data files in use today. DNG is also flexible enough to adapt to future technologies and has recently been updated to work with cameras that store proprietary lens correction data in the raw file. Because DNG is an open standard, the specification is freely available for anyone to develop and to incorporate it into their software or camera system. It is therefore hoped that the camera manufacturers will continue to adopt the DNG file format and that DNG will at some point be offered at least as an alternative file format choice on the camera.

DNG brings several advantages. Since it is a well-documented open-standard file format, there is less risk of your raw image files becoming obsolete. There is the potential for ongoing support for DNG despite whatever computer program, computer operating system or platform changes that may take place in the future. This is less likely to be the case with proprietary raw files. Can you imagine in, say, 25 years' time there will be guaranteed support for the CR2 or NEF files shot with today's cameras?

DNG compatibility

When raw files are converted to DNG the conversion process aims to take all the proprietary MakerNote information that is sitting alongside the raw image data in the raw original and place it into the DNG. Any external DNG-compatible software should have no problem reading the raw data that is rewritten as a DNG. However, there are known instances where manufacturers have placed some of the MakerNote data in odd places, such as alongside the embedded JPEG preview. At one point this was discarded during the conversion process (but has now been addressed in Camera Raw 5.6 or later). Basically, the DNG format is designed to allow full compatibility, but is in turn dependent on proper implementation of the DNG spec by third-parties.

Note that converting JPEGs to DNG won't allow you to magically turn them into raw files, but with the advent of lossy DNG, there are better reasons to now consider doing so. Where a JPEG has been edited using Camera Raw or Lightroom, when you save using the DNG format a Camera Raw generated preview is saved with the file. The advantage of this is that Camera Raw/Lightroom adjustments can now be seen when previewing such images in other (non-Camera Raw aware) programs.

Should you keep the original raws?

It all depends if you feel comfortable discarding the originals and keeping just the DNGs. Some proprietary software such as Canon DPP is able to recognize and process dust spots from the sensor using a proprietary method that relies on reading private XMP metadata information. Since DPP is a program that does not support DNG, if you delete the original CR2 files you won't be able to process the DNG versions in DPP. The only solution here is to either not convert to DNG or choose to embed the original raw file data when you convert to DNG. This means you retain the option to extract the CR2 raw originals any time you need to process them through the DPP software. The downside is that you end up with bloated DNG files that will be at least almost double in size.

Saving images as DNG

To convert images to DNG, you can either do so at the time you import photos from the camera (see page 141), or when you click on the Save Image button in the Camera Raw dialog. This will open the dialog shown in Figure 3.84, where you can see the options available when saving an image using the DNG format.

Lossy DNG

In Camera Raw 7 it is now possible to save DNG files using lossy compression while preserving most of the raw DNG aspects of the image, such as the tone and color controls. To do this you need to check the 'Use Lossy Compression' option. When this option is enabled you can also reduce the pixel dimensions of a raw image by selecting one of the resize options shown in Figure 3.84. If you limit the resulting DNG image size by the number of megapixels, the compression amount will be unaffected and the pixel dimensions of the final image will adapt to fit the number of megapixels. Whenever you resize a DNG in this way the image data has to be demosaiced, but is still kept in a linear RGB space. This means that while the demosaic processing becomes baked into the image, most of the other Develop controls such as those for tone and color remain active and function in the same way as for a normal raw/DNG image. Things like Lens Correction adjustments for vignetting and geometric distortion will be scaled down to the DNG output size. The same is true for sharpening, where the slider adjustments for things like Radius are scaled down to the new downsampled size.

You do want to be careful about where and when you use lossy compression for DNG. On the one hand, 'baking' the demosaic processing is a one-way street. Once done, you'll never be able to demosaic the raw data differently. Will Adobe (or someone else) one day come up with an even better way to demosaic a raw image? They might do, but it's unlikely to make that big a difference. Overall, I would say if you don't need to compress your DNG files, then don't – aim to preserve your raw files in as flexible a state as possible. On the other hand, I do foresee some uses. A lot of photographers are into time-lapse video created using digital SLR cameras. Here I reckon it would be a good idea to archive the raw stills for such projects as lossy DNGs. Another benefit of lossy DNG is that I am now able to provide more images from this chapter as downsized DNGs for readers to experiment with.

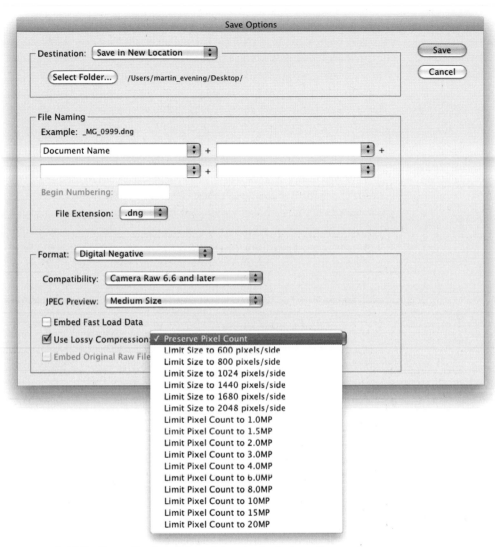

Figure 3.84 The Camera Raw Save Options dialog, showing the Lossy Compression DNG options, including the pixel size menu choices.

Maintaining ACR compatibility

If you refer back to page 136, you can read how it is possible to use the DNG Converter program to convert new camera files to DNG and thereby maintain Camera Raw support with older versions of Photoshop and Camera Raw.

DNG Converter

Adobe have made the DNG Converter program (Figure 3.85) available as a free download from their website: www.adobe.co.uk/products/dng/main.html. The DNG Converter is able to convert raw files from any camera that is currently supported by Camera Raw. The advantage of doing this is that you can make backups of your raw files in a file format that allows you to preserve all the data in your raw captures and archive them in a format that has a greater likelihood of being supported in the future. I personally feel quite comfortable converting my raw files to DNG and deleting the original raw files. I don't see the need to embed the original raw file data in the DNG file since this will unnecessarily increase the file size. However, if you do feel it is essential to preserve complete compatibility, embedding the original raw file data will allow you to extract the original native raw file from the DNG at some later date. The advantage of this is it provides complete compatibility with the camera manufacturer's software. The downside is that you may more than double the size of your DNG files.

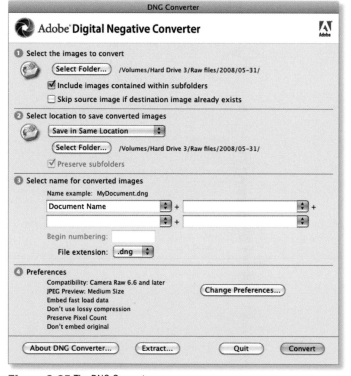

Figure 3.85 The DNG Converter program.

Chapter 4

Sharpening and noise reduction

This chapter is all about how to pre-sharpen your photographs in Photoshop and reduce image noise. Here, I will be discussing which types of images need presharpening, which don't and what are the best methods to use for camera captured or scanned image files.

In previous editions of this book I found it necessary to go into a lot of detail about how to use the Unsharp Mask filter and the Photoshop refinement techniques that could be used to improve the effectiveness of this filter. Now that the sharpening and noise reduction controls in Camera Raw have been much improved, I strongly believe that it is best to carry out the capture sharpening and noise reduction for both raw and scanned TIFF images in Camera Raw first, before you take them into Photoshop. Therefore, the first part of this chapter is devoted entirely to Camera Raw sharpening and noise reduction.

Real World Image sharpening

If you want to learn more about image sharpening in Camera Raw, Lightroom and Photoshop then I can recommend: *Real World Image Sharpening with Adobe Photoshop, Camera Raw, and Lightroom* (2nd Edition) which is available from Peachpit Press. ISBN: 0321637550. The first edition was authored by Bruce Fraser. This new version is an update of Bruce's original book, now co-authored by Jeff Schewe.

Print sharpening

I should also mention here that this chapter focuses solely on the capture and creative sharpening techniques for raw and non-raw images. I placed this chapter near the beginning of the book quite deliberately, since capture sharpening should ideally be done first (at the Camera Raw stage) before going on to retouch an image. The output sharpening, such as the print sharpening, should be done last. For more about print output sharpening, please refer to Chapter 12.

When to sharpen

All digital images will require sharpening at one or more stages in the digital capture and image editing process. Even if you use the finest resolution camera and lens, it is inevitable that some image sharpness gets lost along the way from capture through to print. At the capture end, image sharpness can be lost due to the quality of the optics and the image resolving ability of the camera sensor, which in turn can also be affected by the anti-aliasing filter that covers the sensor (and blurs the camera focused image very slightly). With scanned images you have a similar problem: the resolving power of the scanner sensor and the scanner lens optics can lead to scans that are slightly lacking in sharpness. These main factors can all lead to capture images that are less sharp than they should be.

When we come to make a print, all print processes will cause some sharpness to be lost, so it is always necessary to add some extra sharpening at the end, just before sending the photograph to the printer. Also, between the capture and print stages you may find that some photographs can do with a little localized sharpening to make certain areas of the picture appear that extra bit sharper. This briefly summarizes what we call a multi-pass sharpening workflow: capture sharpening followed by an optional creative sharpen, followed by a final sharpening for print.

Why one-step sharpening is ineffective

It may seem like a neat idea to use a single step sharpening that takes care of the capture sharpening and print sharpening in one go, but it's just not possible to arrive at a formula that can work for all source images and all output devices. There are too many variables that have to be taken into account and it actually makes things a lot simpler to split the sharpening into two stages. A capture image sharpening should be applied at the beginning and an appropriate amount of output sharpening should be applied at the end, dependent on the type of print you are making and the size of the print output.

Capture sharpening

The majority of this chapter focuses on the capture sharpening stage, which is also referred to as pre-sharpening. It is critical that you get this part right because capture sharpening is one of the first

things you do to an image before you start any retouching work. The question then is, which images need sharpening and of those that do need sharpening, how much sharpening should you apply?

Let's deal with JPEG capture images first. If you shoot using the JPEG mode, your camera will already have sharpened and attempted to reduce the noise in the capture data, so no further pre-sharpening or noise reduction is necessary. Since JPEG captures will have already undergone such a transformation there is no way to undo what has already been fixed in the image. I suppose you could argue that since some cameras allow you to disable the sharpening in JPEG mode, you could do this separately in Camera Raw, but I think this runs counter to the very reason why some photographers prefer to shoot JPEG in the first place. They do so because they want their pictures to be fully processed and ready to proceed to the retouching stage. So, if you are exclusively shooting in JPEG mode, capture sharpening isn't something you really need to worry about and you can skip the first section of this chapter.

If you shoot in raw mode it won't matter what sharpen settings you have set on your camera; these have no effect on the raw file, since it's an unprocessed image. Any capture sharpening must be done either in the raw processing program or afterwards in Photoshop. Up until recently most experts (myself included) were suggesting that you disable the sharpening in Camera Raw and use Photoshop to apply the capture sharpening. Well, all that changed with the Camera Raw 4.1 update and it now makes sense to carry out the capture sharpening at the Camera Raw image processing stage *before* you open your images in Photoshop.

Capture sharpening for scanned images

Scanned images may have already been pre-sharpened by the scanning software and some scanners do this automatically without you even realizing it. If you prefer to take control of the capture sharpening yourself you should be able to do so by disabling the scanner sharpening and use whatever other method you prefer. For example, you could use a third-party plug-in like PhotoKit Sharpener™, or follow the Unsharp Mask filter techniques I describe in the Image Sharpening PDF on the website. So long as you export your scanned images using the TIFF or JPEG format, you can open these images via Camera Raw, and use the same raw image sharpening methods as original raw files that I describe here.

PhotoKit™ Sharpener

Bruce Fraser devised the Pixel Genius PhotoKit Sharpener plug-in, which can be used to apply capture, creative and output sharpening via Photoshop. The work Bruce did on Photokit capture sharpening inspired the improvements made to the Sharpening controls in Camera Raw. It can therefore be argued that if you use Camera Raw you won't need to use Photokit Sharpener capture sharpening routines. Adobe also worked closely with Pixel Genius to bring the Photokit Sharpener output routines to the Lightroom Print module. If you are using Lightroom 2.0 or later, you will be able to take advantage of this. However, if you have Photoshop and Lightroom, Photokit Sharpener can still be useful for the creative sharpening and halftone sharpening routines it provides.

How to use the Unsharp Mask filter

The main book no longer covers the manual pre-sharpening techniques that use the Unsharp Mask filter. However, you will find a 20-page PDF document on the website that fully describes how to work with the Unsharp Mask filter sliders and outlines some of the advanced ways you can use the Unsharp Mask filter to achieve better capture sharpening results.

So what about all those techniques that rely on Lab mode sharpening or luminosity fades? Well, if you analyze the way Camera Raw applies its sharpening, these controls have almost completely replaced the need for the Unsharp Mask filter. In fact, I would say that the Unsharp Mask filter has for some time now been a fairly blunt instrument for sharpening images, plus I don't think it is advisable to convert from RGB to Lab mode and back again if it's unnecessary to do so. Compare the old ways of sharpening (including the techniques I described in my previous books) with the Camera Raw method and I think you'll find that this is now the most effective, if not the only way to capture sharpen your photos.

Process versions

As I mentioned in Chapter 3, in order to distinguish between pre-Camera Raw 6 and post-Camera Raw 6 sharpening and noise reduction, Camera Raw saw the introduction of Process Versions. As a result of this, legacy photos processed via Camera Raw 5 or earlier and photos processed via Lightroom 2 or earlier are classified as using Process 2003. All photos that have been edited subsequently in Camera Raw 6 or later can now be edited using Process 2010 or Process 2012.

Improvements to Camera Raw sharpening

Camera Raw 6 and 7, using the latest Process 2010 or 2012, offer better demosaic processing, sharpening and noise reduction. The combination of these three factors has led to better overall image processing. Having said that, it should be noted that only those cameras that use the three-color Bayer demosaic method are affected by this change. The demosaic processing for other types of sensor patterns such as the four-color shot cameras and the Fuji SuperCCD have not been modified. However, improvements have been made in the demosaic processing for specific camera models. For example, an improved green balance algorithm addresses the problem of maze pattern artifacts which were seen with the Panasonic G1 and this may also improve the image resolution for some other camera models too.

Let me try and explain what exactly has changed and how Camera Raw is now different. We can start by looking at the two image examples shown in Figure 4.1, where the top image shows a photograph edited using Process 2003 and the bottom one shows

Process 2003

Process 2010

Figure 4.1 This shows a comparison between a raw image processed in Process 2003 (top) and Process 2010 (bottom). Shown here is a magnified 4:1 comparison view.

Ideal noise reduction

The thing to understand here is that the ideal noise reduction in the demosaic process isn't where every trace of noise gets removed from the image. OK, so you might think this would be a good thing to achieve, but you would in fact end up with a photograph where the image detail in close-up would look rather plastic and over-smooth in appearance. What the Camera Raw engineers determined was this: it is better to concentrate on eradicating the noise we generally find obtrusive such as color and luminance pattern noise (which is usually a problem with high ISO capture), but preserve the residual luminance noise that is random in nature. The result of this precise filtering are images that are as free as possible of ugly artifacts, yet retain a fine-grain-like structure that photographers might be tempted to describe as being 'film-like'.

the same image processed via Camera Raw using Process 2010 (the underlying demosaic processing is effectively the same in Process 2012). What you see here is a section of an image that's been enlarged to 400% so that you can see the difference more clearly. The first thing to point out is that the new demosaic process is now more 'noise resistant', which means it does a better job of removing the types of noise that we find unpleasant such as color artifacts and structured (or pattern) noise. At the same time, the aim has been to preserve some of the residual, non-pattern noise which we do find appealing. The underlying principle at work here is that colored blotches or regular patterns tend to be more noticeable and obtrusive, whereas irregular patterns such as fine, random noise are more pleasing to the eye. The new demosaic process does a better job of handling color artifacts and filters the luminance noise to remove any pattern noise, yet retains some of the fine, grain-like structure. The net result is that Camera Raw is able to do a better job of preserving fine detail and texture and this is particularly noticeable when analyzing higher ISO raw captures.

The next component is the new revised sharpening. Sharpening is achieved by adding halos to the edges in an image. Generally speaking, halos add a light halo on one side of an edge and a dark halo on the other. To quote Camera Raw engineer Eric Chan (who worked on the new Camera Raw sharpening), 'good sharpening consists of halos that everybody sees, but nobody notices.' To this end, the halo edges in Camera Raw have been made more subtle and rebalanced such that the darker edges are a little less dark and the brighter edges are brighter. They are still there of course but you are less likely to actually 'see' them as visible halos in an image. You should only notice them in the way they create the illusion of sharpness. The Radius sharpening has also been improved. When you select a Sharpen Radius that's within the 0.5–1.0 range the halos are now made narrower. Previously the halos were still quite thick at these low radius settings and it should now be possible to sharpen fine-detailed subjects more effectively. You'll also read later about how the Detail panel Sharpen settings are linked to the Sharpen mode of the Adjustment tools. This means you can use the adjustment brush or gradient filter as creative sharpening tools to 'dial in' more (or less) sharpness. Lastly, we have the new, improved noise reduction controls which offer more options than before for removing the luminance and color noise from a photograph.

Sample sharpening image

To help explain how the Camera Raw sharpening tools work, I have prepared a sample test image that you can access from the DVD. The Figure 4.2 image has been especially designed to highlight the way the various slider controls work when viewed at 100%. Although this is a TIFF image, it's one where the image has been left unsharpened and the lessons you learn here can equally be applied to sharpening raw photos.

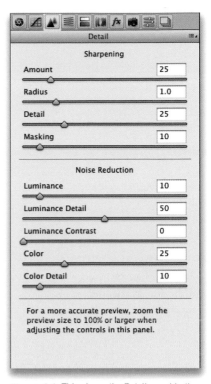

Figure 4.3 This shows the Detail panel in the Camera Raw dialog. Note that the Luminance Detail, Luminance Contrast and Color Detail sliders only appear active if the image has been updated to Process 2010 or Process 2012.

Figure 4.2 The sample image that's used on the following pages can be found on the website. To open this photo via Camera Raw, use Bridge to locate the test image and use File ⇨ Open in Camera Raw, or use the ⌘ R ctrl R keyboard shortcut.

Detail panel

To sharpen an image in Camera Raw, I suggest you start off by going to Bridge, browse to select a photo and choose File ⇨ Open in Camera Raw, or use the ⌘ R ctrl R keyboard shortcut. The Sharpening controls are all located in the Detail panel in the Camera Raw dialog (Figure 4.3). If the photo won't open via Camera Raw, check you have enabled TIFF images to open via Camera Raw in the Camera Raw preferences (see page 166).

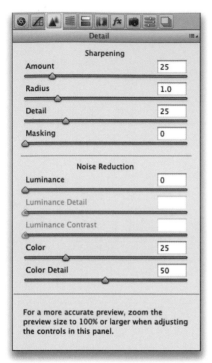

Figure 4.4 This shows the default settings for the Detail panel in Camera Raw when processing a raw image.

Sharpening defaults

The Detail panel controls consist of four slider controls: Amount, Radius, Detail and Masking. When you open a raw image via Camera Raw, you will see the default settings shown in Figure 4.4. But if you open a non-raw image up via Camera Raw, such as a JPEG or TIFF, the Amount setting defaults to 0%. This is because if you open a JPEG or TIFF image via Camera Raw it is usually correct to assume the image has already been pre-sharpened and it is for this reason the default sharpening for non-raw files is set at zero. You should only apply sharpening to JPEGs or TIFF images if you know for sure that the image has not already been sharpened. Note that the TIFF image used in the following steps normally opens with zero sharpening and noise reduction settings.

The Noise Reduction sliders can be used to remove image noise and we'll come onto these later, but for now I just want to guide you through what the sharpening sliders do.

The sharpening effect sliders

Let's start by looking at the two main sharpening effect controls: Amount and Radius. These two sliders control how much sharpening is applied and how the sharpening gets distributed.

If you want to follow the steps shown over the next few pages, I suggest you download a copy of the Figure 4.1 image from the website and use Bridge to open it via the Camera Raw dialog. To do this use File ⇨ Open in Camera Raw, or use the ⌘ R ctrl R keyboard shortcut. Then go to the Detail panel section (Figure 4.4). If you are viewing a photo at a fit to view preview size you will see a warning message that says: 'For a more accurate preview, zoom the preview size to 100% or larger when adjusting the controls in this panel', which means you should follow the advice given here and set the image view magnification in the Camera Raw dialog to a 100% view or higher. The test image I created is actually quite small and will probably display at a 100% preview size anyway. The main thing to remember is that when you are sharpening images, the preview display should always be set to a 100% view or higher for you to judge the sharpening accurately. In addition to this I should also point out that the screen shots over the next few pages were all captured as grayscale sharpening previews, where I held down the ⌥ alt key as I dragged the sliders. Note that you only get to see these grayscale previews if you are viewing the image at a 100% view or bigger if using Process Version 2003.